S0-BCU-120

IMPRESSIONIST AND POST-IMPRESSIONIST
DRAWING

NICHOLAS WADLEY

IMPRESSIONIST AND POST-IMPRESSIONIST DRAWING

Dutton Studio Books
New York

DUTTON STUDIO BOOKS

Published by the Penguin Group
Penguin Books USA Inc., 375 Hudson Street,
New York, New York, 10014, U.S.A.

Penguin Books Ltd, 27 Wrights Lane,
London W8 5TZ, England

Penguin Books Australia Ltd, Ringwood,
Victoria, Australia

Penguin Books Canada Ltd, 2801 John Street,
Markham, Ontario, Canada L3R 1B4

Penguin Books (N.Z.) Ltd, 182–190 Wairau Road,
Auckland 10, New Zealand

Penguin Books Ltd, Registered Offices:
Harmondsworth, Middlesex, England

First published by Dutton Studio Books, an imprint of Penguin Books USA Inc.

First printing, October 1991
10 9 8 7 6 5 4 3 2 1

Copyright © Nicholas Wadley, 1991
All rights reserved

Library of Congress
Catalog Card Number: 91-71092

Without limiting the rights under copyright reserved above,
no part of this publication may be reproduced, stored in
or introduced into a retrieval system, or transmitted, in any form, or by any
means (electronic, mechanical, photocopying,
recording, or otherwise), without the prior written permission
of both the copyright owner and the publisher of the book.

ISBN: 0-525-93362-X

This book was designed and produced by
LAURENCE KING LTD, LONDON
Designed by Karen Osborne
Typeset by Wyvern Typesetting Ltd, Bristol
Printed and bound by C.S. Graphics, Singapore

Contents

Photo Credits

© ADAGP/SPADEM, Paris and D.A.C.S., London 1991: Fig. 97; Plates: 108, 108a.
Galerie Brame and Lorenceau, Paris: Plate 107.
Agence Bulloz, Paris: Plate 30.
Caisse Nationale des Monuments Historiques et des Sites, Paris: Fig. 48; Plate 100a.
Christie, Manson and Woods, London and New York: Fig. 89; Plates: 52b; 70.
Courtesy of the Royal Academy, London (Photos Prudence Cuming Assocs): Plates: 37, 37a, 37b, 59.
© D.A.C.S. 1991: Figs. 21, 96; Plates: 38b, 77, 77a.
Devonshire Collection, Chatsworth. Reproduced by permission of the Chatsworth Settlement Trustees: Fig. 53.
Archives Durand-Ruel, Paris: Figs: 9, 80; Plates: 16b, 17a, 17b, 27a, 29, 35b.
Estate of Henri Matisse © D.A.C.S. 1991: Figs: 91, 92.
Courtesy Kunsthalle, Mannheim (Hauck-Werbe Studios): Fig. 21.
Marlborough Gallery, London: Plate 17.
Musées de la Ville de Paris © D.A.C.S. 1991: Plates: 49a, 57, 82b.
Courtesy of the Art Gallery of Ontario, Toronto: Plate 16.
Courtesy of the Oscar Ghez Foundation, Geneva: Plate 21b.
Photo Service of the Réunion des Musées Nationaux, Paris (Louvre, Département des Arts Graphics, Fonds Orsay):
Colour plates: I, III, VII, VIII, XIII.
Figs: 3, 6, 13, 17, 19, 32, 35, 51, 52, 75, 79, 83, 95.
Plates: 1b, 2, 6b, 8, 12b, 13, 13a, 15a, 23b, 26a, 27, 31a, 42, 48, 48b, 51, 52a, 54, 55a, 56a, 56b, 60, 69, 70a, 72b, 75, 75b, 77, 77a, 77b, 80a, 81a, 85b, 86b, 87b, 98b.
Rheinisches Bildarchiv: Plate 108.
Rijksbureau voor Kunsthistorisches Documentatie, s'Gravenhage: Plates: 90b, 91b.
Agence Roger–Viollet, Paris: Plate 103.
Photo Routhier, Studio Lourmel, Paris: Figs: 40, 59, 85, Plates: 32a, 34a, 36, 36a, 38, 38a, 107a.
Sotheby's Fine Art, London and New York: Plates: 17a, 25a, 97a.
Documents Robert Schmit, Paris: Plates: 1a, 107b.
Wildenstein Institute, New York: Plate 34.
Witt Library, Courtauld Institute, London: Fig. 53; Plate 13b.

Acknowledgements

I am grateful to those friends, colleagues and others whose discussion, advice and help have facilitated, sharpened, redirected or confused in rewarding ways my thinking and research for this book, over a long period. Among many such people, I am indebted to the late Keith Roberts, who first suggested the idea and to Laurence King, who was prepared to wait for its realisation; also, in many and various ways, to Dore Ashton, Blanche and Michel Bronstein, Else Bülow, Stephen Bury, Françoise Cachin, John Elderfield, Richard Field, Claire Frèches-Thory, Robert Gordon, John House, Christopher Lloyd, Stephanie Maison, Ronald Pickvance, John Rewald, Lawrence Rosen, Conal Shields, Pierre Schneider, Martin Sims, Ben Snyder, Herman Swart, the late Stefan Themerson, Richard Thompson, Gary Tinterow, Kirk Varnedoe, Judith Wechsler, Gerard Wilson and Christopher Yetton. I thank Barbara Wright and Judith Landry for their inventive guidance through problems of translation; Martha Kapos and Susie Morgan for their helpful comments on parts of the text; and Jasia Reichardt for her invaluable, unfailing support and imaginative criticisms.

Like anyone working on a book of this sort, I have been deeply dependent on the assistance and expertise of those who curate and service departments of drawings in museums. As well as countless people in England to whom I am equally grateful, I thank the following for their help and for making time to deal patiently with my persistent enquiries. In Austria: Marie-Luise Sternath at the Albertina, Vienna. In Denmark: Peder Munk at the Ny Carlsberg Glyptotek; Erik Fischer at the Royal Museum of Fine Arts, Cophenhagen; Hanne Finsen at the Ordrupgaardsamlingen. In France: Françoise Soulier-François at the Musée des Beaux-Arts et d'Archéologie, Besançon; Dominique Brachlianoff at the Musée des Beaux-Arts, Lyons; Arlette Serullaz and Françoise Viatte at the Musée du Louvre, Paris; Marianne Delafond at the Musée Marmottan, Paris; Monique Nonne and Anne Roquebert at the Musée d'Orsay, Paris. In Germany: Gottfried Riemann at the National-Galerie, Berlin; Karl Heinz Schultz at the Walraff-Richartz Museum, Cologne. In the Netherlands: J. W. Niemeijer, Vincent de Keyser and Marja Stykel at the Rijksmuseum, Amsterdam; Han van Crimpen and Sophie Pabst at the Rijksmuseum Vincent van Gogh; Toos van Kooten at the Rijksmuseum Kröller-Müller, Otterlo; A. W. F. M. Meij and Ger Luijten at the Boymans-van Beuningen Museum, Rotterdam. In Sweden: Ulf Cederlöv at the Nationalmuseum, Stockholm. In Switzerland: Franziska Heuss at the Kunstmuseum, Basel; Dr Terrucchi at the Kunsthaus, Zurich. In the United States: Barbara Shapiro and Judy Wineland at the Museum of Fine Art, Boston; Miriam Stewart at the Fogg Art Museum, Cambridge; Douglas Druick at the Art Institute of Chicago; Paula Berry at the Armand Hammer Foundation; Calvin Brown, Helen Mules and Susan Romanelli at the Metropolitan Museum, New York; Robert Evren at the Museum of Modern Art, New York; Roberta Waddell at the New York Public Library; Evelyn Phimister and Stephanie Wiles at the Pierpont Morgan Library, New York; James A. Ganz at the Philadelphia Museum of Art; Gregory Jecmen at the National Gallery of Art, Washington; Rafael Fernandez at the Sterling and Francine Clark Art Institute, Williamstown.

With the publishers, I am also grateful to all those museums and private collectors who have given permission for drawings to be reproduced, and to the many people who have helped Sara Waterson to locate elusive photographs.

Nicholas Wadley

Preface

This book spans the period from a time when there were accepted rules for drawing to a time when there were not. For the young impressionists, the main objection to the rules of drawing they were required to learn was that they were too remote from the realities of drawing from nature. Many of them felt that any rules were inhibiting; for some, the existing rules were not precise enough. John Ruskin's book, *The Elements of Drawing* (1857), was one of the most open-minded drawing manuals of its time, and exceptional in that it did attempt to establish principles for drawing from nature. (The book was later known to some of the impressionists.) Ruskin includes rules for making perspective drawings of landscape on glass, with a brush tied at the end of a stick, which the young van Gogh would have appreciated had he read them. But van Gogh would almost certainly have noted in the margin against this passage, as did the original owner of my own copy, 'length of stick?'.

It is not surprising that academies of art always concentrated more on rules governing the practice of drawing than on anything else. As well as being one of the most universal activities, in the sense that everyone has some experience of it, drawing is by nature a highly arbitrary affair. When Walter Pach published his collection of essays on artists in 1938, he called it *Queer Thing, Painting*. The practice of making black marks on white paper as representations of the real, three-dimensional world is at least as intrinsically bizarre as painting, and – in the absence of colour – even more abstract and cryptic. Degas likened it to a subtle kind of mathematics.

A study of the drawings of many painters over a given period is also, on the face of it, arbitrary. It involves isolating a part of each artist's oeuvre – the most private and speculative part – as well as separating drawings from the paintings to which they are often intimately related. If the paintings by the artists discussed in this book were not as familiar and well documented as they now are, such a study would be less accessible and of limited interest. Much of the meaning of the drawings and our curiosity about them arises from their relationship to the paintings. By comparison with their paintings, our familiarity with the drawings of the impressionists and post-impressionists is much less uniform, the product of an inadvertent tradition of treating drawings either in monographs on the outstanding draughtsmen or as a very marginal supplement to studies of painting. Redon was already complaining in the nineteenth century that drawing was not taken seriously enough by writers on art.

Substantial research and analysis has been devoted to the drawings of Degas, Cézanne, van Gogh and Seurat, and serious studies written on Manet, Pissarro and Gauguin. Among others, Theodore Reff's work on Degas, Lawrence Gowing's on Cézanne, Ronald Pickvance's on van Gogh, Robert Herbert's on Seurat and Richard Field's on the graphic work of Gauguin are inspiring studies that have given us exemplary foundations and methods. Yet in this field of monographs on artists' drawings, the literature is still very unbalanced, even in those cases where catalogues raisonnés have been published. There has been very little work on the drawings of Cassatt, Renoir or Morisot; almost nothing on Monet and Sisley. The first monograph on Caillebotte's drawings has just been published. The catalogue raisonné of Monet's drawings was unfortunately going to press at the time of writing, and its much-needed researches unavailable. Two or three pictorial anthologies of impressionist drawing were published during the 1980s, but the only serious attempt to look at the whole subject has been the catalogue by Christopher Lloyd and Richard Thompson of an exhibition of works from British collections (Oxford, 1986).

This unevenness in the literature is both responsible for and a product of large gaps in our knowledge of drawing of the second half of the nineteenth century. It is also influenced by two other issues. One is a matter of 'quality': not only the very varied attitudes to quality exhibited in drawings of the period, but also our subsequent prejudices about what may or may not be considered as 'good drawing', worthy of study. The other is the more basic matter of an imbalance created by the randomness of survival.

The survival of drawings is more vulnerable to chance than that of most works of art, and it seems likely that the casualty rate of impressionist drawings has been high enough to condition our understanding of the subject. The preservation or not of an artist's early drawings says a great deal about his or her own attitude to their value. Care of drawings at an artist's death is affected by whether there is a Lucien Pissarro or a Theo van Gogh (and son) to look after them. The subsequent preservation, loss or temporary disappearance of a drawing is subject to any number of random factors. Sketchbooks have been, and occasionally still are being dismembered and dispersed. Many more drawings than paintings remain in private collections, and the mobility of drawings, even of those that have entered museums, is greater. The cataloguing and the documentation of museum collections often take third place to those of painting

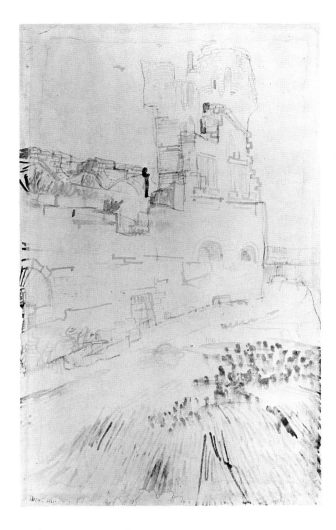

and sculpture, and are less complete in some cases than in others.

Of those drawings that have survived, many have changed in appearance. Discolouring of paper by over-exposure to light has transformed the balance of line to ground in many drawings. Where gouache, or in Seurat's case lead white, was used to heighten a black-and-white drawing, what was a correspondence between the whites of pigment and paper has sometimes become a contrast. Friable chalks and charcoal have been rubbed. Inks have faded. There are spectacular examples among the early Arles pen drawings of van Gogh (Fig. 1). They were originally drawn in an astringent violet ink – a colour he often used in watercolours – the fugitive pigment of which was so vulnerable to light that many lines have all but disappeared. Surviving lines have faded into a translucent pale brown and the drawings are often catalogued as in brown ink. The only traces of the original colour are to be found around the edges, where they have been protected from light under a passe-partout mount.

On other drawings, the authenticating stamps of ateliers, auction sales or museums have been superimposed, or inventory numbers written, intrusively enough to interfere with the drawing's integrity. Stamps are not sensitive to the scale, tone,

colour or delicacy of mark. In some cases the artist's own signature constitutes the same sort of interference. On a tiny sketch of Sancho Panza that Gauguin once owned – reproduced here two-thirds actual size (Fig. 2) – Daumier wrote his initials in a script large enough to threaten the existence of Don Quixote in the background. We must assume that a similarly disruptive effect caused by Whistler's butterfly monogram, which is often the most substantial or highly coloured element in his drawings, was intentional.

The quality of drawings by impressionist and post-impressionist painters is a central issue in their history. Judged by traditional standards, the works discussed here include some of the most remarkable in the history of drawing and some that would scarcely be regarded as drawings at all. Impressionist attitudes towards drawing were formed by a profound and cumulative dissatisfaction with academic criteria for 'good drawing', which came to a head in the third quarter of the century. The impressionists needed drawing to be different for their own purposes. They were drawing new subjects; they were looking at nature in different ways; and they were moved by different ideals. By the end of the century, these factors had changed attitudes towards drawing to the same degree that impressionism had influenced painting. In the process, the status of drawing as an independent art alongside painting, emancipated from its preparatory role, had been considerably enhanced.

The main text of this book investigates what is possible in the way of definitions of impressionist and post-impressionist theory and practice of drawing, and traces their sources. It does so through an analysis of the intricate web of correspondences and differences that unite or divide the artists. It is a history of changes, not of 'progress'. In the second section of the book, the commentaries to the plates focus on individual drawings and their place in the oeuvre of each artist.

In the interests of not inhibiting the enquiry, I have allowed myself the luxury of the broadest possible answers to the questions 'what is a drawing?'; and 'who or what is an impressionist?'. All works on paper are considered as relevant, as is the role of drawing in painting. The theoretical backgrounds to painting and drawing are often shared, and there are many instances of the practices of drawing and painting informing each other. The book does not attempt to trace the separate and rich histories of impressionist printmaking or book illustration. It does not set out to resolve problems more appropriate to a monograph, such as dating, even though this particular problem is more acute in drawings than anywhere else. Biographical information is not given for its own sake. These issues are broached or ignored as the context demands.

The artists included are those whose work bears

Fig. 1 VAN GOGH: *Ruins of Montmajour*, May 1888, Arles
Pencil, reed pen and ink
$18^5/_7 \times 12^1/_5$ in
(47.5 × 31 cm)
Rijksmuseum Vincent van Gogh, Amsterdam. F1423

Fig. 2 DAUMIER: *Sancho Panza behind a tree*, c.1870?
initialled
Black chalk
irregular $3^1/_3 \times 2^1/_3$ in (8.2 × 5.9 cm)
(formerly in Gauguin's collection)
Statens Museum for Kunst, Copenhagen.
Inv. KKS Tu 25,9

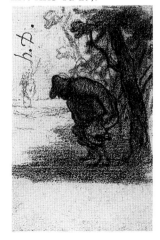

significantly on the changes wrought upon drawing between the 1860s and the end of the century. Definitions of impressionism are fraught with ambiguities, most acutely so in drawing. For every generalized truth there are as many exceptions as confirmations: for every Monet to say one thing, a Degas to say the reverse. By the 1880s, the term 'impressionist' was often used to mean, simply, 'modern' or radical. The varied and sometimes conflicting ideas of contributors to the eight group exhibitions are some indication of this. A founder-member like Monet could complain by 1880 that the exhibition had become 'a great club, which opens its doors to the first-come dauber'. Artists have not been included for discussion in this book solely by virtue of featuring in those exhibitions. Many who did exhibit are not even mentioned. Boudin and Redon are included, not because they exhibited with the impressionists on a single occasion, but for the pervasive influence of their respective attitudes to drawing. Among those who never exhibited with them, there are several who surely would have done so, either had they lived long enough, in Bazille's case, or had the exhibitions continued after 1886, in the cases of Bernard, Lautrec and van Gogh. They are included here because of their intimate involvement in the art of impressionist drawing. The same applies to the work of Manet, Jongkind and Whistler. The prominence given here to Manet's radical and influential drawing in no way condones the simplistic error of the contemporary critics who described him as one of the impressionists. There is a chapter devoted to 'the post-impressionist reaction' of the 1880s, but, as a general principle, the book treats the work of both generations as a single, continuous evolution. The reaction has many positive features and even the extreme position adopted by Gauguin has some formative roots in his experience of impressionism.

The history of drawing in the last forty years of the nineteenth century is not adequately explained by the habitual, sequential use of the two terms impressionism and post-impressionism. Apart from anything else, they confuse our grasp of relationships in time. Boudin's early seascape pastels belong in the same era as those by Delacroix which they so much resemble;

Cézanne's last watercolours and the first Picasso drawings that reflect their influence were almost contemporary. The careers of van Gogh and Seurat were both ended a decade before those of the 'impressionists'. After the deaths of Pissarro and Gauguin in 1903, and of Cézanne in 1906, Degas, Renoir and Monet still had ten or twenty years to live. The degree to which these relationships cut across any simple idea of two consecutive movements is significant. The evolution of drawing during and after impressionism is as striking for the diversity of individual directions and initiatives as for its coherence.

The history of this evolution begins with the influential originality of drawings by Delacroix and Daumier and with the polarity between Delacroix and Ingres, who was seen as the exemplar of drawing in the academic or classical traditions. It concludes with fin-de-siècle drawings, which, while they have little overtly in common with impressionism's first intentions, derive from them. The drawings of Bonnard form a postscript that is interesting for his assimilation of first post-impressionist and then impressionist practices.

It is a story full of extreme contrasts and paradoxes. The presence of a draughtsman like Degas among a group of painters whose art was (and occasionally still is) considered by its very nature to be the antithesis of drawing made this almost inevitable. Drawing had featured significantly in the great debates of line versus colour and realism versus idealism that had preceded impressionism, but those controversies pale beside the heat and fury – on both sides – of arguments about the quality and probity of drawing that surrounded impressionism. From such radical beginnings emerged several artists whose work and thinking express not only a deep respect for great draughtsmen of the past, but also a consciously held common ambition to forge modern practices of drawing that were worthy of traditions.

The history of impressionism's spectacular and influential incursions into the theory and practice of the art of drawing is a sprawling subject. The unapologetic intention of this book is less to order the subject into conveniently accessible compartments, than to throw light on the way that it sprawls.

IMPRESSIONISM
AND THE ART
OF DRAWING

1 Impressionist Drawing

Imagine that someone with no knowledge whatsoever of the practice of drawing (he might be from another planet) saw, for the first time, an artist sitting in front of a landscape alternately looking at what was before him and making black marks on a sheet of white paper. Noticing the lack of similarity between the landscape and the signs on the paper, the observer might ask himself: 'what should I be interested in?'. If then a second artist came to sit in front of the landscape and made marks on his own sheet of paper, the observer would notice in these marks not only a lack of similarity to the landscape, but also a lack of correspondence between the two sets of signs. Asking again 'what should I be interested in?', his reasonable conclusion would be that the difference between the two drawings could tell him something about differences between the two individuals who made them.

It is widely acknowledged that drawings allow us 'closer' to an artist than does the public face of painting or sculpture. The modern appreciation of drawings, however slight or unsophisticated they might be, is founded on this as much as anything else. In the case of the impressionists, many of the special qualities that we normally associate with the impromptu intimacy of a drawing are already accessible in their paintings, the exposed freedom of their execution having every appearance of an impulsive, spontaneous response to what was seen. Nevertheless, drawings by the impressionists do tell us things that their paintings do not. They emphasize striking differences between individual attitudes, reveal an educated consciousness of certain traditions in drawing and, finally, they often expose the complexity of preparation for paintings that purported to represent the unrehearsed vision of an innocent eye.

Odilon Redon, contemporary of the impressionists and father-figure to many post-impressionist artists, acknowledged that 'we cannot move our hand without moving our whole being, in obedience to the laws of gravity. A draughtsman knows this.' He also observed that 'a truly sensitive artist will not find the same invention in different media, since each material will influence him in its own way'.[1]

There was little consensus regarding media among impressionists and post-impressionists: their drawings are remarkable for the variety of their means, and for an experimental and often idiosyncratic attitude towards materials. Most drew variously in chalk, charcoal, crayon, pastel, wash or soft pencil: media that were not conducive to linear manners of drawing, but were soft enough to respond sensitively to

movement and pressure of the hand. Van Gogh's extensive and fluent use of pens for drawing was exceptional: perhaps the ease with which he took to the medium reflects the amount of time spent with a pen in his hand to write letters. Sometimes similarities in the use of the same medium by different artists can tempt us into seeing an influence that may or may not be there: for instance, when Gauguin has a pen in his hand, his drawing looks much more like van Gogh's than in any other medium. In other cases, artists reacted quite differently to the same medium. Once Seurat started to draw with conté crayon, it became almost second nature to him, whereas van Gogh never felt at ease with it: he found the stick hard to hold and complained that it kept breaking. Renoir was astonished that Degas was able to achieve all that he did with a medium 'as disagreeable to handle' as pastel. The variety of impressionist drawings is attributable to different hands and the temperaments behind them more than to different materials.

The sketchbooks of several artists offer glimpses of personal traits – manifestations of humour, caricature, eroticism, fantasy – that are not evident in the apparently humble submission to nature of impressionist painting. Bazille's drawings suggest a far more complex artist than do his surviving paintings. We see Sisley treating the figure; Monet considering motifs that he did not paint; Gauguin improvising with ideas; and, among van Gogh's drawings in St Rémy and Auvers, hints of a substantial revival of interest in the figure that went unrealized in his late paintings. The minds and personalities behind the art of Degas, Cézanne and Seurat are most clearly exposed in their drawings.

The word 'impression' (and hence, in its time, impressionnisme) carried two shades of meaning: firstly, the simple imprint that one material leaves on another and, secondly, an individual and original response to external stimulus. The former is like a single physical transaction, the latter is subjective and prone to idiosyncratic variation and nuance.[2] The broadly accepted definition of impressionism contrives to embody both of these meanings, in describing an art that depicts not nature so much as sensations of nature; not the thing seen so much as the act of seeing. Because of the immediacy of drawing from nature – the relative speed, slightness and simplicity of the activity (there is no mixing of paint involved, no loading, cleaning or changing of brushes) – drawings reveal more directly than painting this duality of objective and subjective impulses.

Paul Valéry wrote about it in the context of Degas.

'I know of no other art that involves more *intelligence* than that of drawing. Whether it is a question of extracting from the totality of what is seen the one inspired line that is right, of summarizing an ensemble, of not losing control over one's hand, of *recognizing* a form and *rehearsing it to oneself* before *depicting* it; or whether it is that one's imagination governs the moment and one's idea forces obedience, becoming enhanced and clearer as it is realized on the paper before one's eyes; all of one's mental resources are engaged in this task, which reveals no less powerfully whatever personality the artist may have.'[3]

Valéry's description fits Degas well. It may be applied to the drawing of other impressionists in varying degrees. The 'recognizing and rehearsing' of things seen is strongest in Cézanne, Seurat and van Gogh. The inventive 'idea' governing a drawing is strongest in Redon, Seurat, Gauguin and van Gogh. In the drawings of others, the process often appears more arbitrarily improvised, with a less discerning quality of mark and less 'control of the hand'. For a minority of those involved – particularly Monet, Bazille and Sisley – the quality or sensitivity of the drawn mark itself seems not to enjoy a high priority. The same is true at times of Manet, Pissarro, Renoir and Morisot – in fact of most of the first generation. There is a significant sense in which early impressionism abandoned the self-conscious Art of drawing in pursuit of other priorities, such as drawing against time and capturing the *ensemble*.

It is generally true that all art, including drawing, is shaped more by other art than by the study of nature. Manet talked of nature as a sort of safety-rail to keep art from stumbling into banal clichés. Redon spoke of using the discipline of exact drawing from nature chiefly to sharpen his sensibilities and stimulate his imagination. But some of the most radical qualities of impressionist drawing are radical precisely because they were spontaneous responses to the momentary appearances of nature, and nothing else. Cézanne, whose own drawing was formed from complex sources, stresses earnestly and repeatedly to younger artists that nature holds all the answers. Boudin and Jongkind had convinced the young Monet of the same truth and, inasmuch as there was a body of theory for early impressionism, this was one central thesis. In extreme cases of drawing's total dependence on the impression of nature, the activity was so carelessly impromptu and the result so desultory and incoherent by any traditional standards, that Valéry's elaborate model – with every mental faculty involved – would seem patently inappropriate.

It is however misleading to generalize. For one thing, the drawings of any one of these artists embrace several quite different manners of drawing for various circumstantial reasons. Furthermore, what we see as artlessness in some examples – those of Manet, Jongkind or Morisot for instance – while sometimes literally carelessness, is in part the practised

Fig.3 BAZILLE: Page from a sketchbook, *c.*1865
Pencil
9 × 12 in
(22.9 × 30.5 cm)
Louvre, Dépt. des Arts Graphiques
Inv. RF 5260, p.23 verso

expression of a conscious attitude. Valéry's looking – formulating – drawing sequence is so inbred in Jongkind's later watercolours or Monet's last sketchbook pages as to have become intuitive. What is clear, contrary to established legend, is that for most of the artists, at least some of the time, drawing became a significant, consuming and prolific activity.

In the cases of Degas and Pissarro, the amount of time they devoted to drawing is evidence enough of this, even if it were not supported by constant emphasis on the importance of drawing in their letters. When we look beyond the facts of quantity to what we might consider as quality in drawing, our awareness of a divide between Degas and his immediate contemporaries becomes inescapable. Like Seurat later, Degas felt a profound allegiance – by instinct as well as training – to traditional criteria of 'good drawing'. Degas told Sickert in 1885: 'I have always tried to urge my colleagues to seek new combinations along the path of draughtsmanship, which I consider a more fruitful field than that of colour. But they wouldn't listen and have gone the other way.'[4]

The distinctiveness of Degas's work as draughtsman was commented on in his own time. In 1880, the critic Ephrussi compared his 'academic impressionism' to the 'pure impressionism of Pissarro'.[5] On the death of Manet three years later, Gauguin wrote to Pissarro that the mantle of leader now fell on Degas, 'an impressionist who draws'.[6] Pissarro himself acknowledged the 'gap between Degas and all the others'. Commenting on an album of reproductions of Degas drawings (whose very publication is noteworthy), Pissarro wrote in 1898: 'It is here one can see what a real master Degas is; his drawings are more beautiful than those of Ingres and damn it, he is modern.'[7]

Comparison of archetypical impressionist drawings by Degas and Pissarro reveals the nature of the difference that prompted Pissarro's admiration (Figs. 4, 5). This lies in the greater content and, in traditional terms, the sheer quality of Degas's draughtsmanship. Beside the precision of observation that is so deftly

Fig.4 DEGAS: *Dancer*,
c.1885
Chalk
13 × 9 in
(32.9 × 23.1 cm)
Boymans-van Beuningen
Museum, Rotterdam.
Inv. F-II-131

Fig.5 PISSARRO: Sheet of
studies, mid-1880s
Black chalk and coloured
crayons
8⅓ × 6⅔ in
(21.2 × 17 cm)
Boymans-van Beuningen
Museum, Rotterdam.
Inv. F-II-21

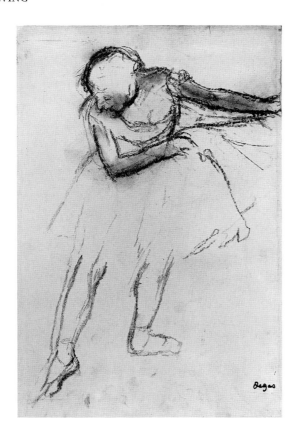

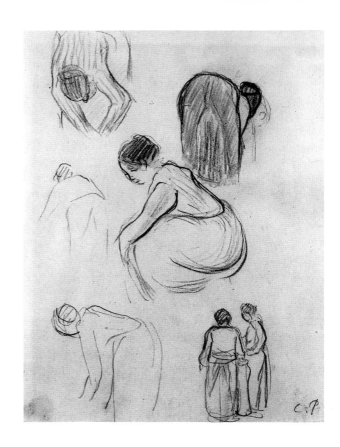

carried in the most coarse and fugitive of Degas's chalk lines, Pissarro's sketches look relatively inept. It is just arguable that some of the contrast stems from difference in intention behind the two studies, one concentrating on an individual pose, the other comprising several rapid notes of natural movement. We are after all familiar with some masterly drawings by Pissarro. What is characteristic of much of the drawing of the first-generation impressionist is his very casual, uneven attitude both to style and to searching detail. When speed of impression was at a premium, concepts of 'good drawing' were not. The consistent quality of Degas's drawing is attributable to an obsessive attitude enhanced by education, as well as to his native facility.

Of the works exhibited in the course of eight impressionist exhibitions, from 1874 to 1886, between a quarter and a third were on paper, but very few (about 120) were catalogued simply as '*dessin*'. Some prints were exhibited. Watercolours, gouaches and pastels were often shown alongside paintings and apparently considered as complementary. But, for most of the impressionists, drawing remained a private activity. Many of them never exhibited drawings. For Gauguin it was a matter of principle that his drawings were the concern of no one but himself.[8]

One of the earliest attempts to explain the role of impressionist drawing was made by the Italian critic Diego Martelli in a conference address on the impressionists, in Livorno, in 1880.[9] Martelli tried to establish a case for their drawings as vehicles for the sense of touch, not of sight. He argued that while their paintings were concerned with purely visual phenomena (colour, light), their drawing was concerned with values such as solidity, weight and distance not evident to the innocent eye. So remote is this interpretation from any consensus view that we might arrive at today, that we can only wonder whose drawings, apart from those of his friend Degas, Martelli may have seen.

The purely visual quality of most drawings in the impressionist tradition, and the inadequacy of their improvised marks to cope with other data, is emphasized by the presence of written notes in some of them. For example, in a highly impressionistic Delacroix drawing (Fig. 6), there are several sorts of inscription apart from the descriptive title and the date of the drawing. Most of his words refer to local colours – the most common form of annotation – and some to flowers. On one of the outlined areas of shading that form a screen across the sheet, he felt it necessary to add the information '*lointain*'. Pissarro's notes on an Upper Norwood drawing of 1870/71 (Fig. 7) range from '*ciel gris*', to '*palissades*', to '*vigoureux*'. On another, earlier landscape drawing (Pl. 42a), Pissarro wrote '*soleil du matin*', with an arrow pointing to the appropriate spot. All of this underlines the role of the sketches as schematic *aides-mémoire*: the drawn and written notes are two languages serving the same purpose.

The vast majority of drawings made by the impressionists were some form of extension of their activity as painters. The extreme example is that of Monet. After his early caricatures, he did almost no

drawing that was not directly related and subservient to his painting. But in the early years, relatively few impressionist drawings were preparatory studies for particular paintings. The major exception was in the preparation for figure paintings that were 'composed': most characteristically by Degas and Caillebotte, but in the early years also by Monet, Renoir, Bazille and, occasionally, Cézanne. It is reasonable to assume that in Renoir's case, and perhaps in others too, there were more such drawings than we now know. In the 1880s and 1890s, with a revival of wider interest in figure painting, there was a substantial increase in drawings as preparation for paintings. The drawn studies for prints by Lautrec, Cassatt and others are a part of that development.

Since working directly from the motif was of the essence in impressionist landscape painting, there was no obvious preparatory role for drawing to play. Most of the artists kept sketchbooks or notebooks. Allowing for some idiosyncratic variation, the drawings in them – figures or landscapes – are, as often as not, from nature, and comprise an open-minded prospecting for motifs that may or may not be taken up in paintings. A number of them are framed by a drawn rectangle, as if sighting a painting motif. Exceptionally, throughout his life, Pissarro made some drawings of landscape that relate directly to the particular motif of subsequent paintings. But even in his case, they are only occasionally preparatory studies in the traditional sense of an organizing or refining 'filter' between experience of nature and painting from nature. Landscape drawings anticipate paintings in that the manners of drawing and painting were, in a generalized way, compatible. Drawing was after all informed by the same 'way of seeing' and can be interpreted as a form of rehearsal of the act of painting. In this sense, Pissarro rehearsed the *ensemble* of his paintings through drawing, and for Cézanne, too, his drawings and watercolours were part of the continuing process of learning how to cope with the landscape in paint. In 1901, Monet experimented with pastels to resolve problems of treating the Thames in his London paintings.[10]

Many of the artists also made drawings *after* paintings – sketches in letters or in notebooks, and, in some instances, drawings as illustrations to articles in journals – which are a form of re-enactment of painting in pen or pencil.

Finally, there are some categories of drawing, including many of those in colour, which were more or less independent of painting. Cézanne's watercolours, many of them of the same motifs as concurrent paintings, were seldom studies: they stood as a complementary activity and were exhibited as such. This is also true of Degas's pastels; of pastel portraits by Manet, Renoir, Pissarro, Morisot and Cassatt; and of the watercolours of many other artists. For some, print media provided an arena for experimental drawing: Degas's monotypes, Pissarro's and Whistler's

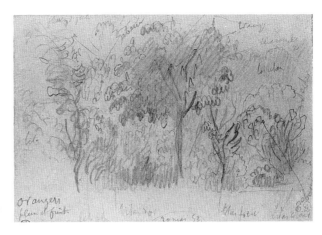

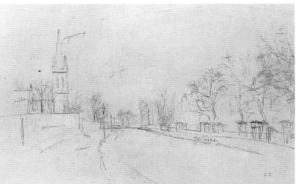

Fig.6 DELACROIX: *Arbres et arbustes au printemps*, dated 20 May 1853
Black chalk
5 × 7²⁄₅ in
(12.7 × 18.8 cm)
Louvre, Dépt. des Arts Graphiques. Inv. RF 9555

Fig.7 PISSARRO: *All Saints Church, Upper Norwood*, 1870/71
Pencil
11¹⁄₆ × 17¹⁄₂ in
(28.4 × 44.5 cm)
Metropolitan Museum of Art, New York
(Gift of Sam Salz).
Inv. 56.173

etchings, Gauguin's 'traced drawings'. Drawings and lithographs by Redon form the nucleus of his oeuvre; the same is true of drawings and prints by Lautrec. Gauguin's manuscript illustrations were a quite distinct activity, complementary to his painting and carving. Seurat's first exhibited work was his portrait drawing of Aman-Jean (Pl. 101a), submitted to the Salon of 1883, and a large proportion of his later drawings were made solely as drawings. Although seldom as highly wrought as his *Aman-Jean*, many are as autonomously complete.

Van Gogh's drawings are an eccentric case: firstly, because his early graphic work, like that of Redon, is that of an artist who was primarily a draughtsman; secondly, because drawing continued to represent for him a major activity in its own right. He talked of making 'studies' for drawings, as for paintings.[11] Some of his Arles and St Rémy drawings are highly finished, independent works, and his elaborate copies after paintings from the same period, for Theo and others – more interpretation than literal copy – are really a form of 'presentation drawing'.[12]

Seeing impressionist paintings for the first time, van Gogh wrote in 1888, 'one is bitterly, bitterly disappointed, and thinks them slovenly, ugly, badly painted, badly drawn, bad in colour, everything that's miserable'.[13] An intimate of impressionist circles in the 1860s, Fantin-Latour, felt progressively dismayed – almost betrayed – by Manet's flirtation with impressionist painting techniques during the 1870s. He wrote in 1874, 'everything I see here looks lax; too

easy, weak in drawing and washed out in tone – above all unfinished, lacking in effort'.[14] Such was also the consensus of public opinion that had greeted successive exhibitions of impressionist art. Reactionary attitudes to technique were far more hostile than those to subject matter, and their most moderate criticism was that the work exhibited did not progress beyond the condition of the sketch. The name 'Impressionism', ironically given in the first instance, implied the same thing. Much subsequent hostile use of the term was a taunting smear campaign along these lines. In all of this, the least acceptable aspect of impressionism's 'rudimentary execution' and 'wilful incoherence' was 'the most profound ignorance of drawing'.[15] Time and again, grudging acknowledgement of a certain talent for colour was qualified with laments of a lack of training in draughtsmanship. Manet had been condemned for the ineptitude of his drawing ten years earlier and he was often connected with the impressionists in this derogatory context.

The cardinal importance of drawing in the public case against the impressionists is echoed in the writing of their apologists by a constant emphasis on the authority of Degas's drawing.[16] In a similar vein, the supportive critic Georges Rivière went out of his way to defend in Caillebotte 'the noble, simple, sincere and highly realist drawing which is the first among his qualities'.[17] The same motive lies behind Morisot's disarming suggestion in 1886 that Renoir's drawings should be put before a public 'which generally imagines that the impressionists work in a very casual way.'[18] By 1911, Wynford Dewhurst went so far as to claim that 'Impressionists are consummate draughtsmen, as innumerable portraits and figure pieces, etchings and pastel drawings amply attest. They have passed years of their lives in academic study, and are in every possible way a fully equipped and intellectually capable body of men.'[19]

Criticism of impressionist drawing not only ridiculed its gaucheness. It extended to absolute condemnation of a lack of the most basic professional competence, often assuming a moral/political dimension. Albert Wolff's review of the 1876 exhibition was admittedly playing to the gallery, but voiced the establishment view in talking of an insolent absence of decorum: 'Since they know perfectly well that a complete lack of artistic training prevents them from ever crossing the void that separates mere effort from a work of art, they barricade themselves within their lack of ability.'[20]

This was not just a battle with Parisian critics. Leroy's famous question in front of a Monet in 1874 – 'what are all those innumerable black tongue-lickings . . . do I look like that?' – may be compared with the judge's equally famous rhetorical question to Whistler at the Ruskin libel hearing of 1878: 'Are those figures on top of the bridge intended for people?'.[21] Sickert suggested later that a cultured writer 'will use the word "Impressionism" with a sneer, will touch it, as it were, with the end of his lips much as a lady might use the word "Socialist" in a drawing room'.[22]

Standards of 'finish' in art amounted to an expression of moral propriety. As Zerner and Rosen suggest, lack of finish stood for the lack of 'qualities of probity, assiduity, professional conscience – and also discretion'.[23] 'The probity of art' was Ingres's own epithet for drawing. The polarity that existed between these established values and those of artists associated with impressionism was unbridgeable. Impressionism was seen by reactionary critics and historians as the extreme example of a widespread abandonment of principles, and abhorred by them as either amoral permissiveness or the self-indulgent pursuit of originality.

If a confrontation was inevitable, no less was its focus upon drawing and academic training.

NOTES

1 Redon 1961, pp. 27–28; Redon, *Lettres*, 1923, pp. 33–34.
2 For a long and interesting discussion of this, see Schiff 1984, pp. 3–52.
3 Valéry (1936) 1983, p. 85.
4 Sickert, 'Degas', *Burlington Magazine*, November 1917.
5 *Archives* II, p. 339.
6 Gauguin, *Correspondance*, 1984, No. 35.
7 Pissarro, *Letters*, pp. 319–20.
8 See notes to Plate 76.
9 Martelli 1979, pp. 24–25.
10 See notes to Plate 33.
11 See notes to Plate 91.
12 Pickvance suggests that van Gogh modified the drawing style of these copies according to the recipient; for instance, that the stippled pointillist technique is less evident in those drawings sent to Bernard, who felt some antipathy towards neo-impressionism. (In a symposium paper, Rijksmuseum Vincent van Gogh, Amsterdam, 9 May 1990.)
13 Van Gogh, *Letters*, 1958, III, p. 432, W4.
14 Letter, 16 August 1874. Quoted in Ottawa 1983, p. 217.

Gauguin also thought that Manet had 'made a mistake in following the impressionists' (letter, Jan. 1884. Gauguin, *Correspondance*, 1984, No. 43).
15 Chevalier, *L'Artiste*, May 1877; Ballu, *Chronique des Arts et de la Curiosité*, April 1877.
16 Flint (1984, pp. 20–21) makes the same observation about critical reaction in England.
17 *L'Impressionniste*, 14 April 1877.
18 See notes to Plate 30.
19 Dewhurst 1911, p. 293.
20 *Figaro*, 3 April 1876.
21 Leroy, *Charivari*, 25 April 1874. Accounts of the Ruskin trial vary in detail: another version has the judge asking Whistler: 'Are those shapes intended to represent figures?' The quotation given here is from Pennell 1925, p. 172.
22 *A Free House*, 1947, cited in Flint 1984, p. 14.
23 Zerner and Rosen 1984, p. 221. Their last chapter, 'The ideology of the licked surface', is a penetrating account of polar attitudes behind 'official' art, and of the mythology that is still evolving around them.

2 The Academic Tradition

Criteria for criticism of impressionist drawing were founded on the coherent strength of the academic tradition. Drawing as taught in the studios of established artists involved three things: first, a system of learning; second, a conventional language; and third, the principle that drawing was the intellectual discipline upon which all art was founded. These established artists not only adhered to the conventions and principles in their own work, but were in a position – as jurors for Salon selection and in other fields of influence – to ensure that the success of others depended on observation of the same values and practices. Zola berated the Salon jury as 'pensioners of academies, bastard pupils of bastard master',[1] and Degas described the establishment as having 'the chessboard of the Fine Arts on their table and we, the artists, are the pawns'.[2]

Artistic education at the Ecole des Beaux-Arts and in private ateliers consisted almost entirely of drawing.[3] The student learned to reproduce the model in front of him, drawing in line, and then in line with shading; working from the treatment of parts to the whole. The models were, successively, geometric forms, engravings after the masters and plaster casts, from which the student mastered effects of light, half-tone and shadow. By copying from copies from the masters, ideal proportions and a sense of style became an instinctive part of reproducing whatever the student had in front of him. Having assimilated such

instincts, the student was then allowed to progress to drawings from the nude: first a rapid linear sketch of the whole pose, usually in contours composed of a succession of straight lines, and then an elaborate finished drawing (académie), in which the contour was complemented by the sort of finely gradated shading that had been learned from copying casts. Corrections of life drawings by the studio master were as much adjustments towards ideals of beauty and proportion as towards accurate observation.

Most drawing was from the figure, and students practised and perfected their techniques during early morning and evening hours spent in various free drawing studios, such as the Atelier Suisse. There was also instruction in anatomy and perspective. Teaching of the history of art is implied rather than described in accounts of the syllabus, but students also normally registered as copyists at the Louvre, and sometimes at the Bibliothèque Nationale as well. It appears that they were able to copy master drawings as well as paintings and sculpture.

Only after mastering drawing were students allowed to proceed to painting. The first stage of a painting was the tracing onto the canvas, in charcoal, of a pricked or squared-up drawing, whose outlines were then re-established in sepia with a sable brush.[4] In the certainty and precision of this delineation, most of the important work of a painting had already been done. Colour added charm and ornament.[5] 'Drawing includes everything except colour: expression, internal form, the planes, modelling', Ingres is quoted as saying. 'Drawing is everything, it is all of art.'[6] The sketch, drawn or painted, was an accepted part of the repertoire of preparation for a painting, but only a minor part and equally subject to idealizing principles.

Charles Blanc's *Grammaire des Arts du Dessin* (1870), summarizes the principles of academic teaching. This standard text was certainly consulted by Seurat and van Gogh, and probably others. Blanc defined drawing (masculine; rational) as superior to and more essential than colour (feminine; to do with charm and sentiment). 'It is colour that characterizes, most particularly, inferior nature, while drawing as the means of expression becomes more dominant in proportion as we ascend the hierarchy of beings.'[7] Beauty and drawing are prerogatives of the intelligence. The straight line represents the infinite, the sublime, unity (there is only one). The curved line is the image of variety (there are many). Harmony is born from the analogy of opposites. The vertical symbolizes man; the other three principal lines (the horizontal, and ascending or descending oblique

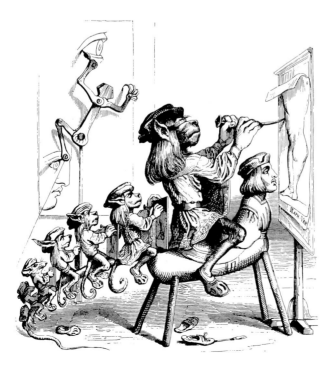

Fig.8 Grandville: Academic instruction in drawing, Xylograph, *Un Autre Monde*, 1844, Pl. XIII Bibliothèque Nationale, Paris

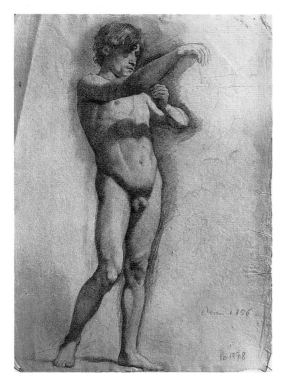

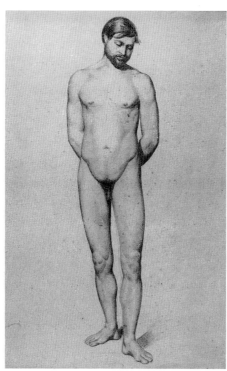

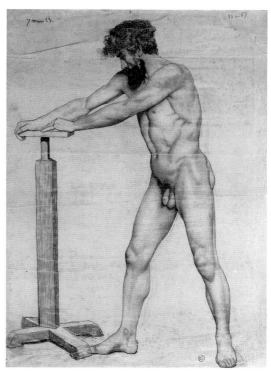

Fig.9 DEGAS: *Académie, male nude, c.1856/58*
Pencil on green paper
12 × 8⁷/₈ in (30.7 × 22.5 cm)
Collection Marianne Feilchenfeldt, Zurich

Fig.10 CÉZANNE: *Académie, male nude,*
signed and dated 1862 on verso
Pencil and black crayon
24 × 18¹/₂ in (61 × 47 cm)
Musée Granet, Aix-en-Provence. C76

Fig.11 BAZILLE: *Académie, male nude,*
dated 7 March 1863
Conté crayon and charcoal
24 × 18¹/₃ in (61.1 × 46.3 cm)
Musée Fabre, Montpellier. Inv. 49-5-2

lines) express respectively calm, gaiety, sadness.[8]

Blanc emphasized that exact imitation is not the most faithful rendering: in mechanically capturing 'the real', one does not capture 'the truth'. 'Drawing expresses a higher reality . . . the character of the object that is drawn, the character of the artist, and – in great art – what is known as style.'[9] He exhorts the artist to look beyond the surface to the essential: this will also reveal his soul. The cardinal principle for drawing is that the whole is more important than the part. He advises emulation of Raphael but not of Dürer ('too much attention to detail precludes achievement of *grandeur* and *style*') and warns against the eccentric example of Michelangelo, despite his greatness. 'Moral beauty' is more important to aim for than truth to nature.[10] He warns repeatedly against the simple transcription of appearances, arguing that within natural truth one may find the typical truth and that this is style. In conclusion, Blanc lists the *mots sacrés* of art in this order: 'the sublime, the beautiful, the ideal, style, nature'.[11]

Such was the model definition of drawing against which the impressionists were measured in their own time. Almost all of them had experienced academic training at first hand in various academies and ateliers.[12] Often the experience was reluctantly entered upon, sometimes under parental pressure (Monet, Cézanne), and brief in its duration. In many cases we know little of the drawings made, but those

académies that have survived suggest that the impressionists applied themselves more or less submissively to the task of assimilating the system, with varying degrees of success (Figs. 9–14). The authority of academic drawings by Degas and Seurat is outstanding, but drawings by Pissarro, Bazille and Cézanne are also remarkable for a degree of diligent conformity to the idiom, considering the character of other contemporary drawings by these artists. Cézanne attended the Municipal School of Drawing in Aix intermittently between 1859 and 1862, preparing for the entrance examination of the Ecole des Beaux-Arts, which he failed probably in 1862. His references in letters of 1861 and 1863 to working long hours, morning and evening, drawing the figure at the Académie Suisse in Paris, probably describes the common practice of his peers as well. In Antwerp in 1886, van Gogh also worked long hours, day and evening, drawing from casts and the nude model, even if the crude vigour of life drawings made there (Fig. 14) expresses something of the mutual incompatibility that existed between him and his tutors.[13] Despite the independent mastery of his Neunen drawings of 1885, his letters from Antwerp repeatedly affirm his conviction of the need to spend a solid year drawing casts and the figure.

No drawings by Monet, Renoir or Sisley have survived from their time as students in Gleyre's studio. We know that Renoir passed successive

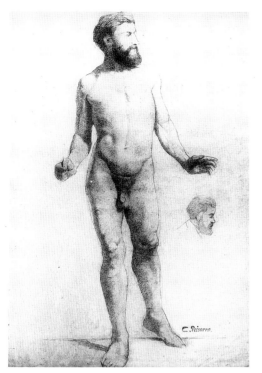

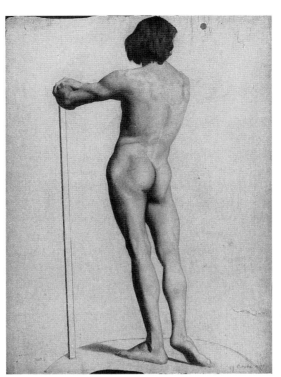

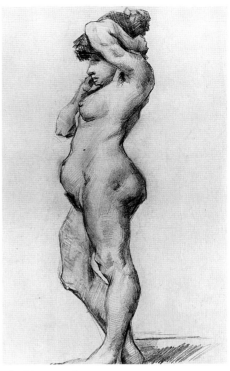

Fig.12 PISSARRO: *Académie, male nude, c.*1863
Charcoal/black chalk?
27¹/₂ × 16⁵/₇ in (70 × 42.5 cm)
Formerly Beilin Gallery, New York

Fig.13 SEURAT: *Académie, male nude,*
dated 27 October 1877
Charcoal and chalk
25 × 19 in (63.5 × 48.2 cm)
Louvre, Dépt. des Arts Graphiques.
Inv. RF 38901 dH 265

Fig.14 VAN GOGH:
Standing female nude, 1886
Pencil
19²/₃ × 15¹/₂ in (50 × 39.5 cm)
Rijksmuseum Vincent van Gogh,
Amsterdam. [F] SD 1699

drawing examinations, at least adequately,[14] and that Sisley seriously intended to enter the competitive examinations for the *Prix de Rome*.[15] Monet later remembered working in Gleyre's studio, 'conscientiously . . . with as much application as spirit'.[16] Regretfully, we can only speculate about the encounter of the eclectic early facility of Monet and Renoir with academic conventions.

The most powerful evidence of antipathy towards academic instruction comes from verbal accounts by the artists themselves, often written or related much later and perhaps coloured by memory in the retelling. Monet's well-known account of a criticism by Gleyre hinges on the master telling the pupil that his study of the model was too naturalistic: 'when one executes a figure, one should always think of the antique . . . style is everything'. Monet realized that 'truth, life, nature . . . the only *raison d'être* of art, did not exist for this man'. He fostered rebellion in Renoir, Sisley and Bazille, so he tells us, and precipitated their leaving. Renoir told Vollard that Gleyre was of no help at all to his students, but at least had the merit of giving them complete freedom.[17]

Redon's experience was more uncomfortable. He had entered the Ecole des Beaux-Arts with the sincere wish 'to take my place in the sequence of other painters, to be a student as they had been'.[18] He felt so persecuted and suffocated by the teaching of Gérome that learning to draw from nature afterwards was a slow and painful process. 'He recommended to me that I imprison within a contour a form that I saw as pulsating. Under the pretext of simplification (but why?), he made me shut my eyes to the light and to neglect the matter that I saw. I could never do this The pupil saw nothing but the triumphal proliferation of forms; the master drew with great authority . . . all that was inorganic He understood nothing about me Submission would have required sainthood of the pupil, which was not possible.' Later in the same memoir, Redon describes the breeding effect of the teaching of his master Gérome. 'The daily programme included the confection of a sketch which the master corrected with his natural conscientiousness In practice, this only gave birth to a number of compositions in tune with the master's taste and in which the most puerile form of archaeological research was predominant.'[19]

Gauguin, almost alone in not having experienced such teaching at first hand, was among the most vehement in condemning it. Averse to rules as a matter of principle, he could not tolerate the 'cookery' of academic drawing and prided himself on remaining 'untouched by the putrid kiss of the Ecole des Beaux-Arts'. 'A pretty thumb-stroke that smoothly models the meeting of nostril and cheek! that's their ideal.'[20] 'One learns to draw and afterwards to paint, which amounts to saying that one begins to paint by colouring in a ready-made contour, rather like painting a

Fig.15 GIRODET: *The Trojans taking leave of their country*, before 1827
Black chalk
$10^{3}/_{8} \times 15$ in
(26.5 × 38.2 cm)
Nationalmuseum, Stockholm.
Inv. NMH 560/1971

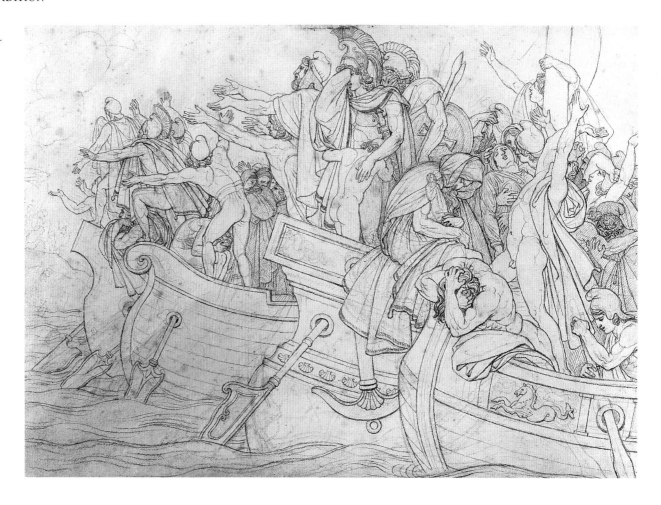

statue. I swear that so far I have learnt only one thing from this whole exercise: that colour is merely an accessory.'[21]

Girodet's authoritative study for a painting (Fig. 15) epitomizes much of what the impressionists found unacceptable about academic drawing, in its schematic style, tight linearity, histrionic pose and gesture, and pseudo-scholarly authenticity. Collectively, the central issues of criticism levelled against this practice by the impressionists were these. Academic drawing isolated drawing from colour; it treated style as a first priority and conformity as desirable; it celebrated sophisticated technique as an end in itself; its disciplined emphasis on dry, linear precision negated the expression of sensations; its preoccupation with ideals of beauty and proportion was divorced from the real world. Drawing, furthermore, was seen essentially as a studio activity, which the art of impressionism in principle was not. 'I've never had a studio myself, and I don't understand how someone could shut himself up in a room', Monet told Taboureux in 1880. 'To draw, yes, but to paint, no.'[22]

This black–white, conservative–radical polarity has been qualified by some recent writers. Boime (1971) stresses that the leading studios, of Couture and Gleyre, were relatively liberal in character. Couture was after all an admirer of Boudin's work. The drawing style of Couture's most famous pupil, Manet,

Fig.18 GLEYRE: *Allegories of Justice and Glory*
Pencil
$12^{1}/_{2} \times 9^{1}/_{2}$ in
(31.8 × 24.2 cm)
Fogg Art Museum, Cambridge, Mass.
(Bequest of Grenville L. Winthrop).
Inv. 1943.834

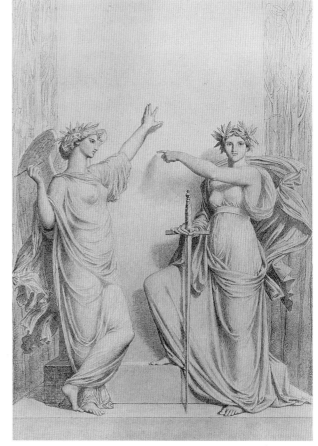

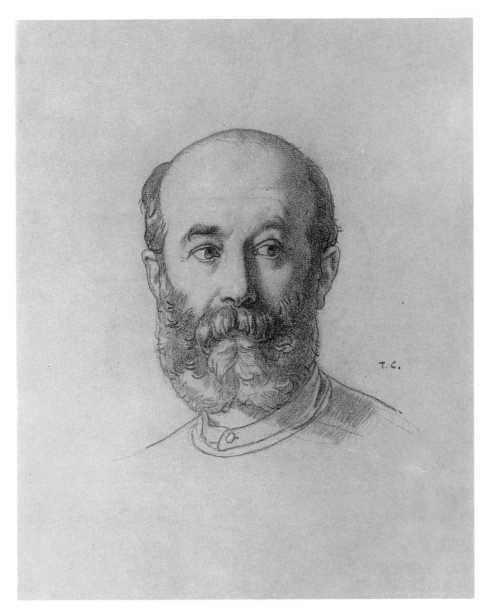

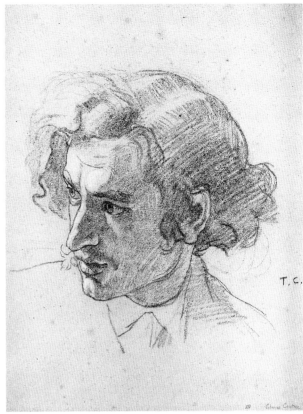

Fig.16 COUTURE: *Portrait of Dr Valentini*, initialled
Black chalk, heightened with white
20 × 16 in
(50.7 × 40.9 cm)
National-Galerie, Berlin.
Inv.16b/1

Fig.17 COUTURE: *Head of a man*, initialled
Chalk and pencil
$17^1/_3 \times 13^2/_5$ in
(44 × 34 cm)
Louvre, Dépt. des Arts
Graphiques. Inv. RF.36005

combining cursive contours with delineated areas of tone, bears broad comparison with the manner of Couture himself (Figs. 16, 17). If the pomposity in form and content of Gleyre's drawing looks patently irrelevant to the concerns of the young impressionists (Fig. 18), Renoir's suggestion of a *laissez-faire* attitude in the studio appears more representative than the gist of Monet's anecdote. Both Bazille and Renoir acknowledged the value of a practical training there.[23] (Boime even proposes that the relative freedom of Gleyre's painted sketches influenced impressionist painting techniques.[24])

The third quarter of the nineteenth century saw moves to revise the rigid conservatism of academic instruction, led by Eugène Viollet le Duc and Horace Lecoq de Boisbaudran.[25] Lecoq castigated the slavish imitation fostered by the Ecole des Beaux-Arts and the *Prix de Rome* competitions and suggested that the relentless duration alone of the course ensured the eradication of any naïve originality, sincerity or natural instincts.[26]

In 1866, Lecoq became director of the Ecole Royale et Spéciale de Dessin (the 'Petite Ecole' to the Beaux-Arts's 'Grande Ecole'), at which he had already taught for some years. The principles of his teaching, focusing on sensitivity to individual instinct, natural conditions and, above all, memory, were set out in his *Education de la Mémoire Pittoresque* (1847, revised 1862). Lecoq defined drawing as 'looking at the object with the eyes, and *retaining its image in the memory* whilst drawing it with the hand'. Left to its own devices, the memory was wont to become 'disastrously overcrowded with masses of incoherent matter'. He set out to train the memory in what he called 'stored observation' and to clarify the mental process in drawing which embodies: receiving data, discriminating and then translating it into marks on paper. His practice exercises, in which the student was required to study the model and then to draw it from memory, progressed from simple objects to moving figures,

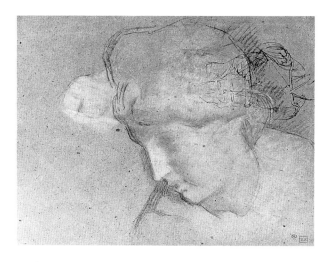

Fig.19 LECOQ DE
BOISBAUDRAN: *Head of a
woman and figure studies*
Black and white chalk on
grey paper
9⁵/₇ × 13 in
(24.7 × 32.8 cm)
Louvre, Dépt. des Arts
Graphiques.
RF 15.885

working out of doors as much as in the studio. Lecoq found that students had unequal ability to memorize form (and colour), but that his training enabled all of them to look less frequently at the model when drawing from life. He contrasted the authenticity of working from naturally moving models *en plein air* against the distortion of the body by fixed studio poses and stable lighting. He stressed that the flexibility of his teaching fostered personal invention as well as the ability to identify with the individualistic qualities of the masters.[27] He made a point of not showing his own drawings to his pupils, for fear of imitation. (It may be only coincidence that Lecoq's drawings are today very difficult to find.)

Fantin-Latour was among Lecoq's students in the early 1850s, and it was probably through him that such ideas filtered into impressionist circles. Closest personally to Fantin were Whistler, Degas and Manet. The importance of memory in the making of Whistler's *Nocturnes* ('painted from my mind and thought') is obvious enough.[28] Manet's views on memory are less clear. In 1876, Mallarmé reported Manet's belief that 'the eye should forget all else it has seen It should abstract itself from memory';[29] and Antonin Proust quotes similar views in his *Souvenirs*.[30] In the early 1880s, Manet advised a younger painter to 'cultivate your memory, because nature never gives you anything but references'.[31] This last sentiment seems closest to Manet's lifelong procedures; the former possibly reflects his closeness to Monet in the mid-1870s.

For Degas, Lecoq's ideas were assimilated as principles. 'It is all very well to copy what one sees, but much better to draw what one has retained in the memory. It is a transformation in which imagination collaborates with memory. One reproduces only what is striking: that is to say, the necessary. Thus, one's recollections and invention are liberated from the tyranny which nature exerts.'[32] One notebook jotting by Degas is pure Lecoq: 'For a portrait, set up the model on the ground floor and work on the first floor, to get used to remembering forms and expressions.'[33]

Degas also disseminated Lecoq's ideas. It was probably through him that they became seminal for the writing of Duranty's *The New Painting* (1876).[34] In 1883, Pissarro passed on to his son the advice of Degas to draw again from memory each evening what he had drawn in the life class during the day: 'the observations you make from memory will have far more power and originality than those you owe to direct contact with nature. The drawing will have art – it will be your own.'[35] Degas may also have been the source of similar ideas in Gauguin's theory. For Gauguin, the filter of memory was all-important, and in principle his method was not far from that of Whistler. He advises Schuffenecker in 1888: 'Don't copy nature too much – Art is an abstraction: draw it out of nature while dreaming before it and think more of the creation.'[36] In *Avant et Après* he writes: 'It's good for young artists to have a model, but they should draw a curtain across it while painting. It is better to paint from memory, and then the work will be your own.'[37]

The major abstainers from this common endorsement of the value of memory were Monet, Renoir and Sisley. The position on which Monet's impressionism was founded was virtually its polar opposite. His fervent wish to be free of all preconception was about forgetting not remembering. He later advised others to 'forget what you have in front of you' when painting. The scant attention paid in his drawings to any identifiable properties of topography, distance, texture and so on, is an expression of this wish. The implausible extremeness of this ambition and its conflict with the instincts of memory lay behind some of his own difficulties and certainly contributed to the confusions that beset Renoir and Pissarro in the 1880s.[38] In Monet's last paintings, often worked on simultaneously as cycles, and in the studio away from the motif, the wedding of memory to imagination came to play an increasing role.

During the 1880s, several of the young post-impressionists were students of Frédéric Cormon. He was described by A. S. Hartrick as 'one of the most liberal-minded teachers I have known',[39] and it is clear that the atmosphere of the teaching ateliers had by this time become relatively relaxed. In Couture's studio in the 1850s, Manet had demanded of a theatrically posed model: 'do you stand like that when you're buying radishes at the greengrocer's?'[40] The casual pose of some of Whistler's nude drawings seems to take informality to subversively ironic extremes (Fig. 20). Beside the artifice of pseudo-classical poses traditionally adopted by studio models, those drawn by Bernard, Lautrec and van Gogh in Cormon's classes appear relatively natural (Figs. 21, 22; Pl. 88). Lautrec felt moved to complain that Cormon's teaching and criticism made too few demands of him, and Bernard describes van Gogh working in the same studio with a disciplined intensity of his own making.[41] Such reactions combine with the initial

response to academic education of Redon, mentioned earlier, to confirm that what the painters of both generations objected to was never the rigour or discipline of the training, but the rigidity and archaic irrelevance of its syllabus.

Looked at as a whole, the impressionists' attitudes towards academic theory were not simple. In many instances they appeared averse to theory *per se*. Cézanne dismissed intellectuals as 'a pack of ignoramuses, cretins and rascals'; and Gauguin warned: 'Take care not to tread on the foot of a learned idiot; its bite is fatal'.[42] But they had read widely and, increasingly in old age, almost all of the impressionists elaborated their own theories and were not averse to giving copious advice to others. There is even a distinct possibility that some of Monet's most quoted advice on painting from nature originated from Ruskin's 1857 *The Elements of Drawing*.[43] Some of Cézanne's advice to younger artists may have been derived from the theories of Couture.[44]

In extreme instances, the impressionists came close to turning their backs on tradition in their obsessive attention to nature. Cézanne attributed Emile Bernard's intellectual constipation to too much museum study and Pissarro suggested that 'all the necropoles of art should be burned down'.[45] It was Pissarro, too, who dismissed Bernard's friend Anquetin as 'another one who rummages in the portfolios of the masters'.[46] But the impressionists were widely cultured, and the letters and other writings of most of them are packed with informed and passionately partisan references to older art. 'What, me a

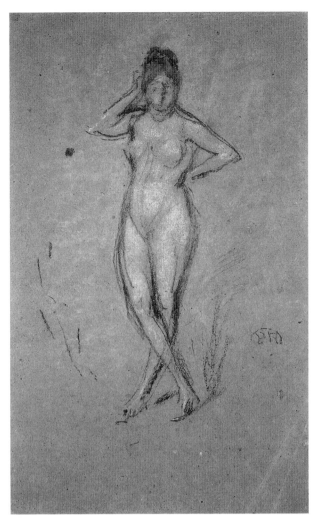

Fig.20 WHISTLER: *Standing female nude*, insignia
Pastel on brown paper
$11^{1}/_{4} \times 7^{1}/_{6}$ in
(28.6 × 18.2 cm)
National Gallery of Art, Washington
(Rosenwald Collection).
Inv. 1943.3.8806

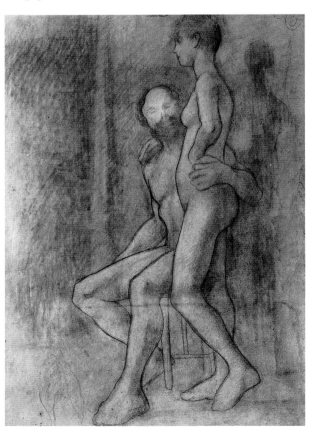

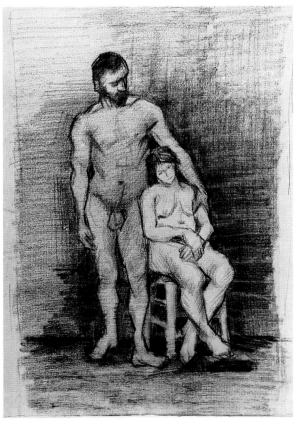

Fig.21 BERNARD: *Seated male nude and standing female nude*, dated 1885
Charcoal
$22^{6}/_{7} \times 17^{1}/_{3}$ in
(58 × 44 cm)
Collection M. and Mme Altarriba, Paris

Fig.22 VAN GOGH: *Standing male nude and seated female nude*, 1886/7
Black chalk, charcoal
$12 \times 8^{1}/_{2}$ in
(30.5 × 21.5 cm)
Rijksmuseum Vincent van Gogh, Amsterdam.
Inv. F1363a recto

Fig.23 INGRES: Study for *Raphael and the Fornarina*, c.1813
Pencil
10 × 7³/₄ in
(25.4 × 19.7 cm)
Metropolitan Museum of Art, New York
(Robert Lehman Collection).
Inv.1975.1.646

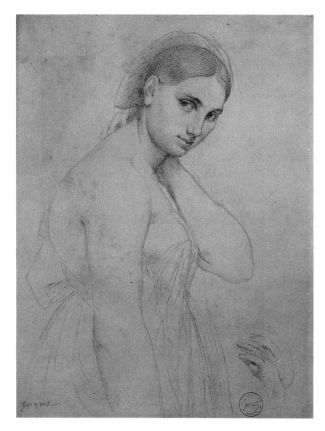

I MANET: *Seascape by moonlight*, c.1873
Watercolour over pencil
7⁵/₇ × 7 in
(19.6 × 17.9 cm)
Louvre, Dept. des Arts Graphiques.
Inv. RF 30.504. dL377

revolutionary!' explodes a Gauguin aside. 'Me? – who is full of love and respect for Raphael!'[47]

For the impressionists, it was the debased condition of the academic tradition rather than the tradition itself that was the ultimate stumbling block. The range of attitudes towards the drawing of Ingres is a case in point. Redon voiced the view of many of his generation in writing that it was 'lacking in reality and vital warmth . . . the haughty and fastidiously paternalistic incarnation of official art . . . death itself'.[48] But for Degas and Seurat, and later for Renoir, the quality of Ingres's drawing was a yardstick. Gauguin wrote in 1902 that 'no one around him understood him', and that Ingres 'was probably buried too hastily for he is very much alive today, no longer an official painter, but as someone entirely outside tradition'.[49] Matisse felt able to say later that 'Gauguin himself seems to come straight out of Ingres'.[50]

Familiarity with impressionist drawing practice reveals several echoes of academic theory and training. With the two most accomplished graduates of that training, Degas and Seurat, it is not surprising. 'One must copy and recopy the masters', Degas told Vollard, 'and it is only after proving oneself to be a good copyist that one should reasonably be allowed to paint a radish from life'.[51] Valéry reports that 'Degas declared that the study of nature is meaningless, since the art of painting is a question of conventions, and it was by far the best thing to learn drawing from Holbein'.[52] The central, originating role of drawing in Seurat's elaborate preparation for his large paintings

observes similar principles in its selection, refinement and composition of elements from nature. The separate, complementary use that he made of drawn tonal studies and painted colour studies is also deeply rooted in academic practice.

In the works and ideas of other artists, too, there are clear reflections of the academic tradition, particularly in those preoccupied with figure drawing. The detachment in Manet's figure drawings has an emotional restraint akin to the academic coolness of Degas and Seurat. Zola wrote in 1867 that, for Manet, a head against a wall is nothing other than a more or less white mark against a more or less grey ground.[53] In the mid-1880s, Pissarro reflects his own deep involvement with the figure in exhorting his son: 'go to the academy and seriously devote yourself to drawing the nude. To draw the figure you have to know anatomy. You need four or five months at the academy as a start And besides one must arm oneself at the start with everything necessary for the future fight.'[54]

Jean Renoir refers vaguely to his father's practice of tracing (apparently from paintings) to save the pose of a figure or group that 'was not coming together with the background'. He might save the tracing for months or years before reusing it.[55] This thoroughly traditional practice of recycling images is also evident in Degas, Pissarro and especially in Gauguin. In other aspects too, Gauguin, the arch-outsider, adopts drawing practices that reflect tradition: pricked cartoons, squared-up studies. Of all those in impressionist circles, he most firmly believed in the effectiveness of drawing with strong and distinct contours.[56] Van Gogh's sincere comments about not feeling adequately equipped to paint until he had completely mastered drawing – strongest in early letters, but repeated intermittently throughout his working life – coincide closely with the dogma of the Ecole des Beaux-Arts.

Some of the affinities with the academic tradition that emerged during the evolution of impressionist drawing have to do with a passage from the radicalism of youth to the paternalistic wisdom of old age. Others are the mature clarification of intuitions. Others again are the articulation of principles that were explicit and unambiguous from the outset.

Very few drawings by impressionists, of either generation, would have been recognizable in their own time as bearing much significant relationship to the academic tradition. Some bear none. Those academic values or practices which were assimilated were transformed beyond recognition. They were transformed in part by fundamental differences that existed between the impressionists' ambitions for art and those of the academies, and in part by the impressionists' assimilation of forms and ideas from other, nonacademic art. Ultimately, this transformation played an important role in the demise of the academic tradition of drawing as it stood in the mid-nineteenth century.

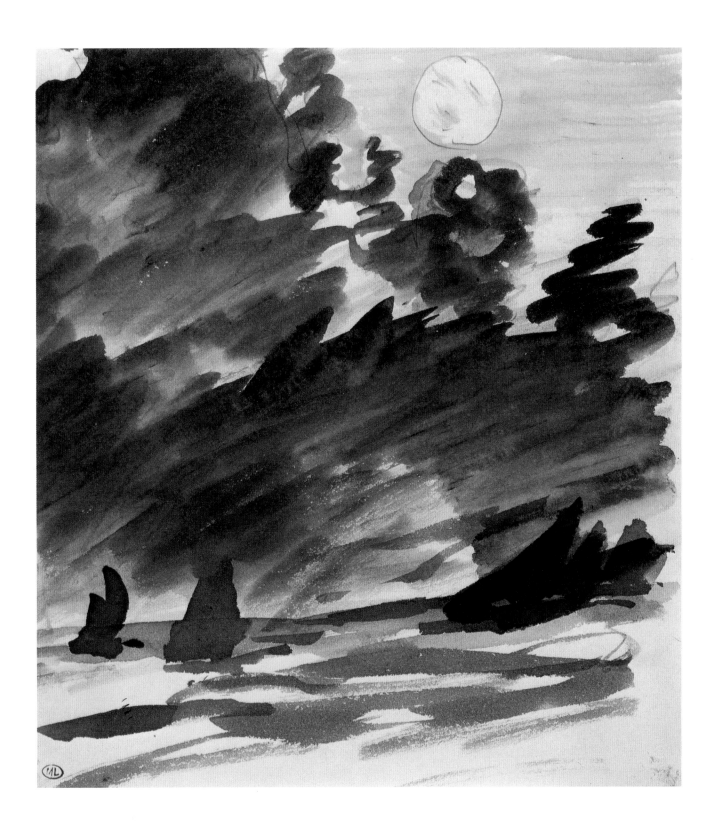

II BOUDIN: *Four women at Trouville*, signed & dated 1865
Pencil and watercolour
$4\frac{2}{5} \times 6$ in
(11.3 × 15.2 cm)
National Gallery of Art, Washington
(Ailsa Mellon Bruce Collection).
Inv. 1970.17.137

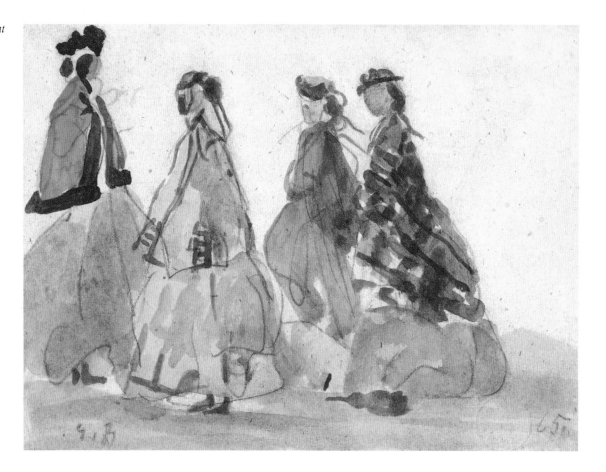

III JONGKIND: *Grenoble*, signed and dated 1877
Watercolour, heightened with white
$8\frac{1}{2} \times 12\frac{1}{5}$ in
(21.7 × 31 cm)
Louvre, Dépt. des Arts Graphiques Inv. RF 4079

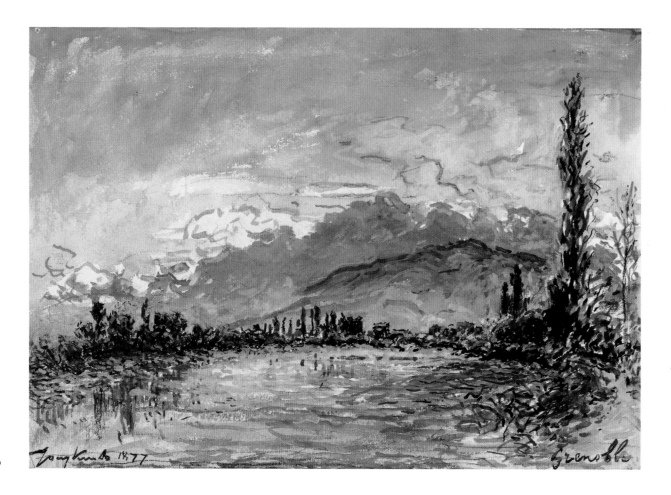

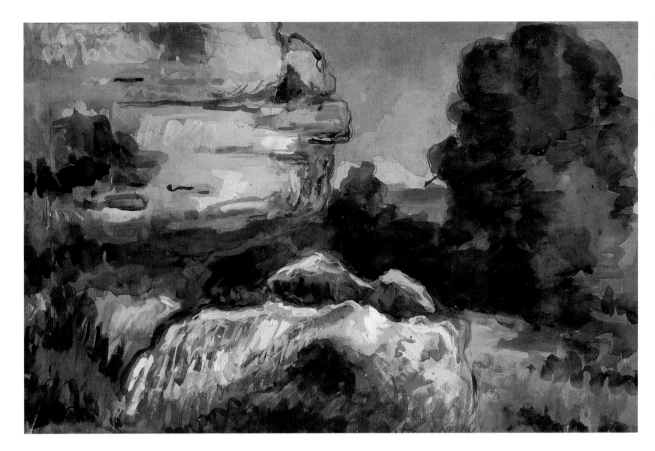

IV CÉZANNE: *Landscape
with rocks, c.*1867/70
Pencil, watercolour,
gouache
9 × 13$\frac{1}{2}$ in
(23 × 34.5 cm)
Staedelisches Kunstinstitut,
Frankfurt-am-Main. R10

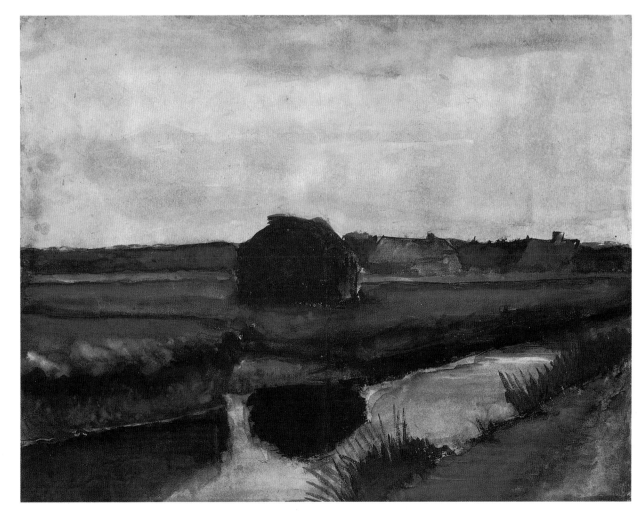

V VAN GOGH: *Landscape
towards evening, Drenthe,*
1883
Watercolour
15$\frac{3}{4}$ × 20$\frac{6}{7}$ in
(40 × 53 cm)
Rijksmuseum Vincent van
Gogh, Amsterdam. F1099

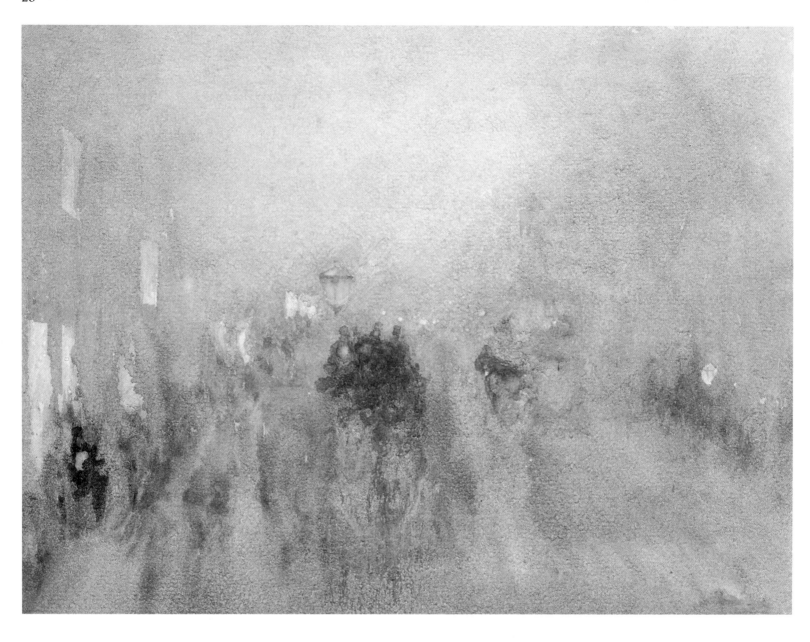

VI WHISTLER: *Nocturne in grey and gold: Piccadilly*, c.1884
Watercolour
$8^3/_4 \times 11^1/_2$ in
(22.2 × 29.2 cm)
National Gallery of Ireland, Dublin. Inv. 2915

NOTES

1 'Mon Salon', *L'Evènement*, 27 April 1866.
2 1892; Degas, *Letters*, p. 248.
3 A good account of the system is given in Boime 1986.
4 See Couture's advice in *Méthode et entretiens d'atelier*, 1867, translated in Nochlin 1966, p. 5.
5 Van Gogh was told at the Antwerp academy: 'Colour and modelling are trivial and easily learned; it's the contour which is essential.' *Letters* II, p. 494.
6 Cited by Maurice Denis in 'La Doctrine d'Ingres' in *Théories*, 1912, pp. 95–101.
7 Blanc 1870, p. 517.
8 Ibid., pp. 35–36. Blanc acknowledges his source as the writing of Humbert de Superville, and reproduces his diagrams.
9 Ibid., p. 570.
10 Ibid., pp. 576–77, 589.
11 Ibid., p. 713.
12 Jongkind studied in Picot's studio, *c.* 1846; Manet with Couture, 1850–56; Fantin-Latour with Lecoq and at the Beaux-Arts, 1850–54; Degas with Lamothe, 1855–56; Pissarro with Lehmann and Dagnan, 1855–56?; Morisot with Guichard, 1855; Whistler with Lecoq and Gleyre, 1855–56; Cézanne at the Ecole de Dessin, Aix, 1858–62; Renoir at the Ecole Impériale and with Signol and Gleyre, 1861–64; Monet with Gleyre, *c.* 1862–63; Bazille and Sisley with Gleyre, *c.* 1862–64; Redon with Gérome, 1864; Cassatt at Pennsylvania Academy and then with Gérome, 1866; Caillebotte with Bonnat, 1873; Seurat with Lehmann, 1877–79; Lautrec with Bonnat and Cormon, 1882–86; Bernard with Cormon, 1884–86; van Gogh in Antwerp and with Cormon, 1886–87; Bonnard and Vuillard with Gérome, *c.* 1888–89. The significant exceptions are Boudin and Gauguin.
13 A fellow student remembered him shouting at his professor: 'So you don't know what a young woman is like, God damn you! A woman must have hips and buttocks and a pelvis in which she can hold a child!' (Van Gogh, *Letters* II, p. 507.)
14 The account of Renoir's academic performance by Jean Renoir, even if heard from his father's lips, appears slightly inflated: 'He passed brilliantly the competitive tests in anatomical drawing, as well as those in perspective and "likeness". He was among the first in the final exam.' (Jean Renoir 1962, p. 99.) Robert Rey cites eight assessments of Renoir from Ecole des Beaux-Arts records. His placings were: 1862 – mentioned (perspective), 68th of 80 (general), 5th of 21 (perspective), 10th of 10 (painted study); 1863 – 20th of 80 (drawn figures), 9th of 12 (painted study), 28th of 80 (general); 1864 – 10th of 106 (drawing?). (*La Renaissance du Sentiment Classique*, 1931, pp. 44–45.)
15 He was prevented by a change of rules, lowering the age limit for candidates from 30 to 25 (Rewald 1955, p. 78).
16 In an interview with François Thiébault-Sisson, *Le Temps*, 27 Nov. 1900. Trans. in Charles Stuckey (ed.), *Monet, A Retrospective*, New York, 1985, pp. 204–18. The following comments on Gleyre's criticism are from the same source.
17 Vollard (1938) 1985, p. 148.
18 This and the following quotation are from Redon (1922) 1961, pp. 21–22.
19 Mellerio 1923, p. 174.
20 October 1897; Gauguin, *Lettres*, 1919, p. 190.
21 From a four-page text in the 'Brittany carnet', Armand Hammer Collection, pp. 29 verso ff.
22 *La Vie Moderne*, 12 June 1880 (*Archives* II, p. 340).
23 Boime (1971) 1986, p. 63.
24 See also Schiff 1984, pp. 78ff, on Couture in this respect.
25 Boime (1971) 1986, pp. 181–84, and the same author's 'The Teaching Reforms of 1863 and the Origins of Modernism', *Art Quarterly*, Autumn 1977, pp. 1–39.
26 Quoted by Duranty in *La Nouvelle Peinture*, 1876, see Moffett 1986, p. 39.
27 Lecoq de Boisbaudran (1862) 1911, pp. 6, 15–16, 39, 77–78. Earlier references to memory in the theory of art are many and varied. Leonardo talks of cultivating the memory in his *Treatise on Painting* (1490s). Alexander Cozens identified a weakness in landscape drawing that is very similar to Lecoq's target area when he wrote that the mental image 'grows faint and dies away before the hand of the artist can fix it upon paper' (*A New Method of Assisting the Invention in Drawing Original Compositions of Landscape* 1785).
28 See Pennell 1925, pp. 46, 113. Boime (1986, p. 61) suggests that it was Gleyre's instruction in memory drawing that prompted Whistler's practice: either way, the ultimate source was probably Lecoq.
29 'The Impressionists and Edouard Manet', *Art Monthly Review*, London, 30 September 1876.
30 Proust (1897) 1988, p. 99.
31 Jamot and Wildenstein 1932, p. 71.
32 Jeanniot, 'Souvenirs sur Degas' 1933, quoted by Rewald 1955, p. 303.
33 Notebook 30, p. 210; Reff, *Notebooks*, 1976, p. 134.
34 For this, see pp. 39–40. The Lecoq-like character of Valéry's description of drawing quoted earlier (p. 13) probably also originated from Degas.
35 13 June 1883; Pissarro, *Letters*, p. 35.
36 Gauguin, *Correspondance*, 1984, No. 159, p. 210.
37 *Avant et Après*, p. 35.
38 See below, chapter 5.
39 A. S. Hartrick, *A Painter's Pilgrimage*, Cambridge, 1937.
40 Antonin Proust 1988, p. 12.
41 See, respectively, notes to Plates 85, 92.
42 Cézanne, *Letters*, p. 326; Gauguin, *Avant et Après*, p. 35.
43 Ruskin recommends looking at nature with an unprejudiced eye, and recording only the colours and shapes that one sees, in terms very similar to those used in Monet's well-known advice to Lilla Cabot Perry. Monet also echoes Ruskin's comparison of the ideal innocence of vision to which a painter should aspire with that of a blind man 'suddenly gifted by sight'. See Stuckey, in Rewald and Weitzenhoffer 1984, p. 108. Monet may have come across *The Elements of Drawing* through Signac, an admirer of Ruskin, who refers to it in *De Delacroix au Néo-Impressionnisme* (1899) and who later completed a translation of it begun by H. E. Cross. The statement by Dewhurst that Cross's translation was published in 1900 is probably a confusion with Signac's book of 1899. See Cachin in Signac 1987, p. 131n, and Dewhurst 1911, p. 296n.
44 Robert Ratcliffe's research, cited in Chappuis I, p. 14. Cézanne had a reproduction of Couture's *Les Romains de la Décadence* on his studio wall in Aix (Doran 1987, pp. 59, 197 n15).
45 For both points, see Cézanne, *Letters*, p. 332.
46 23 March 1898; Pissarro, *Letters*, p. 323.
47 *Avant et Après*, p. 181.
48 April 1878; Redon 1961, pp. 146–47.
49 *Racontars de Rapin*.
50 1945; quoted in Jack D. Flam, *Matisse on Art*, 1973, p. 102.
51 Vollard, *Degas*, 1924, p. 64.
52 Valéry 1960, p. 83.
53 Zola, *Edouard Manet*, Paris, 1867, p. 23.
54 14 Jan. 1884; Pissarro, *Letters*, p. 52.
55 Jean Renoir 1962, p. 345.
56 See note to Plate 72.

3 The Alternative Tradition

Within the pantheon of artists endorsed by the academic tradition, a selective line of descent can be traced from classical antiquity, through Raphael and Poussin, to Ingres. Alongside that history stand the names of major artists whose work did not conform to the ideals and principles of the tradition. Successive academies effectively blacklisted certain artists as unsuitable models for study, and the work of some nonconformists was made in more or less conscious defiance of academic doctrine.

When the impressionists were students, the most prominent living dissenters were artists associated with radical realism. As well as Courbet and Daumier, these included the Barbizon landscape painters – Millet, Corot, Rousseau, Daubigny, Diaz – some of whom the impressionists came to know personally.[1] The essence of their polemical debate with establishment values was 'nature versus art': upholding an art founded in the forms and values of the real world, and rejecting what to them appeared the irrelevance of an art couched in the exhausted language of classical idealism. Couture's image of *The Realist* is a light-hearted expression of establishment attitudes: the realist artist in peasant dress displays his ignorance of the value of classical art by sitting on it, while drawing

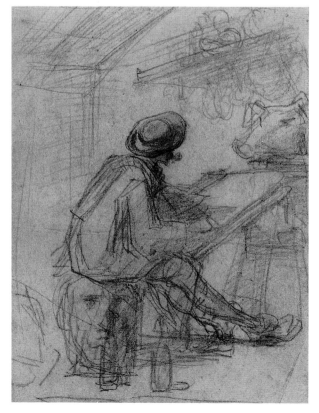

Fig.24 COUTURE: Study for *The Realist*, c.1865
Black chalk
15⅝ × 12 in
(40.2 × 30.6 cm)
National Gallery of Ireland, Dublin. Inv. 18969

his alternative model from the most base reality (Fig. 24).[2] The great seventeenth-century tradition of Dutch landscape and genre painting was regarded by the academies as diverting and picturesque, but secondary, because it treated unelevating subject matter in an unidealized manner. The 'frivolity' of much eighteenth-century French art was viewed in a similar light.

The motives behind most exclusions from the academic pantheon can be traced to principles of drawing and to a polarity of 'line versus colour' that almost amounts to drawing versus painting. It was this that had generated heated arguments of principle between devotees of Poussin and Rubens in the eighteenth century,[3] and, more recently, between followers of Ingres and Delacroix. The succession of non-academic or anti-academic artists amounts to what is effectively an alternative tradition, including Venetian sixteenth-century art, Michelangelo, Rubens and Goya, and in France a line of descent running through rococo, romantic and realist art. Artists from Fragonard to Géricault to Courbet had argued, implicitly or explicitly, for the individuality of the artist in face of an academic stereotype. In critical writing over the same period there is a comparable history of minority dissent, from Diderot onwards, ridiculing the absurdity of academic drawing and speaking for a type of drawing in which 'a few strokes express the rapid fancy', giving rein to originality and the imagination.[4]

The impressionists were associated with this alternative tradition from the outset. There were critical references to their work in the context of 'the great battles between romanticism and academic art';[5] frequent comparisons with seventeenth-century Dutch art; and several uses in early literature on the subject – favourable and unfavourable – of the term 'baroque'.[6] The most cursory examination of drawings within this tradition reveals two things. The continuity of the lineage is repeatedly demonstrated: for instance in the influence of Michelangelo and the Venetians on Rubens; of Rubens on Watteau and Fragonard; of Michelangelo, the Venetians and Rubens on Delacroix; of Fragonard on Daumier. Secondly, it reveals an obvious kinship with the drawings of the impressionists. If we examine the pantheon that accumulates from the written and recorded statements of the impressionists themselves, the most common references are to Venetian art (Titian, Tintoretto, Veronese), to Rubens, to Dutch seventeenth-century art, to Spanish art (Velasquez, Goya), to eighteenth-century France (Watteau, Fragonard,

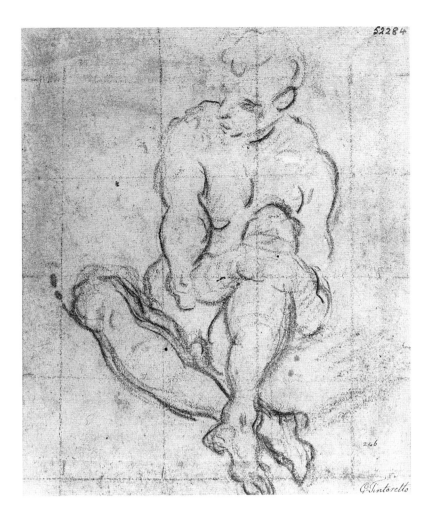

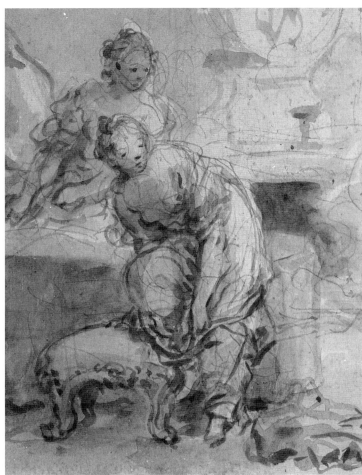

Chardin), to French romanticism (Géricault and, universally, Delacroix) and to realism. In this light, the relatively liberal attitudes abroad in the teaching studios of Couture and Gleyre become both clear and relevant. Against the grain of conventional practice, Couture took his students to look at Venetian art in the Louvre and Gleyre encouraged his students to copy Rubens.

Most typical of the contrast between the two traditions are the respective attitudes towards those great individuals, such as Michelangelo and Goya, whose genius was seen as too subversively eccentric to serve as an academic model. Blanc, like others before him, warned specifically against the corruptive dangers inherent in Michelangelo's example.[7] Delacroix, on the other hand, holds up Michelangelo as the cardinal example of an original source to whom artists should turn for salvation from exhausted academic convention.[8] For Baudelaire, Michelangelo was exceptional in being the only 'non-colourist' painter who possessed what he calls 'graphic imagination'.

One particular Michelangelo carving in the Louvre, the *Dying Slave*, was copied repeatedly in drawings by the impressionists. All three examples illustrated overleaf (Figs. 27–29) emphasize, in their different ways, the sculpture's haunting poise between physical animation and lethargy.[9] Degas's drawing is among the most fully realized and sensitively felt of his early copies after other artists. The directional energy of the background hatching enhances the movement of the pose. Cézanne came back repeatedly to this motif, with increasing understanding, as he got older. In these late examples, the substance and gravity of stone dissolve in a heated exchange of arcs and reasserted lines. Van Gogh's chunky, energetic copy is drawn slightly from above (perhaps from a scaled-down cast or copy) in the broken angular lines of his Paris manner. The subject of this drawing is almost always mistakenly identified. The revised de la Faille catalogue of 1970 goes beyond simple oversight of the source of the motif in listing it as: 'Study after living model: standing female nude'.[10] The example of Michelangelo became as important to van Gogh as that of Millet in his self-justifying defence of figure drawing that was true but not 'correct'. For most French artists, from Géricault and Delacroix onwards, the valuable precedent of Michelangelo's drawing lay precisely in this distinction: that he achieved expressive power despite, or by virtue of, ignoring ideal proportions.

Although Manet had seen his paintings at first hand in Madrid, the art of Goya was available to the impressionists primarily through prints. A copy of a Goya self-portrait appears, next to his own self-

Fig.25 TINTORETTO: Study of a seated nude man
Charcoal on grey paper
9 × 7³/₄ in
(22.9 × 19.7 cm)
Victoria and Albert Museum, London.

Fig.26 FRAGONARD: *The Bedroom* (detail)
Brush, brown ink and wash, over pencil
Sheet 9¹/₂ × 14¹/₂ in
(24 × 36.9 cm)
National Gallery of Art, Washington
(Samuel H. Kress Collection).
Inv. 1963.15.10

Fig.27 DEGAS: Copy after Michelangelo's *Dying Slave*, (right) *c*.1860, stamped
Pencil
13 × 9 in (33 × 23 cm)
Collection Marianne Feilchenfeldt, Zurich

Fig.28 CÉZANNE: Copy after Michelangelo's *Dying Slave*, (below) *c*.1900
Pencil
Page XXVI recto from a sketchbook, 8½ × 5 in (21.6 × 12.7 cm)
Philadelphia Museum of Art (Gift of Mr and Mrs Walter H. Annenberg).
C1208

Fig.29 VAN GOGH: Copy after Michelangelo's *Dying Slave* (far right), 1886/7
Pencil, pen and ink, blue chalk
Rijksmuseum Vincent van Gogh, Amsterdam.
Inv. F1365

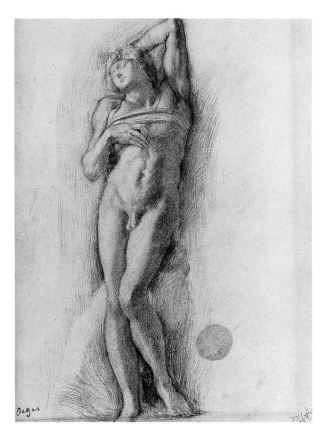

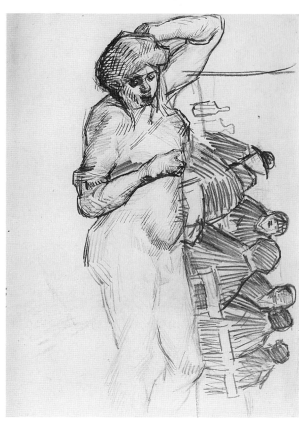

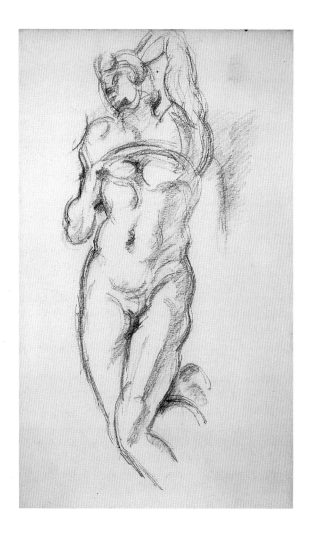

portrait, on a sheet of studies by Cézanne of about 1877 (C405) and something of Goya's intensity lurks behind the violent form and content of many early Cézanne drawings. It is in the drawings of Redon (who dedicated a folio of his prints to Goya) that we find the most profound response both to Goya's subject matter and to the styleless improvisation of his handling of drawing materials (see Pl. 78). As well as the direct force of their subjects, it was the relative freedom from stylistic mannerism or convention in Goya's drawings and prints that made them appear both accessible and 'modern'.

The most influential modern source for the philosophy and theory of drawing within this alternative tradition, and which, with Delacroix's *Journal*, formed its intellectual centre in the late nineteenth century, was the critical writing of Baudelaire.[11] Baudelaire anticipated the pantheon of the impressionist and post-impressionist generations in remarkably precise detail. In his poem 'Guiding Lights', he listed these archetypes: 'Rubens, Leonardo, Rembrandt, Michelangelo, Puget, Watteau, Goya, Delacroix' (*Les Fleurs du Mal* 1857). Add, from his other writing, the Venetians, Daumier, Guys and Boudin, and the pantheon is almost complete. Of primary importance for Manet, Cézanne, Redon and Gauguin, Baudelaire's writing was familiar and of significant value to almost all artists in impressionist circles.[12] The principal exception, remarkably, is van Gogh, who warned Bernard to stay clear of Baudelaire. He seemed to consider Baudelaire an over-

sophisticated Parisian, whose words were 'sonorous but infinitely shallow'.[13] Considering the scale and nature of van Gogh's admiration for Delacroix, we can only wonder if this avid reader of modern French writing was deterred by some initial antipathy – perhaps to the decadent values of the poetry – from ever reading the bulk of Baudelaire's essays.

Baudelaire opened his discussion of drawing in his first *Salon* (1845) in characteristic fashion. 'When we say that a picture is well drawn, we do not wish it to be understood that it is drawn like a Raphael. We mean that it is drawn in an extempore and *graphic* manner; we mean that this kind of drawing, which has something analogous to that of the great colourists, Rubens for example, perfectly renders the movement, the physiognomy, the hardly perceptible tremblings of nature, which Raphael's drawing never captures.'[14] Sensitivity to nuance in nature, if not the most constant theme, is one that recurs in his descriptions of drawing that he values. The paragraphs in his *Salon of 1859* devoted to Boudin's pastels stressed the subtlety and accuracy of Boudin's improvisations in front of sea and sky – so true that if one covered the artist's written notes, one could guess the season, time and weather.

In his canonical *Salon of 1846*, Baudelaire refined his distinction between the drawing of the colourist and other, inferior forms of drawing. He explained that austere, meticulous drawing of detail and contour is antipathetic to the colourist, but that a certain sort of drawing that employs 'flowing and fused lines' and a 'total logic of his linear ensemble' is integral to the colourist's art. In the long chapter on Delacroix, he launched his main attack against 'the tyrannical system of straight lines'. He identified three types of drawing: 'the exact or silly' (which is negative, absurd, and anyway incorrect); 'the physiognomic' (which is naturalistic); and 'the imaginative', which is 'the noblest and strongest and can afford to neglect nature – it realises *another* nature, analogous to the mind and the temperament of the artist'.[15]

Baudelaire named three great draughtsmen of his time: Ingres, Delacroix and Daumier. Among 'pure draughtsmen', those whose drawing is governed by reason rather than temperament, Ingres was the only artist who deserved attention. For all his faults and despite his doomed attempt to reconcile pure drawing with the passion for colour 'of a fashionable milliner', Ingres 'draws admirably well, and he draws rapidly'. Baudelaire forgave Ingres for pursuing erroneous ideals because he did so with a natural, light and economic touch. Although, in a later essay (on the 1855 *Exposition Universelle*), he charged Ingres with archaic contrivance and sharp practice, the brunt of his hostility was reserved for Ingres's pupils and followers, many of whom were masters of teaching ateliers. Baudelaire dismissed out of hand those who have 'coldly, deliberately and pedantically chosen the displeasing and unpopular part of his genius to

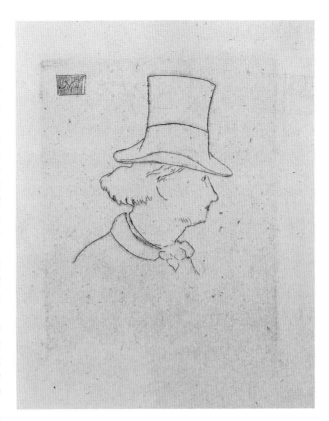

Fig.30 MANET: *Profile portrait of Baudelaire*, 1862/69
Etching
$4^1/_4 \times 3^1/_2$ in
(10.8 × 8.9 cm)
New York Public Library

translate into a system; it is their pedantry that preeminently distinguishes them'.[16]

Baudelaire's attack against 'the straight line', if it can be taken literally at all, refers to the stylized angularity of some academic drawing. Blanc referred to the unique and infinite 'sublimity' of the straight line and Ingres is reported to have said that 'beautiful forms are straight planes rounded'.[17] The stylistic mannerisms of some of Seurat's student copies (Fig. 31) adhere closely to Ingres's ideal. More meaningfully, Baudelaire's tyrannical straight line served as a model for the inert and arid condition of academic style at large. It was the antithesis of modernity, of expressive colour, of the vibrancy of nature and of the imagination.

All of these qualities are richly present in his other two great draughtsmen. Daumier, for Baudelaire, was the draughtsman of the century: 'one of the most important men in the whole of modern art'. 'His drawing is full, fluent, but never descends to the *chic*. . . . It is the logic of the sage transformed into a light, fugitive art, which challenges the very mobility of life.'[18]

Delacroix, the 'true poet' of the nineteenth century, was the climax of Baudelaire's discussion of drawing, and inspired his most celebrated, declamatory statement on the subject. 'What am I to say, except that a good drawing is not a hard, cruel, despotic line, imprisoning a form like a straitjacket? that drawing should be like nature, alive and in motion? that simplification in drawing is a monstrosity, like a tragedy in the world of the theatre, and that nature presents

Fig.31 SEURAT: *The hand of Poussin* (copy after Ingres's *Apotheosis of Homer*), *c*.1877
Pencil
$8^1/_3 \times 5^3/_4$ in
(21.2 × 14.6 cm)
Metropolitan Museum of Art, New York
(Gift of Mrs Alfred H. Barr).
Inv. 87.326

Fig.32 DAUMIER: *Thieves*, 1850s?
Charcoal
$13^1/_3 \times 10$ in
(34 × 25.5 cm)
Louvre, Dépt. des Arts Graphiques. RF 36.799

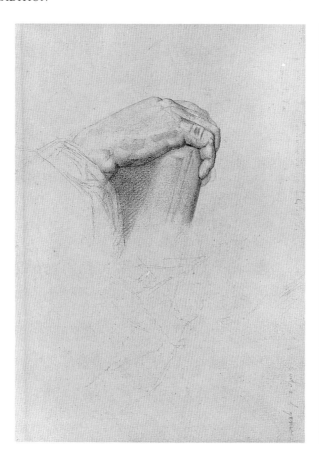

Fig.33 DELACROIX: Study for *Death of Sardanapalus*, *c*.1827
Pencil, pen, brush and ink
$11^1/_2 \times 16^1/_3$ in
(29.1 × 41.6 cm)
Musée Bonnat, Bayonne.
Inv. n.i. 556

us with an infinite series of curved, receding and irregular lines, following an impeccable law of generation, in which parallels are always vague and sinuous, and concavities and convexities correspond with and pursue one another? and, last of all, that M. Delacroix admirably satisfied all these conditions, and that even though his drawing may admit of an occasional weakness or excess, it has at least the enormous merit of being a constant and effective protest against the barbaric invasion of the straight line – that tragic and systematic line whose current ravages in painting and sculpture are already enormous?'[19]

The broad relevance of Baudelaire's illuminating discussion of drawing to concerns of the impressionists is obvious enough, but in some respects his thesis does not match them so precisely. In his last *Salon* (1859), he attacked working from nature as fiercely as he did any antiquarian idealism. Working directly from nature he describes as tedious – a form of laziness among artists who do not trust their memories. For Baudelaire, naïve submission to nature must have represented a threat to the faculty of memory, to its stored riches and powers of transformation. True draughtsmen, he says, draw from an image engraved upon their brains; nature is filtered through the temperament and the imagination. 'Nature is ugly and I prefer the monsters of my fancy to what is positively trivial.'[20] It was this sort of writing that made Baudelaire more relevant, and differently, to the post-impressionist generation. When Gauguin quoted Baudelaire's 'Tell us, what have you seen?' at the start of a chapter in *Noa Noa*,[21] it was an inner 'seeing', with eyes closed, that he had in mind.

The extreme, black side of Baudelaire's fantasy, stronger in the poems than in the essays, was of seminal importance to the drawings of Redon and Seurat – possibly to Degas as well – and to the romantic, private world of Cézanne's imagination. Baudelaire's Poe-inspired belief in the essential strangeness of true beauty is one aspect of this. 'Anything that is not slightly misshapen has an air of insensibility . . . ', he wrote in one of his *Fusées*. 'Hence it follows that irregularity – that is to say the unexpected, the surprising, the astonishing – is an essential part, indeed the characteristic of beauty.'[22] This side of Baudelaire is another facet of his antipathy towards the straight line, but one whose resonance reaches far beyond the world of *plein air* impressionism. He discusses Goya in the context of 'poetic brutality' (*Salon of 1846*), and in his poem 'The Ideal', he brushes aside the triviality of Gavarni ('anaemia's laureate') and writes of a cavernous heart that 'requires Lady Macbeth and an aptitude for crime' (*Les Fleurs du Mal*, 1857). One senses in his admiration for Guys, an identification with the slightly sinister, exotic undertones beneath the dense, sooty masses of his wash drawings. The sublime, the dandified and the bizarre coexist within Baudelaire's private pantheon.

The key values in Baudelaire's writing, which

Fig.34 GUYS: *Standing woman with a veil, c.1855/63* Pen and black ink, watercolour 14$\frac{1}{2}$ × 9$\frac{3}{6}$ in (36.7 × 24 cm) Boymans-van Beuningen Museum, Rotterdam. Inv. F-II-109

underpinned all subsequent impressionist theory, were his impassioned championship of modernity and his belief that great art was that which most clearly expressed the spirit of its time. These are the central themes of his essay on Guys, *The Painter of Modern Life*, of 1863. In a notebook from his final years in Brussels, a late entry says: 'I like to imagine an art in which the quality of duration would be replaced by that of the temporary. An art constantly applied to life. Theatres. Seasons. Sunshine. Dancers and dancing.'[23] Apart from his supportive attitude towards Manet and his positive comments on the drawings of Boudin and Whistler, Baudelaire died too early (1867) to leave us his views on impressionism.

It has long been recognized that his writing on art was heavily and directly dependent on the thinking of Delacroix. There are numerous parallels between Baudelaire's essays and the comments on drawing in Delacroix's *Journal*, especially on the propagation by Michelangelo and Rubens of a type of drawing whose vigour and audacity excused them from accuracy. A characteristic entry from the *Journal* is that of 15 July 1849. Delacroix writes: 'This famous quality of beauty – which some see in a curved line and others in a straight line, all are determined to see in line alone. But here I am, sitting at my window looking at the most beautiful countryside imaginable and the idea of

Fig.35 GAUGUIN: *Head of a woman (after Delacroix)*, *c.*1889, inscribed 'd'après Delacroix' Black crayon 6 × 7²/₃ in (15.3 × 19.4 cm) Louvre, Dépt. des Arts Graphiques (Album Walter). RF 30.569, 46 verso

Fig.36 DELACROIX: *Naiad (after Rubens)*, *c.*1840 Oil on canvas 18¹/₃ × 15 in (46.5 × 38 cm) Kunstmuseum, Basel. Inv. 1602

a line doesn't enter my head. The larks are singing, the river is sparkling with a thousand diamonds, I can hear the rustle of the leaves, but where are any lines to produce such exquisite sensations? [Yet] these people refuse to see proportion and harmony unless they are enclosed by lines. For them all the rest is chaos, and a pair of compasses the only orbit.'[24] The *Journal* was not published until 1893, and Baudelaire is important not least for his role as an intermediary between the impressionists and an artist whom they regarded as a sort of god.[25]

Daumier and Delacroix both acquired the status of heroic, anarchic forebears to the impressionists. Just as Manet had been advised by Couture not to become another Daumier, so Renoir was warned as a young man not to fall into Delacroix's shoes. In the context of drawing, these two are the names most commonly cited by the impressionists, alongside those of Corot and Manet. Daumier's inventive, improvisatory technique and the focus of his imagery run like a thread of inspiration through the drawings of many artists in the last quarter of the century. He emerges as an enduring source for Degas, Pissarro, Cézanne, Gauguin, Seurat and Lautrec – second only to Delacroix.

All the impressionists and post-impressionists acknowledged Delacroix's founding role in modern art. It was to his encounter with Delacroix that Redon owed 'the first awakening and sustenance of my own flame', and the comments of Cézanne, Renoir,

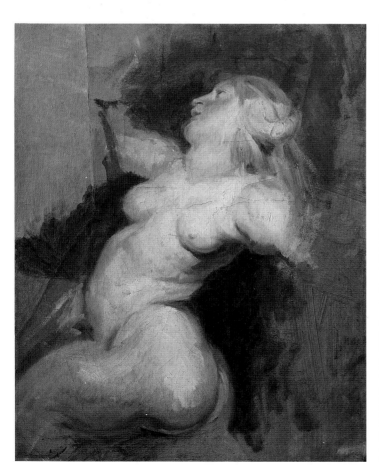

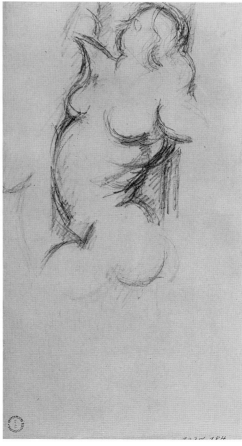

Fig.37 CÉZANNE: *Naiad (after Rubens)*, *c.*1895/98 Pencil 8¹/₅ × 4⁴/₅ in (20.8 × 12.2 cm) Kunstmuseum, Basel. C1128

VII BOUDIN: *Stormy sky*, early 1860s? signed Pastel 8¹/₄ × 11¹/₄ in (21 × 28.6 cm) Louvre, Dépt. des Arts Graphiques. Inv. RF 36.795

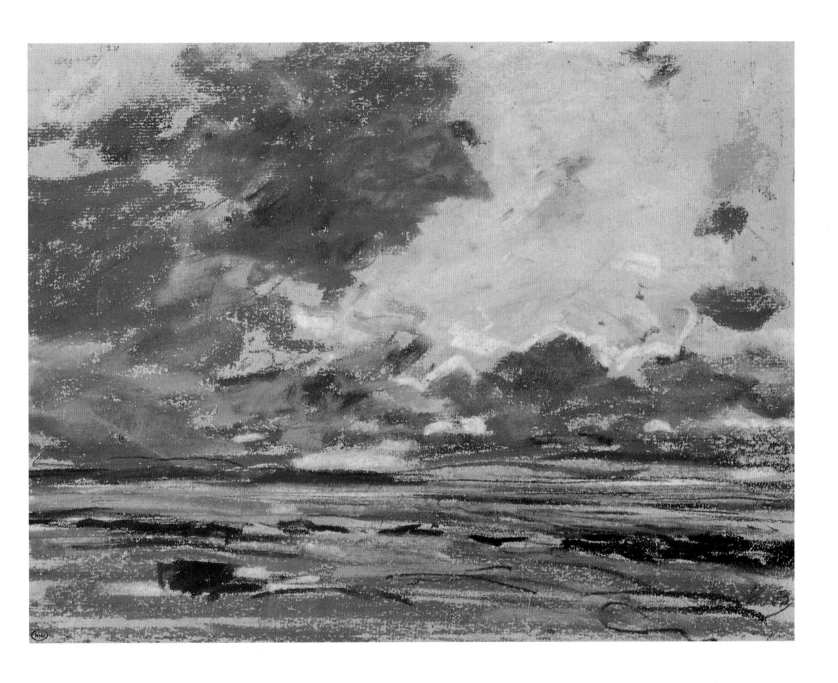

VIII DELACROIX: *Sky study, setting sun, c.*1849
Pastel on grey paper
7¹/₂ × 9³/₇ in
(19 × 24 cm)
Louvre, Dépt. des Arts Graphiques.
Inv. RF 3.706

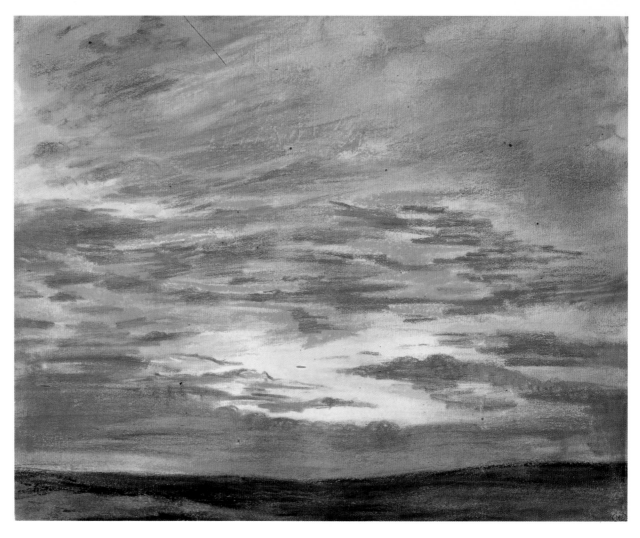

IX MONET: *View of sea at sunset, c.*1874?
Pastel
10 × 20 in
(25.4 × 50.8 cm)
Museum of Fine Arts, Boston (Bequest of William P. Blake). Inv. 22.604

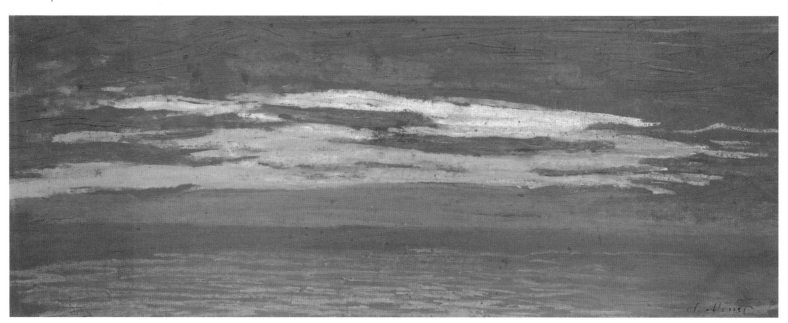

Bazille, van Gogh and Gauguin contain similar sentiments.[26] Degas owned drawings by Delacroix; Gauguin knew Delacroix's work from the collection of his guardian Gustave Arosa; Redon saw drawings in the house of Delacroix's cousin, and Cézanne was intimately familiar with watercolours and drawings in the collection of his mentor, Victor Chocquet. Cézanne copied Delacroix as early as 1864 and was reading (probably rereading) Baudelaire on Delacroix in the last months of his life.[27]

Among Chocquet's Delacroix collection was at least one study after Rubens, and if Delacroix did not initiate Cézanne's interests in Rubens and Puget, he certainly confirmed them.[28] Cézanne repeatedly singled out from Rubens's *Marie de' Medici* cycle in the Louvre, the same figures to copy as had Delacroix. Delacroix's descriptions of Rubens paintings are all centred on their unbounded vehemence and imaginative technical freedoms. He compared the exuberance of these pictures to 'public meetings where everyone talks at once'.[29] The two Louvre panels that Delacroix and Cézanne both copied most often (the *Disembarkation* and the *Apotheosis of Henry IV*) are the loudest and physically most dramatic. The action of the naiads (Figs. 36, 37) unfolds energetically across the surface as well as back and forth in space, and both artists sought to heighten the complex torsion of the movement.

In the 1860s, Emile Zola's articles in support of the new art reaffirmed the superiority of an art that fused expressions of nature (the fixed element) and of man (the variable), over an art that sought only accuracy in front of nature.[30] Jules Laforgue's brilliant essay on impressionism (drafted in 1883, but apparently unpublished until 1896) discussed its freedom from the deep-rooted but puerile prejudice in favour of linear drawing by contour and perspective. To him the impressionist eye was 'the most sophisticated in human evolution The impressionist sees and renders nature just as it is, that is to say solely in vibrations of colour. No drawing, no light, no modelling, no perspective, no chiaroscuro, none of these childish classifications.'[31]

In 1876, the novelist and critic Edmond Duranty published his essay *La Nouvelle Peinture*, its title and the style adopted by the writer smacking of a manifesto. Generally agreed to have originated largely from the theoretical stance of Degas in the early 1870s, it is of most interest for that reason. After Baudelaire, its style does not make inspiring reading and, from the lack of reference to it in artists' letters, this may also have been contemporary opinion. Nevertheless, the publication of this pamphlet in connection with the second group exhibition was an important event and, we might guess, of formative significance to an artist like Caillebotte, whose paintings of 1876–77 adopted a markedly different, more radical approach to images of urban streets.

The core of Duranty's essay is a championship of realist art and proclamation of the need to escape the conventional, the banal and the traditional. Citing the authority of Diderot and Lecoq de Boisbaudran, he attacks the irrelevance of the academies, compares the aspirations of realist art to the achievements of modern French literature and, significantly, treats Courbet and Corot as the fathers of 'The New Painting'. He claims for impressionism, 'a new method of colour, of drawing, and a gamut of original points of view', and states that its founding principle was 'to eliminate the partition separating the artist's studio from everyday life, and to introduce the reality of the street'.

In a short section on drawing, Duranty lists as its goals: 'to know nature intensely and to embrace nature with such strength that it can render faultlessly the relations between forms and reflect the inexhaustible diversity of character. Farewell to the human body treated like a vase, with an eye for the decorative curve. Farewell to the uniform monotony of bone structure, to the anatomical model beneath the nude. What we need are the special characteristics of the modern individual – in his dress, in social situations, at home or in the street. The fundamental idea gains sharpness of focus. This is the joining of torch to pencil, the study of states of mind reflected by physiognomy and clothing. It is the study of man's relationship to his home, or the particular influence on him of his profession, as reflected in the gestures he makes: the observation of all aspects of the environment in which he evolves and develops The artist's pencil will be infused with the essence of life. We will no longer simply see lines measured with a compass, but animated expressive forms that develop logically from one another' On technique, Duranty proposes that 'drawing is such an individual and indispensable means of expression that one cannot demand from it

Fig.38 DEGAS: *Study for a portrait of Edmond Duranty*, 1879 Charcoal and white chalk on blue paper 12¹⁄₈ × 18²⁄₃ in (30.8 × 47.3 cm) Metropolitan Museum of Art, New York (Rogers Fund). Inv. 19.51.9a

Fig.39 MANET: *Cucumber with leaves, c.*1880 Watercolour 13$\frac{1}{4}$ × 10$\frac{1}{4}$ in (33.7 × 26 cm) National Gallery of Art, Washington (Collection Mr & Mrs Paul Mellon). Inv. 1985.64.103

methods, techniques or points of view. It fuses with its goal, and remains the inseparable companion of the idea.'[32]

J. K. Huysmans emerged in the later 1870s and 1880s as one of the most articulate supporters of Degas, Pissarro, Cassatt, Caillebotte, Renoir, Gauguin and, later, of Redon. He argued for the same two priorities: freedom from traditional techniques and the direct expression of modern reality. He saw Degas as the true successor to Delacroix in reconciling drawing to colour and listed a diet of as yet unrealized subjects from modern life that might have come straight from Degas's notebooks. He was profoundly impressed by the authentic sense of ordinary life in Caillebotte's work and praised the individuality and penetration of Renoir's pastel portraits.[33]

The most continuous thread of theory within the alternative tradition is the proposal of modern life and

the real world as the only worthy subjects for the modern artist. Collectively, the corpus of writing from Diderot onwards says relatively little about technique, save the repeated inference that concepts of style were not relevant to modern drawing. In effect they advocate the same state of no-tradition and no-style that Courbet had proposed in his accounts of realist theory.[34] Techniques of drawing should emerge from the circumstantial encounter of each artist with each subject.

Only in Baudelaire, Delacroix and to some extent in Duranty, is there significant discussion of the type of drawing that constitutes the tradition, with their models of nature in which 'everything is in a state of perpetual vibration which causes lines to tremble'.[35] It is a tremulous manner of drawing, curvilinear and open in character, with more concern for effects of flux and movement than for finish. It anticipates the techniques of impressionist painting in its general principle of loose, insubstantial and gravity-less marks. The example of the Rubens–Delacroix–Cézanne sequence demonstrates the strength and continuity of the general principles. It was a tradition that prized the energetic mobility of lines: lines that were free of conventional artifice, that expressed in the most intuitive way the impulse of the artist's imagination and, finally, that were parallel to the variety and vitality of nature.

Taken in conjunction with discussions of the principles and practice of drawing by the artists themselves, the writings associated with the tradition add up to a substantial body of theory. In effect they comprise the principles of a modern, alternative academy. It is noteworthy that those artists who valued and made use of drawing most substantially – in other words, Degas, Pissarro, Cézanne, Redon, van Gogh, Gauguin and Seurat – were not only among the most articulate intellectually, but also comprised those who most believed in the inherent value of a body of theory, whether inherited or of their own making.

Considering the dismissive attitude towards style that is manifest in almost all of this theory, the other major influence on the alternative tradition appears something of an anomaly. This was that most modish of arts, the Japanese print. The antipathy of Cézanne and Renoir apart, there was universal and active interest in Japanese woodblock prints, from Manet and Whistler onwards, and several of the artists had substantial personal collections.[36] Pissarro wrote that 'Hiroshige is a marvellous impressionist . . . these Japanese artists confirm my belief in our vision',[37] and many of the references by other artists also suggest this sort of identification with Japanese art. Enchanted by its freedom from Western conventions, most of them admired the honesty of its truth to nature and the discriminate simplicity of execution. In their lightness and elegant asymmetry, Manet's late brush drawings express very clearly the qualities at the heart of this taste (Fig. 39). Van Gogh longed to draw the

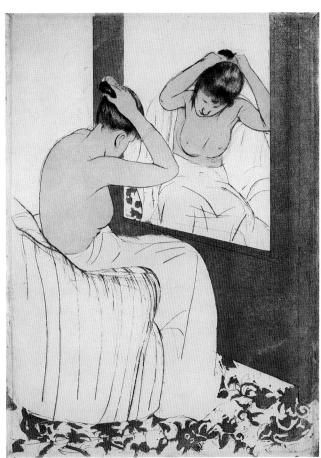

Fig.40 UTAMARO: *Young woman in front of a mirror,* *c.*1791
Woodblock print
$14^{1}/_{2} \times 9^{3}/_{8}$ in
(36.7 × 23.8 cm)
(formerly collection Claude Monet)
Musée Claude Monet, Giverny

Fig.41 CASSATT: *The Coiffure,* 1890/91
Drypoint and aquatint, third state
$18^{5}/_{7} \times 12$ in
(47.5 × 30.5 cm)
National Gallery of Art, Washington
(Rosenwald Collection).
Inv. 1943.3.2745

figure with the fluent economy of the Japanese artist, and Gauguin envied the natural ease of drawing ('not exactly as we do from nature') which he imagined every Japanese child acquired at school.[38]

The formal influence of the Japanese print became more marked in the context of a greater style-consciousness in the 1880s and 1890s, for which it was partly responsible: in neo-impressionist and Pont-Aven school drawing; in the later manner of van Gogh and in the prints of Cassatt and Lautrec (Figs. 41–42). The decorative flatness of Cassatt's large colour prints, with their condensed oppositions of tone and line, and the dramatic use of asymmetrical silhouettes by Lautrec were both directly inspired by the sophisticated fusion of observation and design in Japanese art. Van Gogh considered mounting his large Arles drawings into albums, 'like those books of original Japanese drawings'.[39]

Given the relative flatness and linearity of drawing compared to painting, it is hardly surprising that their assimilation of technical devices from Japanese prints is most evident in the impressionists' drawings. It is arguable that Japanese influence on impressionist paintings becomes apparent in proportion to the use in them of essentially graphic qualities: the asymmetrical disposition of elements across the rectangular surface, an emphasis on silhouettes and on spaces between shapes, and, finally, an exposed linear articulation of brushstrokes. All of these qualities became

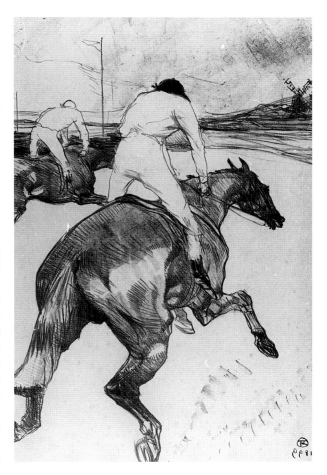

Fig.42 TOULOUSE-LAUTREC: *The Jockey,* signed and dated 1899
Lithograph
$20^{1}/_{4} \times 14^{1}/_{8}$ in
(51.4 × 35.9 cm)
Musée Toulouse-Lautrec, Albi

more pronounced in the paintings of Monet during the 1880s, a time when he was acquiring Japanese prints in some quantity. The same is broadly true of developments in van Gogh's paintings of 1888. In his case, it is also evident that these developments derived from experiments undertaken first in his drawings.[40]

Artists at the end of the nineteenth century, particularly those in symbolist circles, were prospecting so widely among alternative sources for their art that it is no longer possible to speak in terms of a coherent 'alternative tradition'. There was widespread interest in medieval art; Bernard and Gauguin had discussed the relevance of the art of children; and the breadth of Gauguin's enquiry into other cultures had provoked hostile incomprehension among his peers. The common value of all these alternatives lay in their distance from classical Europe.

Considered together, the forms and ideas of the alternative tradition all emphasize, by contrast, the impersonal and public authority of art in the academic tradition. In the nineteenth-century battles of 'Line versus Colour' and of 'Art versus Nature', 'line' and 'art' represented the universal values of an established ideal, elevated above the level of the individual. The causes of 'colour' and 'nature', on the other hand, were associable with individual responses and decisions. The various faces of the alternative tradition all look towards an art founded on personal choice and private experience. Its values to the impressionists reside in this quality above all, and the diversity of their attitudes towards drawing expresses their enthusiastic espousal of its principles.

NOTES

1 On the Barbizon painters, see also chapter 4 below, pp. 47–50.

2 Formerly attributed to a student of Couture, this drawing reveals enough significant differences from Couture's 1865 painting (ill. Rewald 1955, p. 23) to confirm it as a study rather than a copy.

3 In his *Principles of Painting*, 1708, Roger de Piles compiled a chart of artists, awarding marks out of 20 under various headings. Under 'Colour' scores included: Poussin 6, Raphael 12, Rubens 17, Rembrandt 17; under 'Drawing': Raphael 18, Poussin 17, Rubens 13, Rembrandt 6.

4 See, for example, Diderot's *Salon of 1765*.

5 1874; *Archives* II, p. 300.

6 See, for example, Thoré's *Salon de 1863* (trans. in Nochlin 1966, p. 61) and Meier-Graefe's *Renoir*, 1912 (trans. in Wadley, *Renoir, a Retrospective*, New York, 1987, p. 247).

7 On Blanc, see previous chapter, pp. 17–18.

8 See, among many examples, Delacroix's *Journal* entries for 30 Dec. 1823 and 4 Jan. 1824.

9 The *Dying Slave* was a significant motif for other artists as well. His head appears as a cast at the centre of Fantin-Latour's *The Drawing Lesson* of 1879 (Musées Royaux, Brussels) and was the inspiration behind Redon's *Closed Eyes* (1890, Louvre). Redon was moved by the 'elevated intellectual activity' beneath the closed eyes: 'the sleep of a slave awakens our dignity' (Redon 1961, p. 95).

10 De la Faille 1970, p. 480. I first identified this drawing correctly as a copy after Michelangelo in Wadley 1969, p. 34. The adjacent drawing relates to a painting of 1887, *Restaurant Interior* (F549).

11 See Mayne 1964, 1965. For an illuminating discussion of the character of Baudelaire's criticism and of his relationship with Delacroix, see also Brookner 1971, pp. 59–87. On Delacroix's *Journal*, see below p. 35.

12 It was possibly through Baudelaire's writing that Gauguin was introduced to the work of Edgar Allen Poe. On this, see Merlhès's essay in the 1989 edition of *Cahier pour Aline*, pp. 44ff.

13 See van Gogh, *Letters*, Vol. III, pp. 503, 505, 507, 522.

14 Mayne 1965, p. 5.

15 Ibid., p. 59.

16 On Ingres, see Mayne 1965, pp. 83, 133; on 'Ingrisme', pp. 85, 106.

17 For Blanc see above p. 17; for Ingres, see Denis, 'La Doctrine d'Ingres' in *Théories*, 1912, pp. 95–101.

18 'Le Rire et la Caricature', *Variétés Critiques*, 1924, Vol. II, pp. 120–129.

19 Mayne 1965, p. 142.

20 Ibid., p. 155.

21 *Noa Noa*, Louvre MS, p. 26.

22 *Fusées* XII, 1856; *Journaux Intimes*, 1920, p. 16.

23 1864/66; trans. in Quennell 1986, p. 224.

24 Delacroix 1951, p. 100. In his *Salon of 1846*, Baudelaire had written: 'From Delacroix's point of view the line does not exist.' (Mayne 1965, p. 59.)

25 Redon recalled spending one evening following Delacroix around in adolescent awe; Monet and Bazille used to watch him at work through the window of his Paris studio (see Rewald 1955, p. 77).

26 See 'Delacroix' in Redon 1961, pp. 170–183. Pickvance suggests that a renewed study of Delacroix lies behind the increasingly abstract curvilinearity of van Gogh's St Rémy drawings (Otterlo 1990, p. 286).

27 Cézanne may have borrowed Delacroix paintings to copy (Rewald, 'Chocquet and Cézanne', *Gazette des Beaux-Arts*, July–August 1969, p. 56). On Baudelaire, see notes to Plate 67.

28 The Delacroix copy was bought on Degas's advice by Julie Manet at the Chocquet sale, 1899. In 'Mes Confidences', a questionnaire of the 1860s, Cézanne gave Rubens as his 'favourite painter' (Chappuis 1973, I, pp. 26–27).

29 *Journal*, 12 Oct 1853 (1951, p. 195).

30 See e.g. Zola's *Mon Salon*, 1866.

31 Laforgue 1988, pp. 169–70.

32 The extracts here are quoted from Moffett 1986, pp. 43–44, in which both Duranty's French text and a complete annotated translation are given, pp. 477–84, 37–47.

33 *L'Art Moderne*, 1883: on Degas pp. 111–21; on Caillebotte pp. 93–4; on Renoir p. 249.

34 See Courbet statements of 1855 and 1861, Nochlin 1966, pp. 33–36.

35 Baudelaire, *Salon of 1846* (Mayne 1965, p. 48).

36 Monet's collection (now at Giverny) totals 199 items; van Gogh's (now in Amsterdam) totals 490.

37 Pissarro, *Letters*, p. 207 (and see also p. 28).

38 Van Gogh, *Letters* III, p. 55; Gauguin, *Avant et Après*, pp. 32–33.

39 Van Gogh, *Letters* II, p. 575.

40 On this relationship of drawing to painting, see also chapter 5 below, pp. 72–73, and the notes to Plates 38, 92, 94–6.

4 Drawing as seeing

The recurrent theme of all relevant theoretical writings and of the impressionists' own statements was the need for a type of drawing that would embody the immediacy of experience. The common ambition was that drawing, regardless of its subject and as well as representing the palpable world of things, should be equivalent to the act of seeing.[1] The hand should move as swiftly and naturally as the eye. Lecoq de Boisbaudran's memory training was aimed at reducing the inertia gap between seeing and drawing. Pissarro urged his son to draw so incessantly that it became instinctive, and van Gogh dreamt of drawing with the natural ease and speed of handwriting.[2] A similar concept of total immersion lies behind the practices of Degas, Cézanne and – in his painting at least – Monet. With some exception in the case of Degas, it was a matter of principle that the immersion should be in reality (variously called 'nature' or 'life'), not in art.

The objective was much wider than the simple expedient of capturing movement. Baudelaire had described it as 'the fugitive, fleeting beauty of present-day life' and Duranty proposed that 'the artist's pencil will be infused with the essence of life'.[3] The young Cézanne, like Delacroix before him, drew fast as if to keep pace with his mood and imagination. Guys,

Boudin and Manet all retouched drawings made *in situ* – often in a different medium – in a manner that enhanced rather than diluted their urgency. Baudelaire describes Guys in his studio, selecting up to twenty drawings at a time to develop, simultaneously, to an advanced state. The mature drawing styles of Cézanne and van Gogh embody qualities of transience in techniques that are anything but impromptu or hastily-considered. Daumier's precedent in these practices was important for all of them.

As mentioned earlier, one of the most radical characteristics of the new drawing was its freedom from style. Behind Redon's statement that 'an artist who has found his style does not interest me',[4] lie not only his delight in discovery, but also the thought that the resources of such an artist were not flexible enough to respond sensitively to the various and changing phenomena of nature. The importance of stylelessness was manifold. The simple, uncultivated mark carried in itself a sense of the fugitive, and of the insubstantiality essential to an art concerned to express unpremeditated sensations.

Style in drawing was traditionally associated with 'finish' and with elegance of line. Neither of these qualities enjoyed much priority in impressionist drawings. Although some are more highly worked than others, discussion of whether or not impressionist drawings are 'complete' is seldom relevant to their context. Except in the case of van Gogh, the traditional distinction between a sketch and a finished drawing was virtually discarded in impressionist practice. Line does not play a major role in their drawings and their choice of materials usually mitigated against it: they seldom drew with pen or fine pencil.

Pissarro suggested that drawing any one thing informs the drawing of anything else – he advised Lucien that 'when you have trained yourself to look at a tree, you know how to look at a figure' – and the same principle quite clearly informed the drawing practices of Cézanne and Renoir.[5] For Redon, on the other hand, stylelessness also involved the freedom to treat different things in different ways. In taking Jongkind to task for the similarity of his drawings, Redon wrote: 'It seems to me that nature, always so complex and varied, demands for each effect, for each object, a different manner of execution.'[6]

In impressionist practice at large, both of these opposing views have some relevance. All drawing, whatever the subject, contributed to the artists' thinking about what drawing could and should be. Some of the principal variations in manner are more to do with the purpose of a drawing than its subject. At the

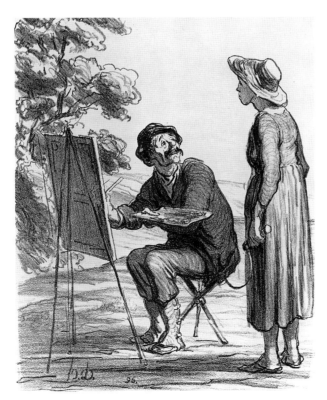

Fig.43 DAUMIER: '*Don't move! You are superb like that*' Lithograph, published in *Le Charivari*, 12 April 1865
Bibliothèque Nationale, Paris

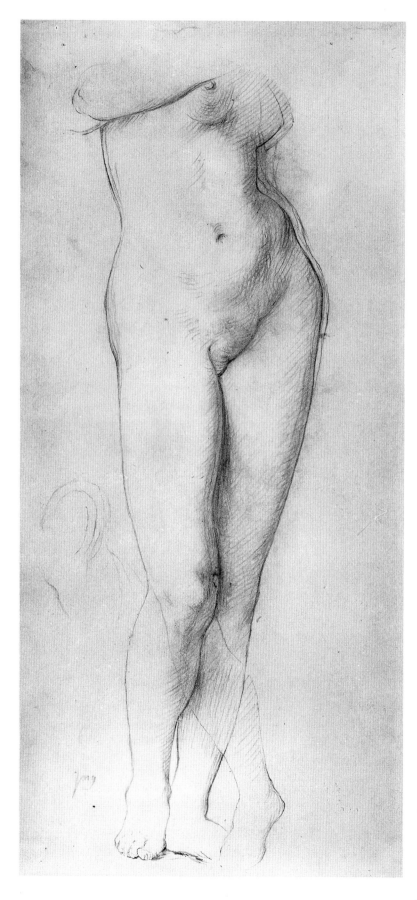

Fig.44 INGRES: Study for *La Source*, c.1856
Pencil
14 × 6²/₃ in (35.5 × 17 cm)
Boymans-van Beuningen Museum, Rotterdam. Inv. F-II-177

same time, new subjects and different attitudes towards them did impose or inspire particular technical treatments.

Drawing against time

The constant flux of nature lay at the heart of all the aspirations for a new form of drawing and generated many of its technical innovations. Discussing the modernity of Guys, Baudelaire described 'an intoxication of the pencil or brush almost amounting to frenzy'. Laforgue saw the accommodation to changing circumstance – in the artist as well as the motif – as the artist's greatest task. 'The object and the subject are therefore irremediably shifting, ungraspable and unable to grasp. It takes genius to apprehend the flashes of identity between subject and object.'[7] Laforgue's description applies exactly to the context of Monet's series paintings and comes close to pinpointing the complicated genius of Degas's last pastels.

In his notebooks of the late 1850s and early 1860s, Boudin complained repeatedly of an elusive transience in the beauty and poetry that unfolded before his eyes in nature. He despaired of ever acquiring the genius, speed and daring necessary to capture these qualities in his art. He felt helpless and stupefied. If the vague beginnings of a large painting approximated to his first vision, he found that as soon as he developed it, the dream of what it might be evaporated.[8] Of course Boudin's dream for painting was unattainable: he was expecting art to do something it could not. While many other artists, from Ford Madox Brown to Monet, voiced the same complaints and with similar disillusion, it is worth noting that Constable, whose sketches from nature, many of them annotated, have been likened to Boudin's and seen as proto-impressionist, did not himself consider them as art. It is true not only of Boudin but also of most of the impressionists that they came closest to their ideal of instant response to changing sensation in their coloured drawings. For one thing the media of pastel and watercolour allowed more rapid transcription than oil. They were also free of the inhibitions of line and the artifice of black and white. The impressionists' frequent exhibition of such drawings suggests that these were considered as art.

Many black-and-white drawings broached directly the problem of keeping pace with a moving motif. The alterations in a figure drawing like Ingres's study for *La Source* (Fig. 44), are essentially refinements and corrections towards a resolution, but they also reflect change and say something about movement while the drawing was in progress. In many of Degas's studies of dancers, the sensation of movement through time is pronouncedly of a different order (Fig. 45). They generate a kinetic effect, of hands or limbs moving around other more stable elements. It became increasingly common practice during the nineteenth century

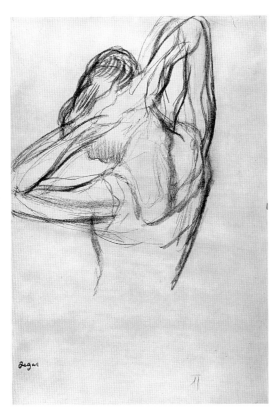

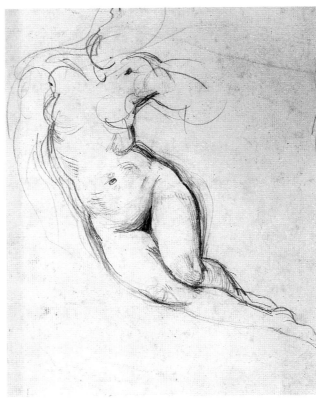

Fig.45 DEGAS: *Study of a dancer*, c.1895-1900
Black chalk
14¼ × 9 in
(36.2 × 22.8 cm)
Statens Museum for Kunst, Copenhagen. Inv. 8523

Fig.46 DELACROIX: *Seated female nude*, 1852/54
Pencil
Detail of a sheet, 7¼ × 10¼ in (18.4 × 26 cm)
Boymans-van Beuningen Museum, Rotterdam.
Inv. F.II.68

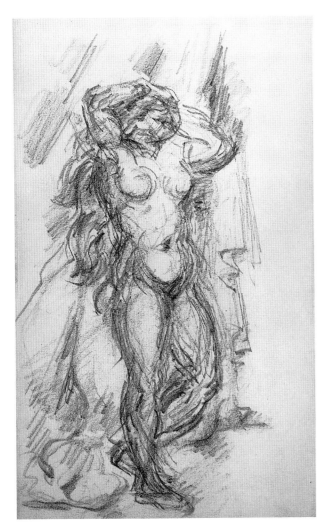

(for Delacroix, Lecoq, Degas, Rodin, for instance) to draw from the moving model. The multiple contours in some figure studies by Delacroix and Daumier also begin to express, simultaneously, the expansive growth of the drawing and the muscular energy inherent in the life of the subject. A developed use of multiple contours became an integral part of Cézanne's late manner, even in drawings of static objects. It served as a model for constant flux.

Outside the studio, where the issue of drawing against time was most acute, the drawings of Daumier prefigured impressionist attempts to express movement in a very pure form. In the drawing sometimes called *Pursuit* (Fig. 48), description and even the identity of the motif are at a low premium and the loose array of primitive lines coalesces into a vivid impression of speed. Valéry wrote of Daumier transforming muscles into rags hanging from a framework of bones, but often, as here, there appears to be no framework and the lines live their own life, free of gravity. Baudelaire tells us that Daumier drew through the filter of a vivid memory, but the shorthand manners of Lautrec and Degas treating comparable subjects (Figs. 49, 50) were improvised in front of the motif. The race against time produces a frenzied execution in Lautrec's drawing and a practised economy in that of Degas. Both are heavily conditioned by the nature of the subject; differences between them are those of handwriting and experience. When van Gogh drew *café-concert* musicians in Paris, his strange mannerisms were essentially the product of working against time, and the same can be said of an unaccustomed incoherence in some of

Fig.47 CÉZANNE: *Standing woman doing her hair* (after Delacroix), c.1887/90
Pencil
Page from a sketchbook
Philadelphia Museum of Art (Gift of Mr and Mrs Walter H. Annenberg).
C968

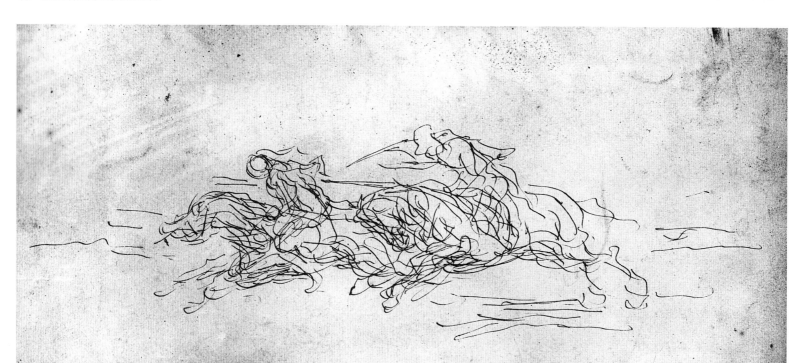

Fig.48 DAUMIER: *Two horsemen galloping,*
Pen and ink
$5^3/_4 \times 11$ in (14.6 × 27.9 cm)
Formerly Collection Claude Roger-Marx, Paris

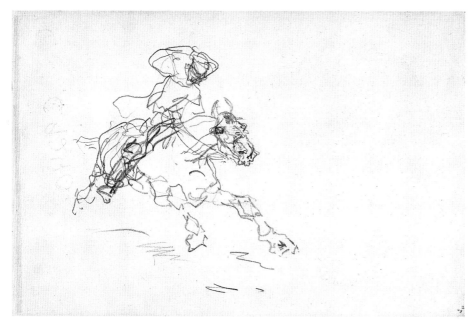

Fig.49 TOULOUSE-
LAUTREC: *Rider on a
galloping horse, c.*1881
Pencil
$6^2/_3 \times 10^3/_5$ in
(17 × 26.9 cm)
Nationalmuseum,
Stockholm.
NMH 128/1968 recto

Fig.50 DEGAS: *Horse and
rider, c.*1875/77
Pencil
$3^1/_3 \times 5^3/_7$ in
(8.5 × 13.8 cm)
Bibliothèque Nationale,
Paris.
Inv. Dc 327d No.7(df)

Seurat's urban drawings (Pl. 92b, 93b, 103).

Perhaps the least coherent of drawings of this sort are to be found among Manet's scribbled *in situ* sketches (Fig. 51.) The furious energy of this study of a woman is such that the movement of lines across the page seems almost to live again each time we look at it. The haste of the drawing relates to exigencies of time rather than to the decorous pace of a game of croquet. In such drawings as this, speed of execution was of the essence and finish of no concern at all. Bazille's closely observed but contrived study of birds in flight (Fig. 52) looks almost inert by comparison.

It is characteristic of impressionist drawings that they reveal the duration of their execution. In this alone they bear a stronger sense of transience than most earlier drawings, and the act of drawing more closely approximates to seeing.

Landscape

Not surprisingly, it is drawings of landscape by earlier artists that reveal most clearly attitudes and techniques that may be likened to impressionism. The variety and the relative freedom of earlier landscape drawings is attributable in part to the absence of any clear academic stereotype: landscape as a subject occupied a relatively minor, and even then insecure place in the academic syllabus.[9] In addition, the very inconstancy of landscape as a model from which to draw prompted a diversity of improvised responses. The landscape drawings of Rembrandt, whose work was cited as exemplary by Pissarro, Degas, Redon, van Gogh and Seurat, are as good an instance as any of

'proto-impressionist' qualities (Fig. 53). In most of his drawings from nature, there is a calculated scale of marks from relatively coarse foreground notations, through the more finely focused principal motif in the middle distance, to the faint suggestion of distant elements. This scale creates a powerful illusion of a fragment of nature, in movement, rapidly seen.

For most of the artists involved, impressionism as an alternative to academic art began with the liberating experience of painting and drawing from landscape. The earliest surviving drawings of Pissarro, after his arrival in France, are all of landscape (Pl. 40b, 41). According to Monet's recollections, it was the working visits to the forest of Fontainebleau that he made with Renoir, Sisley and Bazille that finalized their break from the atelier of Gleyre.[10] The four of them made contact, there and in Paris, with older artists – Corot, Millet, Rousseau, Diaz, Daubigny – who had worked in the district of Barbizon intermittently for several decades. Their active and supportive interest in the work of the impressionists is well known and documented: notably of Corot for Pissarro and Morisot; Daubigny for Monet; Diaz for Renoir. Most of them also knew Courbet. Pissarro apart, very little survives of the impressionists' landscape drawing from this period, although there is plenty of evidence that they drew. A few examples of drawings by the Barbizon painters, while inevitably an arbitrary choice, give some idea of the character and diversity of prevailing idioms. Their variety arises from problems inherent in the drawing of a motif that is almost always subject to erratic movement and changes of light, problems that are particularly acute with a landscape that is full of trees. Faced with this complexity

Fig.51 MANET: Study for *la Partie de croquet à Boulogne*, 1871
Pencil
4 × 2½ in
(10.1 × 6.4 cm)
Louvre, Dépt des Arts Graphiques. Inv. RF 30.412

Fig.52 BAZILLE: *Birds in flight*, late 1860s?
Charcoal
9½ × 13⅗ in
(24.1 × 34.5 cm)
Louvre, Dépt. des Arts Graphiques.
Inv. RF 5259, fol. 36 verso

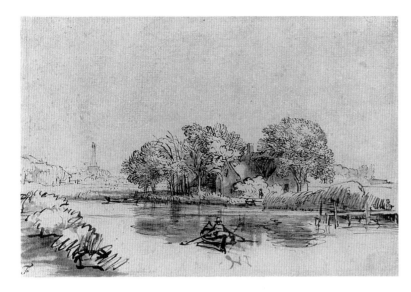

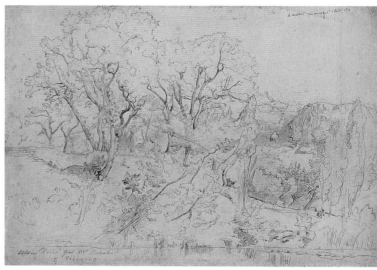

Fig.53 REMBRANDT: *View on the Bullewijk looking towards Ouderkerk, c.*1650 Pen and brown wash, heightened with white 5¹⁄₄ × 8 in (13.3 × 20.4 cm) Chatsworth Collection. Inv. 1033

Fig.54 COROT: *Le Martinet, près Montpellier,* inscribed and dated 1836 Pencil, pen and ink 13 × 19²⁄₃ in (33.3 × 49.9 cm) Metropolitan Museum of Art, New York (Rogers Fund). Inv. 26.169.2

and instability, the artist's decisions and the means he uses all derive from discriminations between the general and the particular.

The graphic techniques of the Barbizon painters differed enormously, not only from artist to artist, but also with different media and different motifs. The drawing that Corot gave to Pissarro (Fig. 54) is characteristic of many of his landscape studies of the 1820s and 1830s, treating in fine detail those elements reconcilable with line and in the broadest generalization those that are not. Pissarro and Cézanne each adopted similar solutions at times. Rousseau's chalk drawing (Fig. 55) combines hints of particular patterns of growth and of the relative movement of trees and clouds, with the stability of its dense tonal fabric. Although it is more homogeneous in its effect than the Corot, neither of these drawings directly addresses itself to the transient qualities of landscape. The chalk drawings of Daubigny and Diaz (Figs. 56, 57) approach more closely an impressionist sense of immediacy: Daubigny, in a forthright combination of silhouettes and gradated hatching, and Diaz, with the range of soft notations and scattered lines that attracted the interest of Renoir.

Just as this generation freely acknowledged their direct descent from seventeenth-century Dutch art, so the impressionists identified closely enough with the Barbizon painters to discuss inviting Corot, Courbet,

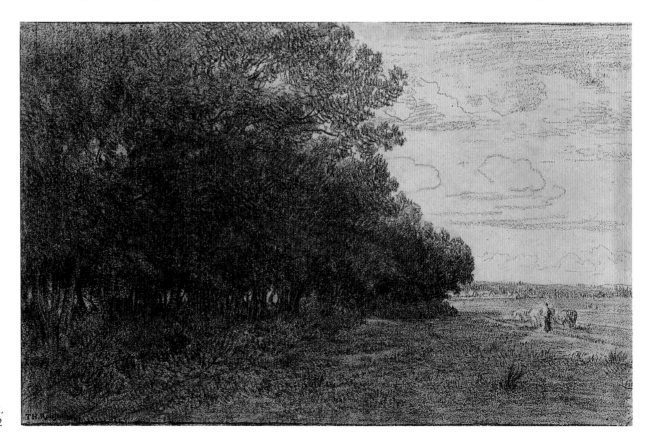

Fig.55 ROUSSEAU: *Fringe of a Coppice,* 1840s? Black chalk 12 × 18⁴⁄₅ in (30.4 × 47.8 cm) Statens Museum for Kunst, Copenhagen. Inv. Tu 34a,2

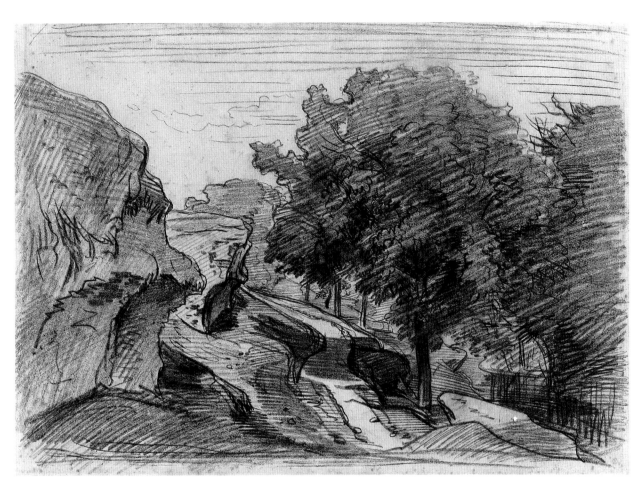

Fig.56 DAUBIGNY: *Rocky landscape*, 1860s? Black chalk on brown paper 17²/₃ × 24³/₄ in (44.9 × 62.9 cm) Metropolitan Museum of Art, New York (Gift of Mrs Arthur L. Strasser) Inv. 60.64

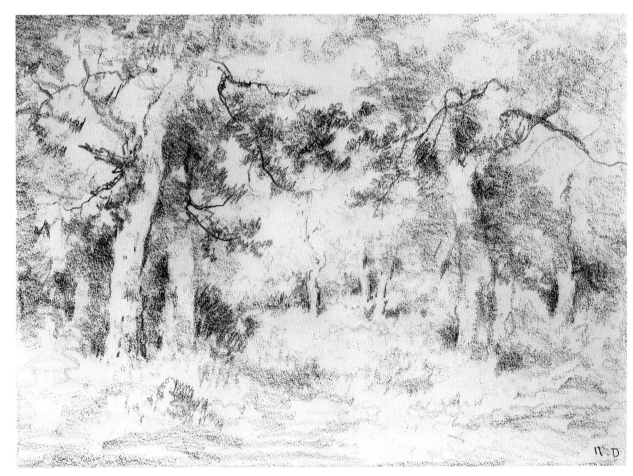

Fig.57 DIAZ: *Forest clearing*, 1860s? Black chalk 6¹/₂ × 9 in (16.5 × 23 cm) Rijksmuseum, Amsterdam. Inv. 1951.441

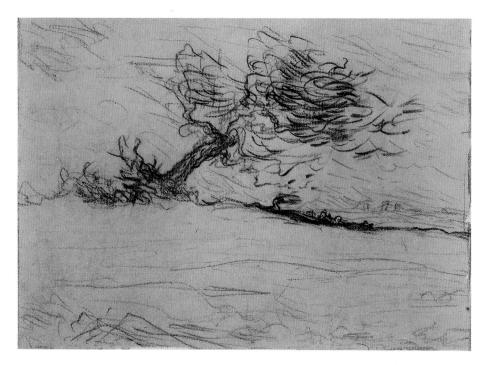

Fig.58 MILLET: *Coup de vent, c.*1873
Charcoal
$8^1/_3 \times 11^3/_5$ in
(21.1 × 29.5 cm)
Statens Museum for Kunst,
Copenhagen.
Inv. Tu 34 a1,8

The distinct characteristics of impressionist land-scape drawing that emerged in the 1870s, most visible in the sketchbooks of Pissarro, Monet and Cézanne, all involved a greater concern with effects and relationships than with the motif *per se*. Monet explained later, to a Dutch critic in 1891: 'For me a landscape does not exist as a landscape since its appearance is changing all the time; it lives according to its surroundings, by the air and light, which constantly change.'[13] Although the pine trees of Cézanne, the apple trees of Pissarro and the olives and cypresses of van Gogh are particular and instantly identifiable, likeness of this sort was not at a premium. The main concern was to master the dilemma by which Boudin had felt both inspired and frustrated, the recording of sensations of nature which resided in the very movement and change that made them unattainable. Most of the impressionists complained at one time or another of the impossibilities of working in wind, snow, rain or blinding sunlight and of competing with the speed of clouds and the sun.[14] Morisot (trying to work from a boat!) lamented in 1875: 'Everything sways, there is an infernal lapping of the water; one has the sun and wind to cope with, the boats change position every minute.'[15] In one of van Gogh's Saintes-Maries drawings (F1437), in the time between his first pencil notations and the second stage in reed pen, the sun had moved and was redrawn in its new position. Pissarro, writing from Rouen in 1883, complained: 'Here the weather is always changing, it is very discouraging. . . . I have even been forced to change the effect a bit, which is always dangerous . . . the next day it was impossible to go on, everything was confused, the motifs no longer existed.'[16] The

Diaz and Daubigny to exhibit with them when their independent exhibitions were first mooted in the 1860s.[11] The essence of their influential precedent was to encourage the impressionists towards an unprejudiced confrontation with nature's appearance. In their hands, landscape drawing became simpler and was emancipated from the various forms of mannered stylistic convention that had been prevalent. For Monet, the value of this precedent was crystallized by the personal guidance he received from Boudin and Jongkind.[12]

Fig.59 MONET: *Cliffs at Etretat,* 1885
Pencil
$4^1/_2 \times 7^2/_3$ in
(11.5 × 19.5 cm)
Musée Marmottan, Paris.
Inv. MM5131, p.28 verso

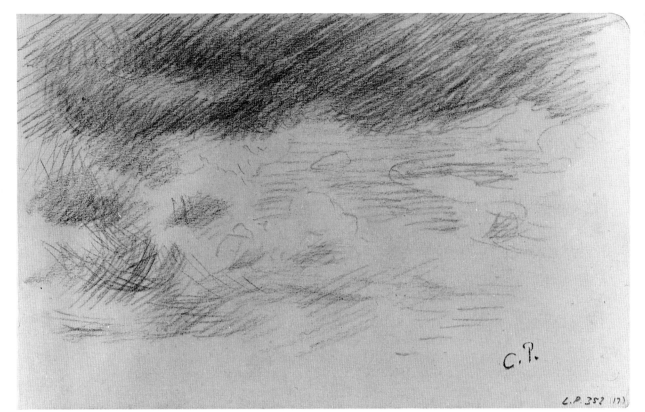

Fig.60 PISSARRO: *Study of clouds, c.*1887/88
Black chalk
$4 \times 6^2/_7$ in
(10.1 × 16 cm)
Ashmolean Museum,
Oxford. Cat. 176B

'motif' existed in the particularity of circumstance more than of place. Selection for the impressionists was a matter of time more than anything else. Cézanne wrote to his son in 1906 that 'sometimes the light is so horrible that nature seems ugly to me. Some selection is therefore necessary.'[17]

In impressionism, the landscape drawing became more limited in scope and specialized in its intention. There are few instances of the picturesque and narrative qualities that feature so frequently in Barbizon drawings; few images of nature torn by the elements as romantic as Millet's *Coup de vent* (Fig. 58). Their landscapes were not 'pictures' in this sense. The panoramic view so often drawn by Rousseau, Corot and others, virtually disappears until its re-emergence in some of the Paris and Montmajour drawings of van Gogh. The impressionist motif is typically a graspable fragment, encompassed in one look rather than surveyed. In Monet's early pastel of the cliffs at Etretat (Pl. 33), his Baudelairean delight in its unexpected compression of near and far is expressed by treating all parts of the motif as one, with no significant variation of emphasis or detail. The eye absorbs the whole, simultaneously. While this equality of emphasis still prevails in his sketchbook drawings of the same motif some ten or fifteen years later (Fig. 59), the comparison reveals striking differences. The short-lived role of such drawings was as the briefest of means to an immediate end. All the panache of his precocious early facility was abandoned in the most cursory of scribbled notations, assessing the potential value of a motif for painting. The drawing is like the

loosest offprint of the act of looking, and took little more time: the various hesitant verticals added at either side suggest the format of the rectangle in which this act was subsequently transcribed into two paintings (W1018, 1019).

The abstractness of the pursuit of sensations inevitably meant that impressionist landscape drawings carry little sense of substance and gravity. Any contrast of marks that exists is not sequential: it does not lead us stage by stage through space; it does not typically use the scale of size, tone and fineness of mark, building towards a focal area, observed above in a Rembrandt drawing. There is usually little significant distinction between foreground and background. Pissarro's notebook sketches often employ vivid tonal contrast to evoke effects of sunlight, but the amount (or lack) of detail is more or less even throughout each drawing (Pl. 42b). The quality of his drawn lines is determined primarily by the urgent pursuit of effect and, in extreme cases, so careless of the coherent identity of the motif that it is almost beyond recognition (Fig. 60). As Lloyd suggests, the intuitive immediacy of the impressionists' drawing was in some measure a way of practising for the innocent directness of their landscape painting.[18]

Cézanne's landscape drawings vary enormously in technique, which is one reason for the wide discrepancies in their dating by different scholars. It appears likely, as Gowing has often suggested, that Cézanne's drawings from any one period embrace a variety of manners: sometimes as a response to different motifs, but sometimes for more arbitrary,

Fig.61 CÉZANNE:
Landscape with trees,
*c.*1875/80
Pencil
Page of a sketchbook,
$4^7/_8 \times 8^1/_2$ in
(12.4 × 21.7 cm)
Art Institute of Chicago
(Arthur Heun Fund).
Inv. 1951.1. C740

intuitive motives. His drawings are eccentric among impressionist landscapes for their more systematic abstractions. There is seldom a detectable presence of sunlight, and his hatchings and tone changes do not consistently represent shadow. Cézanne talked in terms of 'constructions after nature based on method, sensations and developments suggested by the model'.[19] His drawings of trees marry lines that represent direct transcription with others that are 'developments' (Fig. 61). The sense in which Cézanne spoke of his drawings becoming 'more precise'[20] has little to do with the focus of precision at the heart of a Rembrandt drawing.

Inasmuch as Cézanne admitted to any basis of theory, it was acquired through his painful struggle to realize sensations in front of nature. 'I believe in the logical development of everything we see and feel through the study of nature and turn my attention to technical questions later; for technical questions are for us only the simple means of making the public feel what we feel ourselves and of making ourselves understood.'[21] The intuitive abstraction of his various techniques of drawing landscape was a part of the private 'seeing and feeling' process: closer in spirit to Monet's notion of the naïve impression than to any public communication, but nevertheless progressively knowing.

Of all impressionist landscape drawings, the least naïve were the poetic improvisations of Degas. His half-serious mocking of *plein air* painters is well known.[22] Valéry emphasizes that all of Degas's landscapes were made in the studio, implying deliberate perversity, and cites anecdotes about Degas making studies of rocks, indoors, from heaps of coke.[23] Most

of Degas's landscapes were experiments in mixed media, drifting veils of pastel over monotypes in coloured oil or ink (Pl. XI). The motifs are remembered or imagined, and in variant reworkings of different proofs from a single monotype, he sometimes changed the weather, in the same way that he might adjust the pose of a figure. Degas explained to Vollard that 'the air you breathe in a picture is not the same as the air out of doors'.[24] Degas's consciousness of the artifice of art was more acute than anyone's. There is little fresh air in his landscapes. Their hot-house vacuum is closer to the ideas and practices of Redon, Whistler or Gauguin than to most impressionist landscapes.

The city and the figure

When Duranty wrote of taking down the studio wall that separated the artist from the real world, what he had principally in mind was that art would walk out into the streets of Paris. Among Degas's early notes of motifs for the modern artist, he suggested: 'On smoke. Smoke of people smoking pipes, cigarettes, cigars, the smoke of trains, of high chimneys, of factories, of steamboats, etc. The crushing of smoke beneath bridges.'[25] The enthusiasm for the external face of urban modernity was realized most fully in the light, colour and movement of Parisian boulevards, bridges and stations painted by Monet, Renoir, Pissarro and Caillebotte. Among drawings, the most apposite include those of London, mantled in smoke, by Monet and Pissarro (Fig. 62).

The dissolution of the figure into the urban

Fig.62 PISSARRO: *Waterloo Bridge, c.*1890/91
Charcoal
5 × 6³/₄ in
(12.7 × 17.1 cm)
Ashmolean Museum,
Oxford. Cat. 243E

environment was a striking enough characteristic of impressionist images to be observed with dismayed incomprehension by conservative critics.[26] Whistler's drawings represent this aspect of impressionism in a pure form. In his watercolour of Piccadilly (Pl. VI), even those elements of the motif that most nearly approach materiality are suggested by the most ephemeral, abstract notations. The slightly later city drawings of the Italian artist Medardo Rosso – admirer of Daumier and Degas, and of the writings of Baudelaire – are also quintessential examples of impressionism. Rosso wrote that 'each object is in reality part of an ensemble and this whole is controlled by a tonality which, like light, reaches to infinity What is important to me is to lose consciousness of matter Nothing is material in space.'[27] These ideas bear close comparison with Monet's description of landscape.[28] Like the impressionists' own paintings and drawings, many of Rosso's drawings were entitled 'effect'. Within their tonal ensemble, the figure is treated indiscriminately as part of the environment (Fig. 63).

In the figure studies that Caillebotte drew for his paintings of Paris streets (Pl. 39), each figure is clearly defined in bold contours, and the drawing is anything but spontaneous, but their almost disinterested observation and their complete lack of consequence,

Fig.63 ROSSO: *Effect of a man walking down the street, c.*1895
Pencil on card
7 × 3⁴/₇ in
(17.7 × 9.1 cm)
Museo Rosso, Barzio

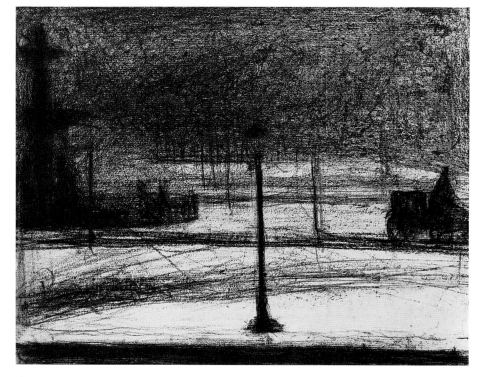

in any narrative or dramatic sense, preserve this democratic notion of the commonplace: of the figure as a mere element in the continuum of city life.

The city as a landscape features more prominently in the drawings of the post-impressionists. Beside the vital modernity of first-generation images of the city, the view of Paris that emerges from drawings by Seurat and van Gogh offers a strong contrast. The areas around Paris were in a state of transition. As well as the proliferation along the Seine of venues for weekend relaxation for Parisians, pictured so affirmatively by Monet and Renoir in the 1860s and 1870s, there were other districts – traversed by the trains of the day-trippers – which were less congenial or picturesque. It was in the representation of this nondescript zone that impressionist drawing struck a radically new note. Close in spirit and detail to the novels of Zola, Huysmans and the Goncourts, it is a genre that has received much attention from historians who have been concerned to undermine the simple image of impressionist art as a sensory celebration of life.[29]

In 1880, Huysmans wrote in high praise of Raffaëlli as one of the most powerful landscapists of the time, who gave expression to the melancholic grandeur of the suburbs.[30] Raffaëlli exhibited with the impressionists, at Degas's instigation, in 1880 and 1881, and it is among his drawings that we find the closest prefiguration of Seurat's urban images (Figs. 64, 65). Several of Seurat's drawings of the city outskirts are devoid of figures, and the prevailing dark tonality of his very personal use of conté crayon – black skies, black buildings, black everything – emphasizes their desolation. Where there are figures, their featureless, hunched shapes are absorbed into the anonymous gloom of these environs (Pl. 103). Van Gogh could not have known these Seurat drawings, but his own Paris street scenes evoke much the same mood and by similar means (Fig. 66). Considering the political commitment of his Dutch drawings and his sympathetic interest in pathetic images of urban deprivation by

Fig.64 RAFFAËLLI: *Landscape with road approaching the city*, (top) 1880s? Charcoal, heightened with gouache 3¼ × 6¼ in (8.3 × 15.9 cm) Metropolitan Museum of Art, New York (Robert Lehman Collection). Inv. 1975.1.683

Fig.65 SEURAT: *Place de la Concorde, winter*, (above) 1882/83 Conté crayon 9⅛ × 12 in (23.2 × 30.7 cm) Solomon R. Guggenheim Museum, New York

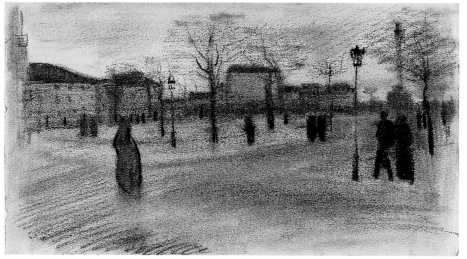

Fig.66 VAN GOGH: *Square in Antwerp* (left), 1885 Pencil, black chalk 4²/₇ × 7⁵/₇ in (10.9 × 19.6 cm) Rijksmuseum Vincent van Gogh, Amsterdam. F1354

X MORISOT: *Spring landscape, c.*1890/91 Coloured crayons and pencil 9⅓ × 7¼ in (23.7 × 18.4 cm) National Gallery of Art, Washington (Ailsa Mellon Bruce Collection). Inv. 1970.17.163

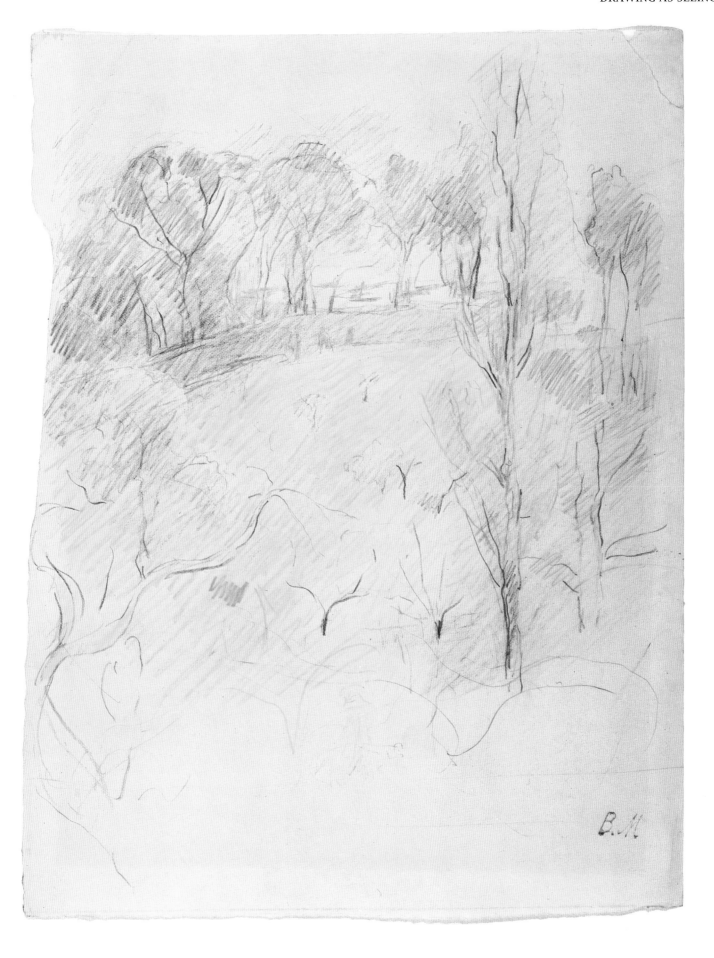

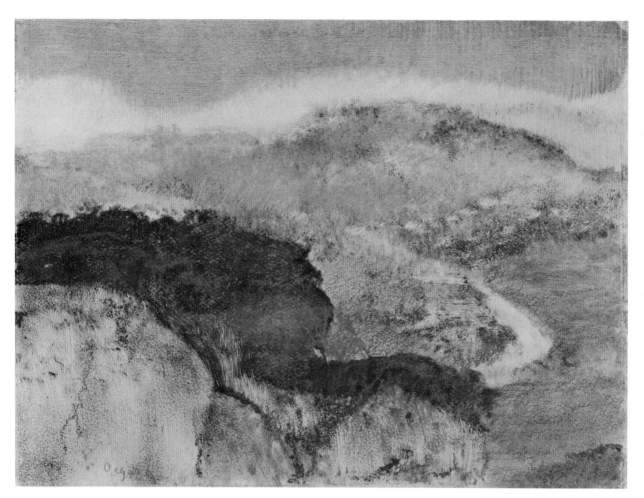

XI DEGAS: *Landscape,*
*c.*1890/92
Pastel over oil monotype
$9^{3}/_{7} \times 13^{1}/_{3}$ in
(24 × 34 cm)
Metropolitan Museum of
Art, New York
(Gift of Mr & Mrs Richard
J. Bernhard).
Inv. 72.636

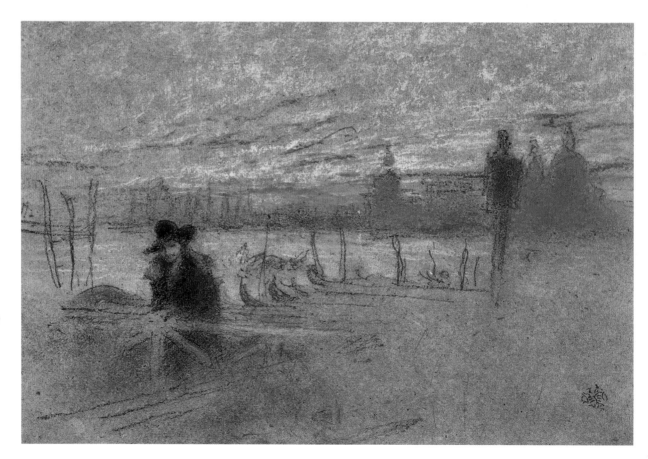

XII WHISTLER: *Riva degli*
*Schiavone at sunset, c.*1880?
butterfly insignia
Pastel and crayon on
brown paper
$7^{1}/_{2} \times 11^{1}/_{5}$ in
(19.2 × 28.5 cm)
Fogg Art Museum,
Cambridge, Mass.
(Bequest of Granville L.
Winthrop). Inv. 1943.617

Fig.67 MILLET: *Man leaning on his spade*, c.1850
Black chalk
12 × 8³/₇ in
(30.4 × 21.4 cm)
Boymans-van Beuningen
Museum, Rotterdam.
Inv. F-II-96

Fig.68 PISSARRO: *Man digging*, 1890
Charcoal
17³/₇ × 11⁴/₇ in
(44.3 × 29.4 cm)
Art Gallery of Ontario,
Toronto. (Gift of Sam and
Ayala Zacks). Inv. 71/302

other artists, this spirit comes as no surprise. Part of the pessimism of these images is attributable to the prevalence of shadow. For the same reasons, the dimly lit urban images among drawings by Whistler and Rosso, although without any explicit social comment, also speak more of the melancholy of the city than of its vitality.

The elusive role of the figure within such images constitutes a dramatic contrast with the monumental figure in the iconography of mid-century realist drawing. This change is largely attributable to the shift from rural to urban subjects. The clearest echoes of Millet's heroic and politically charged peasant drawings are to be found in early drawings of van Gogh and then in the later drawings of Pissarro, when his subject matter became explicitly concerned with the dignity of labour in rural contexts (Figs. 67–69). Pissarro respected Millet's drawings more than his paintings and was delighted when in 1895 his nudes were credited with 'an outdoor and real peasant quality'.[31] Millet's drawings were also influential, in mood and technique, for those among Seurat's early drawings that were of rural subjects or of that part of the landscape that involved the meeting of town and country (Pl. 101, 102). Boudin, Caillebotte, Degas and Gauguin all admired Millet; Degas owned several of his works.

The only draughtsman from the previous generation to treat the urban figure as an heroic image was

Fig.69 VAN GOGH: *Peasant woman gleaning*, 1885
Black chalk
20²/₇ × 16¹/₃ in
(51.5 × 41.5 cm)
Folkwang Museum, Essen.
F1279

Fig.70 DAUMIER: *Wrestler*,
Charcoal
10 × 10⅛ in
(25.5 × 28.8 cm)
Albertina, Vienna.
Inv. 24.127

Fig.71 CÉZANNE: *Standing
bather, c.1886/89*
Pencil
Detail from a sheet of
studies, 9 × 11⅝ in
(22.7 × 29.5 cm)
Kunstmuseum, Basel. C946

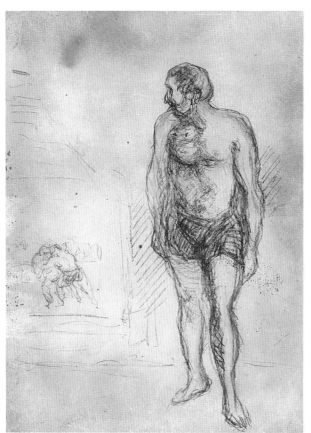

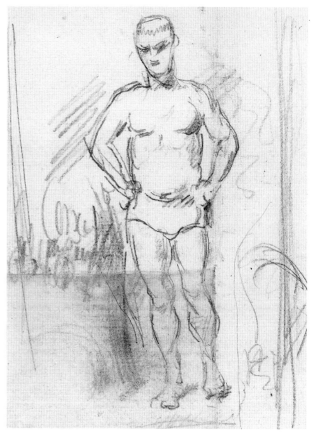

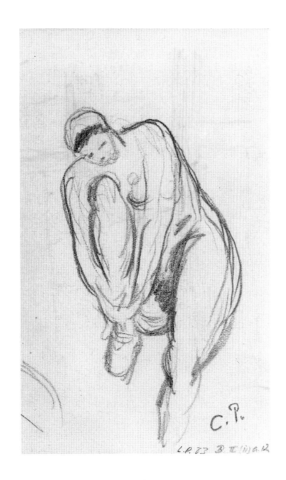

Fig.72 PISSARRO: *Seated
bather*, 1870s?
Black chalk and pencil
Detail from a sheet of
studies, 4³/₇ × 7⅝ in
(11.3 × 19.4 cm)
Ashmolean Museum,
Oxford. Cat. 85G

Daumier. With the exception of a loose, often crude monumental quality in some of the figure drawings of Pissarro, Cézanne and Gauguin – none of them city images – there is little evidence of Daumier's influence on the impressionists in this particular respect. The urban figure in impressionist drawing was neither heroic nor monumental. As well as the vital energy of his line already discussed as a formative influence above, the other reasons that so many of the impressionists collected and admired Daumier's prints and drawings concerned their modernity and their psychological authenticity. Yet it is not until the 1880s that these qualities play any significant role in impressionist drawing. Judith Wechsler has written well of Daumier's drawings, likening his imaging of urban characters to that of Balzac and Baudelaire, as 'description *from without*, as they would be seen by a stranger'.[32] The typical impressionist image of people was from even further 'without'. With the exception of the more sentimental ('romantic' as it was called in its time) impressionism of Renoir, the figure was observed distinterestedly. The effect of this remoteness is to generate a mood in figure drawings at least of passivity and often of melancholic ennui.

Redon recognized in Degas the same 'deep and accurate observation of Parisian life' as in Daumier, and others also made this connection. We know that Degas rated Daumier alongside Delacroix and Ingres

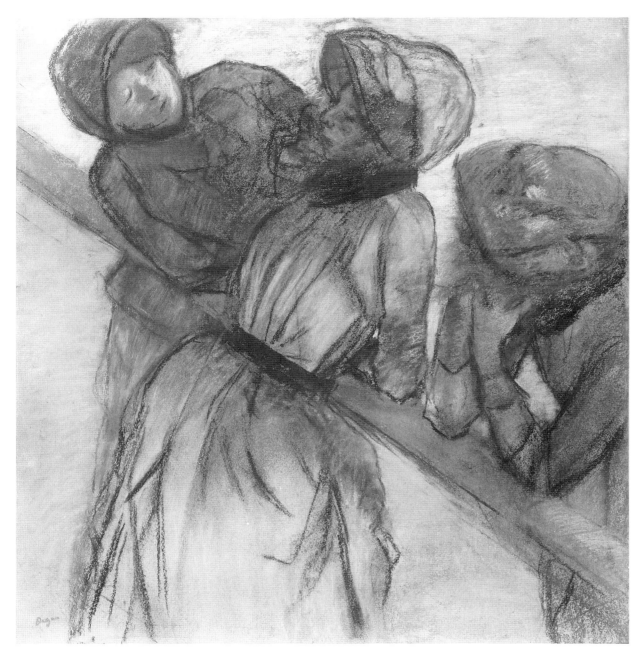

Fig.73 DEGAS:
*Conversation, c.*1882/85
Pastel
$27^2/_5 \times 27^2/_5$ in
(69.6 × 69.6 cm)
Milwaukee Art Museum
(Gift of Mr H. L. Bradley).

as a draughtsman, as had Baudelaire before him. In the wide repertoire of urban subjects that dominates so much impressionist drawing, the prolific pioneering oeuvre of Daumier was a constant inspiration. But if we compare the impressionists' depiction of scenes from the theatre, dance, *café-concerts*, the circus, the boutiques, or the *maisons closes*, with Daumier's entertainers, what stands out, by contrast, is the cool detachment of impressionist imagery. We are struck by the disciplined objectivity of Degas's study of movement and the hieratic, silent calm of Seurat's images.

The title 'Conversation' that has been given to the study of three behatted women (Fig. 73) confirms the potential for an anecdotal reading of Degas's drawings. However, the real interest behind this composition lies more in the eccentric counterpoint of poses –

probably three studies of the same model – around the axis of the rail against which they all lean.

The concern for effects in impressionist interiors, particularly the arresting and unexpected contrasts of scale and artificial light, is quite comparable to the pursuit of an impression in landscape drawing. There is the same tight focus on acutely observed appearances, coupled with an objective distancing from the identity of things (in this case people) that are being observed. The peculiar and memorable strength of Degas's theatre and *café-concert* drawings (Fig. 80, Pl. 10) is that, while they are alive with a pressing and immediate sense of reality, we are nevertheless excluded from any life or meaning beyond its surfaces or the moment. The exactitude of his observation and the accomplished contrivance of its representation are exposed equally and

the cosmetic mask of city life at large (Fig. 75).

In the privacy of their notebooks, many of the impressionists reveal a predilection for caricature. In the sense of a diverting comic relief this is not exceptional: descriptions of the drawing studios in academies frequently mention walls covered with caricatures. The proximity to caricature of the short-hand instantaneous impression that the impressionists sought from drawing is of more serious interest. In its early years, impressionism's first objectives were much to do with a form of instant seizure and encapsulation. The facility of Monet's early caricatures (Pl. 32a) may be compared to the fluent abbreviated likeness of his early landscape drawings. To a greater extent than the late work of his peers, Monet's art remained concerned with the pursuit of 'instant likeness'. It was partly this sharp caricatural facility – the 'prodigious eye' that Cézanne admired so much – that equipped him to pursue it for a lifetime.

The many, often cryptic caricatures in Degas's notebooks are a part of his inquisitiveness about means of representation. Most of Degas's early drawings exhibit the hawk-like shrewdness of his eye for the salient posture and expression. Pissarro advised Lucien to strive for simple and essential lines in drawing: 'Rather incline towards caricature than towards prettiness'. Cézanne spoke of his taste for the impetuous bravura of Gavarni, Forain and Daumier.[33] The caricatural element in Gauguin's drawing provided the means to realize his acute perception of appearances obliquely and without compromising his

Fig.74 SEURAT: *Au Concert Européen*, 1887/88 Conté crayon 12 × 9¹⁄₈ in (30.5 × 23.2 cm) Museum of Modern Art, New York (Lillie P. Bliss Collection). Inv. 121.34 dH 689

Fig.75 TOULOUSE-LAUTREC: *Chanteuse*, c.1895 Pencil 8¹⁄₃ × 6²⁄₅ in (21.1 × 16.3 cm) Louvre, Dépt. des Arts Graphiques. Inv. RF 29.585

simultaneously. A similar duality is strong in Seurat's drawings (Fig. 74). Considering the potential for celebratory energy in the subjects they are treating, any qualities of pleasure or warmth, such as we might find in Renoir's images of the city at play, are remarkable by their absence. The cumulative effect of this poignant ambiguity is to generate senses of pathos and irony. The cool impersonality with which Degas and Seurat depict the nightlife of Paris evokes, behind its bright mask, the thought of lives spent in mechanical repetition, stoically resigned. There is something of this, too, even in the far more characterful drawings of singers and dancers by Lautrec, whose spectacular formal invention most closely echoes the exuberance of Daumier's work. The closeness to caricature in the extravagance of Lautrec's performers and in the distorting effects upon their faces of artificial light also emphasizes the charade of theatre, and to some extent

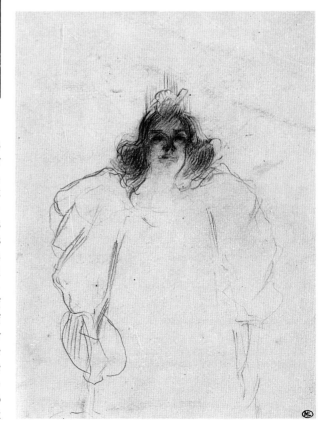

polemical antipathy towards naturalism. Caricature as a metaphor of reality is quite comparable with the stylized representation and the use of arbitrary exaggeration for expressive or symbolic purposes in much post-impressionist drawing: as strong in Seurat and van Gogh as in Lautrec and Gauguin.

Portraiture is the principal exception to many of the foregoing comments on figure drawing, being essentially at odds with a form of drawing that rejected conventional likeness. It was a significant if not prolific genre for the impressionists, and one that exposed personal rather than collective interests and attitudes.

For Renoir and van Gogh, more explicitly concerned with human sentiment than the rest, portraits rank among their major works as draughtsmen (Pl. 25, 25a, 95). Both saw portraiture as a rich and important field for the modern artist, albeit for very different reasons, and in both cases their approach to portraits was quite compatible with the rest of their drawn oeuvres. For others, the distinct demands and more intimate circumstance of the portrait prompted attitudes and sometimes techniques that are in striking contrast to their other figure drawings. The very different attention devoted to the individual sitter, drawn as a person rather than a set of visual sensations, is clear from a greater and more discriminate sensitivity in some drawings by Manet, Monet and Cézanne (Pl. 5, 34, 60). The same is true of Degas, but the decreasing incidence of portraiture in his later oeuvre, after its prominence among his early paintings and drawings, reflects his increasing absorption in a different sort of particularity.

Among Morisot's figure drawings, on the other hand, there is a more constant sensibility to individual presence. Drawings of the domestic interior by both Morisot and Cassatt are generally distinct from the dispassionate, sometimes voyeuristic toilette scenes drawn by Manet, Degas, Renoir and others. The observation, by Huysmans for instance, of a delicate or particularly 'feminine' sensitivity of feeling in their work has occasionally been cited by historians as coloured by a patronizing chauvinism. Nevertheless, the fineness of Cassatt's unsentimental observation of human relationships – particularly strong in her mother and child drawings – remains an outstanding quality of her mature drawings, and one that is only approached by Renoir among her peers (Pl. XIII, 22).

The greater warmth and sensitivity of portraits and related subjects among their drawings goes some way towards offsetting the traditional view of impressionists – of Monet and Degas in particular – as unfeeling or misogynist in the impersonal detachment of their art. It is also true that the values of artists in impressionist circles, in this and other respects, did not remain constant. In style and attitude – in their simple clarity and subtle nuance – the mature drawings of Cassatt seem a far remove from the styleless urgency of early impressionism and from its ambition for drawing to express unrehearsed and unpremeditated visual sensations. This contrast reflects not only difference of temperament, but also more widespread shifts in attitude.

NOTES

1 As early as 1874, Castagnary wrote that 'they are *impressionists* in the sense that they render not the landscape but the sensations produced by the landscape' (*Le Siècle*, 29 April 1874).
2 Lecoq, see above pp. 21–22; Pissarro, *Letters*, p. 32; van Gogh, *Letters*, Nos. 223, 232.
3 Baudelaire, Mayne 1964, p. 40; Duranty, see previous chapter, p. 39.
4 Redon 1961, p. 110.
5 Pissarro, *Letters*, pp. 38–39; Cézanne, see notes to Pl. 64–65.
6 *Salon de 1868*, in *Critiques d'Art* 1987, p. 57.
7 Laforgue 1988, p. 172.
8 Extracts from Boudin's notebooks are in Marthe de Fels, *La Vie de Monet*, Paris, 1929. Some are translated in Nochlin 1966, pp. 85–86.
9 For a discussion of attitudes and controversies, see Boime 1986, ch. VII.
10 Boime asserts, with no supporting reference, that the impressionists studied with Gleyre 'because they felt knowledge of the figure would help them draw landscape' (1986, p. 33).
11 Bazille, letter of 1867, trans. Nochlin 1966, p. 88.
12 See notes to Pl. 23, 31–32.
13 Cited in Gordon/Forge 1983, p. 163.
14 See for instance, Monet in Wildenstein 1979, Vol. III, letter 870; Renoir in Vollard, *Renoir*, 1925, p. 118.
15 Morisot, *Correspondence*, p. 104.
16 Pissarro, *Letters*, p. 42.
17 Cézanne, *Letters*, p. 325.
18 Christopher Lloyd, in Oxford 1986, pp. 13–22.
19 Cézanne, *Letters*, p. 335.
20 See below p. 75.
21 Cézanne, *Letters*, p. 330.
22 Vollard 1937, pp. 45, 56.
23 Valéry 1989, p. 43. His subsequent discussion of the apprehension and comprehension of forms has applications to impressionist drawing.
24 Vollard 1937, p. 47.
25 Reff 1976, Vol. I, p. 134.
26 See above, p. 16.
27 From Edmond Claris, 'De l'Impressionnisme en sculpture', *La Nouvelle Revue*, Paris, 1902.
28 Quoted above, p. 50.
29 For a thoughtful discussion of the character and images of the Paris outskirts, see T. J. Clark, *The Painting of Modern Life*, 1984, Ch. 3.
30 Huysmans 1880, pp. 99–104.
31 Pissarro, *Letters*, pp. 110, 256. For Pissarro on Millet, see also note to Pl. 45.
32 Wechsler, *A Human Comedy*, London, 1982, p. 13.
33 For Degas's caricatures see esp. notebooks 17 and 22 in Reff 1976; for Pissarro, see *Letters*, p. 37; for Cézanne, see note to Pl. 66.

5 The Post-Impressionist Reaction

There are so many constant concerns, in theory and in practice, common to impressionists and post-impressionists, that it is both possible and rewarding to see the history of drawing across both generations as one continuous evolution. In other respects, there were significant and sometimes dramatic changes and divergencies in both theory and practice during the 1880s and 1890s. Venturi went so far as to write in his summary of the movement: 'Impressionism, which was beginning to fragment in 1880, five years later no longer existed.'[1] Roger Fry, who invented the term 'post-impressionism', recognized in the work of the second generation 'a reconsideration of the very purpose and aim as well as the methods of pictorial and plastic art'.[2] The truth is both less extreme and far more complicated than either of these accounts suggests.

The term 'post-impressionist' is itself confusing since it does not only describe the artists who came to prominence in the 1880s and 1890s, Seurat, Gauguin, van Gogh, Lautrec and others. Applied to them, its meaning is straightforward enough. Impressionism was a *fait accompli*, part of their heritage, and the coining

of 'neo-impressionism' (by Félix Fénéon in 1886) to describe the work of Seurat and his disciples, is the most explicit acknowledgement of contemporary revisionist attitudes to that heritage. The emergence of Redon from relative obscurity to a central position of influence is another expression of a will to change. 'Post-impressionist' is equally applicable to changes of attitude among the original impressionists themselves. There were clear indications within this group of a loss of confidence in impressionism's first principles, and of frustrated confusion in face of the increasingly sophisticated demands arising from pursuit of the first naïve impression as a way of painting. This is clearest in the cases of Renoir and Pissarro. In the art of others, notably of Cézanne but also of Degas and Cassatt, the 1880s and 1890s saw a modification of impressionist theory and practice that is also properly definable as post-impressionist. The collective identity of the early years had served very positive functions for all of them, and much of its apparent fragmentation is attributable simply to the mature realization of their distinct artistic temperaments.

As far as drawing itself is concerned, there are both

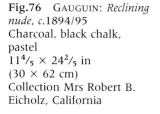

Fig.76 GAUGUIN: *Reclining nude*, *c*.1894/95
Charcoal, black chalk, pastel
11⁴/₅ × 24²/₅ in
(30 × 62 cm)
Collection Mrs Robert B. Eicholz, California

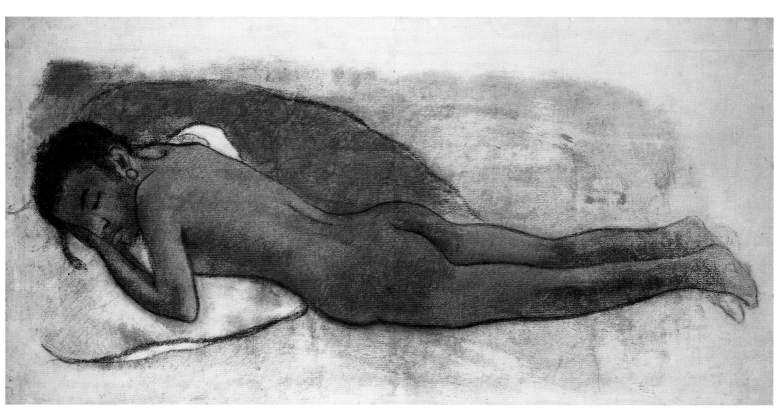

negative and positive aspects to the post-impressionist reaction. Widespread dissatisfaction with the limitations of impressionism was directed more at the movement's early principles and philosophy than particularly at the practice of drawing. At the same time, the distinct manners of drawing that matured in the 1880s and 1890s and which we can easily recognize as post-impressionist are closely derived from impressionist practice. In many senses they constitute the full flowering of impressionism in the art of drawing.

Reactions and New Directions

Comparison of contributors to the first and last of the eight impressionist exhibitions, respectively of 1874 and 1886, reveals a great deal about changes within the group. Of those who had exhibited in 1874, absentees from the last show include Monet, Renoir, Sisley and Cézanne. Of those who had not, the 1886 exhibitors include Gauguin, Seurat, Signac and Redon. The fact that well over a third of the works shown in 1886 were watercolours, drawings, pastels or prints – comfortably the largest proportion in any of the eight exhibitions – suggests a shift of attitude towards drawing.[3]

Although several accounts have come down to us of the monthly 'impressionist dinners' of the early 1890s,[4] it is broadly true that the communal life of the group had by that time largely dissolved. From many other references, it is difficult to conceive of all the diners being present at the table (or even wanting to be present) on every occasion. While in the 1860s and 1870s the artists had worked in close proximity, often painting side-by-side, by the early 1880s several of them preferred to work in increasing isolation in the provinces. In 1884, Monet wrote to Durand-Ruel asking him not to tell anyone, especially not Renoir, that he was leaving for Bordighera: 'I have always worked best in solitude and in response to sensations experienced alone.'[5] Only intermittently was Paris a common locus of activity. One divide that emerged in the 1880s was between those for whom the city remained a focal subject for their art (grouped around Degas and Seurat principally) and those who for various reasons sought less consciously modern, civilized environments (from Monet, Renoir and Cézanne to van Gogh, Gauguin and the Pont-Aven school). There were predilections towards natural or artificial light; figure or landscape; truth or artifice; the intuitive or the scientific; the seen and the felt; the political and the aesthetic. None of these divisive tendencies serves to distinguish between impressionist and post-impressionist principles: allegiances break feely across generations.

Dissent among the first generation surfaced seriously with the defection of some artists from the group exhibitions to the official Salon. Manet had always declined invitations to exhibit with the group ('these little arenas bore me'), and had seen the Salon as the only real field of battle against established values. Renoir (from 1878), Sisley (unsuccessfully in 1879) and Monet (1880) successively chose to submit their work for Salon approval. 'He has returned to the fold of the church', a critic commented on Renoir's Salon success of 1879.[6] Pissarro and Caillebotte viewed the defections as politically inept and morally treacherous. Renoir's wish to dissociate himself from any political activity was an equally fundamental expression of principle. Although each of the defectors did exhibit again with the group, the collaborative identity had been irrevocably compromised.

Equally divisive attitudes emerged regarding the form and content of painting and drawing. Degas, Redon and Gauguin all expressed reservations about working *en plein air* and the hostility of others towards Degas's introduction of such new exhibitors as Cassatt, Forain and Raffaëlli in 1879 and 1880 was connected with this polarity. Degas saw Monet's work as becoming that of a shallow decorator, and Pissarro agreed. Pissarro found Renoir's new attitudes to drawing incomprehensible. The more scientific methods of Seurat, to which Pissarro felt drawn, provoked the condemnation of Renoir, Cézanne, Gauguin and, ultimately, of Pissarro himself.

The one area in which it is possible to identify a generation gap is in the general resistance among the older artists towards increasingly intellectual and theoretical approaches to drawing. Renoir, whose confusion in face of nature had prompted his own revised attitude, said of Seurat's '*petit point*': 'You come to nature with your theories and she knocks them all to the ground.'[7] Pissarro withdrew, disillusioned, from neo-impressionism, anxious to avoid 'all narrow scientific theories that negate any individual character in drawing', and he writes elsewhere of the truth of the impressionists' 'robust art based on sensation'.[8] Cézanne's concept of a 'truth' discovered in nature rather than reasoned through theory lies at the heart of his advice to Bernard to 'turn your back on Gauguin and van Gogh'.

The widespread antipathy towards Gauguin – common to all impressionists except Degas – revolved around two issues. The first was his progressive reaction away from an art based on sensations of nature, towards a symbolic pictorial language, capable of treating what he considered a more profound reality that was not revealed by appearances. The second and most heated antagonism expressed towards him condemned the immorality of his prodigal borrowing from other art. His attitudes were anathema to Cézanne, and neither Pissarro nor Monet felt able to recognize anything in Gauguin's art that was his own. For Renoir, any art that borrowed from other cultures was a mongrel with no integrity of character.

The polemical opposition between nature-based impressionism and symbolism is full of ambiguities.

Fig.77 RENOIR: *Standing bather, seen from behind,* *c.*1890
Pencil
11.²/₃ × 7¹/₄ in
(29.7 × 18.5 cm)
Albertina, Vienna.
Inv. 24.108

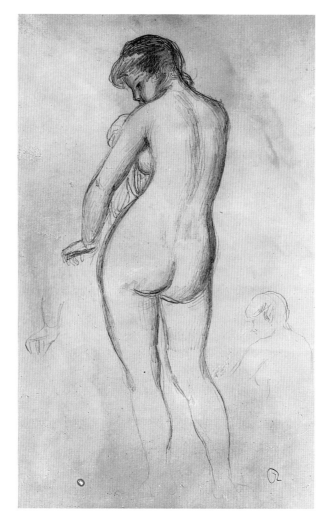

launched the new direction in modern art, 'had neither the lungs nor the kidneys strong enough to realize a major work'. He felt that Manet's followers, such as Morisot, had failed to mature beyond early impressionism, and only in Caillebotte, Cassatt and Gauguin could Huysmans see glimpses of a significant development.[12]

The leading spokesmen for neo-impressionism, such as Fénéon, pursued similar lines of criticism. He wrote that the impressionists lacked any sense of the contemplative or the analytical; their art was 'summary, brutal and approximate . . . they persist in practising their wild bravura at random, launching onomatopoeias that never congeal into phrases . . . the time has come for works that are complete and decisive'.[13] In *De Delacroix au Néo-Impressionnisme*, Signac was far more respectful, but nevertheless he too considered impressionism as flawed by a lack of method, and that as a result its success in realizing particular sensations was always a matter of chance.[14]

The most striking reactions concerning techniques of drawing came from the impressionists themselves. Pissarro and Renoir both lived through a period of critical doubt. Each of them felt beset by the mounting demands that the impressionist pursuit of truth was making on them, not least by problems relating to the very complicated surfaces of their paintings. Both looked to drawing as a means of resolving these problems and, as a result, their variously relaxed attitudes to drawing underwent substantial revision. For Pissarro, 'the old disorderly method of execution has become impossible', and the clarity and stability that he found in neo-impressionism enabled him to compare the 'clear solid draughtsmanship' of his own work of 1886 with that of Monet, in which 'the drawing is completely lost'.[15] He also commended his son at this point for his fine and simple drawing.

Renoir's crisis was more acute. He was now less close to Monet, whose positiveness he always acknowledged as a vital support in the early years. He evidently felt unable to follow the unrelenting extremes of Monet's position. By the early 1880s, Renoir had come to see impressionism as a cul-de-sac and he felt unable to draw or to paint. He turned for security and resolution to traditional practices (Pl. 27) and, in effect, took drawing seriously for the first time in his life. Although both he and Pissarro later relented from their respective extremes of the mid-1880s, the sense of substance and permanence that their drawing acquired during that period was assimilated into their mature work.

A more widespread dissatisfaction with the pursuit of fugitive appearances has been mentioned already. During the 1880s, this issue came to be treated not just as a working difficulty to be overcome, but often as a limitation that was no longer acceptable. Degas became progressively more concerned in his drawing with the complex deceits of manipulating things seen, and Cézanne's later drawings and watercolours reflect

On the one hand there were simple antipathies. Pissarro and Cézanne bristled with hostility towards anything that smacked of mysticism and the 'bustling of religious symbolists'.[9] Félix Fénéon was dismissive of the banality of impressionist realism.[10] On the other hand, van Gogh and Gauguin were great admirers of Cézanne and many of the younger symbolists felt not only respect for but a close affinity with the later work of Monet. Gauguin felt great affection for Renoir's drawing. If we compare the born-again classicism of Renoir's drawing of the 1880s with the mature figure drawings of Gauguin, despite the enormous distance that separates them as artists, we are struck by how much closer each is to the other than either is to the impressionist figure drawing of a decade or two earlier (Figs. 76, 77).

Several supportive writers expressed disappointment with impressionism's failure to reach its promised potential. By 1880, Zola felt almost betrayed that none of the brilliant early essays had matured into great art. Although he could see that all of the original potential was still alive in several artists, 'they are too easily satisfied, they reveal themselves to be incomplete, illogical, exaggerated, impotent'.[11] In the same year, Huysmans wrote that Manet, who had

XIII CASSATT: *Mother and child,* 1897, signed
Pastel
21³/₅ × 18 in
(55 × 46 cm)
Musée d'Orsay, Paris.
RF 2051

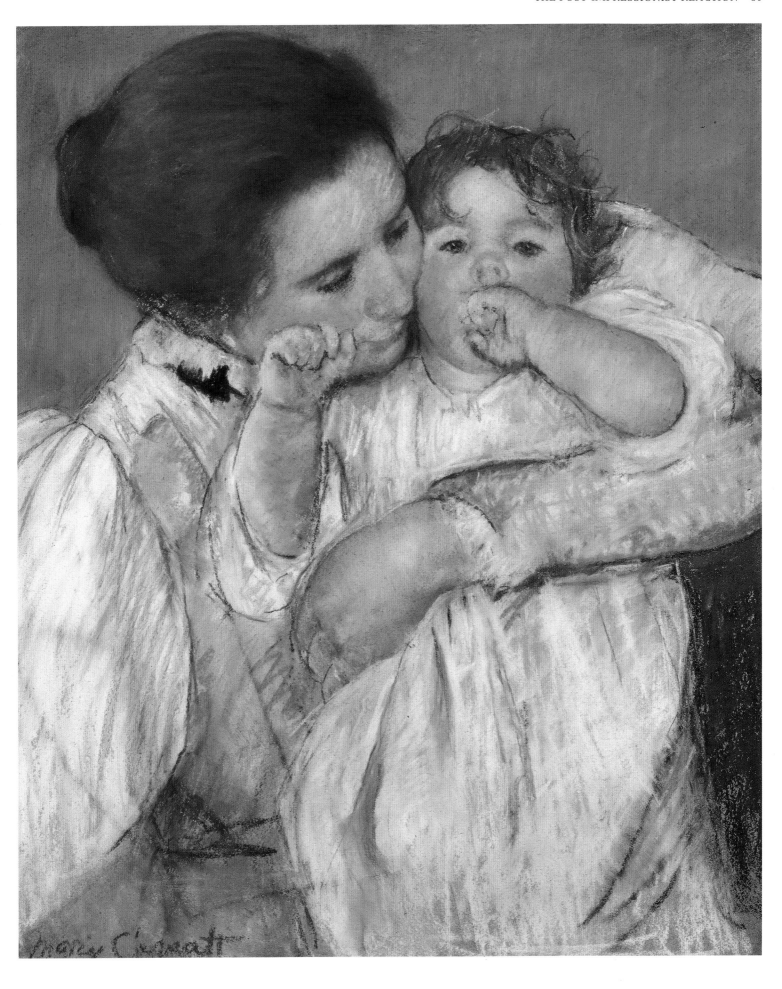

XIV GAUGUIN: *Crouching Marquesan woman, seen from the back, c.1902* Gouache monotype, retouched in grey and white
$30 \times 11\frac{1}{7}$ in
$(53.2 \times 28.3$ cm)
Collection Mr & Mrs Eugene Victor Thaw, New York

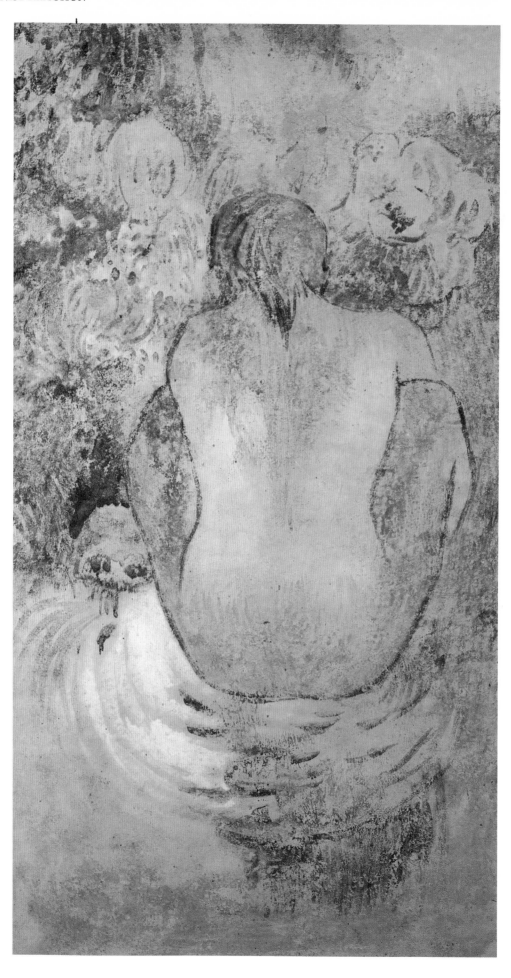

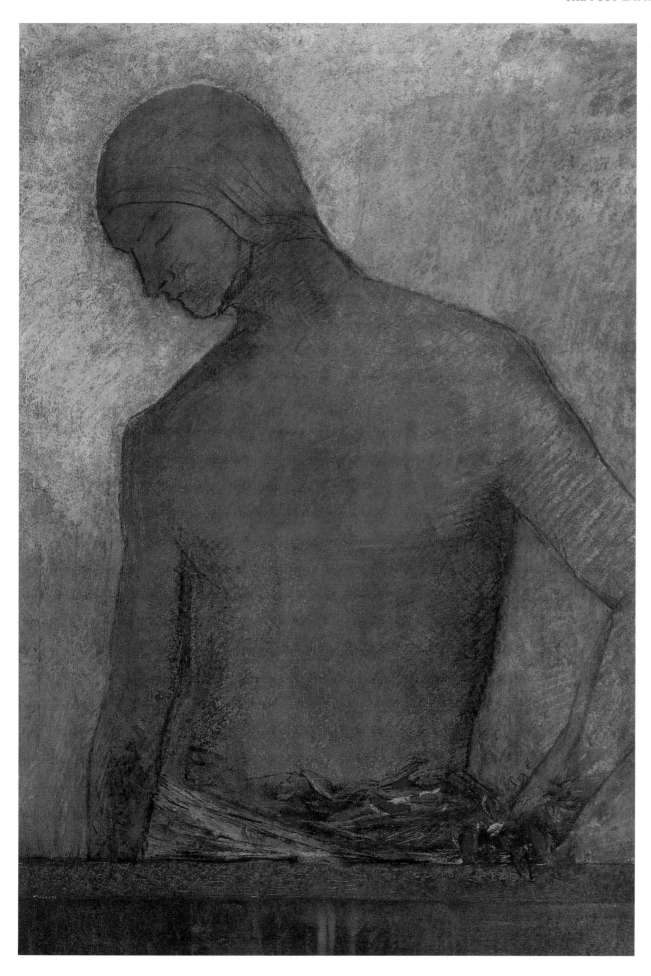

XV REDON: *Half-length figure*, 1890s, signed
Pastel
18 × 12³⁄₅ in
(45.5 × 32 cm)
Musée des Beaux-Arts,
Lyons. Inv. B 965

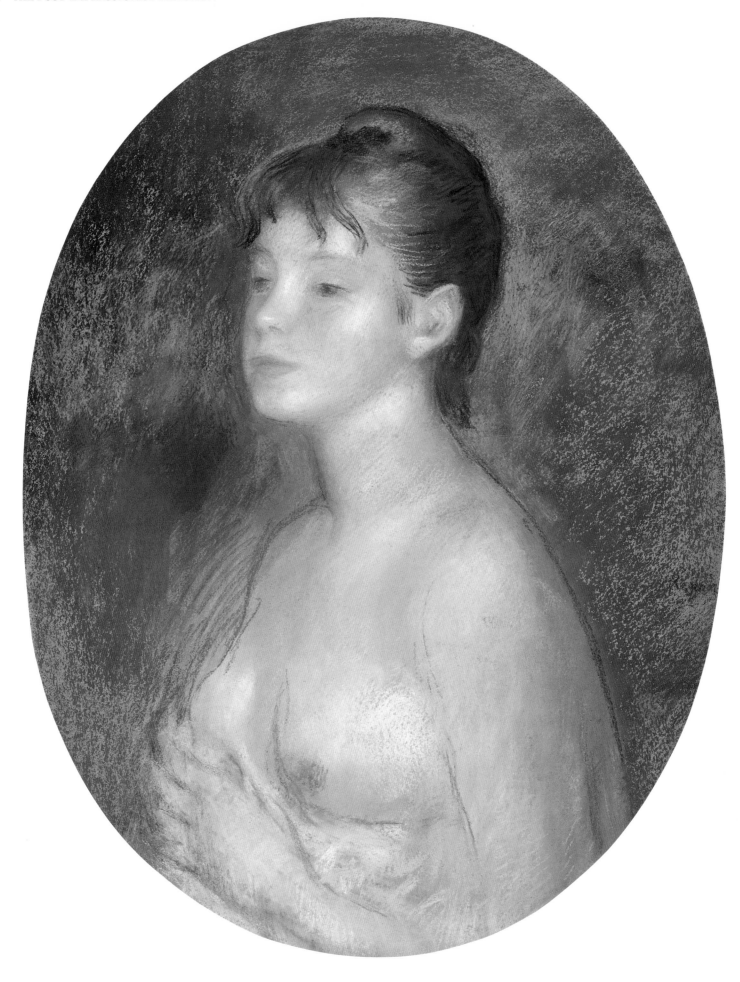

his increasing absorption in the ordering of his sensations. Redon had written as early as 1868 that, for true artists, 'while they recognize the need for a basis in *seen* reality, believable art lies in a *felt* reality'.[16] All three of these artists exerted great influence on attitudes of the 1880s and 1890s. After a decade or more of exercising his dazzling facility, Renoir appears to have become disenchanted with chasing transitory effects. He came to recognize that great art was concerned with other values.[17] Although we know less about Sisley's thinking, his later work also loses something of the self-assured freshness and simplicity of sensation of the 1860s and 1870s. Monet alone remained determined to pursue the impossible dream of an art that might literally match sensations of nature.

Among younger artists, dissent from an art determined solely by the eye went from strength to strength. Withdrawing from Paris to Arles in 1888, van Gogh felt that he could return to his pre-impressionist ideas. He told Bernard that art should be about something more exalted than 'the simple brief glance at reality – which in our sight is ever-changing, passing like a flash of lightning'.[18] Gauguin spoke disparagingly of the impressionists as 'too lowbrow'. 'They search with the eye and not towards the mysterious centre of thought, and from there they fall into scientific reasoning'; whereas he was interested in 'the reproduction of what one may sense from outer nature, but realized with the inner vision of the soul'.[19] Maurice Denis subsequently hailed Redon as the Mallarmé and Gauguin as the Manet of the 1890s generation that 'undertook a reaction against impressionism. No sensations, no windows open on nature.' The artist Paul Sérusier wrote later that 'to make an intelligent drawing, we must use nothing but elements about which we can think. If the hand or the eye gets ahead of thought, we create mere stylishness.'[20]

The art of the 1880s, of older and younger artists alike, aspired to more profound and timeless spheres of meaning. The retreat by many from city to country was itself an expression of this, as was a shift within urban images from the glitter of fluctuating surfaces to a greater concern with lasting human values. The last figure drawings of the older generation (Degas, Renoir, Pissarro), while ostensibly pursuing similar subject matter and without sacrificing the immediacy of their language, became further and further removed from an exactitude of time and place. A similar reconciliation of the immediate with the timeless is explicit in the drawings of van Gogh and Seurat. Cézanne wrote that 'one must become classical again through nature, that is to say through sensation', and his success was acknowledged in Denis's description of him as '*un classique instinctif*', '*spontanément classique*'.[21] Although it is clearer in his paintings than his drawings, and despite what he said about remaining a 'naïve' impressionist, Monet too by the

end of his life had become involved with more ambiguous allusions and meanings in nature.

In the 1870s, impressionism had, in Gowing's happy phrase about Cézanne, 'severed the equation between drawing and dreaming'.[22] In the 1880s and 1890s, the dream was considerably rehabilitated in the drawings of Redon and Gauguin. Gauguin lamented of the impressionists: 'Thought, that sweet mystery, was neither their pretext nor their conclusion They were right to start from the study of coloured nature (just as milk prepares the child for more solid foods): it is necessary in order to progress to a final development. But this they have not achieved. I might go so far as to say that they were not even aware of the possibility of progress. Vainly, blinded by their triumphs, they believed that this was all there was.'[23] Whistler wrote equally forcefully against 'how dutifully the casual in nature is accepted as sublime'.[24]

This reaction against impressionism and its widespread *rappel à l'ordre* inevitably involved a return to ideas and values that had been set aside in its first headlong revolution. Degas was fond of saying 'the secret is to follow the advice the masters give in their work while doing something different'.[25] Cézanne tried to encourage this attitude in Bernard and Camoin in his talk of using the study of great museum art as a resource for treating nature. The major incompatibility by which the young impressionists had felt separated from the generation who taught them had been that Salon art and academic theory were founded on ideal concepts of beauty and 'worthy' symbolic and allegorical subjects that looked beyond the vulgarity of immediate reality. If the change of mood of the 1880s and 1890s did not wholly exorcize this aspect of the radical/academic divide, it went some way towards alleviating it.

The condensed style of Gauguin's mature drawing bears close comparison with Charles Blanc's academic definition of style as 'reality writ large . . . stripped of all irrelevant detail and reduced to its essence'.[26] The theoretical basis of Seurat's drawing took considered account of traditions discredited in the 1860s and, generally, tradition was no longer suspected as a threat to independence. Cézanne, Gauguin and van Gogh all described themselves as links in a chain, and, taken as a whole, the prolific theoretical writings of post-impressionist artists accumulate into a proposal for a modern tradition. Post-impressionist drawing embraced revivals of interest in idealism, in symbolism, in morality, in tragedy, in satire and in a sense of the eternal. After the intense concentration on outward appearances, there was a philosophical shift from outer truths to inner meanings. If the impressionist dream of Boudin and Monet was of the innocent eye of the artist, the post-impressionist dream of Gauguin was of an unprejudiced mind and an unfettered imagination. In Whistler's words of 1888, 'Art is limited to the infinite'.[27]

XVI RENOIR: *Portrait of a young woman*, c.1885, signed
Pastel
25¹⁄₅ × 19⁷⁄₈ in
(64 × 50.5 cm)
Ordrupgaardsamlingen, Copenhagen

Fig.78 REDON: *L'Armure,*
*c.*1885
Charcoal
19⁷⁄₈ × 15 in
(50.5 × 38.1 cm)
Metropolitan Museum of
Art, New York
(Harris Brisbane Dick
Fund).
Inv. 48.10.1

Post-impressionist drawing

In its techniques, post-impressionist drawing was derived from the practices of impressionism. The only real exceptions that consciously revoked impressionism's first principles in almost every respect, were, firstly, Renoir's brief excursion into an academic idiom in the mid-1880s and, secondly, the pure linear manner that Bernard and Gauguin adopted a year or two later. Gauguin's was the most polarized reaction against impressionism. Yet, even in his case, the range of experiment and improvisation of his drawings and monotypes drew freely upon the work of his peers – at different times that of Degas, Pissarro, Cézanne, Redon, van Gogh – as well as on common sources. It was his attitude that appeared to be so distinct: 'All I want is to make simple, very simple art . . . with no aim except to reproduce the concepts of my own mind, as a child might, using only primitive means of art, the only good ones, the only true ones'.[28]

Most post-impressionist drawing used means made available by impressionism – by painting as much as by drawing — but for substantially different purposes. The very abstractness of impressionism's pursuit of sensation, releasing the materials of drawing from their traditional first obligation towards description, postulated a type of drawing whose vitality and character resided in the marks themselves, without or despite external reference. The dimension of conceptual change involved is comparable to Kandinsky's recognition of the sovereign power of colour in one of Monet's haystack paintings in 1895: 'What was absolutely clear to me was the unsuspected power, previously hidden from me, of the palette, which surpassed all my dreams. . . . And at the same time, unconsciously, the object was discredited as an indispensable element of the picture.'[29]

The intellectual conclusion that Kandinsky later derived from this realization – about the supremacy of an art free of any naturalistic reference – was not the conscious concern of the post-impressionist generation. Most of them would have viewed such a conclusion as an impoverishment of art. But the importance put upon the inherent qualities of materials in their drawings and in their writing about drawing, particularly by Redon, Degas, Seurat, Gauguin, van Gogh, expresses a very similar realization.

Van Gogh writes with great feeling about the particular properties of different drawing media, just as passionately and with the same educated insight as he describes the motifs which he will draw with them.[30] It is as if the fulfilment he enjoyed from drawing came simultaneously from his feeling for the subject and from his handling of the matter which made it real – from their coming together and their mutual dependence. The complexity of his reworkings of a drawing in a succession of materials was rather different in this respect from the technical experiment of

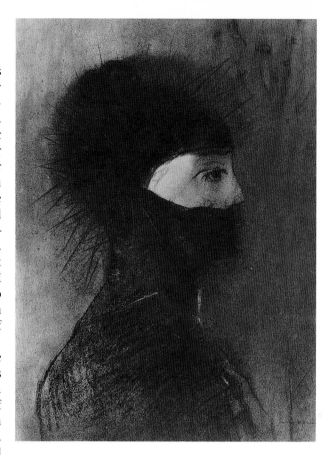

Degas or Gauguin. In van Gogh's case, it was never a question of experiment for its own sake, but more of giving the maximum expressive force and 'truth' to a particular image. The closest parallel to van Gogh's sensibility to the stuffs of drawing is in Redon's sympathetic feeling for charcoal. There are so many correspondences between the way they both write about materials, as well as in some of their moral attitudes towards subject matter, that it comes as something of a surprise to find not a single mention of Redon in van Gogh's letters. They had many friends in common and we know that Theo van Gogh bought Redon's work for the stock of Boussod's gallery.[31]

For Redon, the physical act of drawing was synonymous with thinking or imagining. His compulsion to cover the whiteness of the paper initiated the growth from amorphous matter, through erasures, rubbings and redrawings, to an image. Huysmans, in his inimitable later style, wrote of Redon's emergent image as 'a nucleus in gelatine animated by protoplasms'.[32] Drawings like *L'Armure* (Fig. 78) or *Half-length figure* (Pl. XV) reveal much of their entire gestation from the first soft tones to the final definitive marks, some drawn, some erased, and all apparently very rapidly and spontaneously made. None of the marks, however vague, is inert. It was central to Redon's account of his drawings that the role of the least determinate marks was as active in forming the identity of the image as the most definitive. His anxiety that a title may 'designate' a drawing too much is

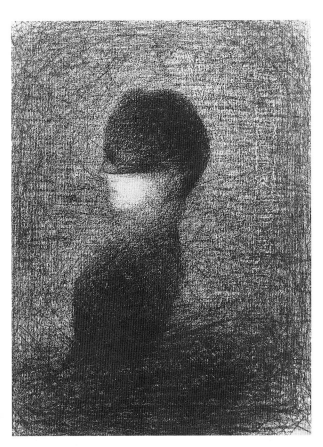

another side of the same thought: 'a title is not justified unless it is vague, indeterminate, and leads even confusedly towards the equivocal'.[33]

The degree to which the often muffled meanings of Seurat's figure drawings are contained within the density of conté crayon marks must have been among the qualities that attracted Redon to them.[34] The enigma of Seurat's *The Veil* (Fig. 79), barely emerging from the matter of the medium, inhabits the semi-articulate, intuitive world which Redon prized. The sympathetic relationship between Redon and Gauguin was based on similar shared values.

Although Degas felt that he seldom understood much of Redon's meaning, he was lost in admiration for the beauty of Redon's use of black.[35] There was a widespread revival of interest among post-impressionists in black as a colour, after its banishment from the impressionist palette. The expressive use of black in melancholic urban images by Seurat and others was mentioned earlier. Deep shadow also plays a dramatic role in the artificially lit urban interiors of Degas and Lautrec, and Gauguin once wrote about the expressive potential of arbitrarily used shadows.[36] Redon described shadow as the breeding ground of ideas for the thinking artist, and black as the medium of the mind.[37] Inspired by the example of Goya, but liberating black from its use as an essentially tragic or macabre element, Redon and Seurat both used their densest, most velvet blacks as the positive extreme in their drawings, neither void

nor substance, but more like an autonomous pictorial metaphor. There is a similar quality in the intensity of some of Gauguin's blacks, and in the way that both Degas and Cézanne – and sometimes van Gogh – made the darkest darks of their drawings not in anything as literal as shadow, but in focal points of energy or movement.

Autonomy in the sensual life of materials appears strongest in those drawings which confront us with a fragment: where the artist has isolated a detail from nature so truncated that we cannot immediately identify what is going on. Unfamiliar and unexpected viewpoints are common among impressionist motifs, especially in Degas's drawings of racecourse and theatre subjects (Fig. 80). His practice of cropping figures dramatically by the edges of the sheet – in foreground or background, and sometimes both – often deprives us of any clear spatial orientation. This heightens an impressionist sense of the arbitrary and impromptu, of a scene that the eye has stumbled upon by chance. In post-impressionist drawings, a comparable use of formal relationships that appear suspended from any pictorial explanation was exploited in ways that had nothing to do with impressions of the instant. This is clear not only in Gauguin's imaginative montages of images (Pl. 69a, 75), but also in those of Cézanne's still-life drawings that appear more concerned with the animated abutments of forms than in what the forms are (Pl. 62a, 62b). It is evident, too, in some of Seurat's studies, in which the banality of subject is belied by the rich mysterious life of the drawing, poised between the exposed white of the paper and the most opaque, soft blacks (Fig. 81). The paradox of such Seurat drawings is that these inanimate objects, drawn with an even, schematic

Fig.79 SEURAT: *The Veil*, *c.*1883
Conté crayon
$11^4/_5 \times 9$ in
(30 × 23 cm)
Louvre, Dépt. des Arts
Graphiques.
Inv. RF 38977. dH568

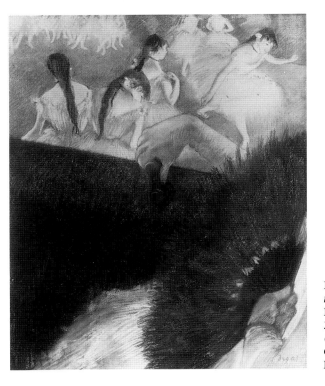

Fig.80 DEGAS: *At the theatre*, *c.*1880, signed
Pastel
$21^2/_3 \times 18^7/_8$ in
(55 × 48 cm)
Collection Durand-Ruel,
Paris. L577

Fig.81 SEURAT: *Still Life* (study for *La Baignade*), 1883/84
Conté crayon
9 × 11⁴/₅ in
(23 × 30 cm)
Fogg Art Museum, Cambridge, Mass. (anonymous loan).
Inv. 4.1969. dH593

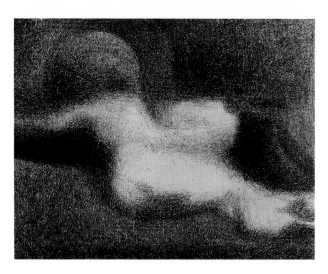

method that recalls his academic studies of inert plaster casts, are nevertheless endowed with an imaginative graphic life that is on a par with the most furiously energetic of Delacroix's pen drawings.

The masterly accomplishment of Seurat's youthful academic drawings, their discipline, consistent method and completeness, underlies all of his later work as a draughtsman, however radical or personal its developments. The evolution of his drawings from urgent and often eccentric first marks towards an ever more homogeneous and sophisticated fabric is thoroughly compatible with academic practice. The same is broadly true of the drawing practices of Redon and Gauguin. The longer they worked on a drawing, the more stable and resolved its surface became. In the later drawings of Degas, Cézanne and van Gogh, an almost totally contrary practice is discernible. Starting from simple, modest notations — like the first pencil marks in a Cézanne watercolour or a van Gogh pen drawing — their drawing becomes increasingly energetic and animated. It is a type of drawing that generates momentum as it goes along, whether in the evolution of major rhythms in a van Gogh landsape or the cumulative urgency with which the crucial axes of a pose are heightened, sometimes again and again, by Degas and Cézanne. This sort of drawing owes a great deal to impressionism and most specifically to the elaborate and animated surface of impressionist painting.

The lack of physical substance in impressionist painting's references to the outside world gave rise to a traditional view of its structurelessness. Kennneth Clark's likening of Monet's cathedral paintings to 'melting ice-cream' is one instance; the image of impressionism drawn by Fry and others, as the wayward child from whom post-impressionism rescued art, is another.[38] Chappuis sees Cézanne's constructive drawing style of the late 1870s and 1880s as the period when 'his style rids itself of impressionistic influences'.[39] Van Gogh considered the emergence of his own mature drawing style as inseparable from the falling away of impressionism's hold over him.

Viewed as a surface rather than as an illusion of the physical world, an impressionist painting appears far from structureless. The exposed rawness of the brushmarks disposed across the canvas endows its surface with a complicated but homogeneous integrity – what a partial modernist eye recognized as 'the Impressionists' inadvertent silting up of pictorial space'.[40] This surface structure of small strokes had an element of consistency arising from the width of brushstroke, but was often a randomly improvised affair. In the hands of Cézanne, van Gogh and Seurat, it became an articulate language of drawing. The small-unit fabric was given order and invested with a considered scale and sequence of marks across the surface. Most manners of post-impressionist drawing involved an all-over fabric of marks.

In Cézanne's work this appears in the system of brushstroke-like hatchings and lines with which he started to draw the L'Estaque landscape around 1880 (Pl. 61). As a technique it is clearly related to the orderly brushwork of his paintings of the 1870s made under the guidance and influence of Pissarro. It became the basis of his mature drawing manner. Most of Cézanne's late comments on drawing, to Bernard or Denis or in letters, stress his antipathy towards contours and modelling.[41] His post-impressionist technique enabled a way of drawing that had its own integrated stability and yet was still alive with an impressionist sense of flux. Denis's talk of Cézanne as 'un classique instinctif' or Pissarro's of 'un sauvage raffiné' both reflect this duality of the stable and the volatile. The movement in Cézanne's last drawings speaks more of an eternal movement inherent in nature than of momentary change in time and place: what Matisse later described as 'the condensation of sensations'.

The complex, impressionist surface of Degas's last pastel drawings, in which black contours and opaque planes interact with veils of animated coloured lines, has the same duality of temporal and timeless (Pl. 16). Fénéon wrote with warmth that 'M. Degas does not copy nature: he accumulates a multitude of studies of the same subject from which his work draws its irrefutable truth'.[42] A comparison of early and late Lautrec drawings reveals a shift from the literal transcription of movement to an embodiment of movement in the arabesque, in which transience and instability are encapsulated in a stable form (cf. Fig. 49, Pl. 89). The last drawings of Monet, in which a waterlilies motif is suspended across the double page of a sketchbook (Pl. 38), also suggest a concern with movement in a timeless continuum more than with what impinges instantaneously on the retina.

The influence of impressionist painting also played a critical role in the evolution of van Gogh's mature drawing style. His Paris drawings of 1887–88 are remarkable for their abandonment of the monumental tonal manner brought to such refinement in Neunen, and for his experiments with a variety of

techniques involving a succession of abrupt, broken lines (Pl. 92, 93). Their textural complexity may be compared to what he described as the 'gymnastics' of his Paris paintings and is quite clearly a response to impressionist brushwork. These improvisations in drawing with a screen of small interrelated marks became the basis for the sophisticated calligraphic handling of reed pen that he evolved in Arles (Pl. 94, 95, Fig. 82).

The same process of imposing a discipline upon the relative informality of the small-unit impressionist technique can be observed in neo-impressionist drawing. Both the 'pointillist' system adopted by Signac, Pissarro and others (Pl. 44, 103a) and Seurat's schematic use of directional lines (Fig. 83) developed the intuitive brushwork of impressionism into a method that was coherent in formal structure and in meaning.[43]

The striking similarity of curvilinear surface organization in the drawings of Seurat and van Gogh is a measure of common sources and common intention. The increasingly frequent appearance of the arabesque in post-impressionist drawings at large can reasonably be associated with the organic, formal energies of the 'alternative tradition' of drawing discussed earlier and with the mannered, linear asymmetry of Japanese prints. It also reflects the various currents of interest in the decorative, expressive and symbolic properties of line.

Seurat's summary of the aesthetic theory behind his method includes an account of the expressive attributes of line and tone based on his study of the theoretical writings of Humbert de Superville (1827), Blanc (1870) and his friend Charles Henry (1885).[44]

His methodical use of a directional articulation of lines to express gaiety, calm or sadness of mood is evident in drawings from about 1886 and becomes increasingly pronounced in his later work. If most other artists resisted so exact an application of theory to drawing, many were actively interested in the symbolism of line. Van Gogh read the work of Blanc and at least knew of Henry through Signac.[45] After the essentially literary symbolism of his Dutch drawings, the characteristics of his later style that are not the direct record of observations are either decorative or more arbitrary and abstract in their symbolic allusion. The extraordinary rhythmic and organic abstraction of *Starry Night* (Fig. 82) appears to be a form of graphic metaphor for elemental forces in nature. Van Gogh writes about such drawings only in the most general terms, comparing them with Delacroix and linking them with discussions he has had with Gauguin and Bernard.[46]

Fénéon recognized analogies between neo-impressionism and the hieratic, linear qualities of Gauguin's art as early as 1889, but Gauguin himself felt there was little common ground. He wrote of man's inherent sensitivity to the expressive meaning of lines as biological ('which no education can destroy'). His often-quoted letter to Schuffenecker about 'noble lines and false lines' and the sadness of the weeping willow is characteristic in expressing his obsessive personal interest in meanings beneath appearances – like his current enthusiasm for graphology – and at the same time assimilating some very conventional, even popular material.[47]

Redon, equally averse to art that was unambiguous, wrote of 'abstract line, that agent springing from great

Fig.82 VAN GOGH: *The Starry Night*, 1889
Reed pen, pen and ink
18$\frac{1}{2}$ × 24$\frac{3}{5}$ in
(47 × 62.5 cm)
Formerly Kunsthalle, Bremen. F1540

Fig.83 SEURAT: Study for *Le Cirque*, 1890
Oil on canvas
21$\frac{2}{3}$ × 18$\frac{1}{8}$ in
(55 × 46 cm)
Musée d'Orsay, Paris. RF 37.123. dH 212

depths and acting directly on the spirit'. To Redon, the abstract line was just one of the characters in the theatre of his imagery. He invited the viewer: 'Imagine arabesques or various meandering lines that disport themselves not on a flat surface but in space, with all that is afforded to the spirit by the profound, limitless dimensions of the sky; imagine the play of their lines projected and fused with all manner of elements, including those of the human face . . . in this you will have the character of many of my drawings.'[48]

Gauguin's discussion in *Cahier pour Aline* of the 'musical' and 'literary' elements in art also directs our attention to the oblique but profoundly expressive meeting between abstract and representational parts of an image. So does van Gogh's distinction between the realism and the arbitrary or 'exaggerated' attitudes that are brought together in his mature drawing and painting.[49] The frequent mention by post-impressionist artists of harmony and their comparisons of art with music all emphasize a more self-conscious concern with abstraction in drawing. It serves to remind us as well that the enthusiastic reading of Baudelaire by this generation was less of the champion of modern life *per se* and more of the romantic aesthete who wrote towards the end of his life: 'Enthusiasm devoted to anything other than abstraction is a sign of frailty and of sickness.'[50] One of his most devoted disciples, Redon, wrote: 'My drawings *inspire*. They defy definition. They determine nothing. They place us, as does music, in the ambiguous world of the indeterminate.'[51]

If all this talk of abstraction and ambiguity seems a far cry from the founding premises of impressionism in the 1860s, so firmly rooted in the perceivable world, it is also true that these same attributes were brought into sharp focus by the impressionists' concern with sensation. The paradox that exists in the late work of Cézanne, Degas and van Gogh – that duality of the 'innocent' intuition responding to sensations of nature and the elaborate artifice brought to bear upon its realization by the educated artist – had been implicit in impressionism from the start. In the more intellectual climate of the 1880s, this paradox became consciously articulated. The impressionists had sought to see things in nature not as objects, but as sensations. Albert Aurier, discussing symbolist theory in 1891, wrote that the artist sees things in nature not as objects but as 'signs of Ideas'.[52]

Drawing in painting

The cardinal issue which had united the impressionists in their condemnation of academic dogma was its separation of drawing from colour. It is a subject that crops up repeatedly in their later statements. Towards the end of his life, Pissarro told Louis le Bail 'it is the brushstroke of the right value and colour which should produce the drawing'.[53] Cézanne said to Gasquet that 'drawing is all abstraction: it must never be separated from colour' and advised Bernard 'as one paints, one draws; the more the colour harmonizes, the more precise becomes the drawing'.[54] Degas spoke in comparable terms about colour developing the depth of a drawing. For van Gogh, the great lesson of the Dutch masters was 'to consider colour and drawing as one'. Monet told the Duc de Trévise 'I have never liked to isolate drawing from colour', and Gauguin demanded in one of his notebooks: 'Can you really make me believe that drawing does not derive from colour and vice versa?'[55]

The Ingres–Delacroix, line–colour debate that had been so divisive during the impressionists' student years had by the end of the century been resolved. Different writers have credited this achievement variously to the late, post-impressionist drawing of Degas, Renoir, Cézanne and Gauguin. At all events, the reconciliation is largely attributable to impressionism, which brought the practices of painting and drawing together. The 'painterliness' of their drawings is clear in the sense that drawings were a rehearsal of paintings and in the degree to which new manners of drawing were derived from painting.

Many of their technical experiments in drawing amounted to a greater proximity to painting. It is obvious in the brushed and wiped improvisations of Degas's monotypes and in his reworking of some of them in pastel; equally in Gauguin's experiments with monotype and in his 'traced drawings' (Pl. XIV).[56] The widespread use of pastel, by Boudin, Degas, Monet, Renoir and Cassatt, provided means for all of them, in effect, to draw and paint simultaneously.

Fig.84 CÉZANNE: *Woman seated at a table*, 1890s? Oil on canvas 25¹/₅ × 20⁶/₇ in (64 × 53 cm) Fogg Art Museum, Cambridge, Mass. (anonymous loan). Inv. 9.1989

Morisot's strange, unresolved drawings in coloured crayons (Pl. X) appear motivated by the same ambition, and the growing predilection of Cézanne and Signac for watercolour also facilitated a union of drawing with colour.

The relationship of drawing with painting was reciprocal: there are as many instances of drawing techniques entering the practice of painting as vice versa. After early impressionism's virtual abandonment of drawing in painting, it is a characteristic of much post-impressionist painting that it is full of drawing.

Three of the major post-impressionists – Redon, van Gogh and Seurat – had substantial careers as draughtsmen before they embarked on their significant oeuvres as painters. In each case their painting techniques were profoundly and progressively informed by their drawing. The open, linear structure of van Gogh's later paintings seems to grow directly out of the drawing style he had developed in Arles. Every mark of the last Auvers paintings is part of a homogeneous linear fabric.

Lautrec's painting was essentially a matter of successive coloured lines, drawn with the brush. The flatness of so much painting associated with symbolism in the 1890s inevitably lent greater emphasis to line and silhouette. Signac was to write later that the painter's first task, faced with his white canvas, was 'to decide which curves and which arabesques are going to cut up its surface'.[57] Seurat's unfinished painting of *Le Cirque* (Fig. 83) was started in very much this fashion. Gauguin's paintings from 1888 onwards are all articulated by an exposed linear structure, often redrawing into and over the colour with a wide variety of marks. He sometimes added final linear emphases to a painting in the same colour as his signature – usually blue or black – as if they were part of the same process of completion. In some of Degas's paintings, too, the final stage seems to have been the addition of a few vital, nervous linear touches. The freedom of Degas's last paintings was visibly affected by his work in pastel.

Correspondence between painting and drawing techniques is most striking in the later work of Cézanne. Rewald emphasizes that, after his earliest works, Cézanne used watercolour and oil for distinct complementary purposes.[58] It appears equally likely that the technique of his late paintings gained in refinement from his experience of watercolour – in a greater translucency of colour and particularly in the dialogues between colour and line. In his later watercolours, each of the separate sequences of pencilled and coloured marks is free and open, but their interaction creates both fullness and clarity, the gravity of the drawn marks anchoring the translucent bloom of the colour. In such late, unfinished canvases as *Woman seated at a table* (Fig. 84), it is possible to see the emergence of an equally complex relationship of line to coloured mark. The first drawn marks on the canvas were in chalk, establishing the general disposition of the whole motif within the rectangle. Next, Cézanne laid in the first broad brushloads of paint, in three or four colours, over and around the chalk lines. Then followed a second stage of drawing: painted lines in a wider range of colours, some of them affirming or echoing the edges of coloured marks, others drawn over these marks and setting up new counter-rhythms. The final state of Cézanne's last paintings was characterized by a subtle interaction of line and colour, alive with correspondences and contrasts. In barely started canvases like this one, we can see how fully this network of contrast and analogy was entered into from the very first marks, in a manner very close to that of his watercolours (cf. Pl. 66, 67).

Unfinished canvases among Monet's last works also serve to demonstrate the extensive role that drawing came to play in his mature painting. Many of the last large *Nymphéas* canvases are composed only of a very rapidly painted array of black and coloured ribbons (Fig. 85). This linearity might be attributable to the nature of his motifs – weeping willows, ripples on the

Fig.85 MONET: *Nymphéas*, 1917-19
Oil on canvas
39³⁄₈ × 118¹⁄₈ in
(100 × 300 cm)
Musée Marmottan, Paris.
Inv. 5118

water, sinuous grasses below its surface – were it not for the growing prevalence of brush-drawn lines in most of the work of his last thirty years. The point at which Pissarro considered that 'the drawing is completely lost' in Monet's work – which occurred in 1886 – was precisely the period when a linear articulation began to appear more forcefully, in Monet's Belle-Ile paintings. It was evidently a development that Pissarro was unable to accept as drawing at all.[59] Signac, on the other hand, praised the vital arabesque in Monet's painting technique. By the turn of the century, in some of his London canvases, Monet was painting with the most extravagantly calligraphic coloured lines.[60]

Considered simply as a type of drawing, these paintings have a great deal in common with the linear vitality of Delacroix or Daumier drawings (cf. Fig. 48), albeit on a vastly bigger scale. Improvised from sensations in front of nature and – at the end – drawn with a large brush at arm's length, Monet's last paintings were a realization of Baudelaire's vision of a liberated drawing with colour. They also constitute the final nail in the coffin of any myth that Monet was a painter who did not draw.

NOTES

1 *Archives* I, p. 75.
2 Introduction to the 'Second Post-Impressionist Exhibition', Grafton Galleries, London 1912. Reprinted in *Vision and Design*, 1961, p. 188.
3 Of 246 exhibits, the catalogue lists 33 watercolours, 25 drawings, 31 pastels, 7 prints. Catalogue entries for all eight exhibitions are reproduced in full in Moffett 1986.
4 See for instance Geffroy 1980, pp. 261–262.
5 *Archives*, I, p. 268.
6 Baignières, quoted by Bénédite, *Burlington Magazine*, 1908, p. 131.
7 Vollard 1985, p. 208.
8 The first quotation cited by Rewald in *Georges Seurat*, Paris, 1948, pp. 131–32; for the second, see Pissarro, *Letters*, p. 171.
9 See Pissarro, *Letters*, pp. 170–171.
10 See Françoise Cachin's diverting paper on Pissarro and cabbages, in Lloyd (ed.) 1986, pp. 95–98.
11 Zola, 'Naturalisme au Salon', 1880 in *Archives* II, p. 280.
12 Huysmans 1883, pp. 91, 111, 158, 253.
13 Fénéon 1966, pp. 87, 91, 96.
14 Signac 1987, pp. 87–97.
15 Pissarro, *Letters*, pp. 97, 91.
16 Redon 1987, p. 56.
17 Vollard 1985, p. 221.
18 Van Gogh, *Letters* III, p. 478.
19 'Diverses Choses', *Noa Noa*, Louvre MS, p. 263; *Cahier pour Aline*, n.p.
20 Denis, *Journal* III, 1959, p. 241; Sérusier, *ABC de la Peinture*, 1921, p. 23.
21 Cézanne, quoted by Bernard, *l'Occident*, July 1904; Denis, *Théories*, pp. 251, 260.
22 Gowing, New York, 1988, p. 18.
23 'Diverses Choses', *Noa Noa*, Louvre MS, pp. 263–64. On Gauguin and dream, see also Wadley, 'Comme en rêve', in *Rencontres Gauguin*, Tahiti, 1989, pp. 25–31. For Redon on dream, see e.g. Redon 1961, pp. 26–27, 163.
24 Whistler 1967, p. 144.
25 Cited by Thompson in Manchester 1987, p. 13.
26 There are also clear echoes of mid-century theory in the later writings of Signac, Denis and Sérusier.
27 Whistler 1967, p. 155.
28 Interview of 1891; see *Oviri* 1974, p. 70.
29 Kandinsky, 'Rückblick 1910–1913', *Der Sturm*, 1913. Trans. in Seitz, *Claude Monet, Seasons and Moments*, New York, 1960, opp. p. 24.
30 See e.g. *Letters* II, p. 2, on the 'gypsy soul' of a crayon. See also Pej in Otterlo 1990, pp. 28–39.
31 The close friendship between Redon and André Bonger, uncle of Theo's wife, appears to have started only after van Gogh's death.
32 Huysmans 1925, pp. 150–51.
33 Redon 1961, p. 26.
34 Redon was not sympathetic towards neo-impressionism at large: he once proposed writing an article 'On the Sterility of everything *Neo*', 1909 (Redon, *Lettres*, 1987, pp. 178–79).
35 Quoted by Thadée Natanson, *Peints à leur tour*, 1948, p. 48.
36 See p. 78.
37 Redon 1961, p. 163. See also notes to Pl. 79.
38 Clark, *Landscape into Art*, 1961 edition, p. 94. In *Retrospect* (1920), Fry retracted some of his prejudice against impressionism; *Vision and Design*, 1961, p. 227.
39 Chappuis 1973, I, p. 16.
40 Clement Greenberg, *Art and Culture*, 1973 edition, p. 50.
41 See notes to Pl. 65.
42 (1886) Fénéon 1966, p. 59.
43 For acknowledgement of sources in impressionism by Seurat (1890), see Fénéon, *Oeuvres plus que complètes*, Paris, 1970, I, p. 508; by Signac (1899), see Signac 1987, p. 105.
44 Seurat's theoretical statement is translated in full in 'The Meaning of the Dots', Rewald 1986, p. 166. For de Superville, see his '*Essai sur les signes inconditionels de l'art*', 1827. On Blanc, see above, p. 17. On Henry, see also Fénéon 1966, pp. 141–46. See also Signac (1899) 1987, p. 104; notes to Plate 107.
45 Van Gogh, *Letters* III, p. 153.
46 Ibid., pp. 182–83, 227.
47 Gauguin, *Correspondence* I, pp. 87–88. On graphology, see also letters to Pissarro, ibid., pp. 71–77.
48 Redon 1961, pp. 25, 27.
49 For Gauguin, see also the 1891 interview with Tardieu, trans. in *Writings of a Savage*, 1978, pp. 110–12. For van Gogh, see *Letters* III, p. 6.
50 *Fusées* (VI), in *Journaux Intimes*, Paris, 1920, p. 10.
51 Redon 1961, pp. 26–27.
52 Aurier, 'Le Symbolisme en Peinture: Paul Gauguin', *Mercure de France* (1891) II, pp. 159–64.
53 Rewald 1955, p. 356.
54 Doran 1978, pp. 123, 36.
55 Van Gogh, *Letters* I, p. 518; Monet, trans. in House 1986, p. 227; Gauguin, in 'Notes Synthétiques', Sketchbook, c. 1884–88, Armand Hammer Collection (trans. in *Writings of a Savage*, 1978, p. 12). The *Synthétisme* of Bernard and Gauguin was described by the critic Dujardin as an art in which 'drawing affirms colour and colour affirms drawing'; *La Revue Indépendante*, May 1888.
56 See Field 1973 for a good discussion of this.
57 Signac (1899) 1987, p. 103.
58 Rewald 1984, pp. 22ff.
59 As early as 1883, perhaps briefed by Monet, Geffroy had started to write of Monet's paintings in terms of their drawing (*La Justice* 15 March 1883, trans. Stuckey, New York, 1985, pp. 96–97).
60 See e.g. W1530, 1606.

6 The Impressionist Heritage

Although catalogues raisonnés of drawings have not been published on all of the impressionists, it is clear that the traditional view of impressionism as synonymous with the death of drawing is misleading. They all used drawing and, in some cases, drew prolifically.[1] The enormous variety in type, purpose and quality of these drawings reveals both that the traditional functions of drawing *vis-à-vis* painting were by no means totally discarded and, conversely, that the art of drawing was irrevocably changed by impressionism.

The wide range of drawing practised in the immediate wake of impressionism bears witness to these changes and anticipates the pattern of later developments. The collective influence of impressionism is visible in the now widespread practice of very informal, rapid drawings from nature; in the more abstract, expressive decoration of much turn-of-the-century drawing; and in the schematic graphic manners of the cubist and futurist generations. In each case there is an intimate correspondence between the practices of painting and drawing, and they share another important characteristic. This is the prominence given to the expression and animation of the drawn marks themselves, liberated from their passive role of representation. In retrospect, it is this that appears to be the central connecting thread of drawing's history in the second half of the nineteenth century: the progressive emancipation of the matter of drawing. It was implicit in the linear exuberance of Delacroix and Daumier, made explicit in a more or less haphazard way in the drawing-as-seeing of impressionism, and finally given a conscious and articulate form in the mature work of Cézanne, Gauguin, Redon, Seurat and van Gogh.

The precedents of van Gogh, Gauguin and Seurat are all visible behind the lively graphic experiments of the Pont-Aven school in the early 1890s, particularly of O'Conor and Seguin (Fig. 86). The Breton landscape became the vehicle for an animated linear articulation of the surface: organic contours containing an elaborate range of textures within them. Much of the drawing associated with art nouveau grew and flourished from the same sources. The convoluted arabesques formed from small directional marks in the drawings of Thorn Prikker, Toorop and others, assimilated attributes from the work of van Gogh and the neo-impressionists and pushed them towards the heady intensity of fin-de-siècle expressive ornament (Fig. 88). To the generation of Kandinsky, Malevich and Mondrian, there appeared to be a logical path leading from here to high abstract art. It is not difficult to understand why much of the subsequent writing of modern art's history, bedevilled by notions of progress, has endorsed this view. It was a language of drawing in which an abundance of expressive content was embodied in the signs. Artists and writers in art nouveau circles celebrated what they saw as the emancipation of a 'life force' inherent in lines.

In much of the post-impressionist drawing practised between the 1890s and the First World War, there is a conscious play with the duality of the line's expressive life and its function as a means of representation. The condensed linear style of Vuillard's early drawings teases maximum effect from line's double role as decorative arabesque and the bearer of an

Fig.86 SEGUIN: *Farmhouse surrounded by trees*, 1893
Etching
7¹/₆ × 12 in
(18.2 × 30.5 cm)
Josefowitz Collection

Fig.87 THORN PRIKKER: *Route de Souvré*, c.1890
Raffaelli crayon
18¹/₈ × 21²/₃ in
(46 × 55 cm)
Boymans-van Beuningen Museum, Rotterdam.
Inv. MB 1972/T-30

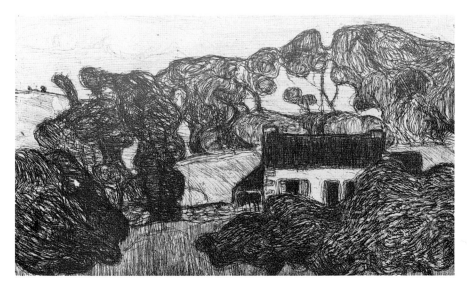

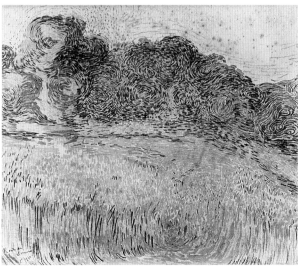

Fig.88 VUILLARD: *Woman in bed*, c.1891, initialled
Watercolour and black chalk
$5^4/_5 \times 9$ in
(14.7 × 22.8 cm)
National Gallery of Art, Washington
(Ailsa Mellon Bruce Collection).
Inv. 1970.17.179

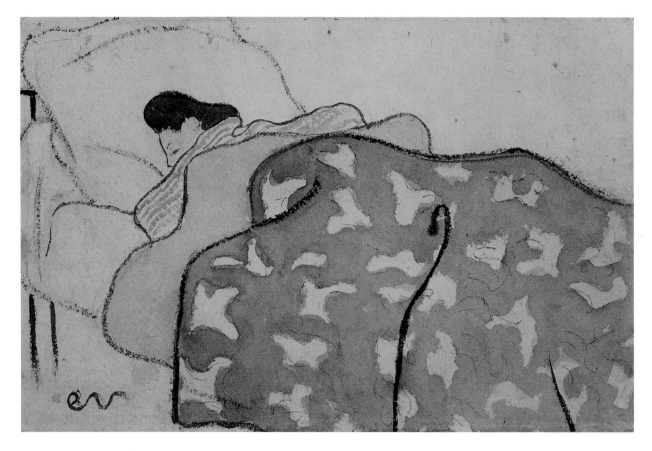

Fig.89 GAUGUIN: *Rocks at the edge of the sea*, c.1890?
Watercolour and black chalk on buff paper
$5^1/_3 \times 4^7/_8$ in
(13.5 × 12.4 cm)
Private collection

image (Fig. 88). The absorption of his monogram into this witty dialogue is reminiscent of the ornamental character of Gauguin's 'PGO' signature (cf. Pl. 74). This sort of drawing by artists of the Nabi group was directly indebted to Gauguin. Stylistically it reflects his powerful use of the arabesque; conceptually it assimilates his distinction between the 'musical' and the 'literary' parts of an image.[2]

Similar qualities, also reflecting a debt to Gauguin, were exploited to quite different ends in the drawings of Munch from the same period. The haunted anxiety of his lithograph *Puberty* (Fig. 90) stems both from the 'literary' attributes of pose and facial expression, and from the 'musical' effects of curvilinear contours, not least in the animation of an ambiguous, phantom-like shadow. Gauguin once advised Bernard against illusionistic use of shadows, but to include them if they were useful for expressive purposes. 'Thus if instead of a figure, you put in only the shadow of a person, this is an original point of departure whose strangeness you have calculated.'[3]

Munch's generation was attracted equally to the drawings and lithographs of Redon, because they found there 'a kind of drawing which the imagination has liberated from the burden of naturalistic detail, so that it is free to treat only the depiction of things imagined'.[4] The universal application of this liberation to all manner of drawing was of more profound and lasting value than its short-lived importance for early abstract art. Marcel Duchamp stressed the importance

to him of Redon's precedent in enabling his break from an art determined by the retina. The theoretical stance that Duchamp adopted around 1910–14 coincides with Redon's ambition 'to place the logic of the visible at the service of the invisible'.[5]

The thorough appraisal of post-impressionist art undertaken by Matisse in the 1890s and 1900s is reflected directly in his practice of drawing and more profoundly in his theory. The manner of the van Gogh *Haystacks* drawing that he owned (Pl. 94b) is echoed in some of his own textured reed-pen drawings of around 1905 (Fig. 91). Matisse's paragraphs on drawing in his *Notes of a Painter* (1908) form a revealing account of current interpretations of post-impressionist theory. He stresses the autonomous identity of each mark on the paper and the importance of preserving this status as the drawing develops. 'If I put a black dot on a sheet of white paper, the dot will be visible no matter how far away I hold it: it is a clear notation. But beside this dot I place another one, and then a third, and already there is confusion. In order for the first dot to maintain its value I must enlarge it as I put other marks on the paper.'[6] The relation of this array of marks to the motif he is drawing is made clear in his adjacent comments on painting: 'I am forced to interpret nature and submit it to the spirit of the picture. From the relationship I have found in all the tones, there must result [. . .] a harmony analogous to that of a musical composition.'[7] The correspondence of this view of drawing to the theory and practice of van Gogh and Seurat is self-evident. The simpler style of rhythmic contour drawing that animates Matisse's paintings of 1905 to 1910 relates more to his study of Gauguin and to the clarity that he admired in Cézanne. This purity of line was to dominate his mature drawing, and he wrote later: 'When you understand an object thoroughly you are able to encompass it with a contour that defines it entirely'.[8] In the closeness of this concept to Ingres's theory of drawing, there is a sense of the wheel coming full circle, except that Matisse came to Ingres through the filter of post-impressionism. His full cognizance of the expressive and expansive power of drawing can be traced to Delacroix via the same route.

It is well known that as students Matisse and Marquet enjoyed repeating Delacroix's maxim about a complete artist being one who is able to draw the likeness of a man falling from a fourth- (sometimes fifth-) floor window before he reaches the ground.[9] A lot of Matisse's drawings are endowed with impressionist senses of captured movement and of drawing against time. The abbreviated arabesques of his *Dance Movement* drawings (Fig. 92) aspired to contain time. Matisse talked of 'limbering up' for such drawings, and the athletic movement of his hand itself echoes the subject: 'My line drawing is the purest and most direct translation of my emotion . . . if it is not adequate, there is no alternative but to begin again, as if it were an acrobatic feat.'[10]

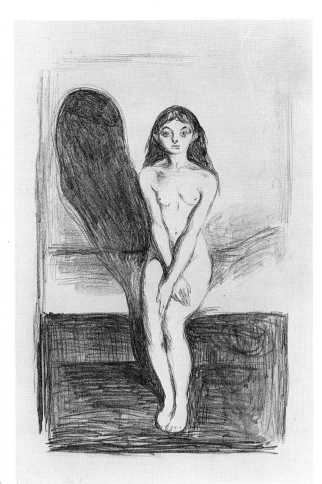

Fig.90 MUNCH: *Puberty*, 1894
Lithograph
$15^{3}/_{4} \times 10^{5}/_{6}$ in
(40×27.5 cm)
Munch Museet, Oslo.

Fig.91 MATISSE: *Mme Matisse seated, Collioure*, 1905
Reed pen and ink
$7^{4}/_{7} \times 9^{1}/_{3}$ in
(19.3×23.7 cm)
Musée National d'Art Moderne, Paris.
Inv. 1984.43.

Fig.92 MATISSE: *Dance movement*, 1949
Pen and ink
$22^1/_6 \times 15$ in
(56.3×38 cm)
Matisse Archives

Fig.93 BOCCIONI: *Forces of a street*, 1911, signed
Pencil
$17^2/_7 \times 14^4/_7$ in
(43.9×37 cm)
Galleria d'Arte Moderna, Milan

Fig.94 GRIS: *Head of Harlequin* (after Cézanne), *c.*1916, signed
Pencil
10×8 in
(25.5×20.5 cm)
Musée National d'Art Moderne, Paris.
Inv. 1793D

Throughout Europe, from England to Russia, the artistic adolescence of artists born in the 1880s bore the imprint of post-impressionism in its various forms. The charged duality of drawn marks as both image and matter is present in highly textured drawings by artists as different as Gilman in London, Kupka in Prague and Vrubel in Moscow. The early drawings of the Italian futurists, hungry for cosmopolitan modernity, ran the gamut of post-impressionist styles. If Boccioni's drawing *Forces of a street* (Fig. 93) reflects cubist forms in its geometry, the ultimate origins of this simultaneous array of fragments of experience are to be found in impressionist urban images of the 1870s and 1880s. The prodigal variety of Picasso's early drawings embraced a similarly wide and eclectic diet of post-impressionist idioms.

In drawings related to early cubism, around 1909–14, attention focused on the precedents of Seurat and – most visibly – of Cézanne. Juan Gris's elegant copy after Cézanne (Fig. 94) is typical of a stylized emulation of Cézanne's constructive method found in much early twentieth-century drawing. For other artists such as Malevich, Seurat's drawing served to provide similar principles. Gris's copy singles out for emphasis the meeting and abutment of forms. The fluid openness of Cézanne's late drawings is condensed into a relatively clinical, intellectual process of systematic displacements and analogies. The motif is realized as a continuum of the rise and fall of

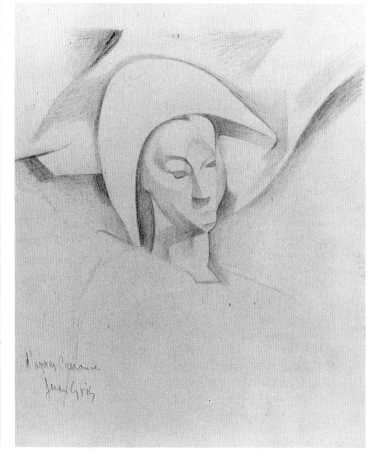

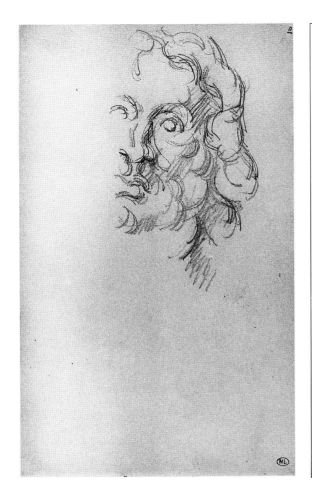

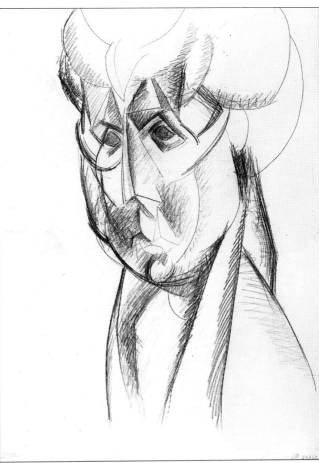

Fig.95 CÉZANNE: *Le Grand Condé* (after Coysevox), *c*.1895
Pencil
$8^1/_2 \times 5^2/_5$ in
(21.6 × 13.7 cm)
Louvre, Dépt. des Arts Graphiques
RF 29.933. C1035

Fig.96 PICASSO: *Head of a woman (Fernande)*, *c*.1909
Chalk
$24^4/_5 \times 18$ in
(63 × 45.5 cm)
Albertina, Vienna.
Inv. 23.460

its parts, alternately solidifying and dissolving. It resembles a relief construction in which there are no voids: space and form are both positive elements in an ordered equation. This is the 'classical', formalist interpretation of Cézanne, hailed by Fry and Bell as an art of 'significant form'.[11]

There is a remarkable similarity between some of Cézanne's late drawings after sculptures and the drawn studies of heads of about 1909–12 by Picasso and Boccioni, both of whom were actively involved in sculpture at the time (Figs. 95, 96). Cézanne's drawing after a Coysevox portrait bust assimilates its baroque extravagance into a rhythmic sequence of rhyming curves. The inert bronze is interpreted in terms of expansive linear relationships, opening out into the white of the paper. Although more geometric in line and more sculptural in its tonal contrasts, the Picasso drawing bears obvious stylistic affinities to the Cézanne. It was not style so much as the ideas implicit in Cézanne's late work that moved Picasso's curiosity most profoundly – ideas that were arguably more exposed in the improvised abstraction of Cézanne's drawings and watercolours than in his paintings. Cézanne's realization of forms in terms of vital relationships appears to have been a catalyst for Picasso's own thoughts about a type of drawing in which he could treat internal and external relationships simultaneously. The various ways in which impressionism raised the issues of movement and time in drawing were primitive ancestors of the cubist artists' interest in the fourth dimension.

The few studies that exist of the history of modern drawing have all acknowledged the founding role of precedents in the late nineteenth century.[12] Impressionism bequeathed to twentieth-century drawing a loosening of traditional restraints and a liberation of the possibilities of drawing. Like all of art's history, it was a matter of change rather than of progress: change for the better in the eyes of most artists, for worse in the eyes of some purist apologists of fine drawing. What has complicated the lives of the latter is that, in the wake of impressionism, the prerequisites of 'a good drawing' have become less easily defined. The change is already announced by van Gogh's talk of drawing that is 'true' but not 'correct' and by Gauguin's post-impressionist declaration that 'good drawing does not mean drawing well'.[13]

In his essay on 'The later Monet' (1959), Clement Greenberg suggested that the informal execution of Monet's last paintings proposed a type of drawing within shallow pictorial space that was of seminal influence for 'the most advanced of advanced painters' in America of the 1950s. 'It was under the tutelage of Monet's later art that these same young Americans began to reject sculptural drawing – ''drawing-drawing'' – as finicking and petty, and to

Fig.97 BONNARD: *Cattle grazing*, 1910/20?
Pencil
6⅓ × 4⅚ in
(16.1 × 12.3 cm)
Nationalmuseum,
Stockholm.
Inv. NMH 126/1970

turn instead to "area" drawing, "antidrawing" drawing.'[14]

The violence with which the impressionists set aside the decorum of traditional conventions in the speed-induced informality of their drawing from nature gave credence to an artless drawing-as-painting, to a drawing that Greenberg could call – affirmatively – 'antidrawing'. It was allied to what Valéry recognized in impressionism as 'the speculative life of the eye', and in practice involved the improvisatory life of the hand. The casual manner of Bonnard's mature drawing (Fig. 97) is an obvious descendant. In the longer term, we can also identify the same broad line of descent in the fugitive traces of Giacometti's pencil drawings, or the informal improvisation of much abstract expressionist drawing. In the wake of Monet's wish to see as if for the first time, the unfettered intensity of such drawing has often been defended for its unaffectedness, untainted by education, and compared to primitive art or to the drawing of children.

At the other extreme of the heritage are drawings with the ascetic poetry of van de Velde's *Sea and Beach* (Fig. 98). Most recognizably, it is a child of neo-impressionism and an ancestor of drawings within the traditions of constructivist and high abstract art. Nothing could be further from artlessness than the reductive purity of its marks. There is no conflict between art and nature here. The paradox of the impressionist heritage is that the true origins of this most austere, ordered drawing are also traceable to the chaos of the impressionist attempt to capture the first naïve impression.

Fig.98 VAN DE VELDE: *Sea and beach*, 1888/89
Black chalk
9 × 12⅕ in
(23 × 31 cm)
Collection Mr & Mrs H. Hartswyker, Amsterdam

NOTES

1 Pissarro's drawn oeuvre has been estimated at around 3,000 items (Brettell/Lloyd 1986, pp.2–3) and that of Degas must be comparable: his notebooks alone contain over 1,300 drawings. Including pastels and watercolours, other approximate totals of extant works are: 1,900 by Cézanne, 1,250 by van Gogh, between 700 and 1,000 each by Manet and Renoir, and 500 by Seurat. There are around 400 watercolours and pastels by Morisot.
2 See above page 74.
3 Gauguin, *Correspondance* I, p.270.
4 Redon 1961, p.28.
5 Ibid. For Duchamp's comment on Redon, see W. Pach, *Queer Thing, Painting*, New York (1938), 1971 edition, p.163.
6 Trans. J. Flam, *Matisse on Art*, London, 1973, p.37.
7 Ibid.
8 1945; ibid., p.37.
9 Alfred H. Barr, *Matisse, His Art and His Public*, New York, 1951, p.38. For the Delacroix quotation, see Mayne 1964, pp.62–63.
10 1939; Flam, op. cit., p.81.
11 See, for example, Fry, 'The French Post-Impressionists' (1912), *Vision and Design*, 1961, pp.188–193; Bell, 'The Debt to Cézanne', *Art* (1913), 1961 edition, pp.179–91.
12 See, for example, K. S. Champa, 'Modern Drawing' in *Art Journal* XXV, 1965–66, pp.226ff; Bernice Rose, *A Century of Modern Drawing*, New York, 1982; John Elderfield, *The Modern Drawing*, New York, 1983.
13 Gauguin, *Racontars de Rapin*, 1902.
14 Greenberg, *Art and Culture* (1961), 1973 edition, p.45.

PLATES

1 EDOUARD MANET
Seated bather
c. 1858/60
Sepia ink with wash, over red chalk
10^1/$_2$ × 7^4/$_5$ in (26.7 × 19.9 cm)
Boymans-van Beuningen Museum, Rotterdam.
Inv. F-II-191

Almost all of Manet's drawings – whether from life or after other art, and few are anything else – reduce their motif to a particular sort of abstraction. The most constant characteristic is a reduction to flatness. Most of his graphic devices, their relative values and their contrasts of tones are not used naturalistically. The lines and marks do not describe the motif so much as simply map out some of its separate elements. The impressive simplicity of this seated nude typifies a sort of drawing which, paradoxically, is full of the transience that we associate with impressionism, but is neither spontaneous nor particularly hurried. It is not clear whether it is drawn from nature, or based on another, tonally more complicated drawing (Bareau 1986, pp. 32–33). It may remind us more of a brush drawing by Rembrandt, Poussin or Goya than of any of his peers.

There are traces of a first brief underdrawing in chalk which is almost obliterated by the simple strength of the brush drawing. Although its dramatic areas of light and dark derive from shadows behind, beneath and around the head, arms and legs, this second state of the drawing effectively takes us further and further from the tactile reality of those things. The sensuality that it conveys has more to do with the full-bodied wash, and with that brutal simplicity of execution that Cézanne and Gauguin appreciated so much in Manet, than with the sensuality of naked skin.

This almost disdainful simplicity is particularly strong in Manet's work of the early 1860s: we can see similar qualities of drawing in his paintings of the period, *Olympia* or *The Dead Toreador*. They have the same highly refined reduction and that same charged paradox of something intensely seen being realized with means that are artfully austere. Such treatment of the nude in an abbreviated scheme of lines and tonal zones has echoes in the drawing technique of Thomas Couture (cf. Figs. 16–17). For all the heated disagreements that took place between them, and of which much is made by biographers from Antonin Proust (1897) onwards, it is nevertheless true that Manet remained a student in Couture's atelier for most of six years, 1850–56. The red chalk drawing of a reclining nude (1b), study for an aborted painting, probably dates from immediately after his years with Couture and is full of the same formal characteristics. Although his handling may become looser, a fundamentally similar technique persists in Manet's later treatment of the nude, in paintings as well as in drawings and pastels.

1a *Woman at her toilet, c.* 1880
Pastel
22^1/$_8$ × 18^1/$_5$ in (56.3 × 46.2 cm)
Formerly collection Alphonse Kahn. JW421

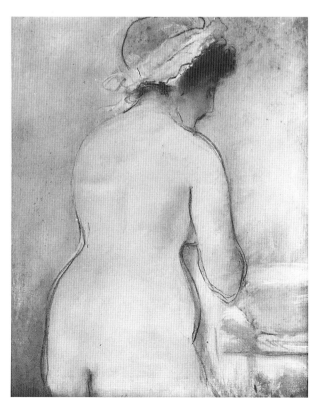

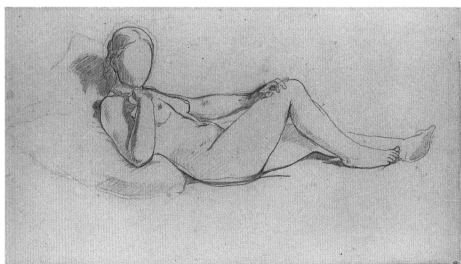

1b *Reclining nude, c.* 1857/59, stamped E.M.
Red chalk
9^3/$_5$ × 18 in (24.5 × 45.7 cm)
Louvre, Dépt. des Arts Graphiques.
Inv. RF 24 335. dL195

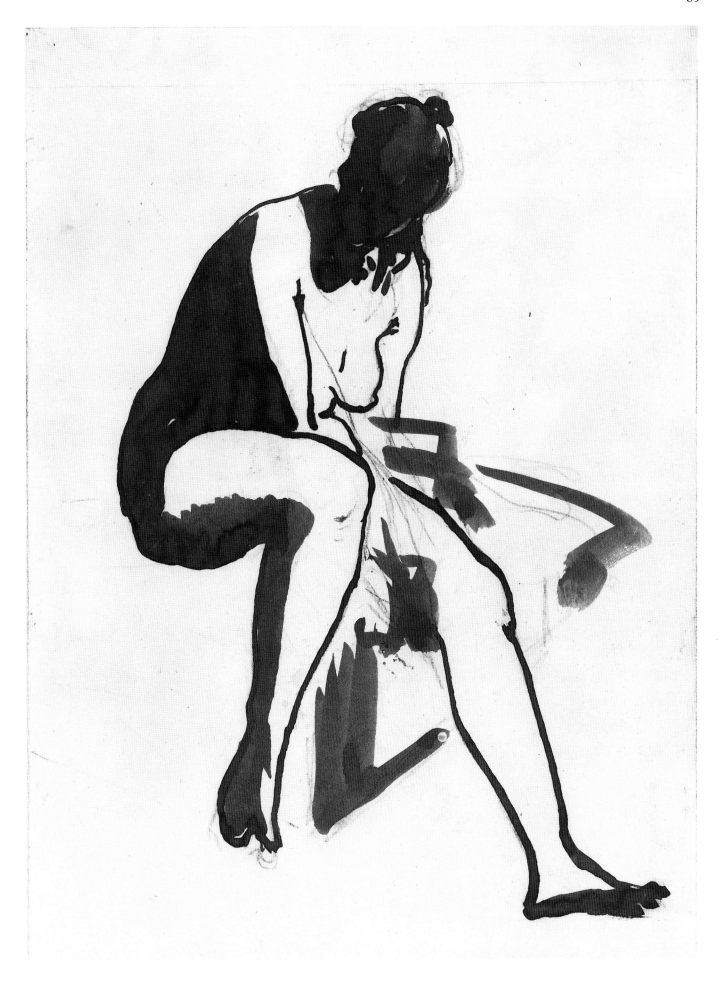

2 EDOUARD MANET
Races at Longchamps
c. 1870, stamped E.M.
Pencil and watercolour
7³/₄ × 10³/₅ in (19.7 × 26.9 cm)
Louvre, Dept. des Arts Graphiques.
Inv. RF30451. dL212

The motif to which this drawing relates exists in several versions. The earliest is a frieze-like study in the Fogg Art Museum (2a); the second a painting of 1865 which Manet dismembered and only two parts of which are now known (JW95). Subsequently Manet made a lithograph (2b) and three further paintings (JW96–98). Their dates and sequence are not clear. (For recent discussions see Reff 1982, Nos. 42–46; Paris 1983, Nos. 99–101. Reff suggests that this drawing may be a tracing from one of the later paintings, in preparation for another.)

The Fogg study is a slightly unwieldy compilation of cameos: the racehorses, the women at the fence, the Guys-like carriage motif and the flattened equestrian portrait to the left. The sequence across its very long format reads like a succession of distinct observed incidents, whose incompatibility may account for Manet's dissatisfaction with the subsequent painting, which he cut into pieces.

The image of the racehorses, head-on to the observer, is the most striking and original of the cameos and this image became, increasingly, the focus of later versions. The motif is a startling and immediate image of modern life: although there was a substantial tradition of horse-racing as a subject for artists, no one had treated it as Manet does here. The lithograph, undated but probably late 1860s, is one of the most truly 'impressionist' of all Manet's drawings, the bravura execution generating strong feelings of the moment – speed, light, transience. But, particularly by comparison with any of the painted versions, the actual motif of the horses contributes less to these feelings than the rest of the drawing.

In the Louvre drawing, this type of paradox is even more poignant. Its purpose was purely practical. The silhouettes are reduced to wavering lines and the unity of the group is indicated only by scribbled hatching. It is like an informal map of an image. The heat of the moment and the violence of the movement have been drained, and yet the few generous touches of watercolour breathe new vitality into these fragmentary graphic remains of the original motif. Against all the odds, the inert skeletal tracing comes to life.

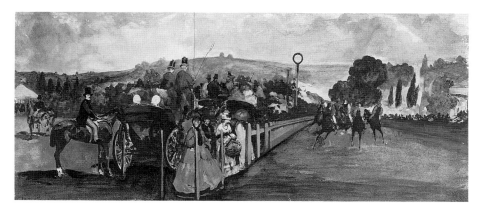

2a *Race course at Longchamps*, 1864, signed
Watercolour and gouache over pencil
8³/₄ × 22¹/₅ in (22.1 × 56.4 cm)
Fogg Art Museum, Cambridge, Mass.
(Grenville L. Winthrop Bequest).
Inv. 1943. 387

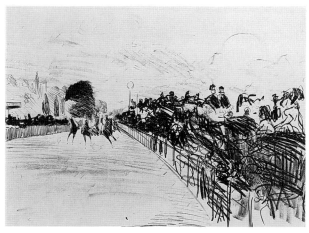

2b *Les courses*, late 1860s
Lithograph, first state
15¹/₄ × 20⁴/₅ in (38.8 × 53 cm)
National Gallery of Art, Washington
(Rosenwald Collection).
Inv. B-11, 151

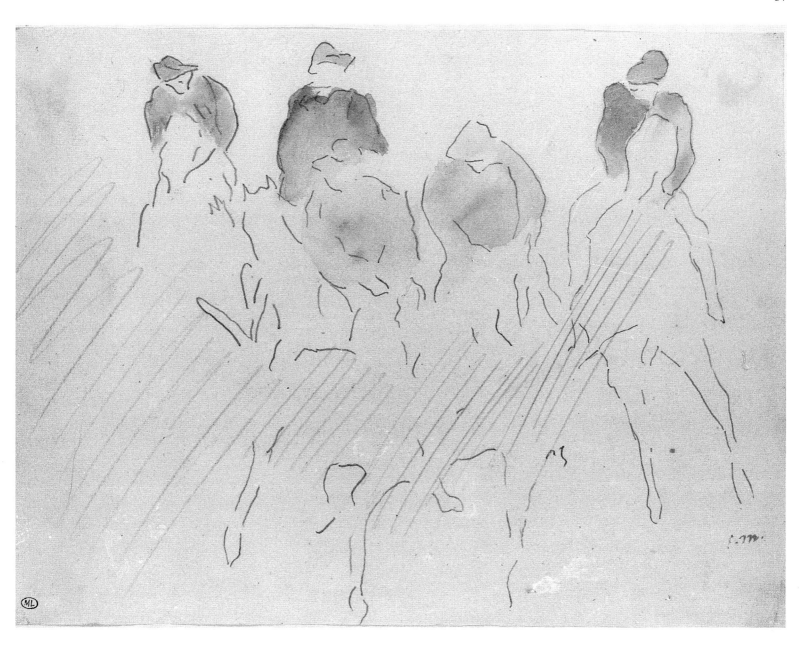

3 EDOUARD MANET
The trial of Marshal Bazaine
1873, stamped E.M.
Pencil
7¹/₄ × 9¹/₃ in (18.5 × 23.8 cm)
Boymans-van Beuningen Museum, Rotterdam.
Inv. F-II-107. dL418

The subject of this drawing is a Versailles courtroom during a treason trial in the aftermath of the Franco-Prussian war. The treatment may be compared to some other Manet works (*The Execution of Maximilian*, *The Barricades*) in which a subject of current political and human concern is treated with the apparent detachment of a dispassionate observer. Imagine Daumier treating the same scene. That Manet was more interested in the subject than the coolness of the drawing implies is confirmed by the existence of a silhouette tracing of the main figures, possibly with a lithograph in mind (Leiris 1969, p. 74).

The shorthand technique of the drawing, made across two pages of a carnet, is a practised manner that Manet used in many on-the-spot sketches of the 1870s. It combines silhouette with hatching. The abbreviated silhouette is more accomplished than it first appears, carrying a caricatural sense of likeness at times. Variations of tone in the hatching suggest colour change as well as depth of shadow. Variations in the direction of lines sometimes serve to distinguish adjacent parts of the motif. A similar schematic technique in his etchings uses directional change to suggest volume (3b).

The speed at which Manet made drawings such as this was a matter of expediency, simply of accumulating as much information as possible in a very matter-of-fact way. Unlike the contemporary drawings of others, it seldom serves to express movement or vivacity of the motif. They seldom have that impressionist energy of a Delacroix or Daumier drawing for instance, or of a Monet painting. They are more on the level of handwritten notes.

3a *Woman on a park bench with two children*, c. 1870
Pencil
4³/₄ × 7¹/₄ in (12 × 18.5 cm)
Boymans-van Beuningen Museum, Rotterdam.
Inv. F-II-46. dL235

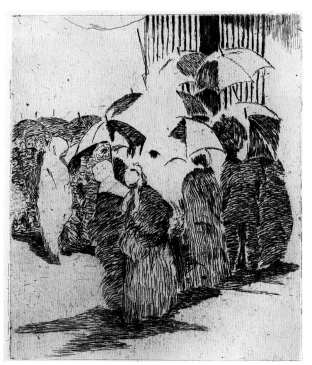

3b *Queue in front of a butcher's shop*, 1870
Etching
6³/₄ × 5⁴/₅ in (17.1 × 14.8 cm)
New York Public Library

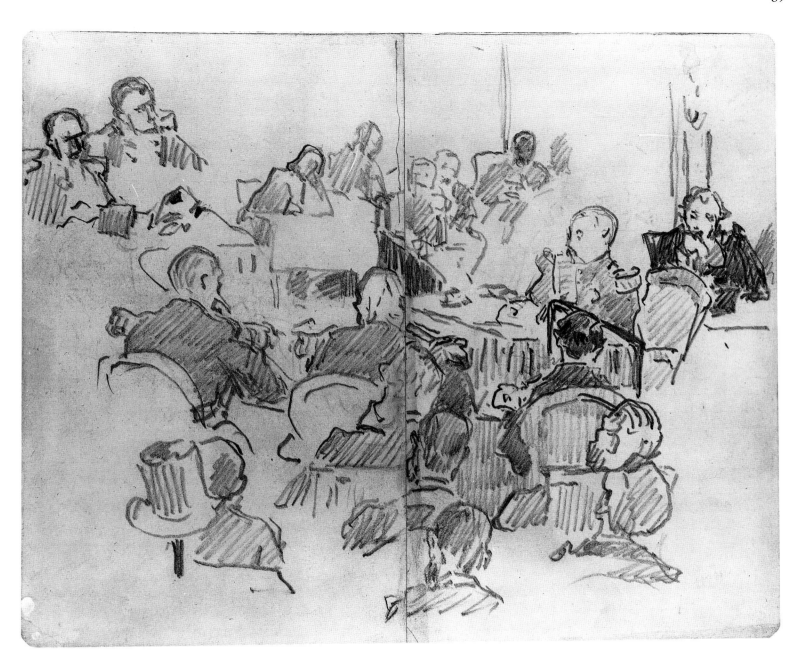

4 EDOUARD MANET
Man with crutches
1878, initialled
Brush and ink
$10^2/_3 \times 7^3/_4$ in (27.1 × 19.7 cm)
Metropolitan Museum of Art, New York
(Harris Brisbane Dick Fund).
Inv. 48.10.12. dL505

Manet's images of modern life embraced more than glimpses of the fashionable world of Baudelaire's dandified *flaneur*, with which he is most often associated. When Couture chided him as a student that 'you will never be more than the Daumier of your day', it was a fairly general broadside against the lack of high-minded ideals in Manet's taste for the real. In practice, there are more pointed associations to be made between Manet's drawings and the world of Daumier's imagery.

The subject of this drawing is a casualty of war, a 'veteran', we can assume, of the Franco-Prussian war of eight years earlier. If Manet's portrayal of him is not strong in pathos it does give off a sense of sympathy. There is further evidence of the artist's underlying allegiances in related works. Another drawing of this figure (Ashmolean Museum) is inscribed '*au moment de la fête*' and the same man is seen, back view, in the painting *Rue Mosnier decked out with Flags* (JW270), whose subject is the public holiday of June 30th, the *Fête de la Paix*, commemorating victory, peace and the glory of France. Like most emotive traces in Manet's work, the irony is coolly enough underplayed to have been overlooked until comparatively recently. The same deceptive blend of casual aloofness and sympathetic interest characterizes most of Manet's drawings from the lower reaches of contemporary urban life.

In technique, the drawing is both deft and clumsy, in the sense that it is full of that gaucheness which in its time appeared as an insolent disregard for conventions of drawing. The artless simplicity and speed of execution – usually strongest when he drew with brush – disguise the amount of information conveyed in the drawing. A study of the rue Mosnier (4a) shows even more clearly what a low priority sophistication of technique *per se* enjoyed in Manet's oeuvre. The lithograph *In the gods* (4b) exemplifies the caricatural brevity of some other drawings – less aristocratic and more characterful than Degas or Cassatt in front of the same motif, closer perhaps to Forain.

4a *The rue Mosnier, Paris*, 1878, stamped E.M.
Ink and wash
$11 \times 17^1/_4$ in (28 × 43.8 cm)
Art Institute of Chicago (Gift of Mrs Alice H. Patterson, in memory of Tiffany Blake). Inv. 1945.15. dL502

4b *In the gods*, 1877, initialled
Transfer lithograph
$8 \times 10^1/_8$ in (20.5 × 25.7 cm)
(Published in 'Croquis parisiens', *Revue de la Semaine*, April 1877) British Museum, London.

5 EDOUARD MANET
Portrait of Marcellin Desboutin
1875, initialled
Watercolour
9 × 5¹/₂ in (22.9 × 14 cm)
Fogg Art Museum, Cambridge, Mass.
(Grenville L. Winthrop Bequest).
Inv. 1943. 386. dL450

Marcellin Desboutin was a painter and poet, who, like Manet, had studied under Couture and who exhibited with the impressionists in 1876. In the 1870s he became a close friend of Manet and was an intimate of the circle that frequented the Café de la Nouvelles-Athènes in the Place Pigalle. This drawing was made around the time of Manet's full-length painted portrait of Desboutin (JW259), which depicts more explicitly the same image of a man fallen on hard times as Desboutin plays in Degas's contemporary painting *L'Absinthe*.

Compared to the apparent carelessness of brushstroke discussed in other drawings, this portrait study shows the articulate delicacy of Manet's handling when his concentration is fully engaged on likeness. Within the same improvisatory freedom of line and wash – here running a rich colour scale from the opaque to the blooming and translucent – details and fine contours are fixed very precisely.

The two other portrait drawings illustrated here (5a, 5b) also reveal, in their very different manners, the strong and sensitive individual presence that we are familiar with from Manet's painted portraits of friends. The oil sketch of the writer George Moore, at a table in the Nouvelle-Athènes, is rapidly drafted in fairly dry brush, alive with a sense of the moment. The first state of an abandoned painting, it gives some insight into the role of drawing in Manet's painting. The hat and coat are drawn in dilute black, the face and hair in ochre and the hands touched in with a silvery range of pinks and greys. The comparatively bland, minimal contours of the lithograph of Berthe Morisot were probably traced from a reproduction or photograph of his painted portrait (JW208). While the drawing is a mere ghost of the painting, it retains the essential poetry of the original image as well as distilling its hieratic simplicity.

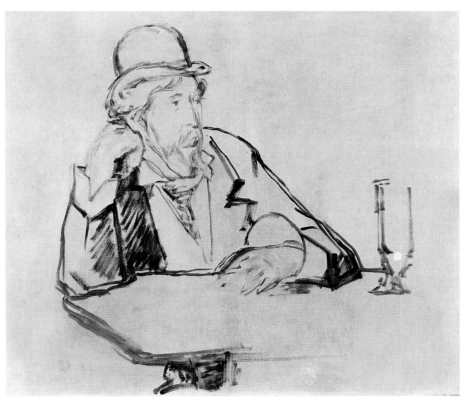

5a *George Moore at the Café de la Nouvelle-Athènes*, 1879
Oil on canvas
25³/₄ × 32 in (65.4 × 81.3 cm)
Metropolitan Museum of Art, New York (Gift of Mrs Ralph J. Hines)
Inv. 55.193. JW337

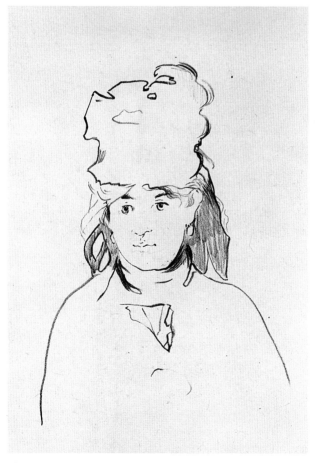

5b *Berthe Morisot, c.* 1872
Lithograph
7¹/₂ × 5¹/₃ in (19 × 13.5 cm)
Baltimore Museum of Art (Collection George A. Lucas)

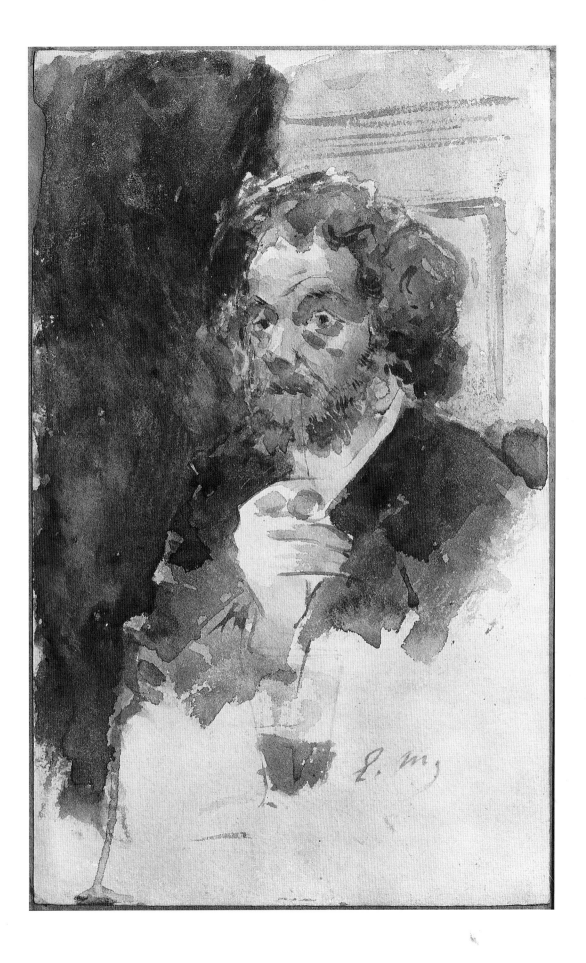

6 EDOUARD MANET
Woman at the bathtub
1879, signed
Pastel on canvas
18½ × 22 in (47 × 56 cm)
Whereabouts unknown

Contemporary attitudes to Manet's images of women were largely formed by his *tour-de-force* paintings of the 1860s. Renoir described Manet to Georges Besson as 'a marvellous painter who never knew how to paint women, not even *Olympia* with whom one would never dare sleep': a comment which tells more of Renoir than of Manet. Redon, who thought Manet best suited to still-life painting, wrote in a journal entry of 1888 of the boredom and discomfort of the women in Manet's *Le Déjeuner sur l'Herbe* and suggested that their conversation couldn't be about anything beautiful. In reality, the variety of attitudes towards women in Manet's drawings is enormous: from a voyeuristic sensuality that is quite on a par with Renoir, to the sensitivity of his portraits, to the modish charm of his late pastels.

There is also a group of pastels from the 1870s, of women at their toilette, which have few of these pretensions. Manet and Degas maintained a sparring rivalry about who painted which modern subjects first. These Manet drawings anticipated the motifs of Degas's 1880 monotypes and of many later lithographs and pastels. They realize Degas's ambition for realistic images of the ordinary. Although they are patently posed, studio images, they give an effect of the commonplace that seems both casual and authentic beside the inspired artifice of Degas's pastels. The women at their bathtubs are inelegant, unathletic and matter of fact, made of inert lines and with that non-heroic quality that Redon found banal. The same coolness of Manet's early nude studies, but without their assured fluency of line, generates an unaffected simplicity that is closest to Morisot among the impressionists and to Bonnard of the next generation.

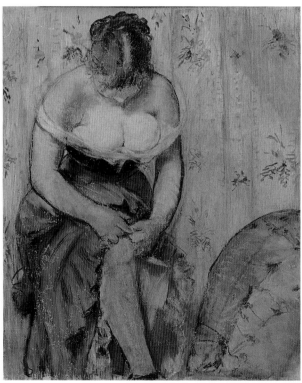

6a *The Garter*, 1879
Pastel
21⅔ × 18⅛ in (55 × 46 cm)
Ordrupgaardsamlingen, Copenhagen.

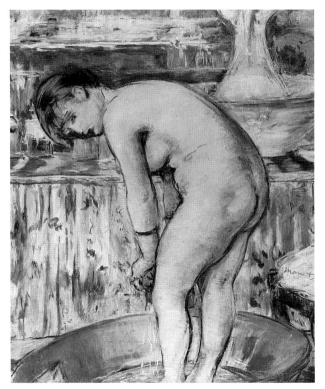

6b *Woman in the bathtub*, *c.* 1879, signed
Pastel on card
21⅔ × 17¾ in (55 × 45 cm)
Louvre Dépt. des Arts Graphiques. Inv. RF 35739

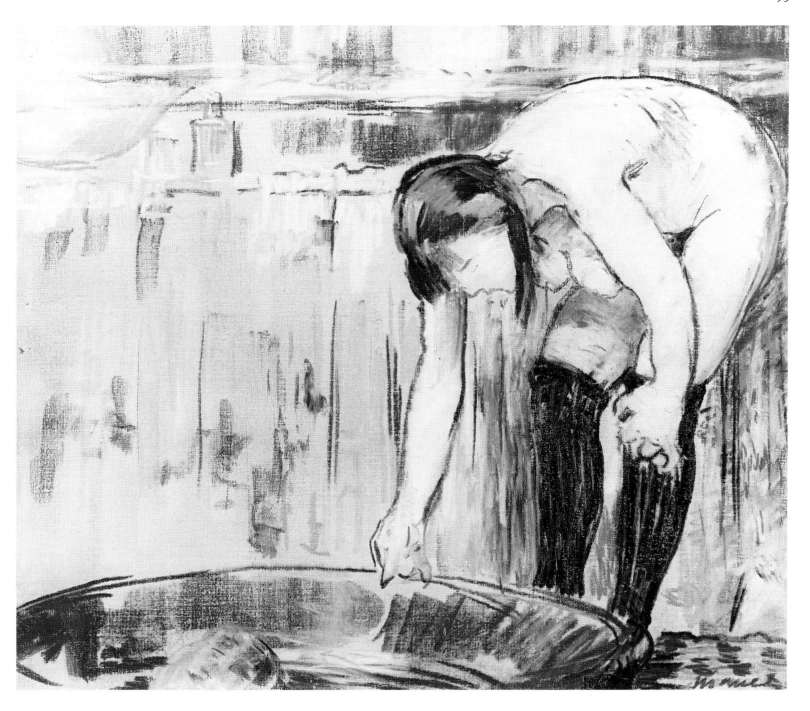

7 EDOUARD MANET
Mme Michel-Levy
1882
Pastel and oil on canvas
29¼ × 20⅛ in (74.4 × 51 cm)
National Gallery of Art, Washington
(Chester Dale collection).

Many of Manet's last drawings were portraits in pastel, bust or half-length, of fashionable women. Their charm and dexterity are comparable to his later flower paintings, as is their deceptive simplicity. It is all too easy to see them as lightweight documents of an elegant society. They have the same stylish panache as the society drawings of Guys, which Manet greatly admired, if without the slightly sinister undertone of Guys that attracted Baudelaire. These Manet drawings served as inspiration for Renoir, Morisot, Chéret and generations of society photographers.

They are bravura fragments, executed with apparently effortless ease, an occasional acid originality of colour, and brilliantly encapsulating the appearance of the time. They fulfil the role of the painter of modern life that Baudelaire had prescribed in his essay on Guys: to show modern man as 'great and poetic in our neckties and patent leather boots'. Baudelaire praised Manet for his blending of 'a vigorous taste for modern reality with a lively and abundant imagination'. Manet's imagination was visual rather than literary. He felt inclined to abandon attempts to illustrate Mallarmé's translation of *The Raven* by Poe because 'you are terrible, you poets, and it is often impossible to visualize your fantasies' (letter, August 1882).

Matisse respected Manet as a simplifier of art: 'he expressed only what impinges immediately upon our senses'. Manet's drawings demonstrate the essential simplicity of this art of sensations. If contemporary taste, predictably, found his individual works fragmentary and incomplete, it is significant that Manet told his friend and biographer Antonin Proust, that he wished his oeuvre to be seen as a whole or not at all.

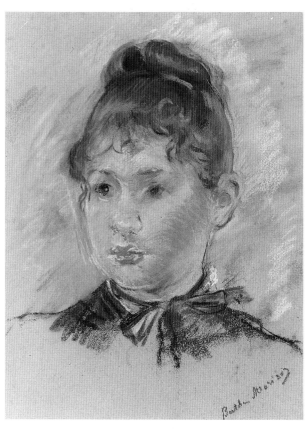

7a MORISOT: *Isabelle*, 1885, signed
Pastel
15¾ × 11¾ in (40 × 29.8 cm)
Robert & Lisa Sainsbury Collection,
University of East Anglia.

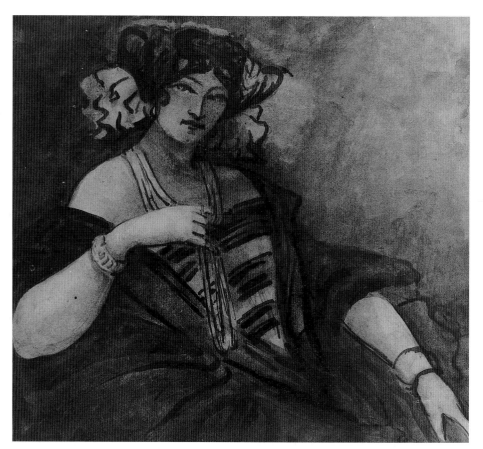

7b GUYS: *Seated woman*, 1860s?
Pen and sepia ink, watercolour
6¾ × 7½ in (17.1 × 19 cm)
Statens Museum for Kunst, Copenhagen
(Herbert Melbye Collection)

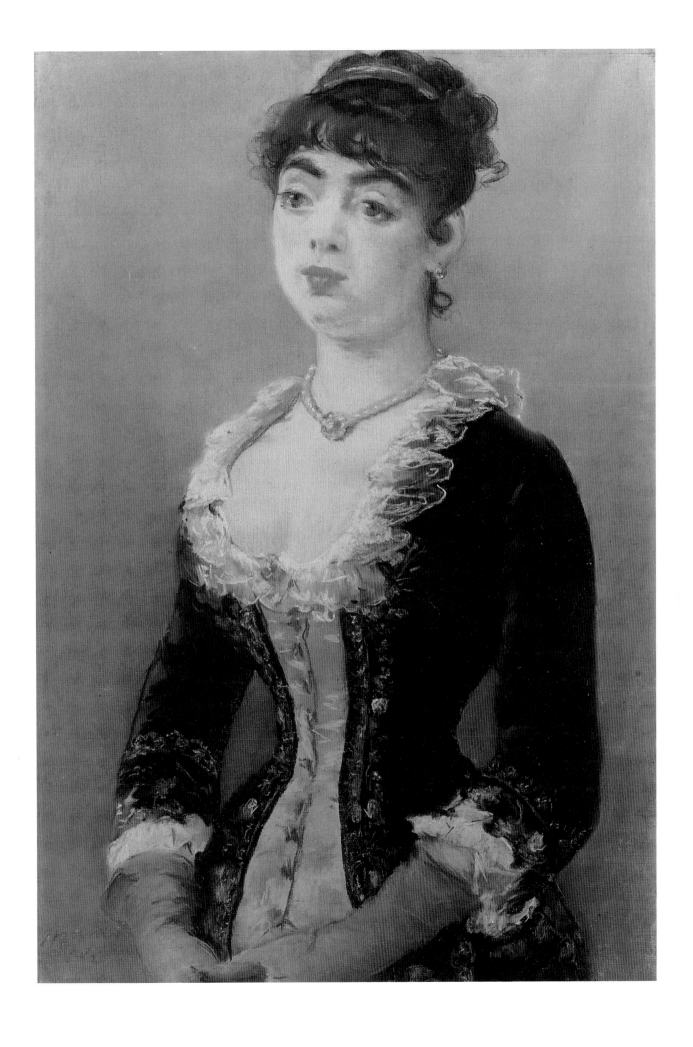

8 HENRI FANTIN-LATOUR
Study for *Truth*
signed and dated 1864
Charcoal
6²/₃ × 8 in (16.9 × 20.2 cm)
Louvre, Dépt. des Arts Graphiques
Inv. RF 12 401

This drawing is one of many variant studies that Fantin-Latour made for a painting that he destroyed after its failure at the Salon of 1865. The allegorical contrivance of a hymn to *Truth* – the symbolic nude figure surrounded by the arts – might find a loose parallel in the early 1860s figure paintings of Whistler and Manet (who is probably represented here as the artist), but in most respects such a project seems antipathetic to the principles of early impressionism. Fantin's underlying beliefs in 'truth' and 'modernity' aligned him closely to impressionism, but his own instincts about how those beliefs should be realized were a measure of his distance from the painters around him.

An intimate of Whistler and Manet, and close friend of Degas, Monet, Renoir, Morisot and others, he shared current admirations for Rubens, Delacroix, Baudelaire and Wagner. The group portraits and *hommage* paintings for which he is best remembered all testify to his involvement with the contemporary pantheon, and there is evidence of a widely-held respect for Fantin's work among his contemporaries.

During the later 1860s and early 1870s, Fantin became progressively disenchanted with the undisciplined practices of impressionism. He had studied for four years under Lecoq de Boisbaudran (see p. 22), but he valued most highly the education gained from copying extensively in the Louvre. The mood and form of his homages to modernity are more deeply rooted in the art of the past, particularly in Romantic art, than in that of the present. His was an art firmly based in studio practice rather than *en plein air*. The melodramatic tonality of early self-portraits carries stronger echoes of his interest in Courbet and in the romantic, tenebrist manner of Millet, than of his training with Lecoq. His drawings for *Tannhäuser* have a feeling for eighteenth-century France that is at least as authentic as anything from Renoir's hand.

Drawings were working tools for Fantin. While the experimental vitality of some of them reflects the values he shared with the young impressionists, the vast majority of his surviving drawings are studies for paintings which reveal his growing distance from the colleagues of his early years. Degas once observed that a painting by Fantin might as easily have been signed by either Whistler or himself, so close were their beginnings (Degas, *Letters*, p. 236).

8a *Self-portrait*, Dated 28 March 1861
Black chalk and stump
14³/₄ × 12¹/₅ in (37.5 × 31 cm)
Musée de Peinture et de Sculpture, Grenoble. Inv. 1467

8b Study for *Tannhäuser: Venusberg*, 1864
Black chalk, squared
9¹/₃ × 12¹/₃ in (23.8 × 31.4 cm)
Musée de Peinture et de Sculpture, Grenoble. Inv. 1470

9 EDGAR DEGAS
Study for *The Bellelli Family*
early 1859
Pastel and chalk
21²/₃ × 24⁴/₅ in (55 × 63 cm)
Ordrupgaardsamlingen, Copenhagen. L64

This pastel is part of the series of studies in a range of media that Degas made for *The Bellelli Family* (L79, 1859–60). The elaborate preparation that he undertook for this painting (see Ordrupgaard, 1983) exemplifies the academic thoroughness of the young Degas and the prime place that drawing held in his working practice from the outset. The advice of Ingres to him that unstinting application to drawing was the way to become an artist is well known. Redon's observation that Degas's admiration for Ingres 'is an intellectual love, the heart has nothing to do with it' was shrewd. The example of Ingres, which is so visible behind many of the early portrait drawings, inspired in Degas a bedrock of intellectual discipline, a yearning 'for things well done, for things made with absolute precision in the manner of Poussin' (letter, December 1872).

The many copies that Degas drew reveal a searching curiosity about all forms of drawing. A copy after the *Mona Lisa* (Metropolitan Museum) is so delicate in its dissolving *sfumato* as to defy reproduction. The breadth of his enquiry is reflected in his own large collection of work by others. He talked of drawing as 'a way of seeing' and 'a way of understanding' and while its outward forms changed considerably, he was to remain absorbed in it as a central concern: a passion, Valéry wrote later, that 'aggravated itself to the point of inhumanity'.

This pastel is probably a final composition study, made in the Bellelli home in Florence, for the painting which was executed in Paris. Although full of sensual qualities that the painting does not have – nervous pencil lines drawn into the soft pastel – it does establish the final disposition of forms. The presence of alternative lower edges, where the pastel is overpainted with thin oil paint, suggests that he may have reworked the study during the painting, whose bottom edge is somewhere between these two. The same may be true of the sensitive study of Laura Bellelli (9a). Boxed lines around her head seem to be part of a squaring-up process, but the vertical chalk line to the right of her profile corresponds exactly to the line of the background picture frame in the painting, moved marginally to the right from its position in the pastel, to set up more charged linear intervals. Most adjustments in the painting are of this sort, heightening the taut, hieratic austerity of organization which lends to the painting its edge of psychological disquiet.

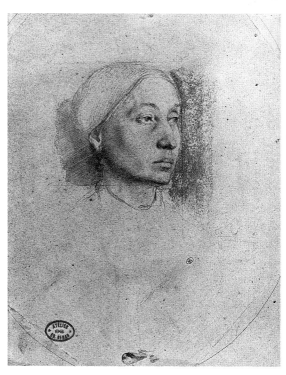

9a *Laura Bellelli*, 1858/59
Chalk and pastel
10¹/₄ × 8 in (26.1 × 20.4 cm)
Louvre, Dépt. des Arts Graphiques. Inv. RF 11 688

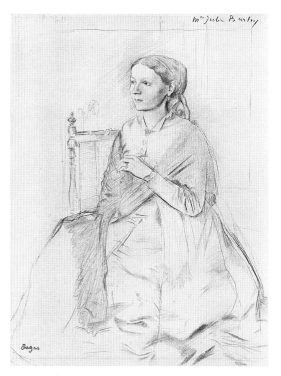

9b *Study for Portrait of Julie Burtey*, 1863
Pencil, touches of white chalk
14¹/₅ × 10³/₄ in (36.1 × 27.2 cm)
Fogg Art Museum, Cambridge, Mass. Inv. 1965.254

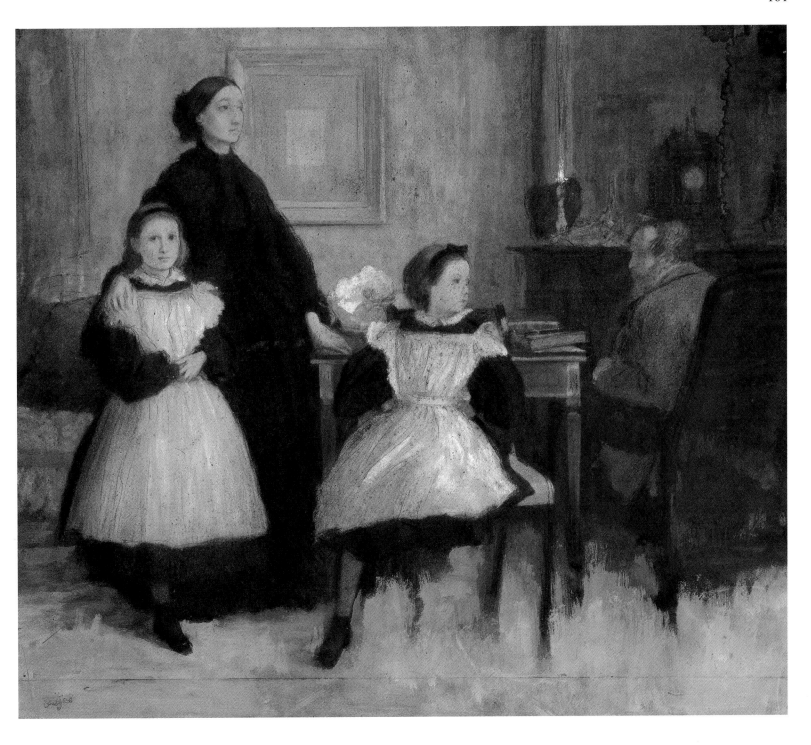

10 EDGAR DEGAS
La Chanson du Chien
c. 1876/7, signed
Gouache and pastel over monotype
Size of sheet 24²/₃ × 20¹/₈ in (62.7 × 51.2 cm)
Private collection. L380

Degas's impressionism was an art of the city and, within that, most characteristically of Paris at night, under artificial light. While it was probably his ideas as much as anyone else's that prompted Duranty to write about the new art that tore down studio walls separating the artist from modern life, Degas himself did not walk across their debris into green fields, blue skies and sunshine. His taunts about impressionist painters littering the landscape are renowned and when he did draw the landscape or seascape himself, he made strangely airless, poetic improvisations with coloured monotype and/or veils of pastel (Pl.XI).

The series of *café-concert* images that he drew in the 1870s are arguably the most sharply realistic observations of Parisian life of his century. The disciplined exactitude of his drawing is visible in every aspect of *La Chanson du Chien*: caricatural likeness; dramatic and picturesque effects of reflected light; the scale of relative focus and the narrative authenticity (almost audible) of the singer's solo performance against the background hubbub of an audience that comes and goes at will. The reality of the moment is conveyed vividly and completely with means that are as artfully contrived as *The Bellelli Family* (Pl.9). 'One must contrive to give the impression of nature by false means', Degas said, 'but it must appear true.'

Like many of his pastels, this drawing is a reworking of a monotype. In this case, the dense combination of pastel and gouache has almost completely obliterated the original image. In others, the density of opaque colour of the pastels over the light, relatively translucent ink of the monotype is what gives the work its distinctive character. While the two stages of work echo traditional practices of painting, working from monochrome underpainting to full palette and from lean to fat paint, there are special paradoxical properties peculiar to this mixture of media. These all stem from the vibrant luminosity of the inert, opaque pastel pigment against the monochrome sobriety of lightweight veils of ink. Two sorts of gravity, scarcely compatible on the face of it, work in parallel. He obtained similar effects from his use of pastel over charcoal.

10a *Café singer, c.* 1877/80
Monotype
3¹/₈ × 2⁴/₅ in (8 × 7.2 cm)
Art Institute of Chicago, Potter Palmer Collection.
Inv. 1963. 822

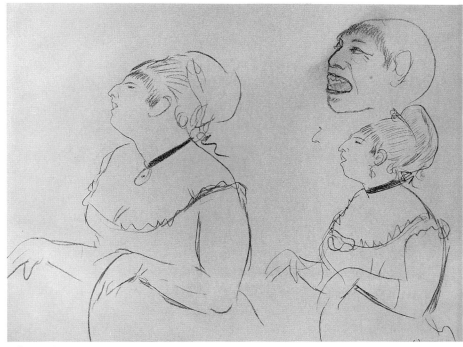

10b Studies for *La Chanson du Chien*, 1876/7
Pencil
Page of sketchbook (Notebook 28, p. 11)
9³/₄ × 13¹/₃ in (24.8 × 34 cm)
Paris, formerly collection of Ludovic Halévy

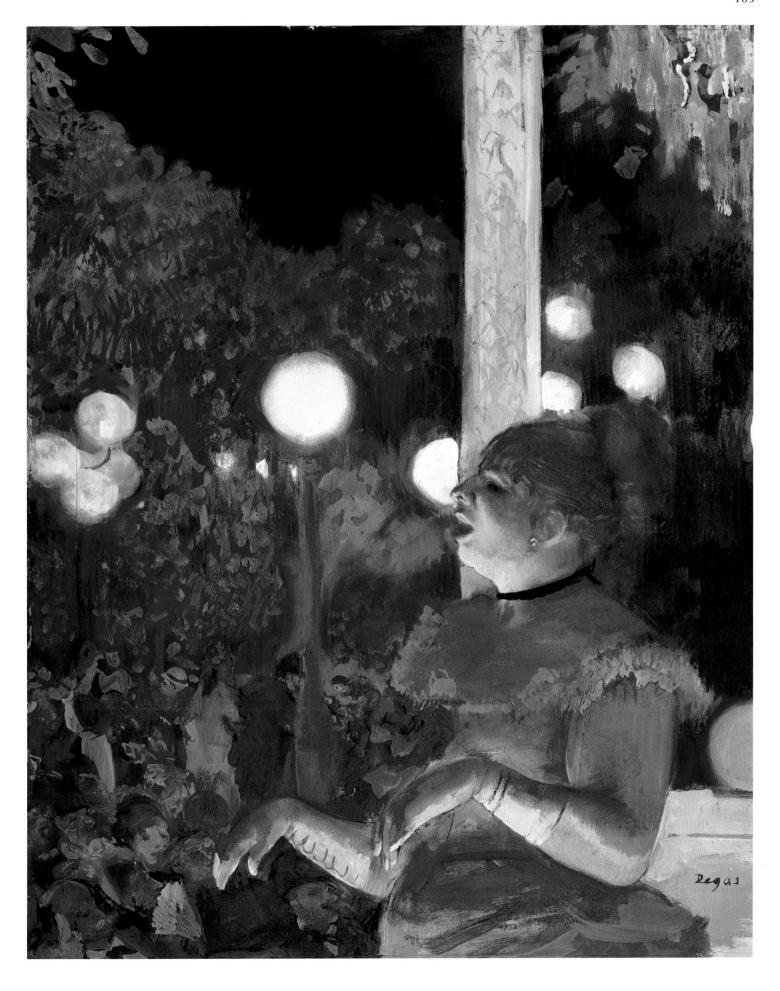

11 EDGAR DEGAS

Dancer, arms raised

c. 1890
Black chalk
12⁷/₈ × 9¹/₄ in (32.7 × 23.6 cm)
Statens Museum for Kunst, Copenhagen.
Inv. Tu 33.4

Paul Valéry writes thoughtfully on Degas's dancers about the 'forming, dissolving and reforming patterns created by the pattern of limbs'. Part of what attracted Degas to dance as a subject was its discipline, its precise regulation by time and interval. Many of his drawings of dancers reveal how closely the activity of drawing became enmeshed in the process of dance. They create a kinetic effect – the hand racing against time – that was impossible either in painting or sculpture, at least as Degas understood them. It is an effect that anticipates the chrono-photography of several decades later. The restatements of arms, breasts and buttocks are not so much corrections as the drawing pursuing the dance, and the heavily-rubbed profile of the back generates an energy that is capable of sustaining the succession of positions. As so often in Degas's drawing, the densest marks stand less for the densest shadows than for the most generous source of motive-energy and direction, or the most telling restatement.

In such studies, Degas pursued the movement of the body at the expense of all thought of individual personality, giving rise to suspicions of misogynist disinterest. He appeared to treat the human body like that of the horse. Gauguin recalled Degas in 1903: 'The racehorses, the jockeys . . . there is no personality to these things, only the life of lines, lines, lines again.' Degas often spoke about art as an objective science in pursuit of reality. He compared its problems variously to a subtle kind of mathematics and to a series of surgical operations.

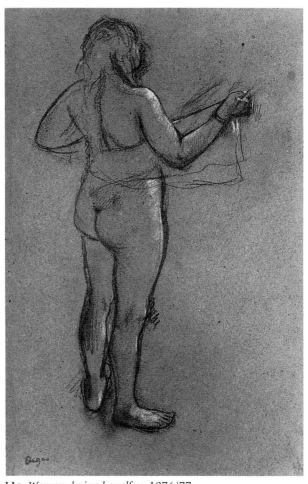

11a *Woman drying herself, c.* 1876/77
Pencil? heightened with white
Ashmolean Museum, Oxford. Inv. III, 347

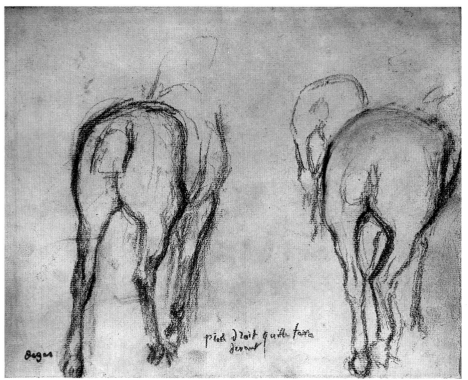

11b *Horses, seen from behind, c.* 1885
Chalk
9³/₄ × 12¹/₄ in (24.7 × 31.1 cm)
Boymans van-Beuningen Museum, Rotterdam.
Inv. F-11-126

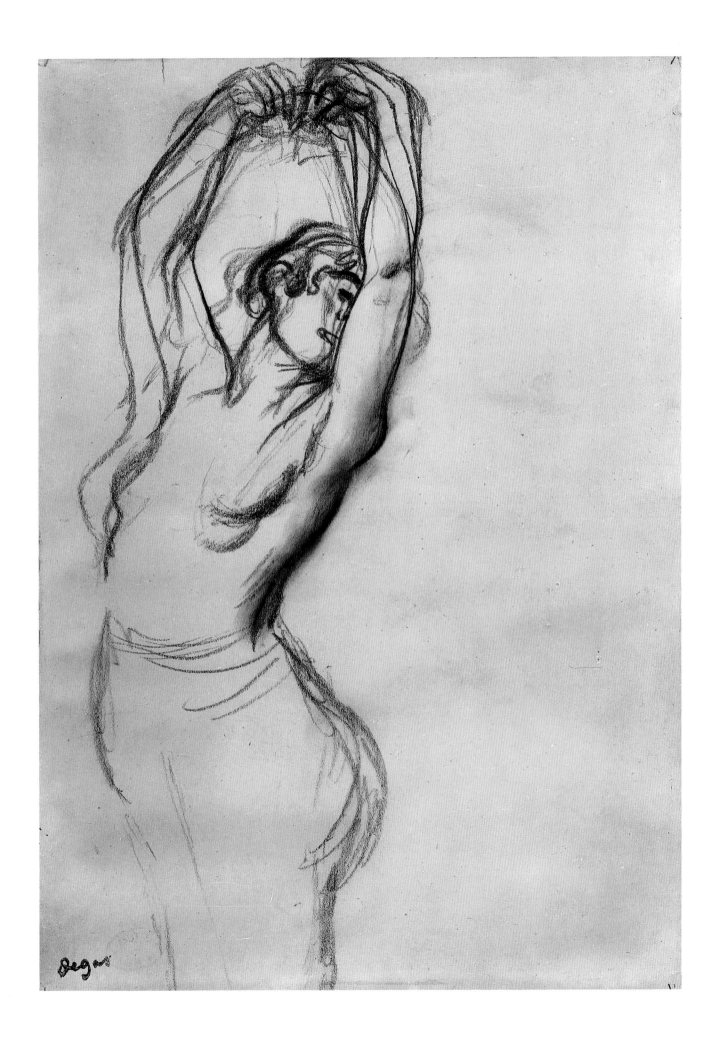

12 EDGAR DEGAS
Dancers at the Old Opera House
c. 1877
Pastel over monotype
$8^1/_2 \times 6^3/_4$ in (21.8 × 17.1 cm)
National Gallery of Art, Washington
(Ailsa Mellon Bruce Collection). Inv. 2398.

This strange drawing has a void at its centre. The stage is drawn in softly muted grey; the audience to the right and the wall of boxes screening the background are both indicated in the most general terms. This emptiness is framed by a sharp pink and grey line of ballerinas to the left, a dark silhouetted coulisse down the right margin and his prominent signature (Degas, the observer) below. It is a type of composition that he had used to dramatic effect in the *Interior*, sometimes called 'The Rape' of 1869 (12b).

The calculated effect is as striking as a Monet landscape in its simultaneous unexpectedness and veracity. The originality of Degas's images of the theatre lies in their carefully manipulated representation of unprejudiced observation. 'No art is less spontaneous than mine', he told George Moore. Inactivity and emptiness lend heightened authenticity to the main subject. In his long series of drawings of the *école de danse*, he accumulates all the simultaneous ingredients of the story like a nineteenth-century novelist – part explanation of why the Goncourts appreciated him so much. We see the endeavour of audition, instruction and performance; the tensions, boredoms and fatigue of waiting; the supporting roles of mothers and chaperones. Often the main event is taken out of focus. There is so much noise, so many people, so much incidental secondary activity that the central incident becomes blurred. His theatre interiors do not evoke glamour and fragrance: they are stuffy, hot and laden with the stale smell of bodies. This may sound like a literary art, but the original acuity of Degas's eye and his deft stage management of effects prevent it being anything but an art of sharp visual immediacy. Roger Fry, reviewing an exhibition of 1912, wrote of the 'formidable cleverness' of Degas's drawings, of his 'unrivalled but dangerous power of witty notation' (meaning, presumably, that his was a seductive but precarious path to follow).

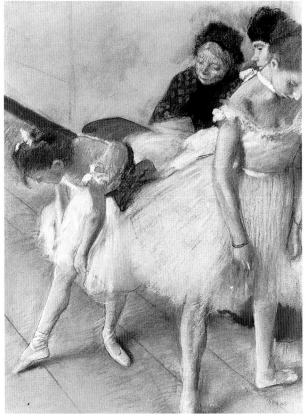

12a *Examen de Danse, Danseuses à leur toilette, c.* 1879, signed
Pastel and charcoal
25 × 18 in (63.4 × 48.2 cm)
Denver Art Museum. Inv. 1941.6

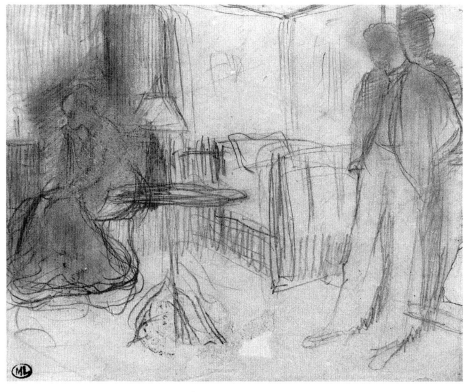

12b Study for *Interior, c.* 1868/69
Pencil
4 × 5 in (10.2 × 12.9 cm)
Louvre, Dépt. des Arts Graphiques. RF 31 779

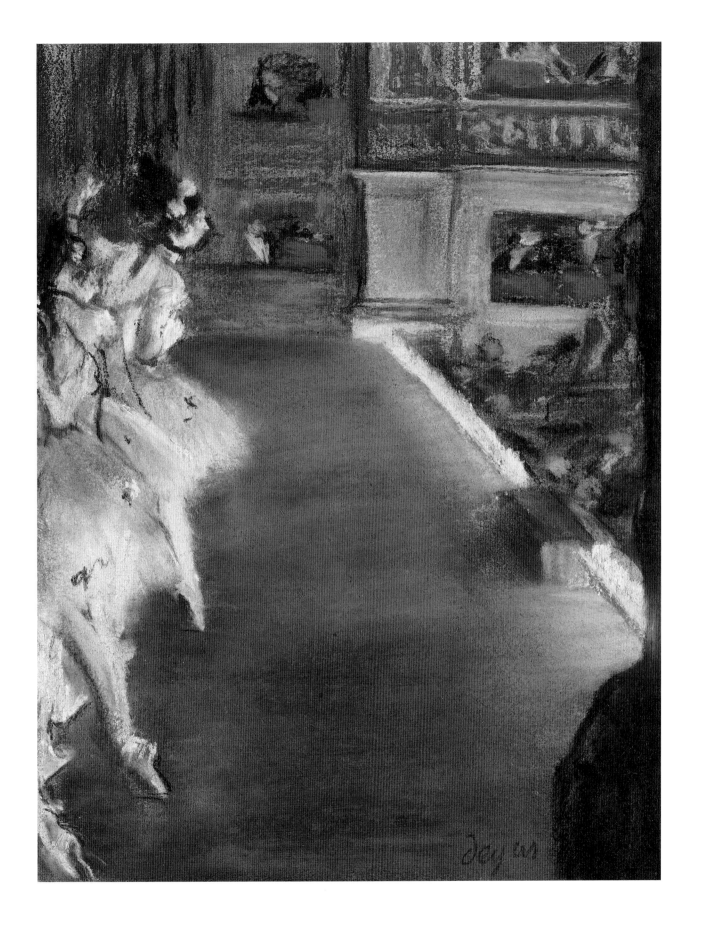

13 EDGAR DEGAS
Nude dancer, holding her head in her hands
c. 1882/85
Pastel and charcoal
19$\frac{1}{2}$ × 12 in (49.5 × 30.7 cm)
Musée d'Orsay, Paris. Inv. RF 29 346

A contrast between dancers at work and dancers at rest features prominently in Degas's drawings from the start, sometimes in the same image. There are similar simultaneous contrasts of subject in theatre drawings which include, for instance, the relaxed interior of a *loge* and the engaged activity on stage, or in those *café-concerts* which show the singer against a sea of half-interested faces (Fig. 80, Pl.10).

Increasingly, the images of dancers at rest assume attitudes and expressions of melancholic ennui, which is echoed in the world-weary fatigue of his laundresses and shop girls (13b). Degas's cumulative account of people in the world of entertainment is bleak. The performance is like a briefly-worn mask behind which is a state of stoic resignation.

Degas's predilection for dense muscular poses was already evident in some studies for his paintings of historical subjects in the 1860s. In this monumental drawing of a resting dancer the growing range and technical mastery of his mature years is clear. The reworking with opaque pastel over the translucent charcoal generates the same striking effect as his use of pastel over monotype (cf. note to Pl.10). The luminosity of direct light in the pastel flesh tones of the back is complemented by subtle lights within the shadow of the charcoal. Each lends life to the other.

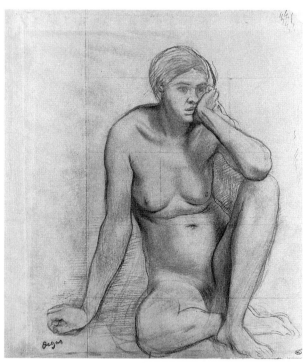

13a *Seated woman* (study for *Scene of war in the Middle Ages*), 1864/65
Black crayon
12$\frac{1}{5}$ × 10$\frac{7}{8}$ in (31.1 × 27.6 cm)
Louvre, Dépt. des Arts Graphiques. Inv. RF 12 265.

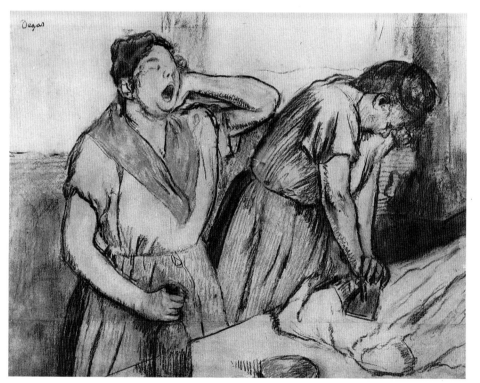

13b *Laundresses, c.* 1891
Charcoal and pastel
23$\frac{1}{5}$ 29$\frac{1}{8}$ in (59 × 74 cm)
Private collection. L786.

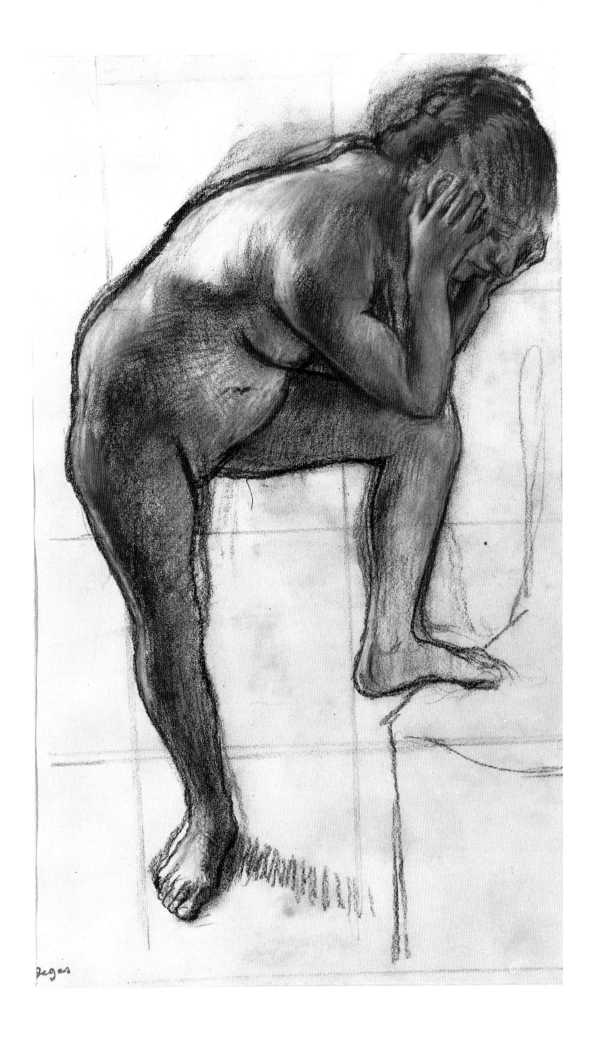

14 EDGAR DEGAS
Edouard Manet
late 1860s?
Black chalk, stumped
13 × 9$\frac{1}{8}$ in (33 × 23.2 cm)
Metropolitan Museum of Art, New York
(Rogers Fund). Inv. 19.51.7

This is the most complete of four or five drawings of Manet that Degas made, probably during the mid- to late 1860s when the two artists were closest. The general disposition of the pose is not unlike Manet's portrait of Zola and its studied informality relates it to several Degas portraits of the period. We may guess that the drawings were made toward a projected painting, but in the event they gave rise to four etchings. Although Manet is shown here in outdoor clothes and another pencil study suggests the context of the racecourse, they are all studio drawings.

The technique of the drawing retains many qualities of his earlier Ingres-like portrait studies. It proceeds from a complex of tentative lines of even weight towards simplified resolution using a wide tonal scale. In this case the pose seems to have changed a great deal along the way, possibly even from a standing figure with cane and top hat in the first instance. Previous states in a Degas drawing are overridden in a number of ways: rubbed across, washed out, sometimes simply bullied out of existence by increasingly dense marks. The rubbing of some chalk marks with a stump extends the range of marks and the variation of texture is rich enough to suggest differences of material – of hat and hair for instance. The final state here is most intense in the refined rendering of the head, observed with sensitivity.

The fine characterization of Degas's portrait drawings and of some studies of individual figures serves as foil and corrective to that pervading sense of the animal-body in his art which has prompted so much writing over the years about his impersonal detachedness. His notebooks are littered with highly animated sketches of heads that are charged with individual presence and a caricaturist's eye for likeness. He was renowned as a piercing mimic.

14a *Double bass player* (study for *The Orchestra of the Opera*), *c.* 1869
Pencil
7$\frac{1}{3}$ × 4$\frac{3}{4}$ in (18.7 × 12 cm)
Collection Eugene Victor Thaw, New York

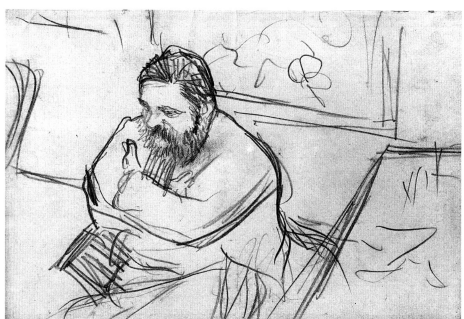

14b *Diego Martelli*, study for a portrait, 1879
Pencil
4$\frac{1}{3}$ × 6$\frac{3}{5}$ in (11.1 × 16.7 cm)
National Gallery of Scotland, Edinburgh.
Inv. PD 3873

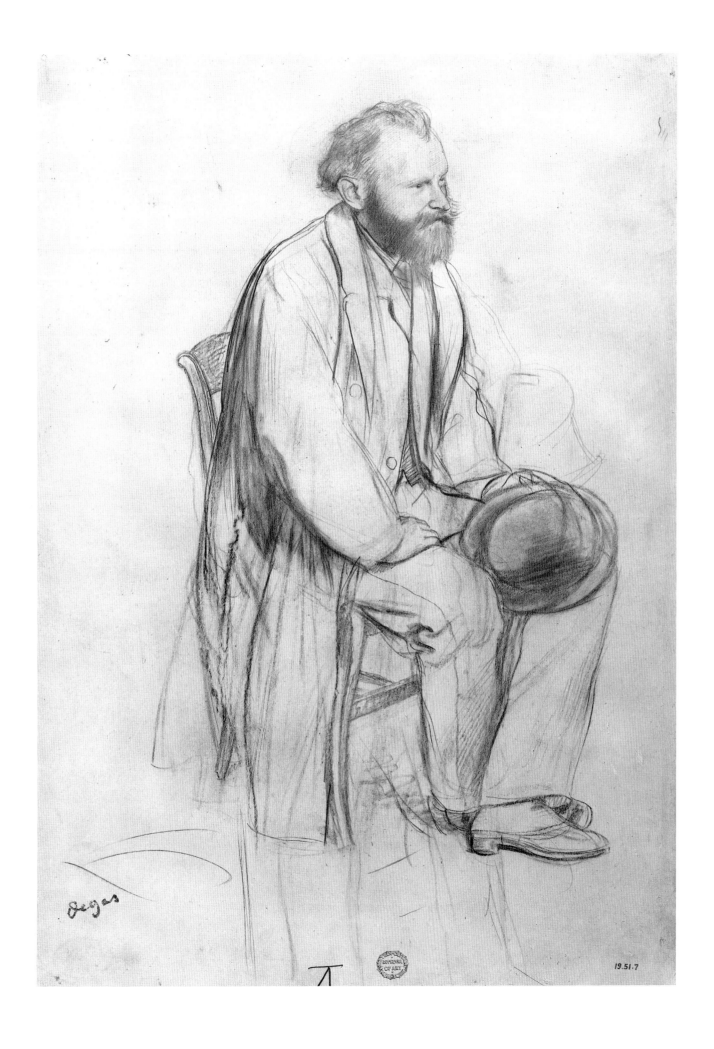

Degas

19.51.7

15 EDGAR DEGAS
Nude woman drying herself
c. 1890
Pastel
21⁷/₈ × 27³/₄ in (55.5 × 70.5 cm)
Philadelphia Museum of Art (Henry P. McIlhenny Collection). Inv. 1986.26.16 L886

The subject of a woman in or just out of the bath, towelling herself, first appeared in Degas's monotypes of *circa* 1880 (Adhémar/Cachin 1974, nos. 129–32) and was to become the most recurrent theme of his late drawings. 'It is essential to do the same subject over again, ten times, a hundred times', he wrote to a friend in 1886. In practice this meant two things. One was the reworking of a drawing in successive versions, drawing after drawing: 'Make a drawing, begin it again, trace it; begin it again, and trace it again.' The other was to pursue the same model in nature in one drawing after another. Some historians have sought to identify the reuse of poses from much earlier drawings: for instance, a drawing after Michelangelo (Fig. 27) as the basis for his yawning laundress (Pl.13b). Considering how much of his working life was spent drawing the body in action, it is hardly surprising that very similar poses reappear from time to time.

The bathing and towelling figures of around 1890 are physically forceful, their robust volumes perhaps reflecting the vigorously modelled wax figures, on which he was working at the same time. This drawing is built up in lights and darks from the warm, middle tone of the paper, veils of quite uniformly hatched pastel lines, zoned into distinct colour areas, green over pink, orange over pink, green and white over grey. The bulk of the figure emerges from the broad tonal contrasts, which are finally reinforced by the retouching in black of contours, the drawing of the hair and other details. This final stage also introduces fine touches of the background colours, green and orange, into the flesh tones.

In a few drawings of bathing women of the 1890s, and some other motifs (Russian dancers, etc), Degas relocated the motif against an invented landscape context (15a). The simplified contours of these figures and their rather ungainly proportions are reminiscent of how Degas saw Cézanne's *Standing bather* in two notebook sketches of 1877 (15b). Perhaps Cézanne's bathers compositions were part of the initiative behind this unexpected experiment: Degas had responded warmly to the large one-man show of Cézanne's work at Vollard's in 1895.

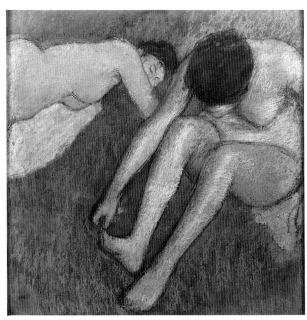

15a *Two Bathers on the grass, c.* 1896
Pastel
27¹/₂ × 27¹/₂ in (70 × 70 cm)
Musée d'Orsay, Paris. Inv. RF 29 950 L1081

15b *Bather* (copy after Cézanne), signed and dated 1877
Pencil
Page of sketchbook (Notebook 28, p. 3) 9³/₄ × 13¹/₃ in
(24.8 × 34 cm)
Paris, formerly collection of Ludovic Halévy

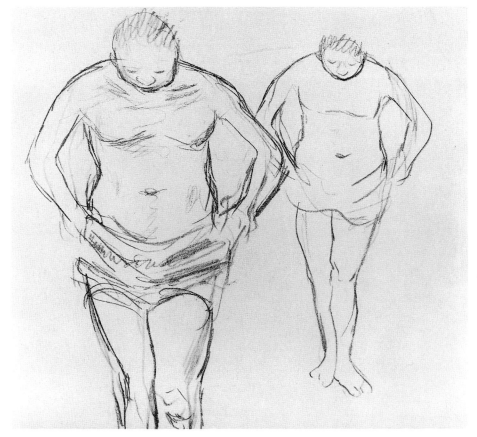

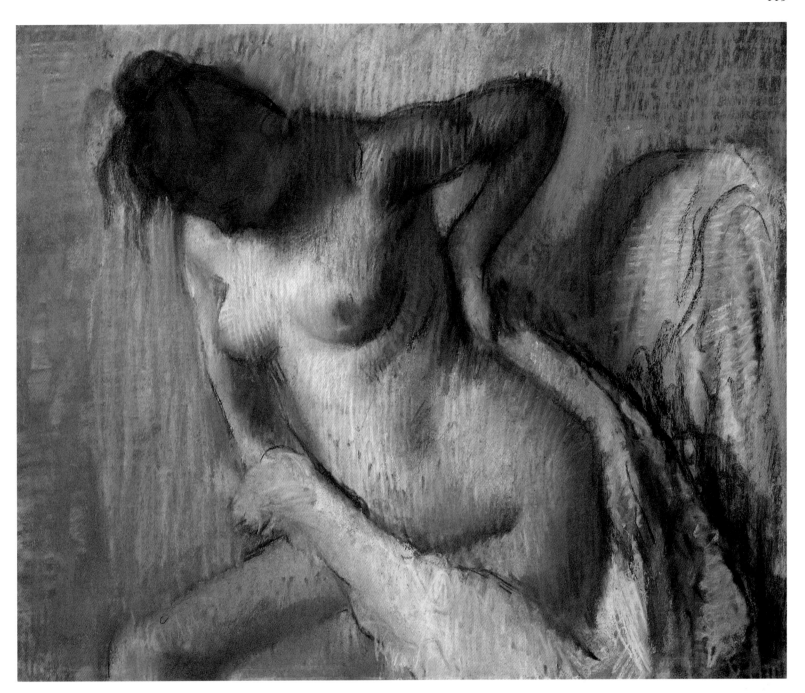

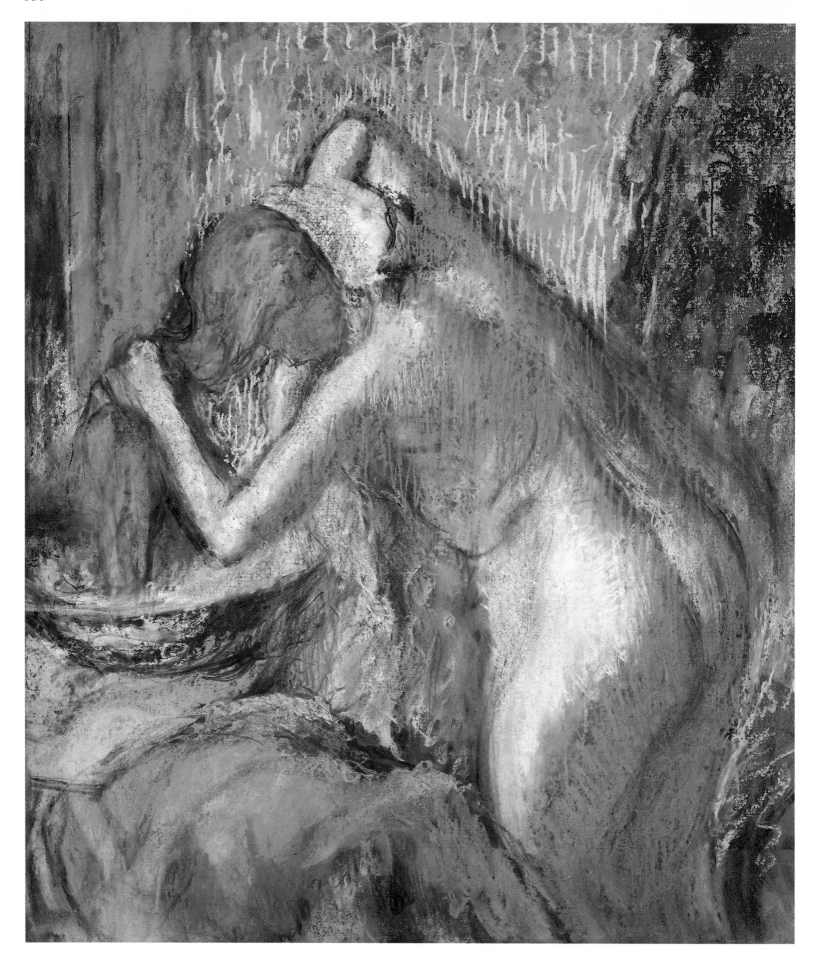

This ebullient pastel reveals the full majesty and freedom of Degas's last manner in the medium. It is conceivable that its motif originated from lithographs of ten years earlier rather than from life (cf. Adhémar/Cachin 1974, 62–68). What is quite clear is that the series of ten charcoal and/or pastel drawings related to it derived progessively from each other (see Chicago 1984, pp. 184–85; Paris 1986, pp. 596–98). The Chicago version (16a), probably later, is the most densely worked and resolved. Unlike this drawing, its various layers of working were secured with successive applications of fixative. However, it does not help our understanding to compare such drawings as studies one for another, any more than it would in the case of Cézanne's various drawings of St-Victoire. Degas's reuse of an established pose as the start of a new work may be compared to Cézanne looking again at the same thing: each time both afresh and, inevitably, informed by previous experience.

Like the Chicago drawing, this pastel started from a loose charcoal drawing on tracing paper of the figure: both possibly traced from a drawing now in Houston (L1423bis), which some historians for their own reasons have dated as much as five years earlier. Next, Degas modified and decided the format of the composition by the addition of further strips of paper, in this case probably during the drawing. The substantial alterations of pose and colour made as the image evolved reveal how freely Degas improvised upon the original ready-made motif. They are all compositional decisions, free of either a model or any strong commitment to anatomical accuracy. In the Chicago drawing, the indeterminate pose of the hips was resolved by extending the diagonal of background drapery across in front of the figure. Here, the integrity of the figure was achieved by the luminosity of the coloured marks drawn over and around the body.

Degas once told Vollard how tiresome it was to wash his pastels and then expose them to sunlight, in order 'to take all the colour out of them'. When Vollard asked him how then he achieved such brilliance, Degas replied: 'By using "lifeless" tones!' (Vollard 1985, p. 117.) It is broadly true of Degas's pastels that their palette is more subdued than those of his contemporaries. He often achieved a strong effect from relatively muted colours by virtue of their contrast with the inert tones of charcoal or monotype around them. Even in this drawing, the full value of his last marks in yellow and hot orange is obtained by their contrast with what went before. Degas spoke to Julie Manet of the 'orgies of colour' of his last drawings and they have a richness of palette that is relatively abandoned – attributable in part perhaps to the impatience of old age or to his failing sight. This scale of freedom can also be seen in a cruder urgency in some of his later charcoal drawings (16b). Whatever the reason, the spectacular colour scale of drawings like this and the abruptness of its oppositions of hot and cool comprise an extraordinary finale to the oeuvre of a man who claimed to value black and white above all else.

16 EDGAR DEGAS
After the bath, woman drying her hair
c. 1905
Pastel on three joined pieces of tracing paper
$33^2/_5 \times 29$ in (85.5 × 73.9 cm)
Private collection. L1424

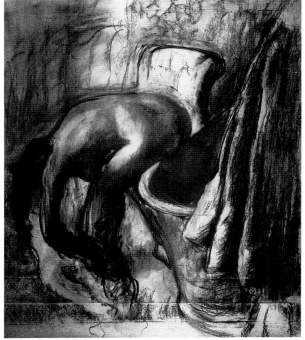

16b *After the bath, woman drying herself, c.* 1900/02
Pastel, charcoal and gouache on tracing paper
$31^1/_2 \times 28^1/_3$ in (80 × 72 cm)
Private collection. L1380

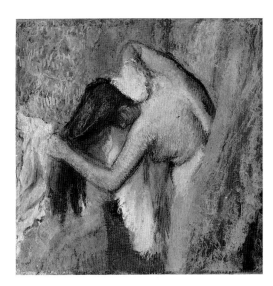

16a *Woman at her toilette, c.* 1905
Charcoal and pastel on four pieces
of tissue paper, mounted on board
$29^1/_3 \times 28$ in (74.6 × 71.3 cm)
Art Institute of Chicago (Bequest of
Mr and Mrs Martin A. Ryerson).
Inv. 1937.1033. L1426

17 EDGAR DEGAS
Seated nude woman
c. 1902, stamped
Charcoal and pastel
33½ × 17¾ in (85 × 45 cm)
Private collection. L1409

Degas's last charcoal drawings, some of them touched with pastel to heighten contrasts, have a simple grandeur. The lithe movement of his 1870s dancers has given way to a breadth of handling and a simplicity of masses: a continuity of contours shortcircuits his earlier concern with the subtlety of parts.

Valéry described Degas as a man of old-fashioned taste who was radical in thought and practice, and his studio as a cross between a museum and an untidy craftsman's workshop, crammed with books, materials and improvised effects. He described Degas's use of the term 'drawing' as meaning 'the alteration which exact representation [. . .] undergoes from a particular artist's way of seeing and working'. The evolution of Degas's drawing manner reflects very clearly the maturing of working practice. It was founded on his deeply-ingrained commitment to traditional disciplines, with all their artifice, but was continually refreshed by his observation, his experimental attitude to materials and his relentless curiosity about the art around him. The 1890s study of a nude (17a) echoes the qualities of his youthful drawings, especially his copies after renaissance art. Yet, despite its claustrophobic shallow relief boxed in by the edges, the volumes have a massive simplicity.

The late drawings were not seen with the dispassionate eye of his youth. Some have the pathos of those ghostly, huddled figures that tremble at the foot of the cross in Michelangelo's last drawings. Increasingly at the end, he valued the riches to be found within the austerity of black and white. He said more than once that if any of his work survived, it should be his drawings. His reported instruction to Forain concerning his funeral was that if there were any oration at all, it should be Forain saying: 'He greatly loved drawing. And so do I.'

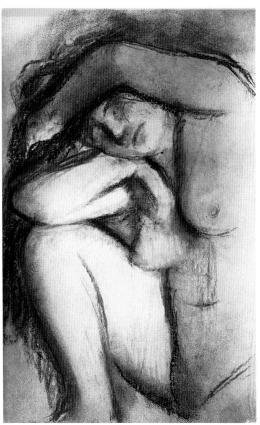

17a *Resting nude*, Late 1890s?
Charcoal and pastel
22 × 14½ in (56 × 37 cm)
Private collection

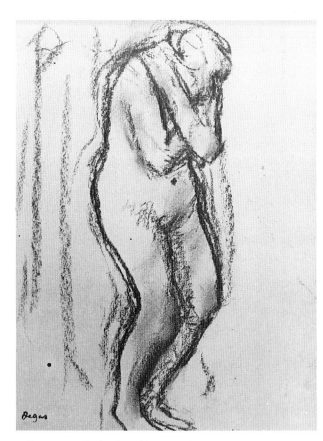

17b *Woman drying herself* ('*La Frileuse*'), *c.* 1902
Charcoal
11⅘ × 9 in (30 × 23 cm)
Whereabouts unknown

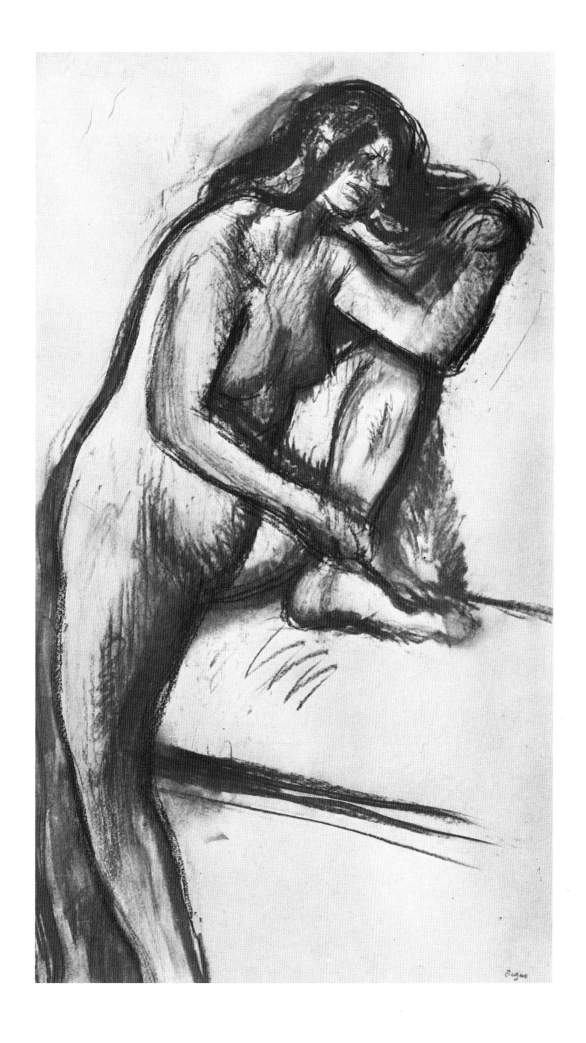

18 MARY CASSATT
Girl seated on a sofa
c. 1883
Pencil
8²⁄₃ × 5³⁄₄ in (21.9 × 14.5 cm)
National Gallery of Art, Washington
(Ailsa Mellon Bruce Collection).
Inv. B-25, 465

We know little about Cassatt's early work as a draughtsman, apart from her own recollections of impatience with academic teaching and the dissatisfaction with the slackness of her drawing of those who taught her. She had studied drawing at the Pennsylvania Academy between 1860 and 1865 and then, during four years in Europe, worked under Gérôme and Couture among others. She settled in Paris in 1874.

Observation of character is evident as a prime concern in her surviving early drawings: an 1876 study of a girl (18a) evokes a strong, almost disquieting personal presence. Nearly all of Cassatt's drawings are studies of people and their relationships, and her close contact with impressionist circles from 1877 did not deflect this interest. The contrast between these two drawings of children is one of maturing technique rather than approach to the subject. *Girl seated on a sofa* is a marvellously sharp-eyed, faintly comic portrayal of the poise of this overdressed child, lifted on to the sofa. The anecdotal realism of her dangling legs, which cannot reach the ground, implies the graceless loss of poise that would be involved in moving from here to the floor. All of this is coolly observed, without the sentiment of the 1876 drawing. Granted that the difference may be discussed in terms of the ages represented, it suggests more convincingly a maturing shrewdness in the eye and means of the observer.

In technique, the great difference is the shift from an all-over focus and fluttering indiscriminate line in the earlier drawing, which is more or less topographical, to the purposeful use of a whole diet of marks in this one: the densely hatched black of the dress, the repeatedly drawn contours of the head and the space created around the hanging legs. A scattering of marks suggests the patterned lace of collar and cuffs without compromising the simple integrity of the figure.

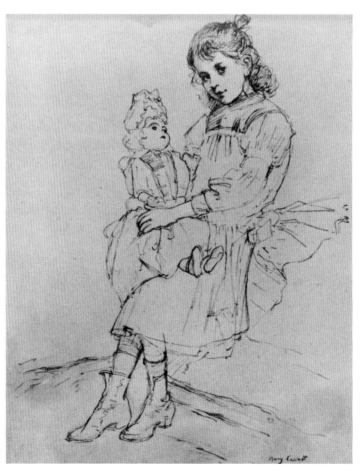

18a *Girl holding a doll*, 1876
Black crayon
12 × 9 in (30.5 × 23 cm)
Private collection, New York

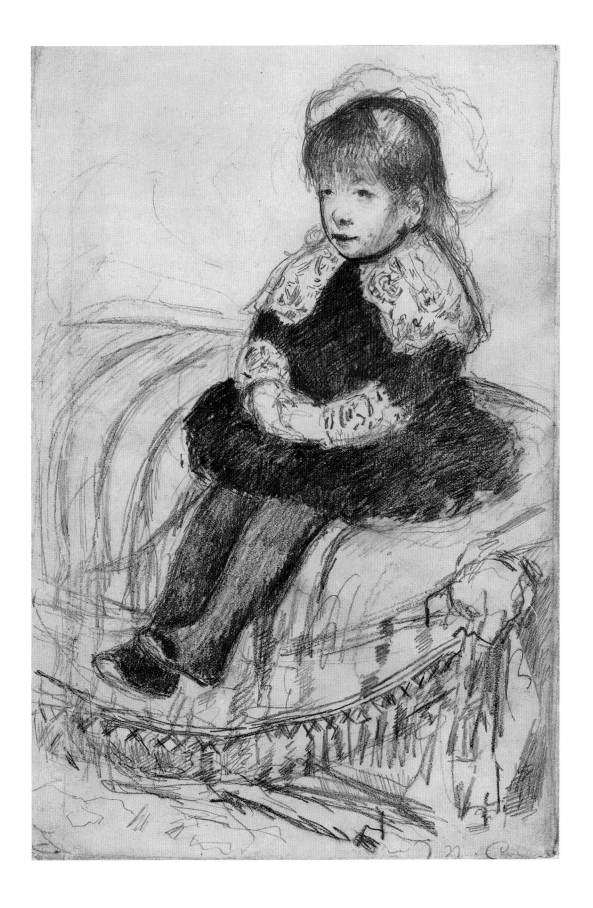

19 MARY CASSATT
The Visitor, study for an etching
c. 1879–80
Pencil
$15^3/_4 \times 12^1/_6$ in (40 × 30.9 cm)
(formerly in the collection of Degas)
Cleveland Museum of Art. Inv. 66.176

Degas had admired a Cassatt painting at the Salon of 1874. They met in 1877 and he was responsible for introducing her into impressionist circles. She exhibited in four of the subsequent group exhibitions (1879, 1880, 1881, 1886). Cassatt had the highest respect for Degas. His art and opinions remained her most important external measure of value, despite the difficulties that this involved. '[He] takes a pleasure from throwing me off the track', she wrote. 'I have half a dozen times been on the point of asking Degas to come and see my work, but if he happens to be in the mood, he would demolish me.' (*Letters*, November/December 1892.) The environment of impressionism seems to have precipitated her move away from a picturesque and romantic quality that had coloured some of her Salon submissions. The extension of her repertoire of subjects from the late 1870s to include urban motifs such as the theatre and the milliner's shop is a measure of Degas's influence over her art.

This drawing was formerly in Degas's collection. The fineness of its mesh of lines reflects its role as study for an etching, but the selection and treatment of the motif are in the wake of Degas. The composition hinges on a dramatic *contre-jour* effect of the woman standing against the window. The tonal fabric of the drawing is built from a combination of delicate atmospheric modelling and forms that are flattened into silhouette. The drama is formal and in works like this, the personality of those represented is at its most subdued in Cassatt's oeuvre.

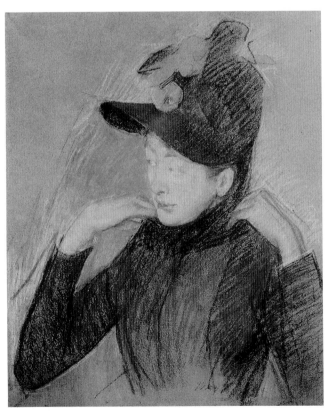

19a *Woman arranging her veil, c.* 1890
Pastel
$25^1/_2 \times 21^1/_2$ in (64.8 × 54.6 cm)
Philadelphia Museum of Art (Bequest of Lisa Norris Elkins). Inv. 50.92.3

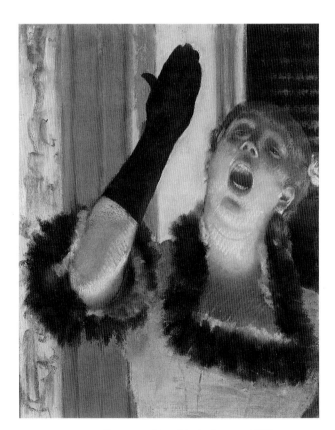

19b DEGAS: *Café singer with a black glove, c.* 1878
Pastel on canvas
$20^7/_8 \times 16^1/_8$ in (53 × 41 cm)
Fogg Art Museum, Cambridge, Mass. Inv. 1951.68

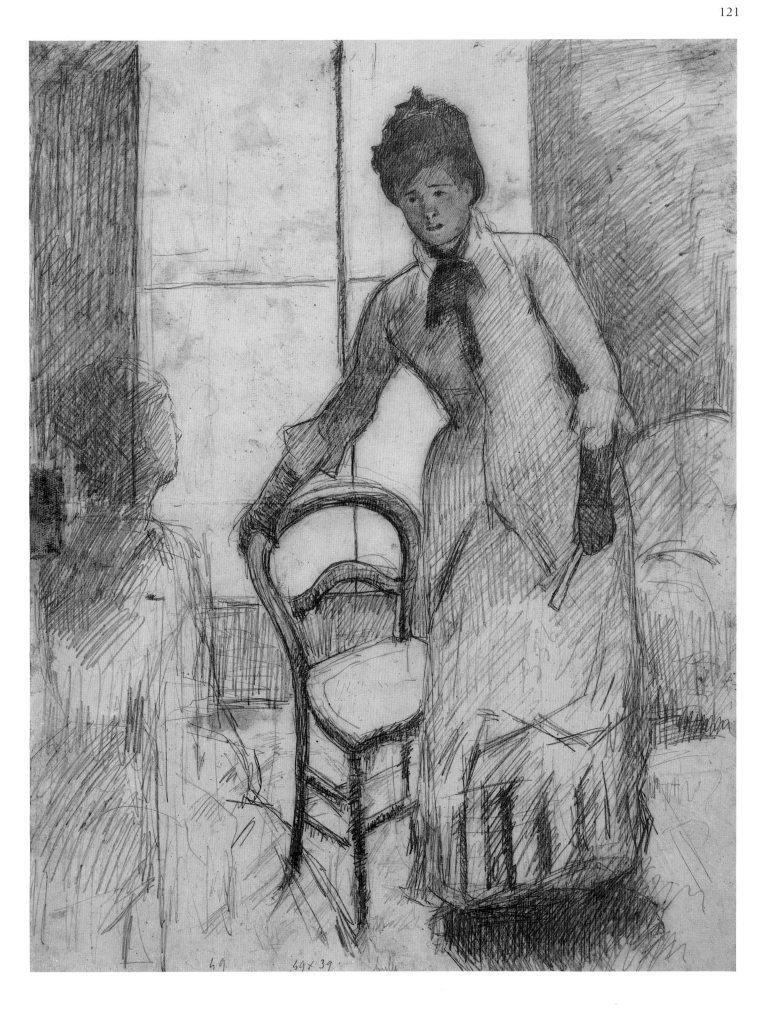

20 MARY CASSATT
La Loge
1882, signed
Pencil
11 × 8²/₃ in (28 × 22.1 cm)
National Gallery of Art, Washington
(Chester Dale Collection). Inv. 1948.5.1.a

The purity of line of this drawing demonstrates clearly how different was the kind of drawing that Cassatt developed through her experience of etching. Much later, she told her biographer Segard that it was her prints of around 1880 that taught her how to draw. This ascetic sequence of contours became the armature of all her mature drawing. Compared to the freedom of a scribbled first-hand sketch of a similar subject (20a), the austere clarity of this manner appears startling. This simpler mode of drawing was probably also inspired by her attention to Japanese woodblock prints. In the etching based on this drawing (Breeskin 18), Cassatt surrounded this linear structure with more or less flat tones.

The dramatic linear juxtaposition of elements that are far removed in space is another instance of Degas's inspiration – in this case his own theatre-box images (cf. Fig. 80). It is a device which Cassatt explored in a series of variants (paintings, prints, pastels) at this period. Degas's drawings and prints of 1879–80 of Mary Cassatt at the Louvre are full of the same calculated disposition of foreground and background elements (e.g. Adhémar/Cachin 1974, no. 54).

20a *At the Opera*, 1880
Pencil
4 × 6 in (10.2 × 15.2 cm)
Museum of Fine Arts, Boston (Gift of Dr Hans Schaeffer).
Inv. 55.28

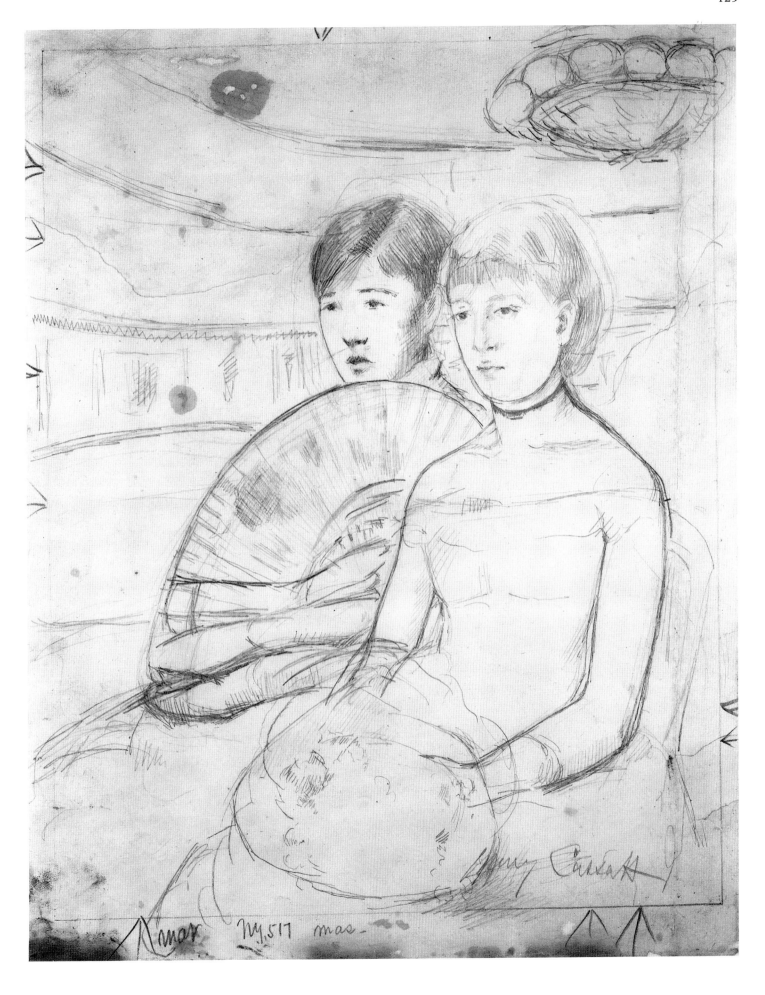

21 MARY CASSATT
La Coiffure, drawing for an etching
1891
Black crayon and pencil
$14^7/_8 \times 10^3/_4$ in (37.8 × 27.3 cm)
National Gallery of Art, Washington
(Rosenwald Collection). Inv. 1948.11.50.

When Cassatt met Degas, he was deeply involved in printmaking with Pissarro and Braquemond. Cassatt joined enthusiastically in their preparation for the (abortive) project of a new journal of graphic art, *Le Jour et la Nuit*, its title probably reflecting the range of urban subject matter as well as suggesting black and white. The fact that half of the sixteen works that Cassatt showed at the fifth impressionist exhibition of 1880 were prints is a product of this intense activity. (Pissarro showed five prints; Degas and Braquemond one each.)

At the end of the 1880s, Cassatt embarked on another active period of printmaking culminating in the large and accomplished colour prints that she made between 1890 and the end of the decade. They are among her major achievements. *La Coiffure* is a study for one of these (Fig. 41) and shows the simple, monumental linearity of her mature graphic style. Of all drawings by impressionist painters, these came closest to the pure line of Japanese prints that so many of them enthused about. But even Cassatt's style has physical properties that are unlike the apparently guileless economy and gravity-free ornament of oriental art. Her line is resolutely pared down, but still carries something of the weight, form and volume enclosed by the contour, which persists even in the decorative flatness of her print.

The close similarity of this motif to a contemporary drawing by Morisot (Pl.51) suggests a connection between the works. But Cassatt's motif was more likely to have been inspired by a Japanese prototype (see Boston 1989, p. 152) and anyway the frequency of this sort of image in the work of other artists (21b) suggests the greater likelihood of simple coincidence.

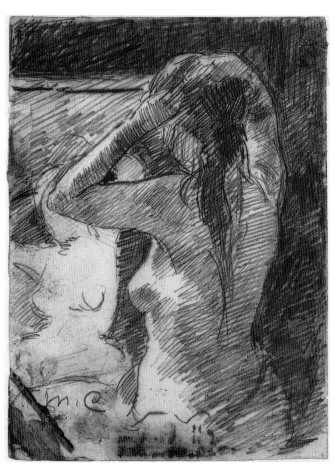

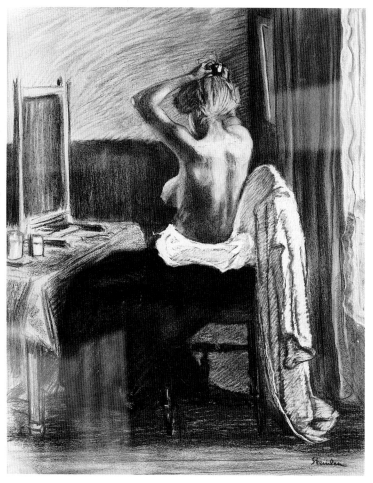

21a *Woman dressing her hair, c.* 1891
Pencil and watercolour
$5^5/_6 \times 4^2/_5$ in (14.8 × 11.2 cm)
National Gallery of Art, Washington
(Rosenwald Collection). Inv. 1954.12.6

21b STEINLEN: *Woman dressing her hair, c.* 1895
Pastel
$24^4/_5 \times 20$ in (63 × 51 cm)
Musée du Petit Palais, Geneva.

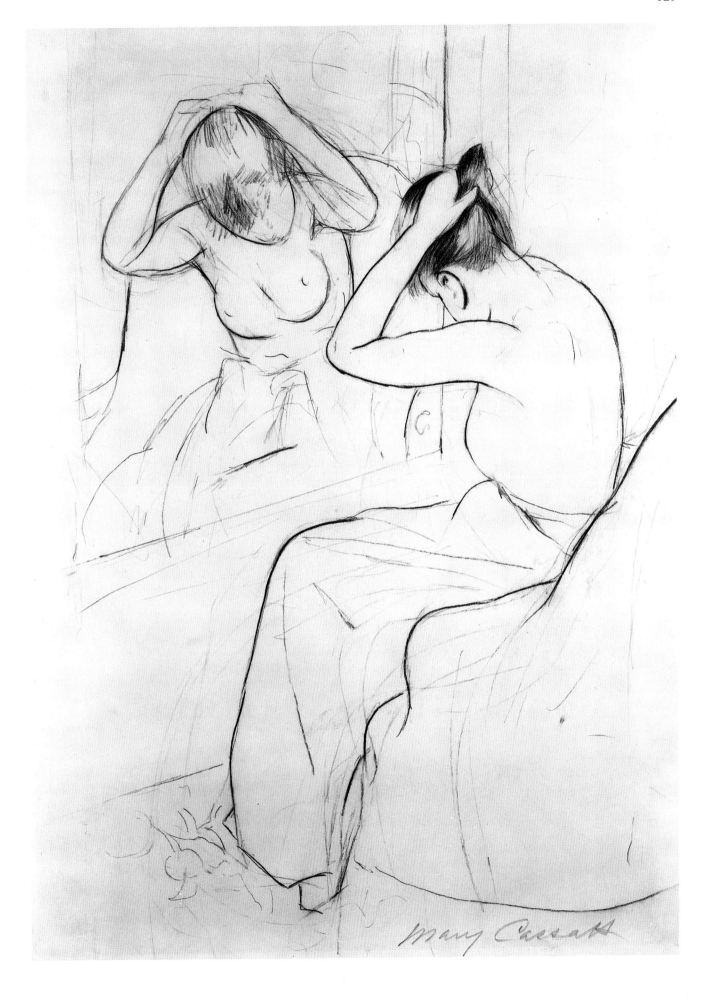

22 MARY CASSATT
Mother and child
1890s?
Pencil
11¼ × 9 in (28.6 × 23 cm)
Fogg Art Museum, Cambridge, Mass. (Bequest of
Grenville L. Winthrop). Inv. 1943.569

When Ludovic Halévy described her as '*l'indépendante Mary Cassatt*' in a note of 1879, presumably he was referring to her participation in the independent exhibitions of the impressionists. Her true artistic independence was realized in her prints of the 1890s and in the long series of drawings and pastels she made between the early 1890s and the onset of her blindness about twenty years later. Their principal subject was the relationship of mother and child.

The casual naturalism of these drawings is broadly comparable to the work of Caillebotte, Degas and others, but Cassatt's absorption with an intimate and often moving closeness of heads is of a quite different order. In 1881 Huysmans was already describing her work as having outgrown the influence of Degas's pastels. He wrote that she had become the independent maker of serene, intimate interiors that were thoroughly French and in a manner unmatched by her peers, despite her being American (Huysmans 1883, pp. 233–34).

The later drawings have an assured mastery and economy: 'no woman has the right to draw like that', Degas told her. In *Mother and child* the main lines are spare vestiges of essentials, complemented by the intense focus of rhythmic lines in the child's hair and fine hatching of detail in both heads.

Woman with dog (22b) has qualities of both impressionist haste and portrait-likeness in the statement and firm restatement of contours. It is a slight drawing, but not without calculation. Her attention to the very particular curve of shadow beneath the nose and over the lip has less to do with drawing against time than with a practised eye for shape.

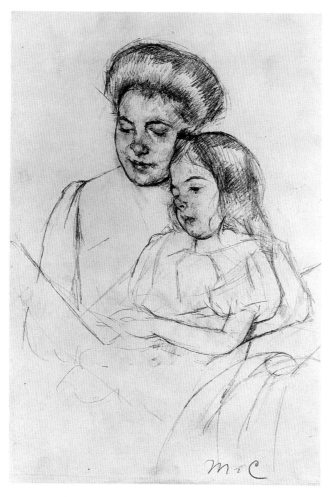

22a *The Picture Book (No. 1), c.* 1901
Pencil
12⅓ × 8 in (31.3 × 20.2 cm)
National Gallery of Art, Washington
(Rosenwald Collection). Inv. 1954.12.10

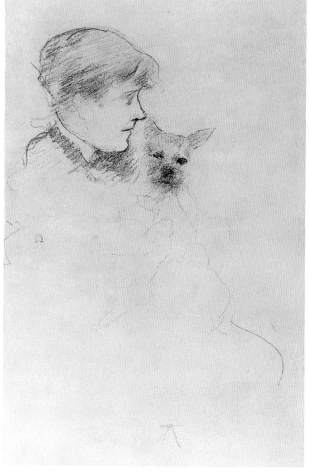

22b *Woman with dog, c.* 1891?
Pencil
5⅗ × 8¼ in (14.2 × 21 cm)
Metropolitan Museum of Art, New York. Inv. 1979.35.3.

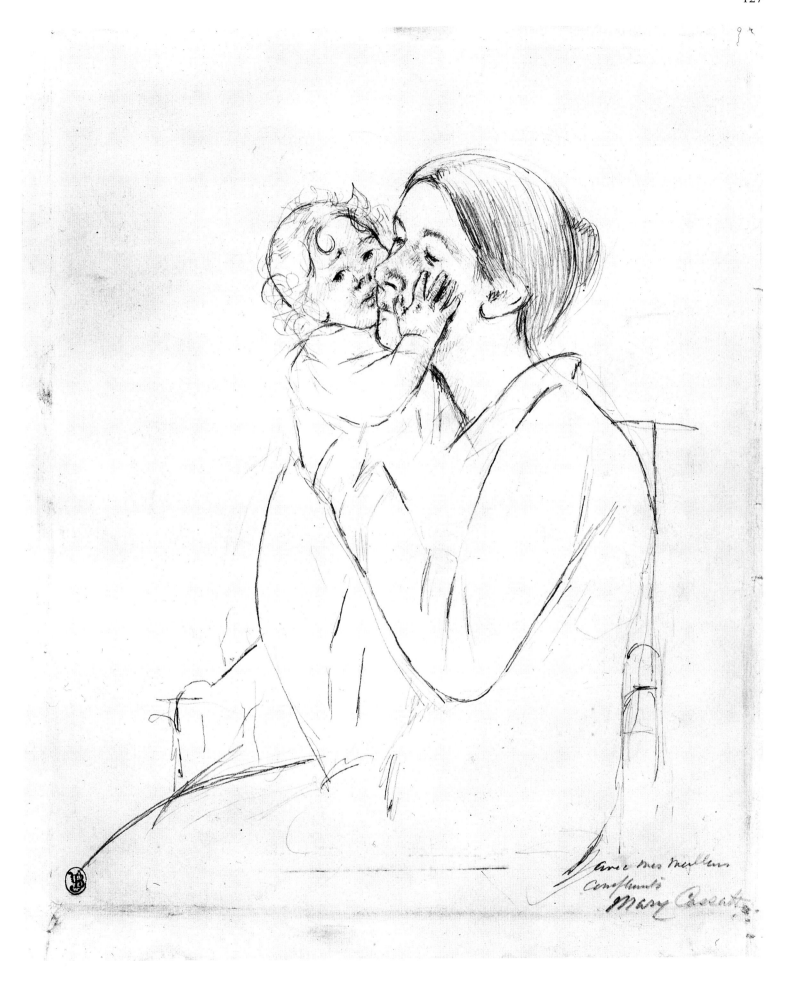

Avec mes meilleurs
compliments
Mary Cassatt

23 JOHANN BARTHOLD JONGKIND
The Harbour, Le Havre
Signed and dated 1862
Black chalk and watercolour
9 × 11⅖ in (23 × 29 cm)
(Formerly collection Paul Gauguin)
Ny Carlsberg Glyptotek, Copenhagen.
Inv. 1025

As early as 1876, a critic hostile to impressionism claimed that all its 'so-called discoveries' were to be found in the work of Jongkind, 'a true artist'. Jongkind's prolific drawings of the 1850s, in Holland and in various locations along the Seine valley, reveal a sharp eye for topography and the picturesque and are drawn – mostly in pencil – in an accomplished and stylish shorthand (23b). By the early 1860s, this mannered facility had loosened into the clear open style of drawing, now usually in chalk and watercolour and concerned more with atmospheric impression than with topography, that so impressed and influenced Monet. In his later recollection of their meeting, Monet recalled that Jongkind 'explained to me the why and wherefore of his manner and thereby completed the teachings that I had already received from Boudin. From that time on he was my real master and it was to him that I owed the final education of my eye.' (Thiébault-Sisson, 1900.) The direct economy of this Le Havre drawing may be compared to the few surviving early drawings of Monet, but more significantly perhaps to the deft rendering of sky and water in his paintings of the early 1860s.

Although Jongkind never exhibited with the impressionists, he remained in their attention. Pissarro described his watercolours as marvels in 1891, and Signac wrote of him as 'the first to repudiate flat tones, to break up his colour and to fragment his touch, obtaining the most rare colouring from elements that were both multiple and almost pure' (1889). The increasingly calligraphic invention of Jongkind's watercolours of the 1870s anticipates the later handling of both Monet and Signac. An 1877 watercolour of Grenoble (Pl.III) prefigures the vibrancy of Monet's paintings of melting snow, alive with translucent blues and violets. The first slight indications of the motif in chalk are almost completely submerged beneath a woven fabric of brushstrokes. A simple tonal contrast, between trees strung across the waterline and the tonally muted but radiant colour of the mountain beyond and water before, is achieved partly by the white paper and partly by opaque white body colour on top. The most saturated colour is buried in distant parts of the motif, a device he often used. This development of Jongkind's watercolours, from an uncomplicated clarity of impression to the tremulous array of coloured notations that he was using by the mid-1870s, forms a central thread in the evolution of impressionist drawing.

23a *La Charbonnière*, signed and dated 27 June 1876
Black crayon and watercolour
9½ × 10 in (24 × 25.6 cm)
Musée des Beaux-Arts et d'Archéologie, Besançon.
Inv. D4382

23b *Street in Morlaix*, 1850s
Pencil
5¼ × 4½ in (13.2 × 11.3 cm)
Louvre, Dépt. des Arts Graphique
Inv. RF 10.196

le Havre 1862
Jongkind

24 AUGUSTE RENOIR
At the Moulin de la Galette
c. 1875
Pastel
18½ × 24 in (47 × 61 cm)
National Museum of Belgrade.

Some of Renoir's friends (Maitre, Bazille) mention in letters of the 1860s that Renoir gave drawings to them, but we know nothing of these. Evidence of what his drawings in Gleyre's studio may have been like is confusing. Prodigious facility with the brush was reported by many contemporaries and Fantin-Latour is recorded as talking of 'a virtuosity that harks back to the Italian Renaissance'. But Renoir's student performance in drawing examinations, although inflated in his son's account, was generally unexceptional. Most surviving drawings of the 1870s are either pastels that are essentially colour studies, or drawings after paintings, made for reproduction in the journals *L'Impressionniste* or *La Vie Moderne*. It appears that during the high period of Renoir's impressionism, when painting was a matter largely of intuitive improvisation in front of the motif, drawing was not significant for him. The fluent, rather Manet-like, painterly drawing that he used in painted portraits of the early 1860s gave way to an art of colour notations with little role at all for line to play.

This pastel relates to Renoir's preparation for the ambitious painting *Le Bal au Moulin de la Galette* (1876) and we can reasonably assume that he made other such studies. It says a great deal about Renoir's attitude to drawing. There appears to be no coherent system uniting either the various parts or the successive stages of the drawing. It began from perfunctory contours and areas of shading in black or red, both of which were rapidly subsumed beneath several unrelated reworkings in more opaque areas of local colour, some of them rubbed. There is some improvisatory separation of profiles in white; some colours change dramatically – and apparently unintentionally – by picking up unstable pigment, such as the two orange-ochre horizontal bands, and finally, there is some loose overdrawing of edges in black. The drawing is essentially about colour, treating adjacent areas in randomly different, speculative ways as the situation or moment suggested. It appears to be the drawing of an artist who does not care for a drawing's stylistic or conceptual coherence *per se*. Nevertheless, the integrity of his pen drawing after the 1867 painting *Lise* (24a), where the homogeneous marks reconstitute the coherence of the painting, suggests that from the start, the inconsistencies in Renoir's drawing were a product of attitude more than ability.

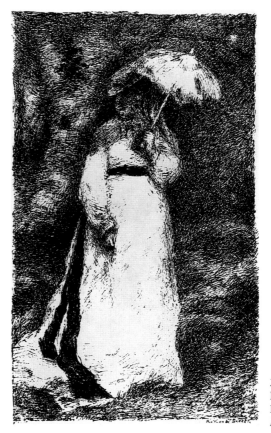

24a Drawing after *Lise*, 1878
Pen and ink
Reproduced in Théodore Duret,
Les Peintres Impressionnistes, 1878

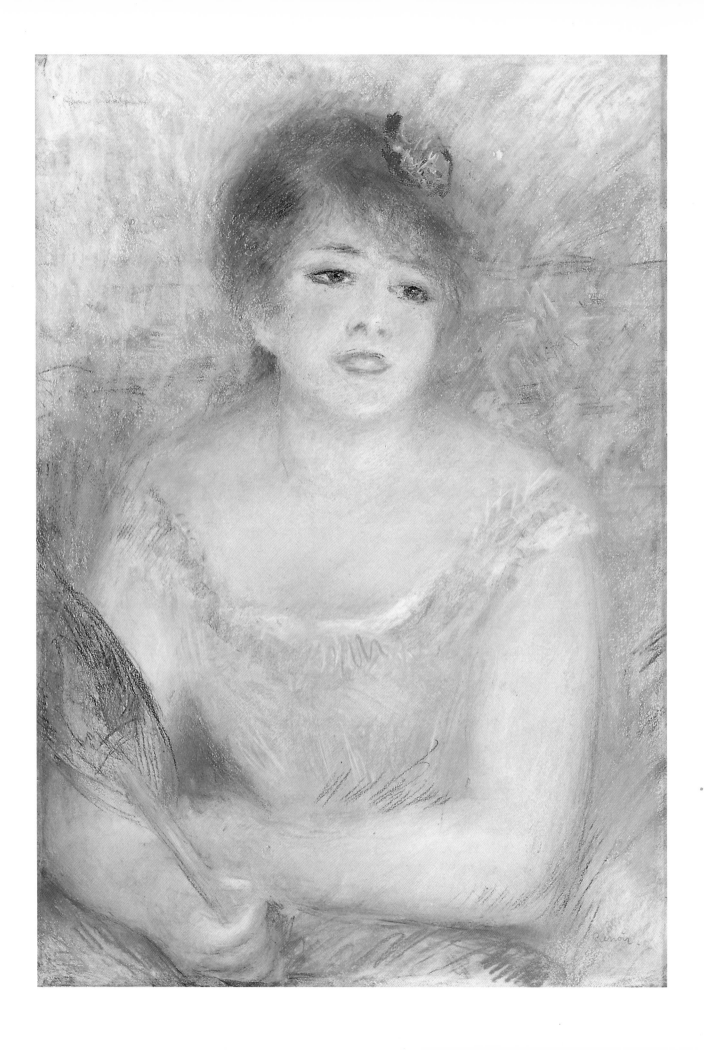

Renoir's pastel portraits of 1878–80 form a distinct group in his drawn oeuvre. They include the only drawings that he chose to exhibit and in other senses as well he treated them like paintings. This drawing of Jeanne Samary has much in common with the two paintings of her, particularly the 1877 half-length version with its vibrant surface and strange colour (Daulte 229). All three express the vivacious and exotic presence of the actress that attracted Renoir to her. (He told Vollard that he had hardly ever seen her on stage, since he felt more at home at the Folies-Bergères than the Comédie Française.)

The intensity of dark eyes and ginger-red hair float out of a surface in which the scattering of informal coloured marks is subdued by milky white overdrawing, applied almost like a glaze. It has the same eccentric coherence as his paintings, quintessentially impressionist and yet quite unlike any other impressionist images. Without the bravura clarity of mark of early Monet or the more constructive fabric of Pissarro or Cézanne, it is as if Renoir's eye flitted from surface to surface, invoking them with such a light touch that the dazzling likeness of his portraits can exist without much sense of gravity or solidity. The fine drawing of Cézanne (25a), in which the curvilinear drawing of hair and beard merge with his coat into a dense mass, is perhaps an exception. But in the pastel of a young girl (25b) which is equally strong in tonal contrasts, the features are as free of structured drawing as those of Jeanne Samary, suspended against the lightness of the head rather than articulated as parts of its volume.

Gauguin enjoyed this quality in Renoir. Near the end of his life, he recalled Renoir as a painter who never learned how to draw, but drew well: 'With Renoir nothing is in its place; don't look for line because it doesn't exist. As if by magic, a beautiful colour or a caressing light say it all . . . Divine Renoir, who didn't know how to draw.' (*Racontars de Rapin*.)

25 AUGUSTE RENOIR
Portrait of Jeanne Samary
c. 1877/78, signed
Pastel
$27^1/_2 \times 18^4/_5$ in (69.7 × 47.7 cm) irregular
Cincinnati Art Museum (Bequest of Mary Hanna).
Inv. 1946.107

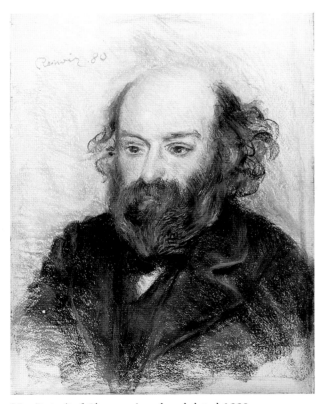

25a *Portrait of Cézanne*, signed and dated 1880
Pastel
$21 \times 17^1/_2$ in (53.5 × 44.4 cm)
Private collection

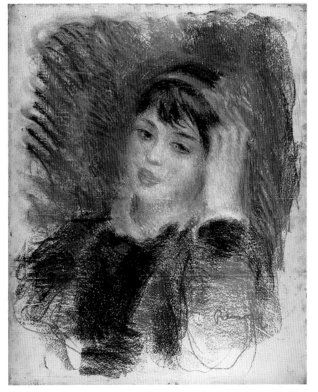

25b *Head of a young woman*, c. 1878/80, signed
Pastel on white board
$22^2/_5 \times 18^1/_2$ in (57 × 47 cm)
Fitzwilliam Museum, Cambridge (anonymous loan)

26 AUGUSTE RENOIR
Study for *Two circus girls of the Cirque Fernando*
1879
Black chalk
12½ × 8⅘ in (31.8 × 22.5 cm)
Collection Saltwood Castle, Kent

The circus was a recurrent theme in Parisian art from Daumier to the early work of Picasso. Similarities between the organization of this Renoir drawing and comparable later compositions by Lautrec or Seurat spring from the exigencies of the subject. The Renoir is essentially a portrait with narrative accessories. The disproportionate clown, bottom right, has none of the dramatic coulisse properties of the motif in Seurat's *Le Cirque* (Pl.107, Fig. 83). Renoir omitted it from the composition of his painting (Daulte 297), perhaps for precisely the reasons that Seurat exploited it, both dominating the middle-ground figures and flattening the space.

The drawing is an oddity in Renoir's work of the 1870s in being a resolved study in preparation for a painting. Most extant drawings related to paintings, such as the carefully reconstructed *Country Dance* (26a), were made after the paintings. This drawing reminds us that the spontaneity of Renoir's impressionism stressed by his supporters in the 1870s was, on occasion at least, more calculated than it appears. The existence of such a study also suggests that there may have been comparable drawings, now lost, for some other paintings.

The softness of this study, coincidentally like Seurat's conté drawings in the way that tone is dragged across the pronounced tooth of the linen-faced paper, is a constant element in Renoir. It reminds us both of the facture of his early landscape paintings and of the melting fullness of his last drawings in chalk and watercolour. Even when, in the mid 1880s, he was aspiring towards a tighter linear control, a study like the fine head of a girl in Belgrade (26b) reveals a similar sensitivity of touch and mood. For all his apparent revocation of impressionist principles in the 1880s, drawings like this are still full of the fluid instinctive drawing of the late 1870s. Features, however tightly drawn, still float unattached within the Ingres-like contours of the head.

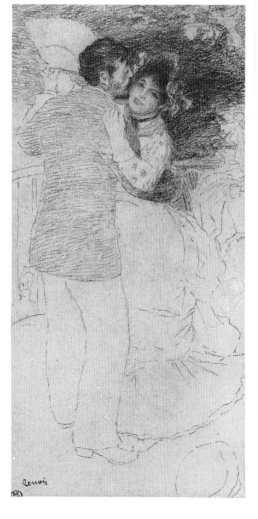

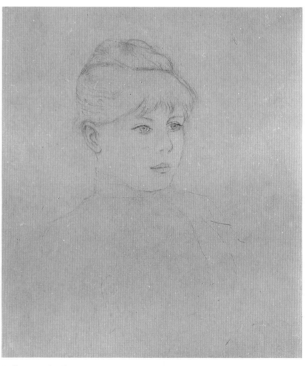

26b *Head of a young girl, c.* 1886/87
Pencil
11 × 9¼ in (28 × 23.5 cm)
National Museum, Belgrade.

26a *Country Dance*, 1883
Chalk and wash
12 × 6⅗ in (30.3 × 16.7 cm)
Louvre, Dépt. des Arts Graphiques.
Inv. RF 31.717

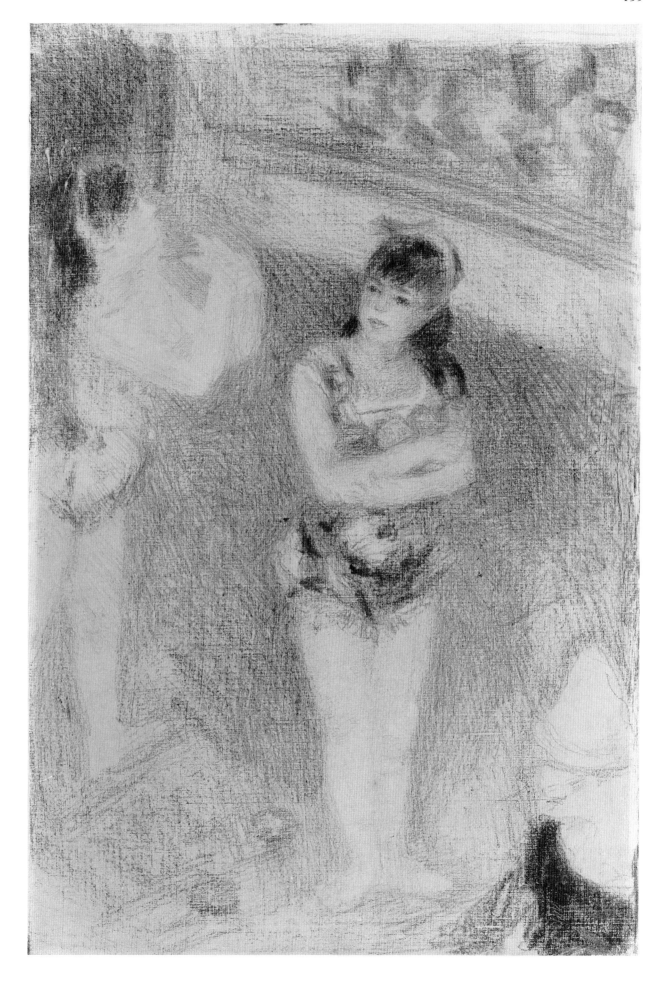

27 AUGUSTE RENOIR
Study for *Les Grandes Baigneuses*
c. 1886
Pencil, crayon and chalk, heightened with white
$42\frac{1}{2} \times 63\frac{4}{5}$ in (108 × 162 cm)
Louvre, Dépt. des Arts Graphiques. Inv. RF 29.660

27a Study for *Les Grandes Baigneuses*, *c.* 1886
Red chalk, black crayon
$33\frac{4}{5} \times 21\frac{1}{4}$ in (86 × 54 cm)
Private collection

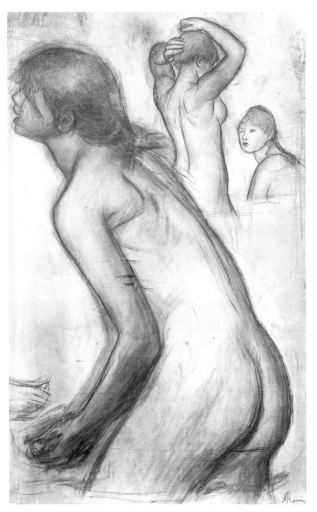

Although it is clear enough to us that Renoir made varied, intermittent use of drawing throughout his career, the quality of his drawing remained a target for hostile critics. As late as 1882, Albert Wolff could still write that if Renoir had only learned to draw, his *Luncheon of the Boating Party* might have been a fine picture. Renoir was always susceptible to criticism and the persistence of such strictures possibly contributed as much as his own innate feelings of insecurity to the radical change in his drawings in the early 1880s. In his later account to Vollard, Renoir spoke of a clean break in his oeuvre around 1883: 'I had reached the very end of "impressionism" with the realization that I knew neither how to paint nor to draw. In a word I was at an impasse.' He went on to describe some paintings of the following years 'in which the smallest details were drawn in pen before starting to paint. Dissatisfied with impressionism, I was striving to be so precise, that I made things of extraordinary dryness.' (Vollard 1985, pp. 209, 213.)

The many studies for the painting *Les Grandes Baigneuses* (Daulte 514) demonstrate both the variety of his experiment and the extreme solution he was seeking. This heavily worked drawing brings together the three principal figures of the composition, with a brief indication of background trees. He recalled struggling with the composition for three years and there is a complex history of change and adjustment in the redrawing and rubbing of this single sheet, which belongs to an advanced stage of the preparation.

Renoir had looked at a lot of renaissance art during travels in Italy, 1881–82, and Ingres had become a yardstick of quality and style for him. Nevertheless, his solution to the problems of drawing remained eccentric and, for all their superficial similarities, quite distinct from the homogeneous conventions of academic drawing with their finely tuned balance of contour and shading (cf. 27b). The similarities lie as much in the artifice of studio-posed figures and the rhetoric of their gestures as in the simplicity of form. Principal differences are to do with Renoir's constant shifting of relative roles of line and modelling as the drawing evolved. The *Grandes Baigneuses* studies give an accurate account of what they are: the self-conscious and earnest attempt to produce systematic, complete drawings of an artist to whom systematic control was unnatural. In some he approaches the seamless beauty of Ingres's painted female nudes, with a continuity of surface that is largely undisturbed by bones and muscles. Others are littered with abnormal anatomical detail and passages of shading that have the look of gratuitous mannerisms.

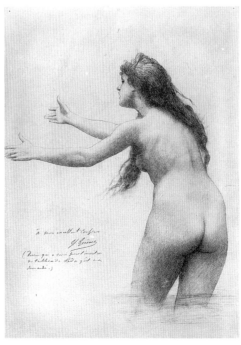

27b GÉROME: *Bathing woman* (study for *Leda and the Swan*), signed.
Black chalk
$13\frac{1}{5} \times 9\frac{1}{5}$ in (33.6 × 23.4 cm)
Pierpont Morgan Library, New York.
Inv. 1986.12

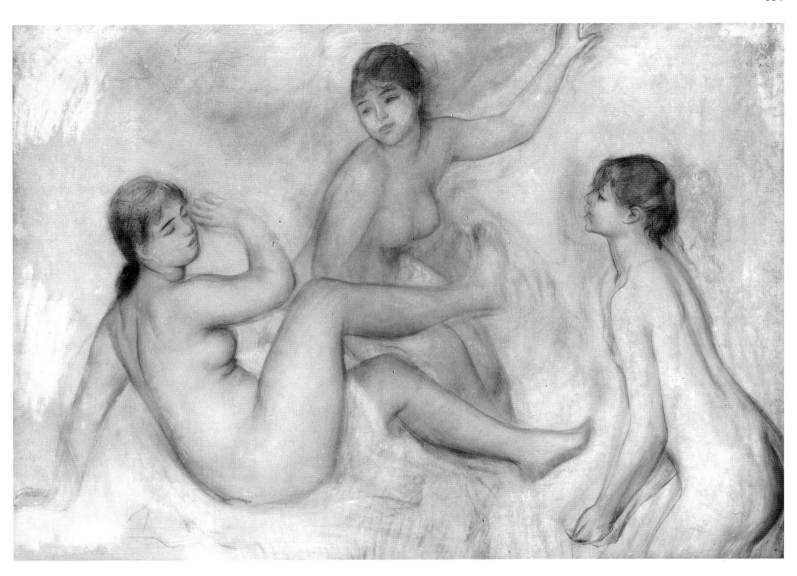

138

138

28 AUGUSTE RENOIR
Study of Trees
c. 1888/90
Pencil
10 × 9¹/₈ in (25.2 × 23.2 cm)
Rijksmuseum, Amsterdam. Inv.1951.21

Rare in being a landscape, unsigned and without a strong provenance, this drawing nevertheless appears to be a convincing attribution. We know that Renoir worked from landscape intermittently throughout the 1880s, from his 1882 stay with Cézanne onwards. He wrote to Durand-Ruel from St-Briac in 1886: 'I have made some drawings and watercolours so as not to be short of material this winter'; and from Tamaris in 1891: 'This métier of landscapist is very arduous for me, but these three months have enabled me to go further forward than a year in the studio.' (*Archives* I, pp. 30, 145.) Many of his landscape studies from this period, in a gauche mixture of amorphous watercolour and leaf-by-leaf drawing, suggest the limitations of working in the studio that he refers to. They also reflect some uncertainty about how to treat landscape in a way that was reconcilable to his current figure drawings. The problem of how to transcribe into paint the detailed linear study for a tree in *Les Grandes Baigneuses* (28a) was to some extent resolved in the painting by concealing it behind a figure.

The pencil drawing in Amsterdam is of a different order and quite clearly from nature. Although there are instances in it of an inclination towards incidental detail, the disposition of lines shows a more searching enquiry into things seen than is usual in his paintings of trees. It bears some relationship to the organic treatment of foliage in the background of *Les Grandes Baigneuses* and, more particularly, to Renoir's *Mont Ste-Victoire* paintings of 1889. Compared to the more arbitrary direction of brushwork in the early 1880s, these reveal a similar search for patterns of growth and movement to those visible here. Maybe the guiding example of Cézanne may be sensed behind his more concentrated looking?

Problems of dating are not easily solved by comparison in this case, not least because of the experimental variety of his landscape drawings. He often appears uncertain how to handle either the medium or the motif of foliage. Watercolours alternate, in cameo studies on the same sheet, between dry brush and full wash, hesitating between broad shapes of trees and minute stylized detail (28b). Perhaps the closest parallel to this pencil drawing of trees may be found in the way that Renoir drew hair.

28a *Tree* (study for *Les Grandes Baigneuses, c.* 1886
Ink on canvas
21¹/₄ × 25³/₅ in (54 × 65 cm)
Private collection

28b *Trees*, sheet of studies, *c.* 1885/86, initialled
Watercolour
12 × 18¹/₂ in (30.4 × 47 cm)
Metropolitan Museum of Art, New York. Inv.1966.96

29 AUGUSTE RENOIR
Mlle Lerolle at the Piano
c. 1892
Chalk
24$^1/_5$ × 18$^3/_5$ in (61.5 × 47.5 cm)
Formerly Durand-Ruel collection, Paris

The figure studies that Renoir made in the 1890s, mostly in chalk, look like a spirited attempt to restore an impressionist vitality and spontaneity to his drawing after the self-conscious classicizing of the 1880s. His endless discussions about art in his later years focused less on Ingres and the Italian Renaissance than on the art of eighteenth-century France. In the early years, his admiration for this art was most visible in the spirit of his motifs – the charm, the modish poses – rather than in technique. The serene and affirmative freedom from gravity that he recognized in the work of Fragonard, Watteau and Boucher was to remain at the heart of his personal values. He spoke of his art as 'nothing new, a continuation of the pictures of the eighteenth century'. His instinctive predilection for the effervescent lightness of French art is revealed in many recorded comments. Discussing his antipathy to Wagner and Beethoven for instance, he told Vollard: 'nothing is as good as a little air by Couperin or Grétry – any of the old French music, in fact. Now that's what you call "finely drawn"'! (Vollard 1985, p.201.)

In the strange striped hatching of many drawings of women of 1890–92, there is what looks like a conscious emulation of Watteau's chalk drawings, and occasionally he uses black and red chalk together after the eighteenth-century manner. The more or less parallel marks are floated onto the paper over cavalier contours without sacrificing lightness of touch. The struggle to be precise has relaxed and the drawing of detail is once more cursory. The motifs themselves have something of Watteau's coquettish evocation of the fashionable spirit of the time as well. We can almost sense Renoir's relief to be back among the sort of subject matter he had treated for most of his life.

29a *Three women, c. 1890*
Black chalk
16$^1/_4$ × 12$^1/_4$ in (41.2 × 31 cm)
Boymans-van Beuningen Museum, Rotterdam.
Inv.F-II-134

29b WATTEAU: *Studies of a woman wearing a cap*, date?
Black and red chalk, heightened with white
7$^1/_4$ × 8 in (18.4 × 20.6 cm)
Metropolitan Museum of Art, New York (Therese Kuhn Bequest)
Inv. 78.12.3

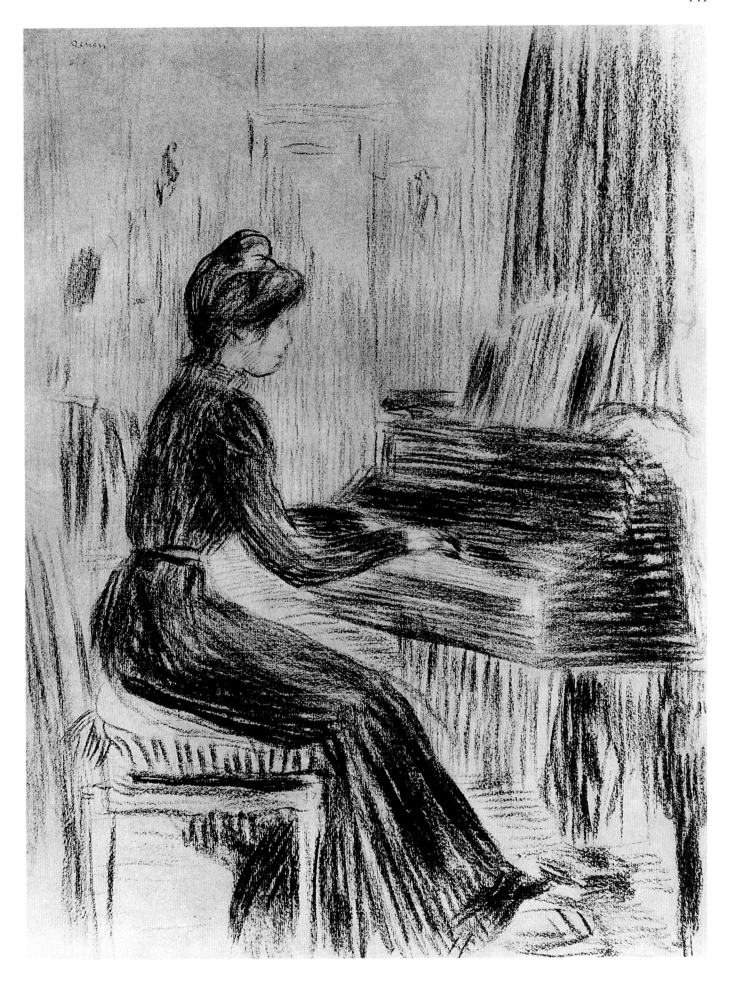

30 AUGUSTE RENOIR
Portrait of Auguste Rodin
signed and dated 1914
Red chalk
21¼ × 17¾ in (54 × 45 cm)
Private collection

By the mid-1880s, even before he had finished the large *Bathers* painting, Renoir was already writing to his dealer that he had resumed for good 'the old manner, soft and gracious' (letter, summer 1885). His late drawings retain the sense of simple volume that he had struggled so laboriously to acquire and reconcile this to the qualities of transience of his impressionist manner. Their tonal contrasts and analogies accumulate into a form of painterly bas-relief. They have the sort of breadth that one associates with an artist's 'last manner', and a simple relaxed freedom that is comparable to the late drawings of Degas, Cézanne and Gauguin. Some of them suggest the limitation of infirmity, his hands in old age being deformed by arthritis. After a visit to stay with him in Cannes, Redon wrote in March 1909: 'Still vital and full of energy. But I believe I saw in his work . . . his force reduced by the onset of feebleness, of hesitation.' Mary Cassatt described 'studies of enormously fat red women with very small heads' (1913). In some of the drawings Renoir achieved the monumental quality to which he had aspired since the mid-1880s, but without the mannerism of his first attempts. In the late drawings from the model and of children, there is the massive sensual grandeur that later attracted the interest of artists as different as Picasso and Moore.

This portrait of Rodin marries the textural sensitivity that he admired in eighteenth-century drawing with a simplicity of structure that he had never realized in earlier works. It also has that resonant individual presence that distinguished Renoir as a portrait painter throughout his life. Matisse admired Renoir most for this quality and compared the 'gift for life' of his portraits to Goya.

Pissarro once described Renoir as 'that most variable of men'. Renoir's approach to his drawings was mercurial and cavalier. They almost always reveal an innate impatience, even when he is applying himself with most concentration. When things go well, they go well, but a Renoir drawing was always vulnerable to a change of direction, often a change of medium, sometimes so extreme and incongruous in its effect as to suggest a flawed sensibility towards media. A critic wrote as late as 1897 that Renoir 'never knew how to hold a pencil', and the inability of those with conventional attitudes to cope with the spectacular uneveness of Renoir as draughtsman is not ultimately surprising. In his warm and perceptive tribute to Renoir's art in 1920, Maurice Denis singled out his 'ingenuousness of instinct' and concluded: 'If there is one reproach one can make about Renoir, it is that he lacked a sense of sin, of original corruption.'

30a Woman with a young girl in a landscape (study for *The Apple Seller*), c. 1890, signed
Red chalk
18¾ × 13 in (47.6 × 33 cm)
Fogg Art Museum, Cambridge, Mass.
Inv. 1943.907

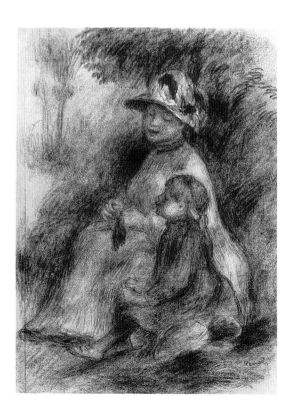

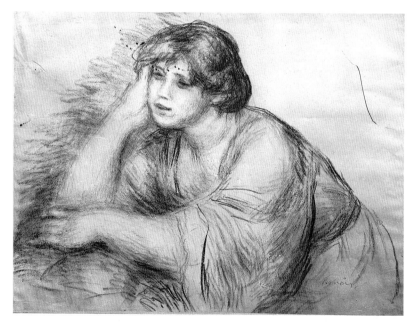

30b Woman leaning on her elbow, c. 1910
Chalk
18 × 26⅓ in (45.7 × 66.8 cm)
Albertina, Vienna. Inv. 24.330

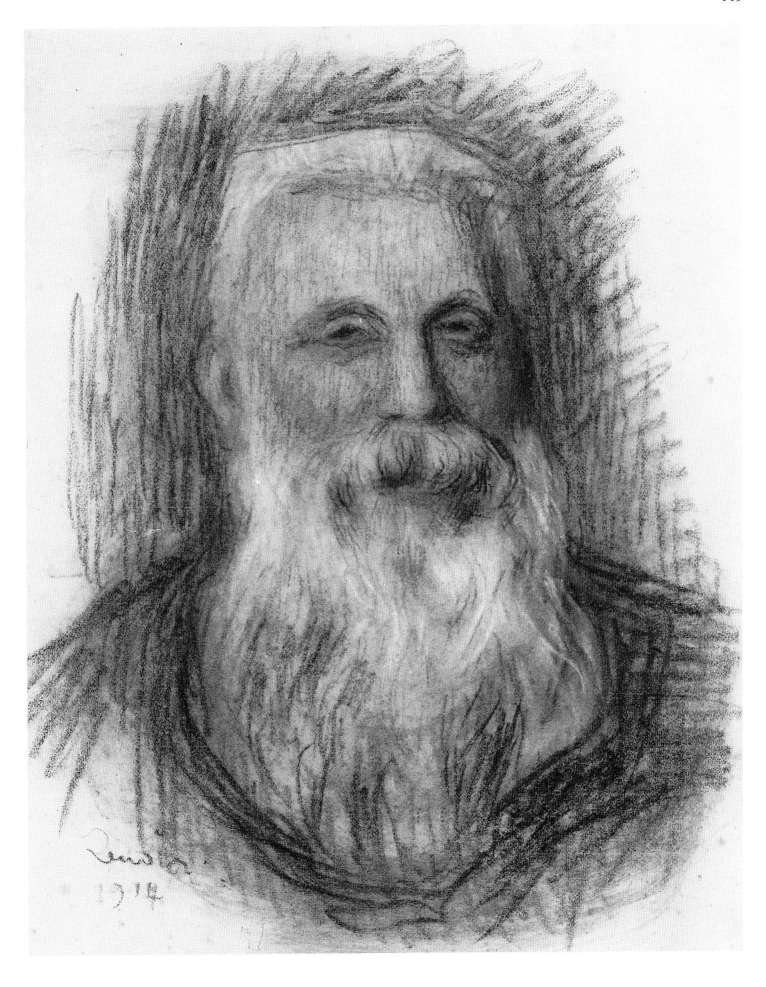

31 EUGENE BOUDIN
Man and woman on the beach
c. 1865
Pencil and watercolour
3³⁄₄ × 4¹⁄₂ in (9.4 × 11.5 cm)
Statens Museum for Kunst, Copenhagen.
Inv. Tu 34a(1), 2

Boudin's association with impressionism is documented by Monet's 'apprentice-ship' to him around 1860 and by his participation in the first group exhibition. In 1859, Baudelaire had written his famous eulogy, following a visit to Boudin's Le Havre studio (p. 33). When in 1883 Durand-Ruel organized a series of one-man exhibitions of impressionists, he opened with a show of Boudin's work that included many pastels and watercolours.

When Monet first saw Boudin's work he was not impressed. Its modest scale and repertoire of middle-class subject matter belies its radical nature. The earliest drawings, mostly in chalk and charcoal, reflect his admiration of the Barbizon generation: shrewd observation of rural nature contained within a homogeneous tonal structure. The drawings of the late 1850s and early 1860s that Baudelaire and Monet saw were mostly of beach scenes and channel seascapes. Baudelaire stressed not only the accuracy of Boudin's record of season, time and climate, but also the poetic expression of his pastels of sea and clouds. Monet talked of his eyes being opened by Boudin to the possibility of working from nature and of being 'governed' by Boudin's advice.

The outstanding quality of his beach drawings is how much is contained in so slight an impression (see also Pl.II). They are the most fugitive suggestions, drawn at speed: a few crumpled, jabbed, staccato lines followed by fewer rapid tones of wash. Some sketches have colour notes that are not always adhered to, which suggests that the wash was, in some instances at least, added later. The relatively subdued palette is punctuated with sometimes dazzling touches of local colour. The drawing is animated with quiet wit.

Although Monet emulated Boudin's beach motifs for a while, it was quite clearly the pastels, in which Boudin confronted transient effects of light and atmosphere, that moved him most profoundly. The dramatic chiaroscuro and strong colour of these drawings (in which Baudelaire may have seen parallels with Delacroix) inspired the character of Monet's own work in the medium (Pl.VII–IX; Pl.33). Boudin's later watercolours suggest some influence of Jong-kind, in their mottled mix of chalk and wash marks and in a very particular greyness, which is both dull and translucent (31b).

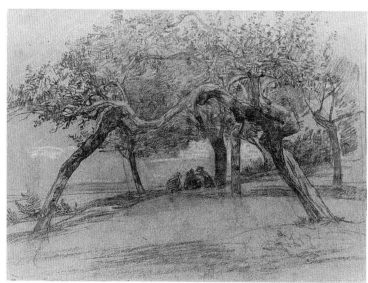

31a *Apple trees*, Early 1850s
Charcoal, heightened with pastel
12¹⁄₂ × 17¹⁄₃ in (31.9 × 44.1 cm)
Louvre, Dépt. des Arts Graphiques. Inv. RF 22.630

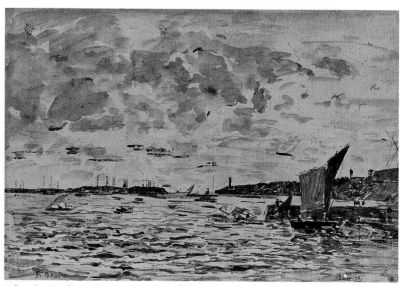

31b *The Harbour, Brest*, signed and dated 1872(?)
Watercolour and gouache over black chalk
9 × 14¹⁄₅ in (23.1 × 36.1 cm)
Metropolitan Museum of Art, New York. Inv. 1980.21.7

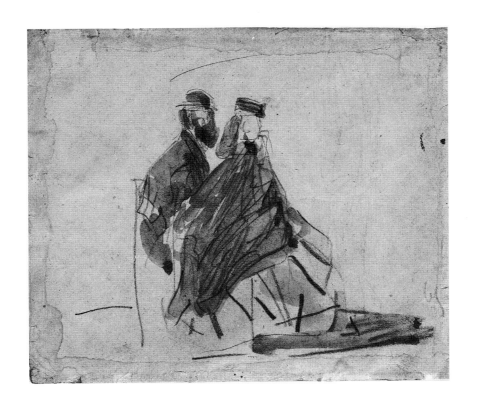

32 CLAUDE MONET
Houses by the sea
c. 1865, stamped
Black chalk
7¼ × 10¼ in (18.2 × 26.1 cm)
Museum of Modern Art, New York (Gift of Mr and Mrs Marion Joseph Lebworth). Inv. 691.81

32a *Sheet of caricatures, people of the theatre, c. 1858*
Black chalk and gouache
13²/₅ × 18⁹/₁₀ in (34 × 48 cm)
Musée Marmottan, Paris. Inv. 5161

The low survival rate of early drawings by Monet probably reflects the relatively careless attitude to drawing that he displayed throughout his life. From all the evidence, there must have been a large corpus of early drawn work. The earliest extant works of any sort are a few of the many caricatures that he drew as a teenager in Le Havre, around 1857–58. He sold enough of them, he tells us, to finance his move to Paris in 1859. He appears to have nurtured his fluency as a caricaturist by copying the published *portrait-charges* of Nadar, but the drawings reveal more than his precocious assimilation of existing conventions (32a). They exude the extraordinary facility for likeness that characterized his early impressionism – that 'vivid and rapid comprehension no matter what the subject' that Zola observed in 1868. A comparably shrewd eye for character, silhouette and the shapes formed between contours is visible in his vigorous chalk drawing of cows (32b), which perhaps reflects the influence of Troyon, whom he knew and admired.

In Paris in 1859, Troyon advised him to enter the studio of Couture and 'learn to draw, that's what you lack above all at the moment'. Instead, he went first to the Atelier Suisse, and then, in 1862, entered Gleyre's studio, as a fellow student of Bazille, Renoir and Sisley. He wrote to Boudin in 1860 that he was 'drawing figures hard' and, with Gleyre, he made 'rough sketches from the model'.

The chalk drawing, *Houses by the Sea*, epitomizes the character of the few surviving early drawings of the Channel coast, and we can assume that this is the manner he adopted in the early 1860s after his contacts with Boudin and Jongkind. The simple reduction of the motif in accordance with effects of light, and the peremptory, assured technique are comparable to his pastels and paintings of Honfleur, Le Havre and Ste-Adresse between 1864 and 1868. Transcription is very direct, the linear features of architecture blocked in with tones of shadow against the pale line of the horizon. It is an instant, sharp-eyed formulation that reveals all of itself at once. There is no subtle nuance to be sought from poring over such a drawing. It has all the assertive simplicity of Monet's early impressionism, in which capture of the salient effect appeared unproblematic.

The only other type of drawing from this period are studies relating to Monet's figure paintings of the mid-1860s. Surviving sketches for *Le Déjeuner sur l'Herbe*, concerned with the contrivance of composition rather than with direct observation, are markedly looser and more hesitant in their improvised execution. A study in the Mellon collection (32c) shows an intermediate state of the composition, without the closed umbrella of foliage of the painted versions (W62, 63b). Its background recalls the meandering, asymmetrical shape between trees of some of his Fontainebleau landscape paintings (e.g. W56).

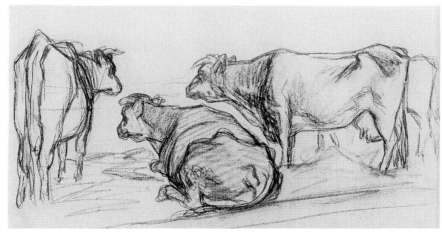

32b *Cows, c. 1864*
Chalk
9½ × 18½ in (24.1 × 47 cm)
Formerly collection Jean-Pierre Hoschedé, Giverny

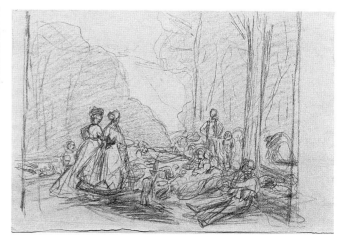

32c Study for *le Déjeuner sur l'herbe*, 1865
Black crayon on blue-grey paper
12³/₈ × 18³/₈ in (31.4 × 46.7 cm)
Collection Mr & Mrs Paul Mellon, Upperville, Virginia.

33 CLAUDE MONET
Etretat
c. 1868/69
Pastel
15³/₄ × 9¹/₄ in (40 × 23.5 cm)
Private collection, New York

Dating of Monet's pastels is problematic, with the exception of the few late, dated drawings in London, whose rapid execution, he said, made clear to him how to go about painting the Thames (letter, January/February 1901). His first use of the medium was probably prompted by Boudin's pastels; there are some striking similarities of technique (cf. Pl. VII). With qualities half-way between painting and drawing, pastel enabled Monet to draw in colour, but the comparison with paintings that this prompts offers confused evidence towards dating.

The eccentricity of this motif, in which the silhouettes of the Needle rock and Porte d'Aval at Etretat are contrasted with a stark foreground silhouette, is reminiscent of the dramatic compositions he painted on this coast in the 1880s. The brevity of statement and its striking luminosity and tonality favour a date during earlier visits to the motif in 1868–69. The drawing has that dazzling instant-likeness of his early work and the audacious facility with which Monet created an image as startling and memorable as one's first sight of such a scene. Choice of the vertical format – very rare in his landscapes for obvious reasons – highlights its strangeness. Later he came to mistrust effects that came as easily as this. In the 1880s paintings at Etretat, colour is more broken and tonality usually far more complicated. The loose pencil drawings of Etretat in his sketchbooks, prospecting for motifs for painting, probably date from the 1880s (Fig. 59).

The very different pastel of a bare (clifftop?) landscape (33a) presents similar dating problems. The uneventful motif underlines how dramatic and eccentric are most of his landscape subjects. Here, there is barren foreground scrubland in muted greens and hot browns, two barn-like houses and the rest is quiet sky, streaked with white, blue and grey. It has the subdued quality of the fields of poppies and oats that Monet painted in the 1890s, with 'the same light spreading everywhere'. Other evidence points conversely, towards an early date for the drawing. He appears to have used the abbreviated signature 'C. Monet' or 'Cl. Monet' on drawings and sketch-like paintings only until about 1879, and, apart from an isolated copy of an 1888 painting (sketchbook MM 5132, 30 verso), there is little evidence of Monet using pastel in the 1880s and 1890s. Although he exhibited more pastels than paintings in the first group exhibition of 1874, none was submitted to subsequent exhibitions. These two drawings probably give some idea of the pastels shown in 1874. Like the London pastels, they appear to have served an experimental role in relation to painting and to have ceased once this function was realized.

33a *Landscape with houses*, Late 1860s/early 70s? signed
Pastel
8³/₅ × 16³/₄ in (21.9 × 42.5 cm)
Metropolitan Museum of Art, New York (Susan Dwight Bliss Bequest, 1966). Inv. 67.55.29

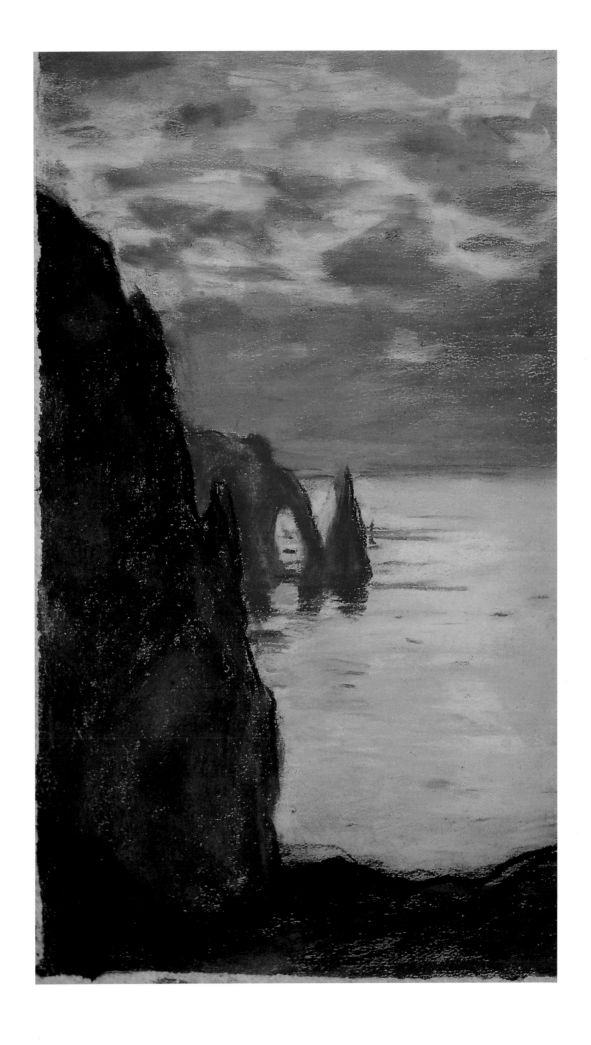

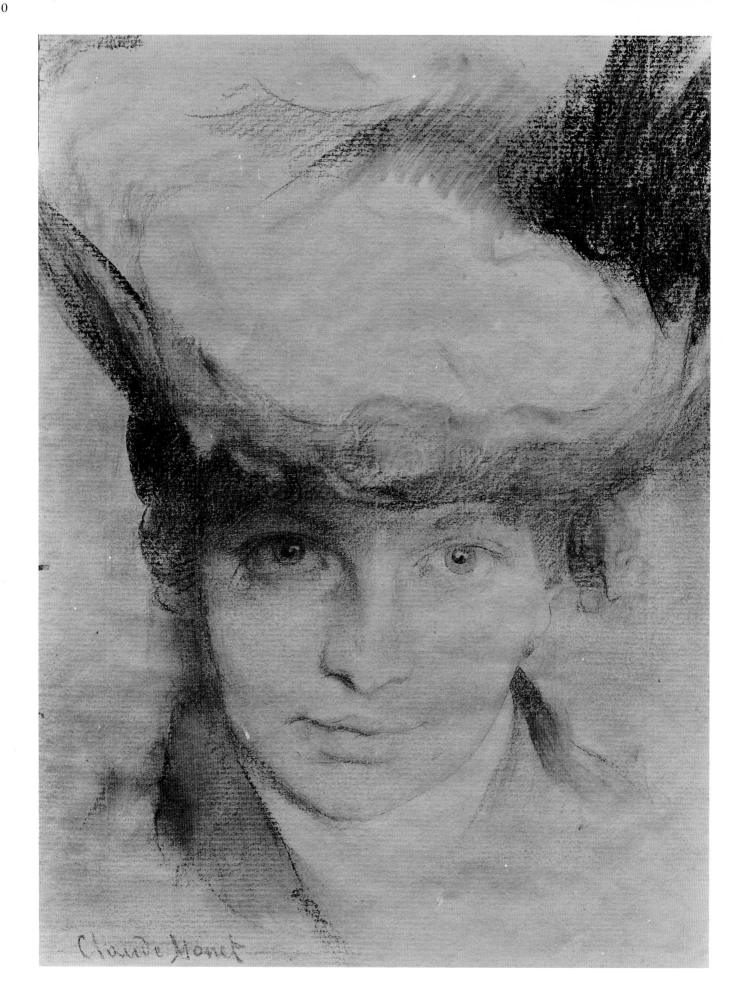

The quality of this very fine portrait drawing, described as a portrait of his wife Camille at least since 1955, comes as enough of a contrast to Monet's other known drawings to create some initial reservations about its authenticity. In no other drawing is there such variety of mark, nowhere else the fineness of line around the eyes and face, and little to suggest a draughtsman who might include this clarity of highlight in the eyes within such Rubensian fullness. It is not discussed in the literature: Seitz (1960) illustrates it without discussion and House (1986) does not mention it. Without the signature, Monet's name is not the first to come to mind. On that subject, Monet observed to Durand-Ruel in 1908 that the signature on a false painting was 'imitated perfectly', but this appears patently too good a drawing to need a false signature.

Its disquieting unexpectedness emphasizes the particular role that history has reserved for Monet's art. Against the dispassionate objectivity, devoid of sentiment, for which he was renowned (and criticized) in his own time, most of his portraits stand out by virtue of their sensitivity. Drawings of his sons and the Hoschedé children are oddities. They do not conform to a traditional view of an artist who was compelled by the extraordinary effects of light and colour to paint his wife on her deathbed, or who would later advise others, 'try to forget what you have before you, a tree, a house, a field or whatever. Merely think here is a little square of blue . . .', and so on. In the early years, this objectivity was not so clearly definable: figure paintings of the 1860s have an anecdotal charm. And there is a lingering picturesque sweetness in some paintings of the 1880s (*Woman with a parasol*, W1077, for instance) that is seldom commented on, perhaps consciously overlooked.

If this is indeed a portrait of Camille Doncieux, mother of his two sons and Monet's wife from 1870 until her death in 1879 – and it appears unlikely to be anyone else – then there are grounds to expect an exceptional drawing. In the work of other artists too, Cézanne's portrait of Achille Emperaire for instance (Pl.60) or Pissarro's drawings of his children, there is an unusual tenderness in the drawing of an intimate. Monet's drawings of his children, although quite different technically, tend towards the same delicacy of sentiment and sensitivity of drawing. Given the artist's will and curiosity to work in this way, such an intense and delicate portrait drawing is compatible with the precocious facility, ease of assimilation and sense of likeness that abound in Monet's early work in various ways. The extraordinary improvisations of colour and mark that characterize the pursuit in his later work of nature's transience are other expressions of the same abilities – what Fénéon later derided as 'his vulgar brilliance'. Uneasily as it may lie in his oeuvre, this drawing is perhaps the most eccentric example of the degree to which Monet's means were determined by what he was looking at.

34 CLAUDE MONET
Portrait of a woman (Camille?)
c. 1868. signed
Red chalk
11¼ × 8¼ in (28.6 × 21 cm)
Formerly collection Mr & Mrs Sydney M Shoenberg, St Louis

34a *Michel Monet and Jean-Pierre Hoschedé*, 1881
Pastel
21¼ × 28¾ in (54 × 73 cm)
Musée Marmottan, Paris. Inv.5060

35 CLAUDE MONET
View of Rouen
c. 1883, signed
Black crayon on *gilot* board
12⅚ × 19½ in (32.6 × 49. 5 cm)
Sterling and Francine Clark Art Institute,
Willamstown. Inv. 1914

With the exception of the pastels and the odd case in the preceding plate, Monet's most complete drawings were those made after paintings for publication in journals. About a dozen have been identified, between 1865 and 1891 (see House 1986, pp. 227–28), including two that were not published. There are impatient references to some of these drawings in letters to Durand-Ruel of 1890 and 1891: 'you know this isn't my strength; anyway I shall do my best.' (*Archives* I, pp. 334, 335, 339.)

This view of Rouen was made after the serene painting of 1872 (W217) to illustrate an article in the *Gazette des Beaux Arts*, 1 April 1883. It is not an exact record of the painting inasmuch as it alters the squarish proportions of the rectangle substantially and changes certain critical relationships. Most noticeably, the tallest foreground mast – which is a dramatic dominant element in the painting, nearly three times the visible height of the spire – is transformed in the drawing to less than twice its height. The drawing appears most concerned with re-enacting the painting's execution, especially in the handling of the poplars to the left; the few dark horizontals (boats?) to the right; the darker brushstrokes along the horizon and the general distinction between the 'real' elements of the motif and their fragmented or diffused mirror-images. The graphic style of the drawing – the scribbled, curvilinear treatment of water, for instance – is much closer to the handling in contemporary paintings than to the crisp, mainly horizontal brushwork of the early 1870s, when *View of Rouen* was painted.

Fishing at Poissy (35a), on the other hand, was made shortly after the painting it copies (W749) – probably for the same article – and there is a much closer correspondence between painting and drawing. Both of these drawings were made on *gilot* board, a finely textured paper which may be scratched into to produce white lines. In *Fishing at Poissy* such lines are cut into the chalk drawing partly to suggest effects of highlight, such as on the rods and the left-hand mooring post, and partly to reduce the tone of the foreground.

In all of these drawn copies, Monet appears to have treated each case on its merits, devising graphic means best able to give an account of the painting in black and white. In an 1883 *gilot* board drawing after one of the *Church at Varengeville* paintings (illustrated in Gordon/Forge 1983, p. 152), he improvised very rich, painterly equivalents to the open linear brushwork. By contrast, the softer chalk or charcoal drawing of 1891 (35b) after one of his *Haystacks* paintings (W1267), combines a very complete rendering of the chiaroscuro of the painting with an almost diagrammatic use of dotted lines to represent those *contre-jour* effects that were achieved in the painting by colour alone.

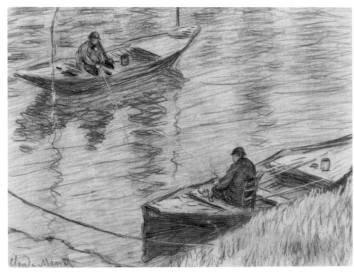

35a *Fishing at Poissy*, 1882, signed
Black crayon on *gilot* board
10 × 13½ in (26.5 × 34.5 cm)
Fogg Art Museum, Cambridge, Mass. Inv. 1965.312

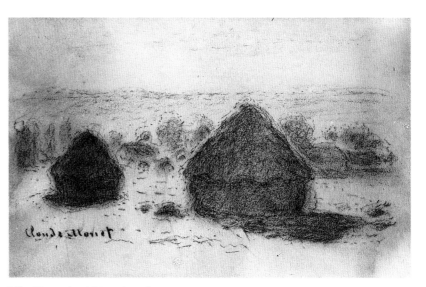

35b *Haystacks*, 1891, signed
Chalk or charcoal
6²⁄₇ × 9²⁄₃ in (16 × 24.5 cm)
Private collection

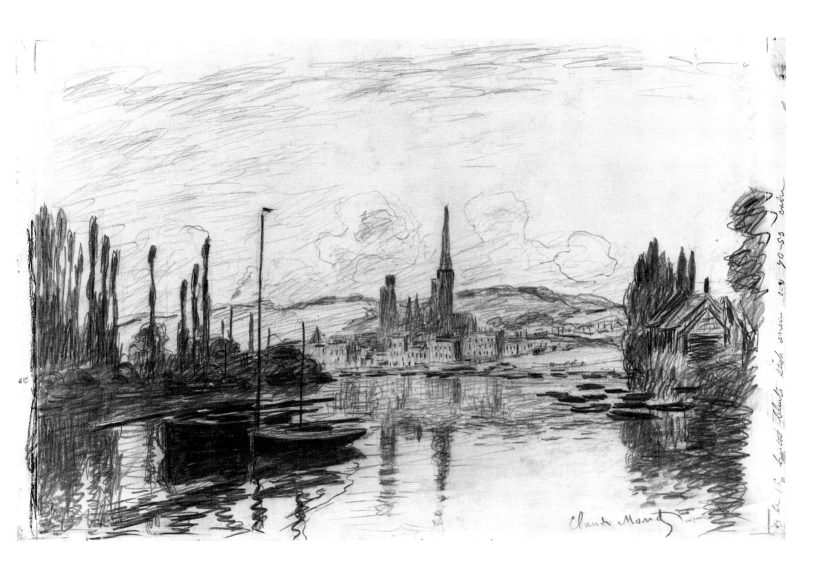

Claude Monet

36 CLAUDE MONET
Gare St-Lazare
1877
Pencil
$10^{1}/_{4} \times 13^{3}/_{8}$ in (26 × 34 cm)
Musée Marmottan, Paris, sketchbook MM 5128,
page 23 verso

Preparatory studies for the paintings of Monet's mature years were confined to drawings in his sketchbooks. They constitute 'studies' only in the sense of a sighting of possible motifs to paint. Many of them include several framing lines, usually verticals, offering alternative dispositions of the motif within a rectangle. The majority could not have served any lasting value as *aides-mémoire* during a painting because they contain so little information, nor do they represent a rehearsal of the act of painting in any meaningful sense. Their speed of execution seems as much to do with an impatience not to waste more time than necessary on drawing as with any conscious impressionist effects of spontaneity. Compared to the inventive emulation of brushstrokes in his drawings after paintings (Pl. 35), the sketchbook drawings betray little interest in technique.

Of the eight sketchbooks that survive intact at the Musée Marmottan, one was devoted to his 1895 trip to Norway, and another, containing only one drawing, was bought in Venice in 1908. The other six contain drawings covering a wide span of years, in at least one case from the 1860s to the 1920s. It seems that he used the books randomly. Drawings of any one motif appear in two or sometimes three different books, not always on adjacent pages. There are blank pages intermittently, and there is little sense of chronology in the sequence.

This drawing is the most elaborate of six studies related to his paintings of the Gare St-Lazare. It approximates to the motif of four views painted within the station, looking out past the framing canopy towards the Pont de l'Europe and tall buildings beyond (W438-441). It includes all the chief features of those paintings – a locomotive seen *contre-jour*, its smoke rising against the roof, and various figures on the tracks – in more detail than is usual in his sketches. The fact that it nevertheless does not correspond precisely to any painting, and features some details that are included in none, suggests that it was an early investigation of the subject, even the first, that facilitated his choice of vantage points from which to paint. Some other drawings from this group represent views outside the station, dominated by signal posts and framed by the Pont de l'Europe (36a). Again the correspondence to paintings of the motif is oblique, and as a preparation for painting, Monet's sketches are in marked contrast to Caillebotte's carefully drawn reference studies of similar subjects (36b).

In Monet's paintings and drawings of Parisian subjects of 1877/78 lie the seeds of the extreme technical improvisation with which he was to treat the rural landscape in the 1880s and beyond. The restlessness of urban motifs (Gare St-Lazare, rue Montorgeuil, rue St-Denis) presented novel and challenging problems, without the secure precedents enjoyed by his early landscapes, and generated the most radical, graphic innovations in execution.

36a *Gare St-Lazare*, 1877
Pencil
$9^{2}/_{3} \times 12^{2}/_{5}$ in (24.5 × 31.5 cm)
Musée Marmottan, Paris, sketchbook MM 5130,
page 13 recto

36b CAILLEBOTTE: study for *Le Pont de l'Europe*, 1876
Pencil and ink
$6^{2}/_{7} \times 7^{1}/_{2}$ in (16 × 19 cm)
Private collection, France

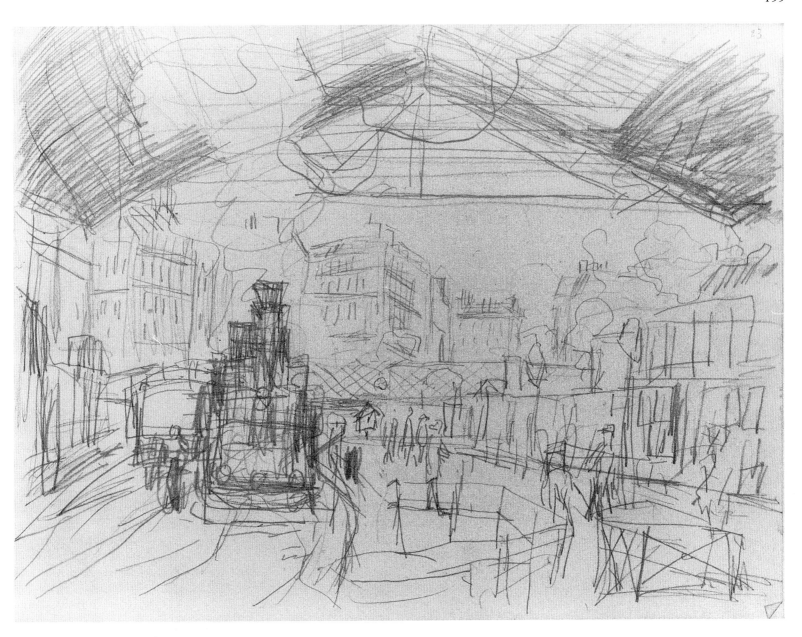

37 CLAUDE MONET
Cows on a river bank
c. 1885/90
Pencil
9¹/₂ × 12²/₅ in (24 × 31.5 cm)
Musée Marmottan, Paris, sketchbook MM 5129,
page 3 recto

This rapid sketch is of a subject that Monet apparently chose not to pursue in a painting. While the relatively domestic nature of the landscape might most resemble his river paintings of the 1870s, the motif itself and the manner of the drawing both suggest that it belongs with his work along the banks of the Epte of the later 1880s. Monet's evident attraction to the symmetry of the reflected image relates to the abiding interest of his Giverny paintings. Certain forms, such as the chevron shape created by the mirrored receding bank, or the four smoke-like plumes of the trees and their reflections, recur in many later paintings.

The image is drawn in continuous running lines, as if the pencil scarcely leaves the paper, pausing briefly to characterize the furthest cow but everywhere else constantly moving on with a purposeful energy and yet with as much finesse as unravelled wool. The line makes little distinction between foreground and background, or between the image and its reflection. The only development in such drawings lies in a reassertion, in slightly firmer lines, of some of the contours. Their urgent, restless calligraphy anticipates the brushwork in coloured lines of such Giverny paintings as the *Japanese Footbridge* canvases.

The many sketches related to his series paintings of the 1890s served his habitual practice of investigating possible vantage points from which to paint. Some represent rejected ideas, like the horizontal study of poplars reproduced below (37a). In no extant painting from his *Poplars* series did he pursue the compositional drama of the isolated trunk to the right, standing clear of the sinuous background curve that features so prominently in so many paintings.

Among prospecting drawings for the major series subjects, there are fewest for the Rouen Cathedral paintings, possibly reflecting his use of photographs of the motif for the same purpose. The study below (37b) is closest to those paintings that gave prominence to the Tour d'Albane to the left (W1345–1349), although none includes this much sky. Another adjacent drawings from the same sketchbook (p. 5 recto) corresponds to the more closely framed motif of most of the paintings. The slightness of these tremulous drawings – less about the magnificent architecture of the Gothic façade than about the dissolution of its surface under ever-changing light effects – undermines a recent tendency among historians to read social or cultural significance into the selection of Monet's motifs. There is little either in what we know of Monet's attitudes to his subjects, or in the way that he drew and painted them, to suggest that Rouen Cathedral represented a monument from France's cultural history for him. He told Thiébault-Sisson that the idea originated from watching the effects of light on the church at Vernon. The extremeness of the cathedral series lies in its contrast between the constant grid of the façade – so obsessively redrawn in canvas after canvas that its identity recedes – and the volatile nature of the light effects that tangibly transformed its appearance. Drawings like this sketch represent, in effect, the only traces of the façade's structure to survive the continual process of transformation.

37a Study for *Poplars on the Epte, c.* 1891
Pencil
9³/₇ × 12²/₅ in (24 × 31.5 cm)
Musée Marmottan, Paris, sketchbook MM 5129,
page 15 verso

37b Study for *Rouen Cathedral façade, c.* 1894
Pencil
4⁵/₇ × 7 in (12 × 18 cm)
Musée Marmottan, Paris, sketchbook MM 5134,
page 6 recto

38 CLAUDE MONET
Two studies for *Nymphéas*

c. 1920
Pencil/crayon
Each 10¼ × 26⅘ in (26 × 68 cm)
Pages 13 verso and 14 recto of sketchbook MM
5128 above, and pages 17 verso and 18 recto of
sketchbook MM 5128 below
Musée Marmottan, Paris

It is not clear what part – if any at all – was played in Monet's mature paintings by a preliminary drawing on canvas. While two contemporary accounts, of 1888 and 1899, mention his practice of a rough charcoal drawing on the canvas, House claims that there is no evidence of such drawing after about 1875. Perhaps the linear mapping-out of his sketchbook drawings unsurped this function for him. Another account of 1888 describes an initial laying-in of each canvas 'with a combination of slashes of comparatively unmixed colour, by means of long thin hog's hair brushes'. (See House 1986, p. 66.) The one or two unfinished canvases among his later works that reveal a relatively complete charcoal underdrawing appear to be exceptional and to support the idea that Monet adopted a singular attitude towards portraits, as discussed above in notes to Plate 34.

The increasingly linear execution of Monet's paintings from the 1880s culminates in the bravura graphic qualities of the final *Nymphéas* paintings (cf. Fig. 85). There are twenty-four such drawings among the pages of two sketchbooks that relate to these paintings. Urgently drawn in a flowing arabesque across facing pages, some of them obscure an earlier drawing beneath. Perhaps, due to his failing sight, he was unaware of the first sketch; perhaps he knew and did not care. Framing lines suggest that most were drafts of painting motifs, but it is possible that some were made as working drawings during the evolution of a painting in the studio, and not necessarily always from nature. The two reproduced here approximate to the configuration of several paintings made for the Orangerie cycle. The foreground bank suggested by the curved line of the upper drawing appears in no painting, but there is a similar shape formed by lilies in several (e.g. W1964 and 1965).

The cursory organic lines of the lower drawing, particularly on the right page, echo the obsession of Monet's last works with a juxtaposition of horizontal and vertical axes on the horizonless water surface. In some of the most linear paintings, this is enacted by the strata of lilies receding from the eye, and the hanging forms of willows which meet and, through their reflection, appear to penetrate the surface (38a). They are the most meditative of all Monet's painted images – still rooted in the intense looking of all of his art, but inevitably suggesting that his constant contemplation of the visual ambiguities of the water surface came to stand for more profound thoughts about an eternal cycle behind the constant flux of appearances: always the same but never the same. The evolution from the fluent immediacy of his early drawings to the painfully achieved ambiguity of these last images is comparable to Cézanne's contrast of his own first *'petite sensation'* to the 'confused sensations' that he described at the end of his life. Monet's final condensation of the complexity of his experience of nature into painted surfaces, alive with drawing and focusing on the meeting of horizontals and verticals, may also be rewardingly compared to more or less contemporary drawings by Mondrian (38b). In those, too, an earlier absorption with the symmetry of reflections in water gave rise to an austere symbolic image of the eternal in nature.

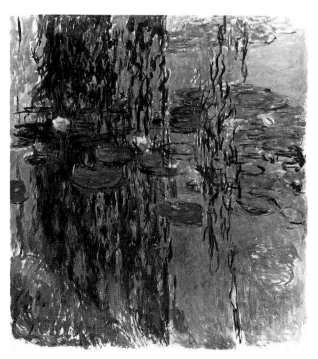

38a *Nymphéas*, 1916/19
Oil on canvas
78¾ × 70⅞ in (200 × 180 cm)
Musée Marmottan, Paris. Inv. 5117

38b MONDRIAN: *Pier and Ocean*,
1914
Charcoal, heightened with
white, on buff paper
34⅗ × 43¾ in (87.9 × 111.2 cm)
Museum of Modern Art, New
York. Inv.1 337 0156

39 GUSTAVE CAILLEBOTTE
Two men with umbrellas
(study for *Rue de Paris: Temps de Pluie*)
1877
Chalk
18¹⁄₈ × 11⁴⁄₅ in (46.1 × 30 cm)
Private collection, France.

In his time Caillebotte was esteemed as far more than the wealthy and supportive fringe-member of impressionism he is most often described as today. For Huysmans, the art of Caillebotte embodied the clearest expression of life, 'the supreme quality of art', with 'an intensity that is truly incredible'. The sobriety and cool detachment of his drawing, which perplexed others, was for Huysmans the essence of modern painting: selecting nothing, rejecting nothing. That Caillebotte eschewed the most extravagant technical improvisation of impressionism was the key to his achievement of 'a strict and absolute truth of tones' (*L'Art Moderne* 1883). In an obituary of 1894, Alexandre singled out the clarity of Caillebotte's drawing as his strength.

Caillebotte used drawing almost exclusively at the service of painting. There are a few very early sketches and on occasion, he – like others – made a drawing after a painting for reproduction. Almost all his other extant drawings are preparatory studies. Between them, the drawings for any one painting constituted the most elaborate preparation by any impressionist painter between the early work of Degas and the major paintings of Seurat. Each part of the motif was considered in detail. Individual figures were drawn and redrawn, grouped and regrouped. Although the study of a kneeling man (39a) was not finally used in the painting *Raboteurs de parquet*, the charcoal drawing is retouched with white in accordance with the painting's raking light. Varnedoe (1987) has proposed revealing comparisons with the academic practices of his studio teacher Bonnat.

This drawing of two men with umbrellas is one of a series of walking figures which formed the cast of *Rue de Paris: Temps de Pluie*. They appear to be studio-posed drawings, but are conceived as anonymous passers-by, their identities concealed or muted, who have incidentally coincided and overlapped. They are all walk-on parts. Their chance relationship has no past and no future and its arbitrariness is echoed by the deadpan regularity of the lines in which they are drawn. Caillebotte's urban images are the quintessence of that absence of narrative focus in impressionism which prompted so many anxious attempts by commentators to uncover hidden anecdote or subversive political intent in an unadorned account of urban experience. There were several perspective studies for the painting. The drawing shown here (39b) plots the position of an umbrella and the relative position and scale of subsidiary figures against the architecture.

39a *Kneeling man* (study for *Raboteurs de parquet*), 1875
Charcoal, heightened with gouache
18³⁄₅ × 12³⁄₄ in (47.3 × 32.3 cm)
Private collection, France.

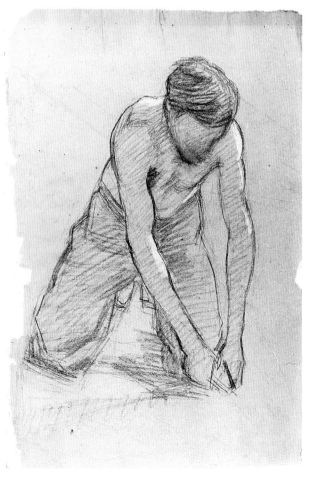

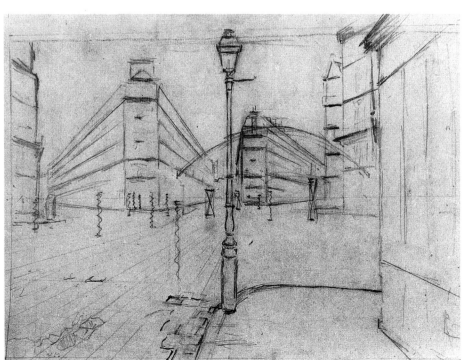

39b Perspective study for *Rue de Paris: Temps de Pluie*, 1877
11⁴⁄₅ × 18¹⁄₈ in (30 x 46 cm) Private collection, New York

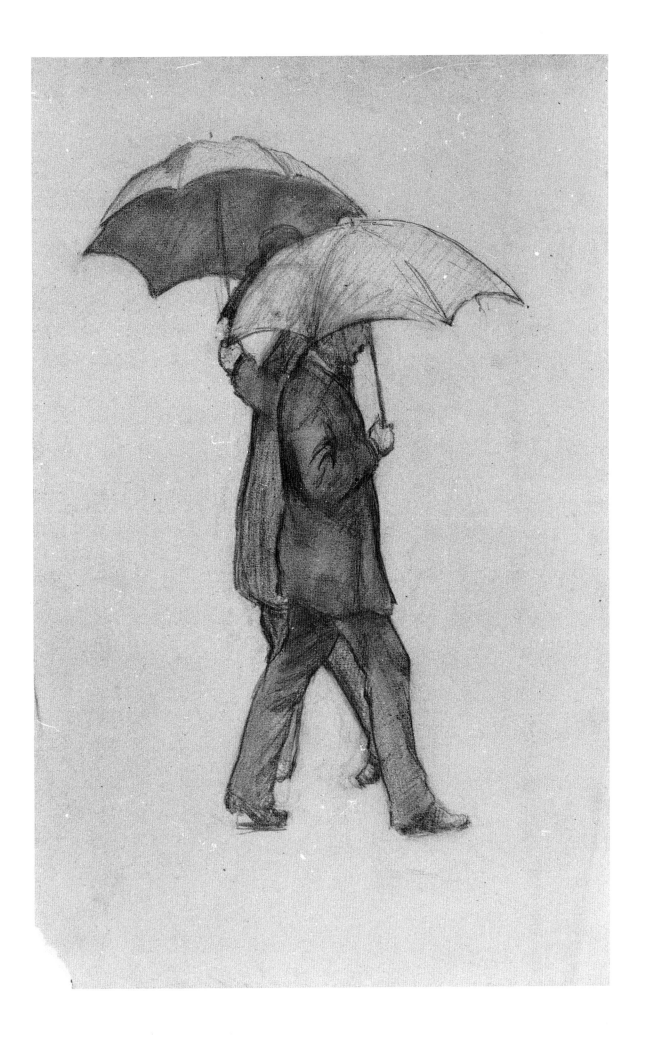

40 CAMILLE PISSARRO
Eclipse of the sun No. 5
c. 1854, stamped
Pencil
11³/₅ × 9¹/₃ in (29.5 × 23.65 cm)
Fogg Art Museum, Cambridge, Mass. (Gift of Mr and Mrs Joseph Pulitzer Jr.). Inv. 1974.161

From the outset of his career, Pissarro saw drawing both as a self-sufficient activity and as a preparation for painting. He was the most prolific draughtsman among the impressionists. Encouragement to understand the importance of drawing through its practice is one of the most recurrent themes in his letters to his son Lucien: 'don't forget to draw'; 'draw more often'; 'draw just for the sake of drawing'; 'no other activity is so intelligent and agreeable'. Like the letters of van Gogh, this remarkable correspondence is a rehearsal – in both its constants and its variables – of what he says to himself.

Apart from five years at a French boarding school, Pissarro spent his childhood in St Thomas, Virgin Islands, where he was born. His first serious activity as an artist was in Venezuela, where he spent two years (1852–54) with the Danish painter Fritz Melbye. The earliest drawings that we know have the sort of received technical clichés evident also in the facile adolescent oeuvres of Monet, van Gogh and others. The slick hatching and jerkily accented contours of this study of trees are visible in several of Pissarro's surviving drawings of the 1850s. Others, in pen and watercolour as well as pencil, show quite different, unrelated mannerisms.

When he finally settled in France, in 1855, his first drawings still show him prospecting among a range of available idioms. The soft pencil drawing (40b) of cottages and trees at Montmorency, where he spent the summers of 1857 and 1859, has a few colour notes and may relate to a (lost) painting. In the domestic character of the landscape and in its increasingly accomplished techniques, it resembles the mid-century drawings of Rousseau, Diaz, Troyon and others.

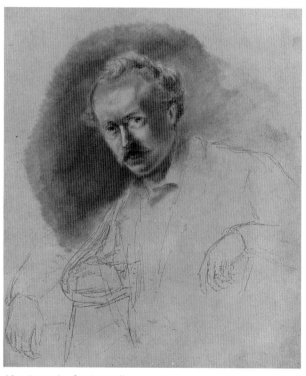

40a *Portrait of Fritz Melbye, c.* 1853
Pencil, rubbed
11¹/₅ × 9¹/₂ in (28.5 × 24.3 cm)
Statens Museum for Kunst, Copenhagen. Inv. Tu 35g, 1

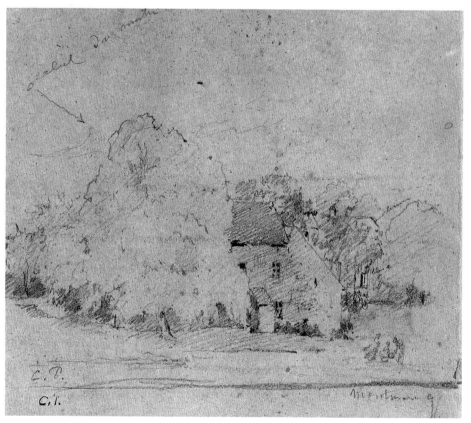

40b *Houses and Trees, Montmorency, c.* 1857, initialled
Pencil
7⁵/₈ × 8¹/₄ in (19.5 × 21 cm)
Kunstmuseum, Basel. Inv. 1978.909

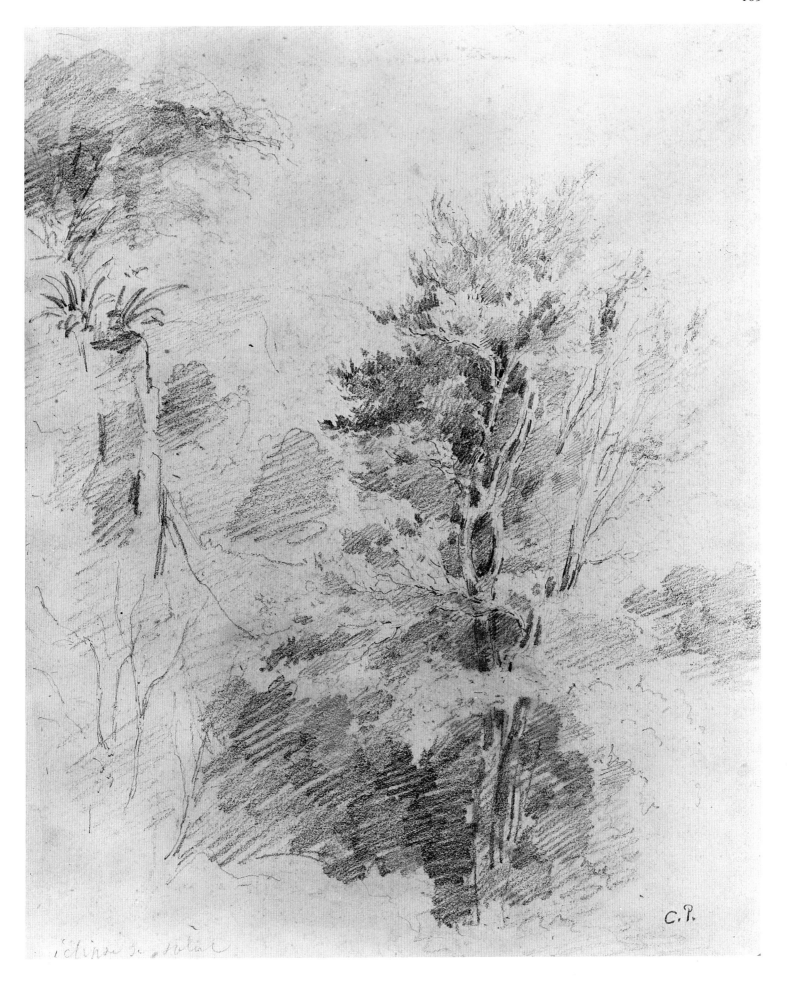

éclipse de soleil

C.P.

41 CAMILLE PISSARRO
Landscape, Montmartre
Dated 1861, stamped
Black chalk
$8^2/_3 \times 11^3/_5$ in (22 × 29.4 cm)
Kunstmuseum, Basel. Inv. 1978.910

In Paris from 1859, Pissarro continued to draw prolifically in the surrounding landscape. Although there are some figure drawings (cf. Fig. 12), the vast majority of his drawings from the 1860s are directly from landscape. He later told Lucien that he worked at the Académie Suisse and other free drawing studios at night, so that he could concentrate on painting during daylight. Possibly many drawings were lost along with the hundreds of paintings that disappeared in the looting of his requisitioned Louveciennes house in 1870–71.

It was at this time that drawing became an intimate part of the activity of landscape painting for Pissarro. His various manners of treating the landscape in drawing reflect the many artists whose work he admired and from whom he was gaining strength and ideas. The broad tonal chalk drawing of the rocky hillscape at Montmartre is comparable to Courbet's manner while at the other extreme are relatively tight pencil drawings emulating the style of Corot (41a; cf. Fig. 54). During the 1860s, he increasingly exploited the inherent qualities of different media for distinct ends, approaching the various needs of landscape painting through drawing in much the same way as Degas approached drawing the figure. Pissarro became more involved in his paintings with 'the ensemble', and his growing predilection for the softness of chalk and charcoal reflects this. *Crab-apple tree* (41b) is one of several drawings of related motifs in which the medium is manipulated to create broad effects of light and shade and simple textural oppositions. He later instructed Lucien that 'you must accustom yourself to seeing the ensemble in a flash and to render its character at once' (25 July 1883).

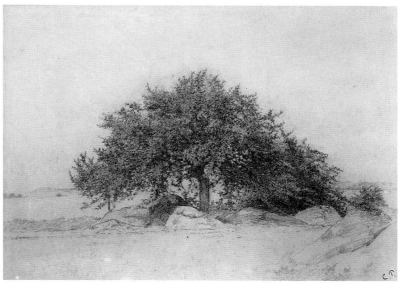

41a *Study of tree roots, c.* 1860, stamped
Pencil
$9^2/_3 \times 16^1/_8$ in (24.5 × 41 cm)
Rijksmuseum, Amsterdam. Inv. 1953.454.

41b *Crab-apple tree, c.* 1860, stamped
Chalk
$15^1/_2 \times 22^1/_2$ in (39.4 × 57.2 cm)
Collection Mr and Mrs Paul Mellon, Upperville, Virginia.

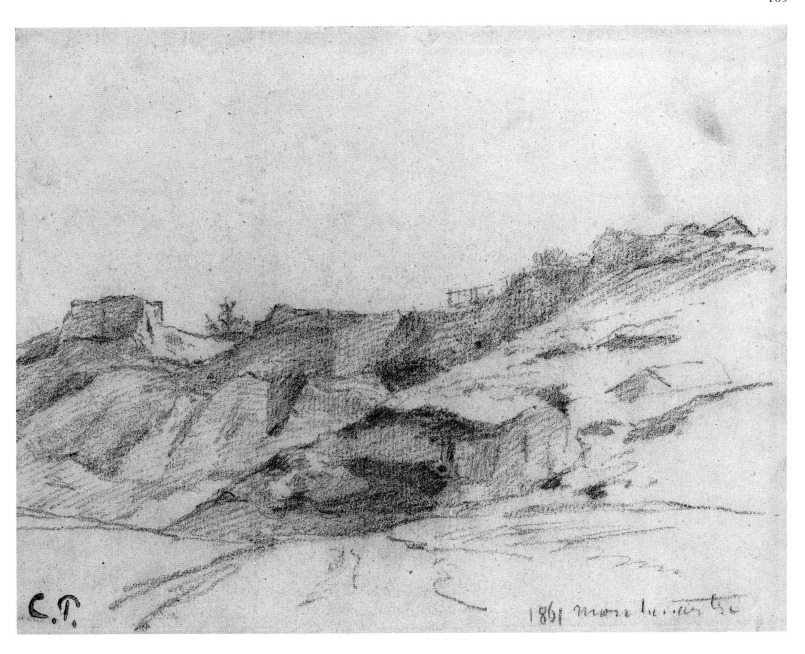

42 CAMILLE PISSARRO
The Serpentine
1871, stamped
Watercolour
5 × 7 in (12.9 × 17.9 cm)
Louvre, Dépt. des Arts Graphiques.
Inv. RF 28.796

Like Monet, Pissarro left France for London in 1870 to escape the Franco-Prussian war. The drawings he made during this first stay, from December 1870 to June 1871, are among the most detachedly impressionist of his career. He recalled later: 'Living in Lower Norwood, at that time a charming suburb, I studied the effects of mist, snow and the spring.' (1902.) This sensitive watercolour seems to fall into the last category. Pissarro's revived use of watercolour, from about 1869, may have been prompted by the example of Jongkind. The particular transience and full-bodied wash of this study – unparalleled in his work before this date and only occasionally used subsequently – is arguably attributable to the influence of Turner. His general attitude to English watercolourists was not particularly respectful, but we know that he spent time looking at Turner in the National Gallery, where some watercolours were permanently on view. Later he successively exhorted Lucien and Matisse to look at Turner's work in London; lamented that none was available to study in Paris, and mentioned Turner in the same breadth as Delacroix and Corot. Only right at the end of his life was he prompted (by the inference of an English critic, Dewhurst, that Turner and Constable were effective fathers of impressionism) to discuss the shortcomings of Turner and his debt to French eighteenth-century art. His discovery of Turner in 1870–71 served to confirm the direction his art had already taken in the 1860s.

Pissarro's pencil and pen drawings of the London suburbs are mostly working studies for paintings, directly drawn from the motif, many of them with notes of colour and atmospheric conditions. They resolve the topography of the motif, the broad silhouettes and tonality, and the lively impressionist spirit of the paintings (42a). These drawings established a working practice. Although some later studies are freer, especially when working in softer media (42b), and increasingly assured, they reveal the same swift record of the outlines and tonal relationships. If the practice of preparatory studies seems at odds with *plein air* immediacy, it is also true that the manner of these drawings rehearses and underwrites Pissarro's practice of landscape painting.

42b *Study of a landscape with fruit trees, c.* 1890, stamped
Black chalk
4 × 6¼ in (10.1 × 16 cm)
Ashmolean Museum, Oxford. Cat. 176A

42a *Upper Norwood, London, with All Saints Church,*
1870/71, stamped
Pen and brown ink over pencil
6⅛ × 7⅘ in (15.6 × 19.8 cm)
Ashmolean Museum, Oxford. Cat. 68E recto

Serpentine —

C. P.

This assured pastel is full of the autograph qualities of Pissarro's 1870s impressionism. Its subject is the domestic French landscape, whose simple, poetic charm had become the focus of his paintings since the mid-1860s. The uncomplicated vision, that 'honesty' of which contemporaries wrote, and the clarity of light are hallmarks. In the reduction of the motif and the firm assurance of his execution it stands between the more busy linear detail of earlier works (Pl.41a, 43a) and the soft dissolving light of a later pastel like *Boulevard de Clichy* (Pl.47). The crisp substantial handling may be compared to his Auvers paintings from which Cézanne learnt so much. Such works were also seminal for Gauguin's early landscapes, under Pissarro's guidance, at Pontoise at the end of the decade.

Apple-picking is drawn on buff paper which provides the middle tonality and from which the drawing moved up and down in tone to extremes of white and black chalk. The soft breadth of the handling of foliage is complemented by both the animated drawing of branches and the solid but simple indication of the figures. Maturing out of the formative influence of Barbizon drawings, it typifies the essential early Pissarro at his most relaxed. The watercolour *Factory on the Oise, Pontoise* (43b) has a comparable clarity and freshness, even though the motif is less pastoral. Recently, historians have tended to read such images as the beginnings of Pissarro's conscious allusion to the inroads of modern industry into the French landscape. There are enough examples to substantiate an argument, but, for all the dominance of vertical chimneys and horizontal smoke, this drawing nevertheless radiates a light and charm that are absent from the painting for which it is a study.

43 CAMILLE PISSARRO
Apple-picking
c. 1870/75, stamped
Pastel with black and white chalk
13²⁄₅ × 19¹⁄₂ in (34.2 × 49.4 cm)
City Art Gallery, York

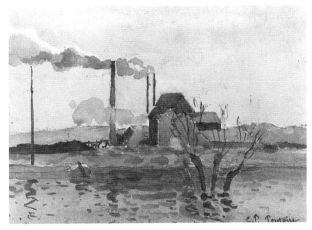

43b *Factory at Pontoise*, 1873, initialled
Watercolour over pencil
7 × 9⁷⁄₈ in (17.7 × 25.1 cm)
National Gallery of Art, Washington (Collection of Mr & Mrs Paul Mellon). Inv. 1985.64.109

43a *Country lane with trees and lake*, early 1870s? signed
Black chalk?
11³⁄₅ × 18¹⁄₃ in (29.5 × 46.5 cm)
Rijksmuseum, Amsterdam, Inv. 1958.113

44 CAMILLE PISSARRO
Market Place, Pontoise
1886, signed
Pen·and ink over pencil
6³/₅ × 5 in (16.8 × 12.7 cm)
Metropolitan Museum of Art, New York
(Robert Lehman Collection). Inv. 75.1. 679

Pissarro's attraction to the circles of neo-impressionist painters in the mid-1880s was twofold. Firstly, the regularity of the pointillist technique seemed to offer a solution to some of his own technical problems with painting, and, secondly, he found there a more serious political commitment than he had managed to identify among most of his impressionist peers. Differences at this level were responsible for many of the serious factional disagreements within the group in the 1880s.

Pointillism as a way of drawing was a very brief incident in Pissarro's oeuvre: there is only a handful of drawings in the manner of this 1886 study. The mechanical procedure by which a tonal scale of dots is distributed across and within a broad pencil underdrawing is reminiscent of the calculated schema of academic drawing. Pissarro's painstaking adherence to the system reminds us of the guileless submission with which he applied himself to the study of one master after another in his early drawings. Like Renoir, he entered another confused phase of learning in his drawing of the mid-1880s. His fierce criticism of Renoir's classicizing experiments with line maybe reflects the intense concentration on his own problems of the time. By 1888, he realized that the monotony of a technique which he had first embraced as 'a new phase in the logical progress of impressionism' was at odds with the 'suppleness, spontaneity and freshness of sensation of our impressionist art'. He later recalled that with this technique it became impossible 'to follow nature's so fugitive and admirable effects . . . [and] to give a particular character to my drawing' (1896).

The subject matter of this drawing is both at one with his personal philosophy and comparable to the simple dignity he recognized in the work of Seurat. In other market motifs, attention has been drawn to Pissarro's contrast of the sturdy integrity of the peasants with their customers, 'the sick bourgeoisie' (Oxford 1986, p. 49). What is beyond doubt is the increasing importance of the figure in his iconography of the 1880s. The peasant women of Pontoise and Gisors are drawn with an heroic but unsentimental sense of scale. The earthbound 'truth to seeing' in his drawing of people and things stemmed from the same instinct that fostered his feelings of anathema towards Symbolism and his rejection of what he saw as Monet's 'romantic' subjectivity. The polar difference here was that while Monet appeared to be in pursuit of nature through its transient flux, Pissarro's conscious quest was increasingly for an underlying order, a dream of visual unity.

44a *The Market Stall*, signed and dated 1884
Tempera and watercolour
24 × 19 in (61 × 48.2 cm)
The Burrell Collection, Glasgow

44b *Baskets, c.* 1889 Charcoal 8⁷/₈ × 12 in (22.5 × 30.5 cm)
Philadelphia Museum of Art (Henry P. McIlhenny Collection). Inv. 1986.26.26

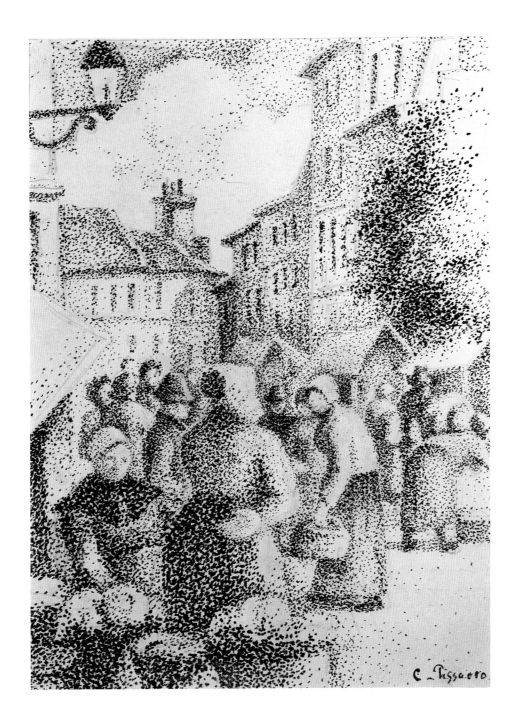

45 CAMILLE PISSARRO
Two studies of a peasant woman
c. 1895
Black chalk and pastel
18 × 17¼ in (45.7 × 43.8 cm)
National Gallery of Wales, Cardiff.
Inv. NMW 412a

Pissarro's paintings of peasant women of the 1880s and 1890s are the most self-consciously composed of his oeuvre. The preparatory drawings for them fall into three categories. There are rapid sketchbook studies made in the fields or market place, most of them in charcoal and wash. *Four peasants working in the fields* (45b) is a page from one of these sketchbooks. Although the Ashmolean catalogue describes it as a study for an etching (Brettell/Lloyd 1980, p. 176), it is likely that these quick sketches were in the first instance part of an open-minded gathering by Pissarro of motifs and fragments which may or may not prove usable later, in the studio. They are drawn in the most cursory manner, a sort of *aide-mémoire* of generalized silhouettes and relationships. Their casualness becomes clear from comparison with van Gogh in front of a similar motif (Fig. 69).

A second category of studies is of individual figures, made with a particular composition in mind and more consciously posed, maybe in the studio. These two fine chalk and pastel studies, probably from the same model, demonstrate the more purposeful structure and clarity that Pissarro employed in preparatory studies. The third category of drawings consists of small compositional studies, freely drawn, often in pen.

Like those of van Gogh, Pissarro's peasant images owe something to the precedent of Millet, but unlike van Gogh, Pissarro distanced himself from the literary and sentimental aspects of mid-century realism. The distance between the gleaner drawings of Pissarro and van Gogh lies not just in the greater urgency of van Gogh's powerful Neunen drawings, but also in Pissarro's antipathy towards the religious fervour behind that urgency. For Pissarro's taste, Millet was 'just a shade too biblical' (letter, 2 May 1887).

The sympathy behind a drawing like *Boy with hands in his pockets* (45a) – closer in feeling to Monet's drawings of children than to van Gogh's – is not coloured by symbolic allusion. It reveals all that it has to say with unassuming simplicity.

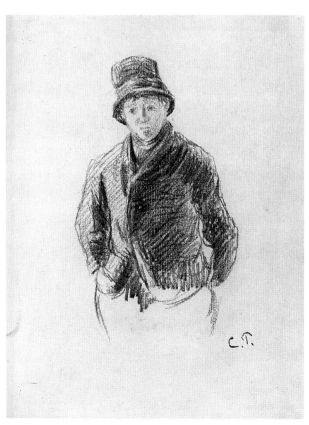

45a *Boy with hands in his pockets*, 1880s?, stamped
Black chalk
12 × 9⅕ in (30.5 × 23.4 cm)
Kunstmuseum, Basel, Inv. 1978.911

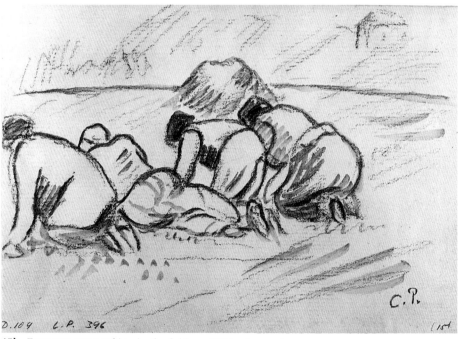

45b *Four peasants working in the fields*, *c.* 1891, stamped
Charcoal with grey wash
4 × 5⅗ in (10.2 × 14.3 cm)
Ashmolean Museum, Oxford. Cat. 225B.

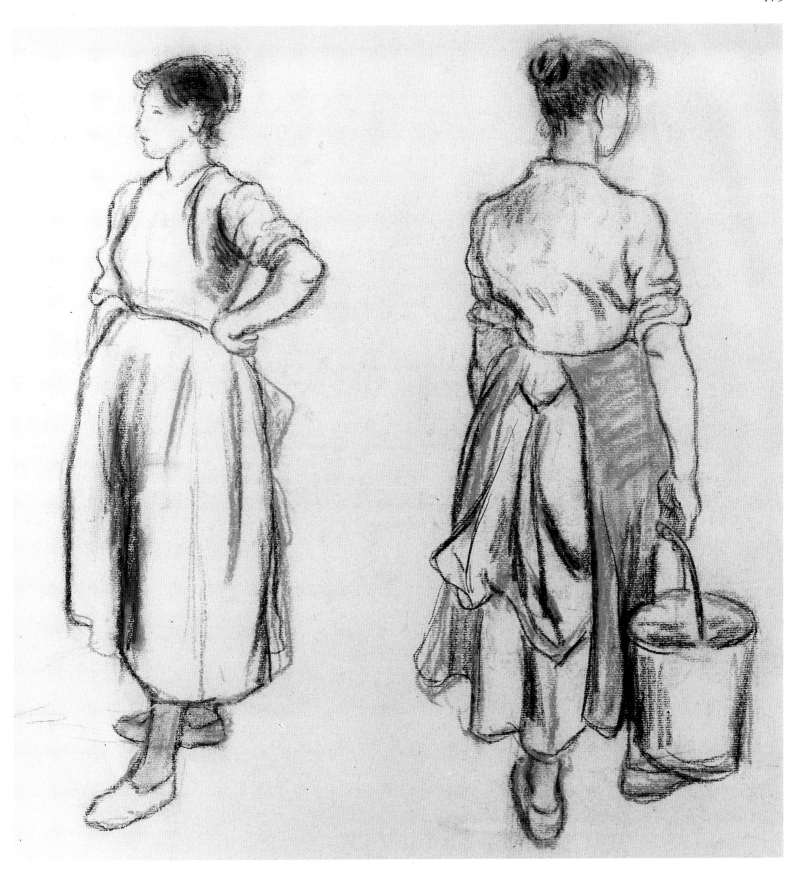

46 CAMILLE PISSARRO
Nude woman bending
c. 1894, stamped
Charcoal
11^1/$_3$ × 8^4/$_5$ in (28.8 × 22.3 cm)
Ashmolean Museum, Oxford. Cat. 257

Between 1894 and 1896 Pissarro made a series of compositions on the theme of bathers: paintings, prints and drawings. This traditional subject had enjoyed something of a revival in the wake of major paintings by Seurat and Renoir. The strongest impetus behind Pissarro's treatment of it came from the watercolours of Cézanne and the drawings, pastels and prints of Degas. Pissarro tackled the subject with great enthusiasm and, in a decade when he was actively involved with printmaking, he made variants in lithographs, etchings and monotypes. They are unusual in his oeuvre in being imaginative and sensual.

He wrote in April 1894 of 'a whole series of printed drawings in romantic style . . . Bathers, plenty of them, in all sorts of poses, in all sorts of paradises.' It was presumably their overt and unaccustomed sensuality that prompted him to write to Lucien of two etchings as 'perhaps too naturalistic, these are peasant women – in full-bodied nakedness! I am afraid it will offend the delicate, but I think it is what I do best, if I don't deceive myself.' (*Letters*, p. 227.) Although, like his contemporaries, Pissarro made and exhibited prints with an eye to public sales, it appears that he explored these qualities in his treatment of the nude more freely when working away from the public face of painting, as if printmaking was a more intimate activity. These works offer the same glimpse of a covert side of the artist beside the propriety of his peasant paintings as does Millet's treatment of the nude.

The monumental quality of this charcoal drawing of a woman bending, with its massive black contours, brings the figure drawings of Degas and Cézanne to mind as well as recalling qualities of Daumier's drawing, so often cited in Pissarro's letters as masterful. Pissarro leant on other art partly because of the difficulty of getting nude models to draw from. In July 1896 he writes of being reduced to posing himself, and some of the bathers images appear to be unclothed versions of drawings from clothed models. This drawing is possibly from a nude model, although the brevity of its detail makes it conceivable as another adaptation. the pose of the seated peasant girl (46a, presumably the same model as for Pl.45) was used in two paintings as it is, but reappears in a modified form as a nude figure in another painting and a monotype. The monotype of bathers on a grassy bank (46b) is an imagined motif, reminiscent of Degas's brothel interiors both in the intimacy of pose and in the freely wiped and scratched technique of its background.

46a *Young woman washing her feet*, 1895
Coloured chalks with touches of pastel
21 × 15^1/$_3$ in (53.1 × 38.9 cm) Ashmolean Museum, Oxford. Cat. 259

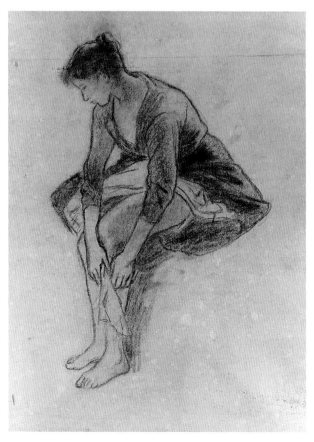

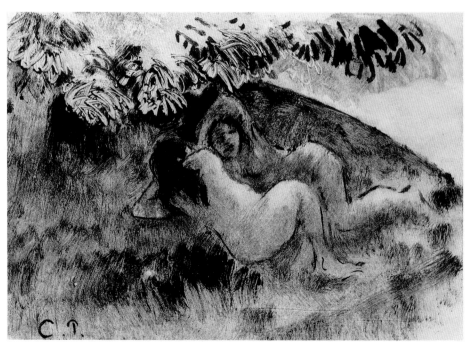

46b *Bathers on a grassy bank, c.* 1894 Monotype 5 × 7 in (12.8 × 17.9 cm)
The Achenbach Foundation for Graphic Arts, San Francisco

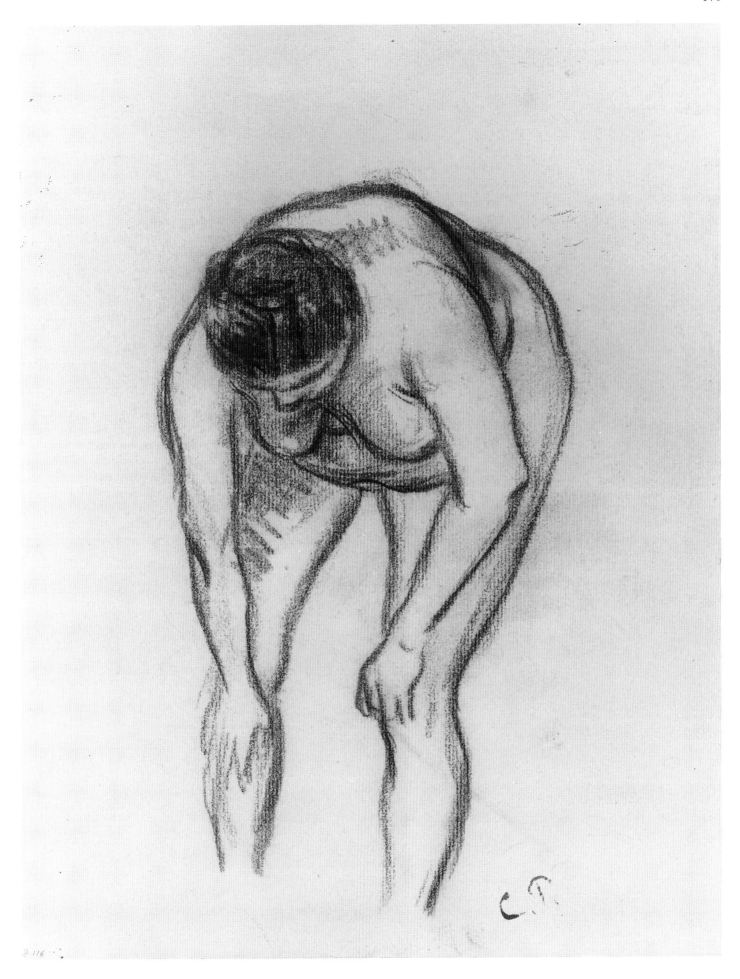

47 CAMILLE PISSARRO
Boulevard de Clichy, effect of winter sunlight
Signed and dated 1880
Pastel
23³/₅ × 29¹/₂ in (60 × 75 cm)
Private collection

This radiant pastel is among the most memorable impressionist images of Paris. It recalls the high viewpoint street motifs of Monet and Renoir in the 1870s and anticipates both Pissarro's views of Rouen and his last series of Parisian paintings. It was a drawing of considerable importance to him: large in scale (the same size as some of his paintings), signed and dated, and exhibited in the 1881 group exhibition.

The accomplished execution and firm tonality of his pastels of the 1870s has given way to a type of drawing that is wholly impressionist in the sense that means are at the service of atmospheric effects. Some sense of gravity obtains from the blacks and blues of foreground vehicles, but the rest is weightless, punctuated by the scattily abbreviated notations of trees. It is a remarkable atmospheric evocation of cold clear light and luminous shadow, muted yet alive with colour. Its apparently artless execution belies the shrewd economy of the observation and in this it anticipates the early Bonnard drawings of Paris.

In Rouen in the middle of the 1880s, he returned to painting urban motifs and he wrote enthusiastically to Lucien of a motif 'in the wet, with much traffic, carriages, pedestrians, workers on the quays, boats, smoke, mist in the distance, the whole scene fraught with animation and life' (26 February 1896). But it is in his drawings that we find the most powerful realization of the effects he was striving for in his paintings. The etching *Place de la République, Rouen* (47b) is among the most authentic of all impressionist images of rain – and there are many – as well as expressing eloquently the more dour, oppressive face of urban life without recourse to literature or sentimentality.

Pissarro's urban scenes do not as a whole dwell on the melancholy of the city. Outside his letters, the most explicit statement of his feelings about human values in urban life is to be found in the small album of pen drawings *Turpitudes Sociales* of 1890. Its cover shows a seated figure of Time (not unlike a self-portrait) looking down over Paris, with the sun of Anarchy rising on the horizon. The moral pictograms have been likened to Doré and the obsessive scratchy technique of the drawings brings them closer to popular prints than to high art. *The suicide of the forsaken* (47a) typifies the moral character of the images, the extreme act of a victim of urban life passing unnoticed in that life's mechanical course.

47a *The suicide of the forsaken*, folio 13 of *Turpitudes Sociales*, 1890, initialled
Pen and brown ink
12²/₅ × 9³/₅ in (31.5 × 24.5 cm)
Collection Mme Catherine Skira, Switzerland

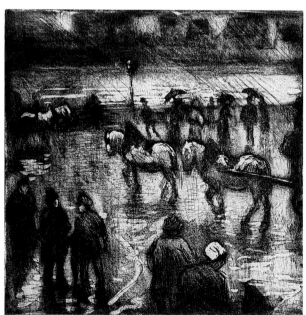

47b *Place de la République, Rouen*, 1883
Etching
5 × 5 in (12.5 × 12.5 cm)
New York Public Library.

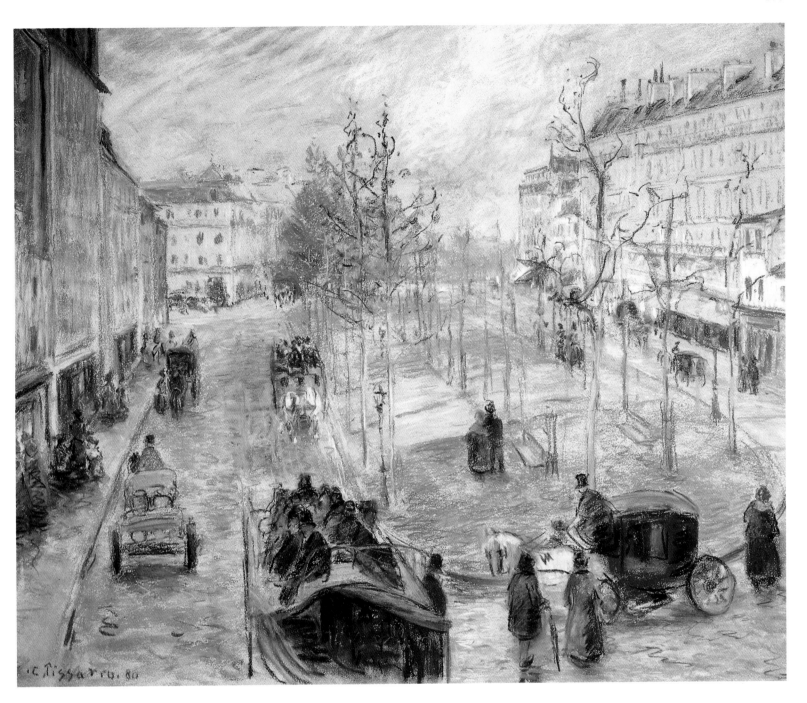

48 *Portrait of Gauguin by Pissarro; portrait of Pissarro by Gauguin*
c. 1880
Black chalk, pastel
14 × 19¹⁄₂ in (35.8 × 49.5 cm)
Louvre, Dépt. des Arts Graphiques.
Inv. RF 29538

In July 1881 Gauguin began a letter to Pissarro *'mon cher Professeur'*. His well-known later defence of Pissarro includes the acknowledgement: 'He has looked at everyone's work you say! Well why not? Everyone has looked at him too but denies him. He was one of my masters but I don't disown him.' (*Racontars de Rapin.*) Pissarro was also master to Cézanne (who writes of 'the humble and colossal Pissarro') and later to van Gogh, who remembered with great respect the guidance Pissarro had given him in Paris 1886–7, and often asked what was Pissarro's opinion of works sent to Theo from Provence.

As to Pissarro's acknowledgement of others, his angry acid comments about unnecessary intrigues among artists do not outweigh his generous appreciation of other painters, especially of those whom he sees as true to the impressionist cause: witness his warm tributes to Jongkind, Morisot and Sisley. As far as drawing is concerned, he is singularly clear-headed in his hierarchy of values. From the past, Holbein is 'the real master'; Ingres and Delacroix are the fathers of modern drawing; he has almost unqualified praise for Daumier, Corot and Cézanne, and – finally – Degas is 'without a doubt the greatest artist of the period . . . What a gap between Degas and all the others.' (*Letters*, 1883–84.)

In this remarkable sheet from around 1880, with complementary portrait drawings by Pissarro and Gauguin, Gauguin appears to look over his master's shoulder. What the drawings expose of difference between the two artists comes as much from what they say of themselves while drawing as from what they reveal of each other. Pissarro's assertive chalk drawing has the same direct clarity as his earlier drawing of Cézanne (48a), or his self-portrait of 1888 (48c). This is the Pissarro whom Zola recognized in 1868 as 'neither poet nor philosopher, simply a naturalist', upholder of 'a pure lasting truth . . . an heroic simplicity'. It is a sort of drawing that speaks clearly of the disciplined truth to seeing by which he converted Cézanne to impressionism. Gauguin's pastel drawing, on the other hand, is distant and allusive in the softness of its texture and colour. It already suggests those qualities of dream and of realities beneath the surface of appearances, which, in Gauguin's later work, were to provoke Pissarro's profound antipathy and incomprehension.

48a CÉZANNE: *Portrait of Pissarro, c.* 1873
Pencil
4 × 3¹⁄₈ in (10 × 8 cm)
Collection John Rewald, New York

48b *Portrait of Cézanne*, 1874/79
Pencil
7²⁄₈ × 4²⁄₅ in (19.6 × 11.3 cm)
Louvre, Dépt. des Arts Graphiques,
RF. 11.996

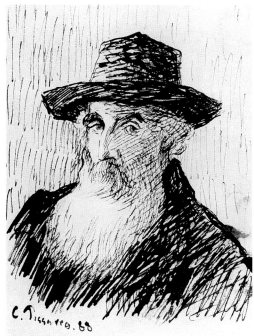

48c *Self-Portrait*, 1888
Pen and ink
6⁷⁄₈ × 5¹⁄₈ in (17.4 × 13 cm)
New York Public Library
(Avery Collection)

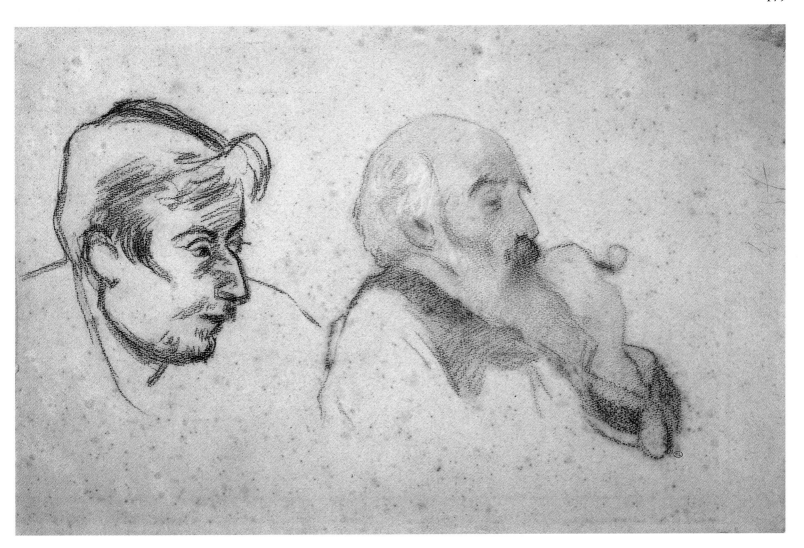

49 BERTHE MORISOT
On the Sofa
1870s? signed
Pencil, watercolour
$7^1/_8 \times 5^1/_2$ in (18.1 × 14.1 cm)
National Museum, Stockholm. Inv. NMH 189/1949

An account by Morisot's brother has survived of the private drawing lessons that she took at the age of sixteen. The teaching began 'with lessons in cross-hatching: with straight strokes for plane surfaces, with curved strokes for convex or concave surfaces; very dense for shadows, less close for half-shadows and very loose for chiaroscuro.' (*Correspondence* 1986, p. 18.) The teaching of her next tutor, Guichard, was built around copying in the Louvre. Redon felt able to observe later that 'there remain permanently upon Berthe Morisot the marks of an early artistic education which set her clearly apart, with Degas, from that group of artists whose rules and ideas have never been clearly formulated' (Redon 1961, p. 162). However, a scant relationship between her training and her independent work is suggested by Guichard's outraged reaction to the first impressionist exhibition. He wrote to her mother that 'she must break absolutely with this so-called school of the future' (*Correspondence* 1986, p. 92).

In the intervening years she had been guided by Corot, 1861–62, who found her immensely talented but wayward. During the 1860s she also met Fantin-Latour, Degas, Bazille and Manet. The will for independence that Corot had identified in Morisot found a sympathetic, positive environment in these circles and she showed in all but one of the eight group exhibitions. She had exhibited pastels in the Salons of 1872–73 and always included pastels and/or watercolours in her submissions to the impressionist exhibitions. A large proportion of her drawings is in these two media.

Morisot's early watercolour portraits are characterized by a formal decorum and sensitivity of touch. The fluid relationship of wash to lines, drawn with pencil and brush, is contained by a discrete localization of colours, tones and pattern. The profile poses and a calculated disposition of forms within the rectangle contribute to the sense of order observed by Redon. The pastel *In the Park* (49a) is similar in character, its sketch-like freedom offset by the dense covering of the paper with saturated colour, and by a careful balance of formal and informal elements in the composition. It is as highly wrought as the paintings she showed in the 1874 exhibition and has something of their anecdotal charm.

49a *In the Park, c. 1874*, signed
Pastel
$28^1/_2 \times 36^1/_8$ in (72.5 × 91.8 cm)
Musée du Petit Palais, Paris.
Inv. P.P.D.746

49b *Mme Pontillon and her daughter*, 1871
Watercolour
$9^7/_8 \times 10^1/_8$ in (25.1 × 25.9 cm)
National Gallery of Art, Washington (Ailsa Mellon Bruce Collection). Inv. 1970.17.160

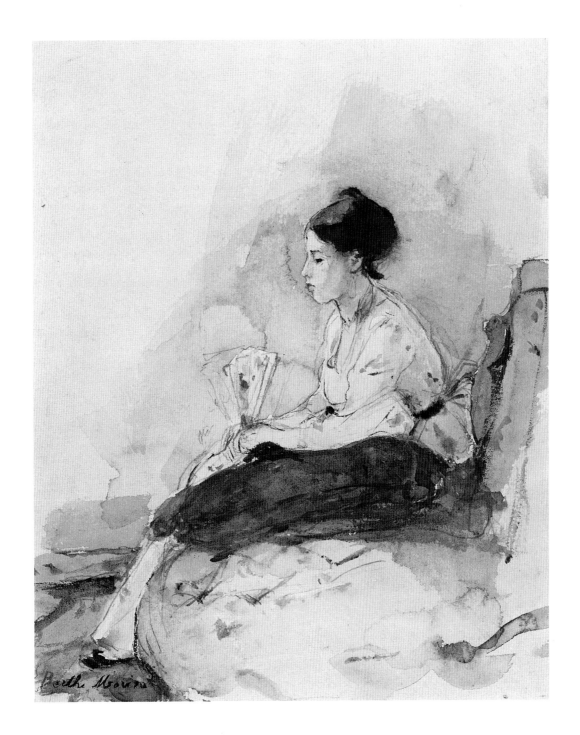

50 BERTHE MORISOT
Marthe Givaudan
1880s? stamped
Pencil
10½ × 9 in (26.7 × 22.9 cm)
Sterling and Francine Clark Art Institute,
Williamstown, Mass. Inv. 1536

Of all Morisot's early contacts, it was her meeting with Manet in the late 1860s that had most lasting effect upon her. His influence may be observed as clearly as anywhere in her early attitudes to drawing, which from the 1870s onwards remained open-minded and relaxed in two senses. Firstly, she flits between a number of techniques, apparently responding to the exigencies of mood, the moment, or the nature of the motif. Secondly, her black-and-white drawings are all very informal, whether studies for paintings or not. As with Manet, if there is anything self-conscious about her drawings, it lies in their studious artlessness. Their structure accumulates from a succession of marks, and in some drawings the most considered of these appear to be the lines with which she signed her name. Her figure studies combine loose contours with rapid hatching, which on occasion is rubbed into a soft tone with the fingers. Characteristically, there are fleeting notations for the features. Like most impressionist drawings, they are not only notes of what she might paint, but also anticipate the technique of those paintings.

For all their impressionist brevity, most of Morisot's figure drawings carry a prevailing sense of individual character that verges on portraiture, or of human incident that verges on narrative. Except in rare landscape studies (Pl.X), she did not use drawing as 'a way of seeing' at the expense of what she was looking at. Despite a stylistic sameness that comes from such autograph mannerisms as her shorthand drawing of eyes, there is a distinct sensibility to personality even in this cursory drawing of Marthe Givaudon. The same is true of the quietly vivacious observation in her two studies of a woman drinking tea (50b). It is without the high theatre of Degas or Lautrec watching people. The drawing is so soft and slight that it is easy to overlook the acuteness of her perception.

50a Study for *Girl in a Green Coat*, 1893, stamped
Pencil
6⁴⁄₅ × 4 in (17.5 × 10.2 cm)
Metropolitan Museum of Art, New York
(Robert Lehman Collection). Inv. 1975.1. 674.

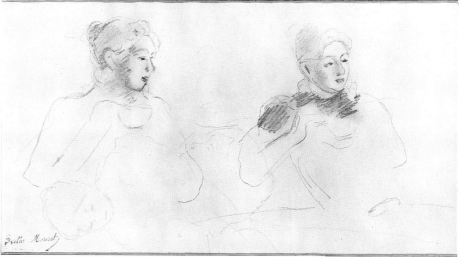

50b *Two studies of a woman drinking tea*, 1880s? stamped
Pencil
8⁵⁄₈ × 14¼ in (22.2 × 36.2 cm)
Fogg Art Museum, Cambridge, Mass. Inv. 1962.17

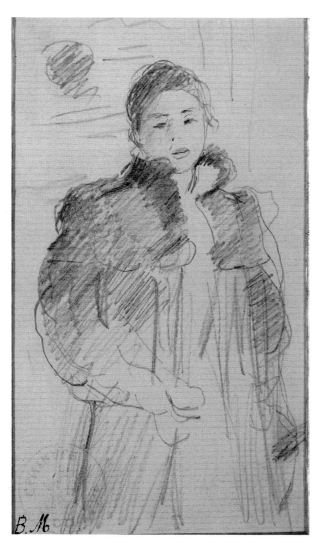

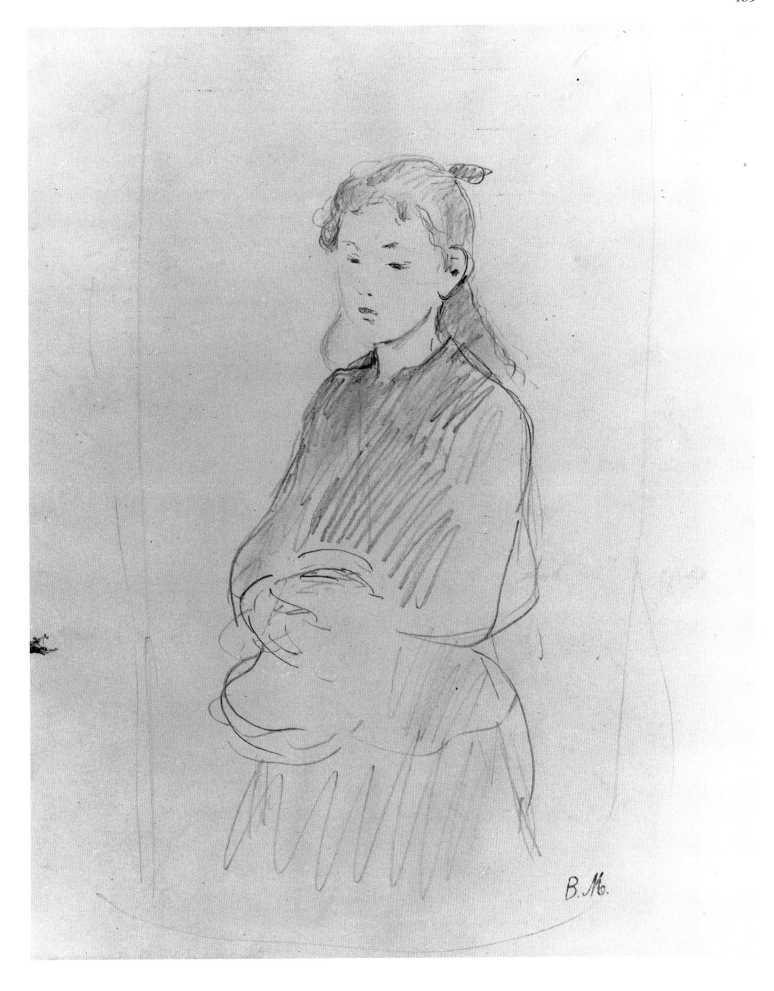

51 BERTHE MORISOT
The Cheval Glass, study
1890
Pencil
11³/₄ × 7⁷/₈ in (29.8 × 20 cm)
Louvre, Dépt. des Arts Graphiques
Inv. RF 12005

This drawing is unusual in Morisot's oeuvre, firstly in being more of a genre motif than the study of an individual and secondly, in probably being drawn from a professional model. The motif is close to a later drawing by Cassatt (Pl.21), and they were both possibly inspired by the toilette images of Manet and Degas, which sought a means of treating the nude in terms of modern reality. It was this quality that attracted the attention of supportive critics, even of Huysmans who did not altogether approve of Morisot since, for him, she suffered all the shortcomings of Manet. He wrote that she had a rare sensitivity to appearances, but 'as always she limits herself to improvisations that are too summary, constantly repetitive'. Nevertheless, she is 'a nervous colourist, one of the only painters capable of understanding the fine delicacies of the mundane toilette' (Huysmans 1883, p. 252).

The fact that there are few nudes in Morisot's oeuvre may say something about her being a woman. More significantly, it expresses an attitude towards subject matter that was almost untouched by traditional conventions. There are a few experimental drawings by her of nudes located in imaginary landscapes, but they appear quite anomalous in the broad context of her work and almost certainly reflect an influence of Degas, Pissarro or Renoir that distracted her temporarily from her intuitive concerns. By the 1880s she had become a close friend of Renoir and was deeply impressed by his pseudo-academic drawings (see notes to Pl.27).

The various studies she made for a group of paintings of peasant subjects, in 1890–91, also show her responding to external influences. They include several nude studies for clothed figures. Studies for *The Reclining Shepherdess* (51a) typify the more ordered sense of structure and substance and the relative impersonality of these drawings. Morisot's brief excursion into this sort of subject matter can be seen as her response to the wave of restlessness that touched most of the original impressionists in the 1880s.

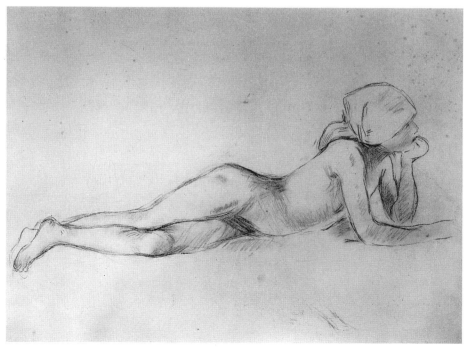

51a *Reclining nude girl, wearing headscarf*, c. 1891
Red chalk
17¹/₃ × 22 in (44 × 56 cm)
Statens Museum for Kunst, Copenhagen. Inv. Tu 35b,3

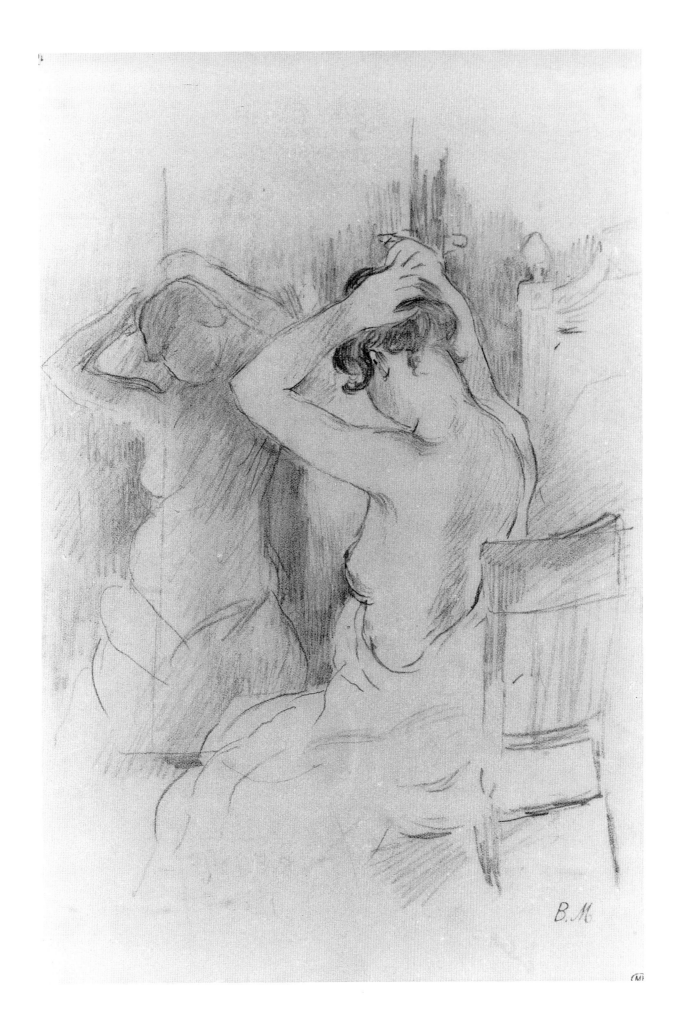

52 BERTHE MORISOT
Julie Manet and Jeannie Gobillard practising
c. 1887/90
Red and black chalk
23 × 21 in (58.4 × 53.3 cm)
Private collection

The majority of Morisot's surviving drawings are datable, for various external reasons, to the period between the 1880s and her death in 1895. It seems more reasonable to attribute this to the greater value that she put upon drawing in her last years than only to the loss of earlier work. She chose to exhibit drawings for the first time at the last group exhibition in 1886.

The unexpected clarity of this drawing, especially in the pure contours of the heads, reflects her passing flirtation with Renoir's style of the 1880s. While subsequent works revert to a looser manner, they retain stronger senses of contour and of physical substance.

The character of Morisot's last drawings is close to the more curvilinear brushwork of her last paintings. In most there is a strong impressionist sense of drawing against time. Degas, who never squandered compliments, assured Morisot that 'her somewhat vaporous painting concealed the surest draughtsmanship' (*Correspondence* 1986, p. 171). At the memorial exhibition of 1896, Degas insisted on the drawings being well hung: 'Those drawings are superb, I think more of them than all of these paintings.' (*Diary of Julie Manet*, p. 86.)

That Julie Manet and her cousin Jeannie Gobillard were the subject of many drawings of the last few years expresses the increasingly intimate focus of her art. Valéry (who later married Gobillard) wrote sensitively about the degree to which Morisot's art and life were integrated. In contrast with Degas, who was 'incredibly ignorant of everything in life that can neither be part of nor serve the work of art', Morisot's peculiarity was 'to live her painting and paint her life, as if the interchange between seeing and rendering . . . were to her a natural function, a necessary part of her daily life' (Valéry 1960, pp. 64, 119). Some contemporaries found the unfamiliarity of this intimately personal sensibility disturbing: they wrote of its strangeness or of an art made 'with her nerves on edge'.

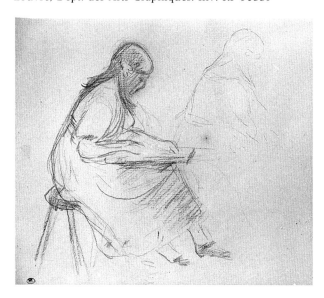

52a *Young girl drawing,* Early 1890s
Blue crayon
7²/₃ × 8¹/₂ in (19.5 × 21.5 cm)
Louvre, Dépt. des Arts Graphiques. Inv. RF 31885

52b *Study of two girls writing at a table,* Early 1890s
Pencil, heightened with pastel
8¹/₇ × 10²/₅ in (20.7 × 26.5 cm)
Private collection

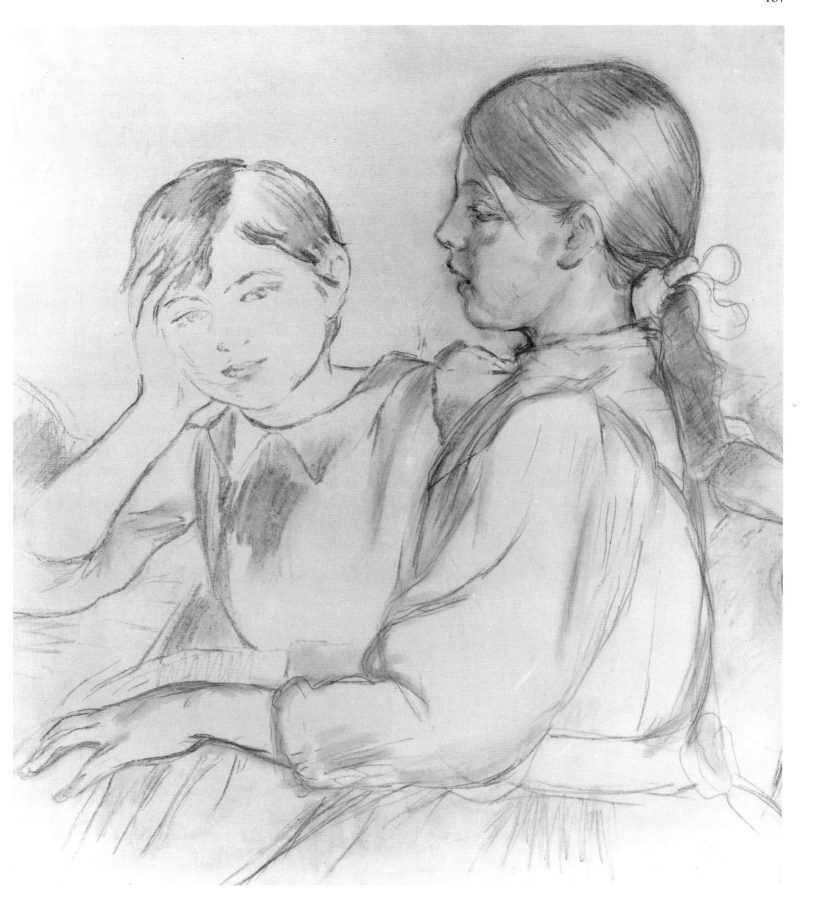

53 BERTHE MORISOT
In the Tuileries Gardens
c. 1885
Watercolour and pencil
10 × 12 in (25.4 × 30.3 cm)
Statens Museum for Kunst, Copenhagen.
Inv. 18291

Arguably her most impressionist works, Morisot's later watercolours were singled out by Redon for the delicacy, subtlety and vitality that distinguished her from her peers (Redon 1961, p. 163). We do not know which four watercolours he saw at the 1880 group exhibition. *Lady in a park* (53b) is of that period and matches his description. It prompts comparison with Boudin or Jongkind in the animated handling of the medium and with Baudelaire's dream of an art that looked vivaciously at the everyday. The handling suggests an eye constantly on the move, things acutely seen but never realized. In a few coloured crayon landscape drawings (Pl.X) there is a similar scattering of visual notations without ambition for a coherent whole.

In this drawing of the Tuileries Gardens, a Manet subject, the picturesque charm of its cameo motif is submerged. We can probably guess who these two girls are, but in the context of the drawing they are as anonymous as the figures on paths below. What is more, their significant reality as figures dissolves in the complexity of the ensemble, which takes the form of a nervous disarray of slight, luminous marks. It is as if a succession of perceptions are laid side by side and coalesce in front of us. While appearing to disdain all qualities of finish in drawing, the impromptu freshness and transient visual truth of the image are manufactured with practised accomplishment.

Mallarmé teased Morisot about the triviality of her subject matter and her taste for 'the moderate groves and mediocre shades of the Bois'. Manet's painting of the Tuileries gardens was peopled by portraits of friends and the famous. The relative inconsequentiality of her subjects is integral to the character of Morisot's work: it was an expression of her vision that she eschewed the full-dress trappings of high art. She once observed that Manet spent most of the Franco-Prussian war at home, trying on his uniform.

53a MANET: *In the Tuileries Gardens, c.* 1862
Chinese ink and wash
7 × 4²/₅ in (18 × 11.2 cm)
Bibliothèque Nationale, Paris, Cabinet des Estampes.
Inv. Dc300d-res no.13

53b *Lady in a park,* c. 1880? signed
Watercolour over pencil
7¹/₂ × 8²/₅ in (19 × 20.8 cm)
Metropolitan Museum of Art, New York
(Harris Brisbane Dick Fund, 1948). Inv. 48.10.8.

54 FRÉDÉRIC BAZILLE
Study for *The Artist's Family*
c. 1868
Pencil, chalk
11⅞ × 7⅞ in (30.1 × 20 cm)
Louvre, Dépt. des Arts Graphiques. RF 5257

Bazille's *académies* from the atelier of Gleyre (Fig. 11) suggest that he applied himself to academic method with more commitment than Monet, Renoir and Sisley, who were fellow students. In other early nude drawings (54b), there is a hint of romanticism and a tonal technique that suggests the influence of Manet, whose work Bazille greatly admired. His caricatural sketches after Manet paintings, in a sketchbook now in the Louvre (RF5259, p. 5), are not copies in the sense of learning by emulation, any more than his drawings after Delacroix or Veronese. They are simply records of art that he valued in the same way that his letters mention Courbet, Corot, Diaz, Daubigny.

Apart from the sketchbooks, a few studies for his open air figure paintings have survived. They vary from squared-up, map-like contour drawings to rough compositional sketches like this one. His most ambitious painting, *The Artist's Family* of 1868, was inspired by the precedent of Manet's and, more immediately, by Monet's large figure paintings of the mid-1860s. Bazille shared his studio with Monet in 1865 and had purchased his *Women in the Garden* in 1866. The role of his preparatory studies for the painting may be compared to Monet's (cf. Pl. 32c), but technically they are gauche rather than just hasty. The contrast between the facility of some of Bazille's drawing and the rankness of crude drawing visible here is striking. The disharmony of this sheet stems partly from its reworking: a tonal sketch in pencil (possibly on the spot) has been aggressively – almost perversely – overdrawn in black chalk.

The apparent ineptitude of Bazille's drawings lies principally in their bewildering lack of consistency, either in style or intention. At one extreme there are linear scribbles (Fig.3), often difficult to decipher but sometimes with a charge of energy and movement that affirms his admiration of Delacroix and Daumier. At the other end of the scale are relatively controlled, sensitive, perceptive studies (54a; Fig. 52). Up to a point the polarity corresponds to the difference between imaginative and observed drawings, reminiscent of the adolescent unevenness of Cézanne's early drawing. Surprisingly, there are few drawings with the austere clarity of his paintings. There is ample evidence in Bazille's sketchbooks of a more serious and spirited commitment to drawing than in the work of Sisley, for instance, and hints of a much more complex and original oeuvre, had he lived, than his surviving paintings suggest.

54a *Manet at his easel, c.* 1869
Charcoal
11⅗ × 8½ in (29.5 × 21.5 cm)
Metropolitan Museum of Art, New York (Robert Lehman Collection). Inv. 1975.1.569

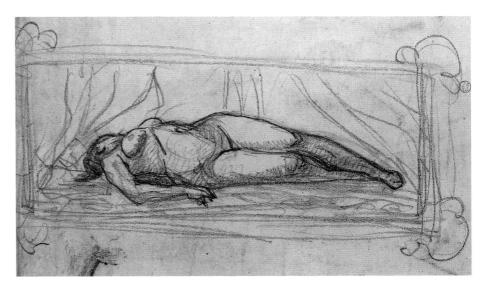

54b *Study of a nude,* 1864
Black crayon
16⅓ × 22½ in (41.6 × 57.1 cm)
Musée Fabre, Montpellier. Inv. 49-5-1

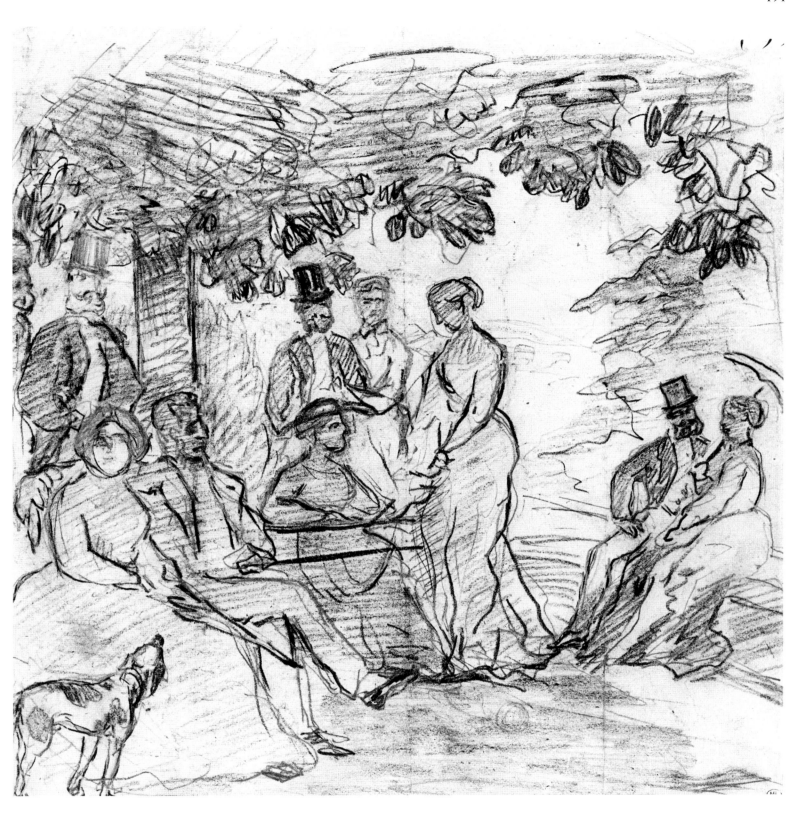

55 ALFRED SISLEY
The Plain of Thomery and the village of Champagne
Initialled and dated 1875 (or 76?)
Black chalk
11 × 16 in (28 × 40.7 cm)
Private collection

The fruits of Sisley's encounter with academic teaching in Gleyre's studio would have been interesting to see, and it appears that he even intended to present himself for the *Prix de Rome* competition (Rewald 1955, pp. 62, 78), but we know nothing of his drawings there. While it is likely that a careless attitude to drawings would put their survival at greater risk, the fact that relatively few Sisley drawings have survived also suggests that he made fewer than most. The broad evidence of those we have is of an artist not significantly committed to drawing as an activity and, of all the impressionists, seeing the least value in its relation to painting. The evidence suggests that, once moved by the example of Monet to paint directly from nature, he seems to have stuck to that principle more completely than anyone else. He contributed drawings to *La Vie Moderne* but probably, like his peers, chiefly for the publicity to be gained. He was almost alone in never submitting anything but paintings to the group exhibitions.

This animated landscape study is a painterly drawing: the differentiation of marks for different parts of the motif corresponds closely to the variety of brushstrokes in contemporary paintings. The motif relates precisely to a painting (Daulte 464) and it is presumably a working drawing for it. The assured vigour of handling of the chalk is not that of an artist unfamiliar with the medium.

The same goes for the fluent drawing in a series of titled sketches after paintings that he made in a notebook of 1883, now in the Louvre (55a). This is in the form of a catalogue with the names of patrons and prices on some pages. There are two related drawings in Rotterdam (55b). In the Louvre carnet, he appears to lose patience towards the end of sixty pages and the calligraphic marks boil over into increasingly cavalier reductions. In the more restrained drawings there is a similar improvisation of mark to match paint that is to be found in Monet's drawings after paintings.

55a *Un sentier aux Sablons*, November 1883
Black chalk
4³/₄ × 7¹/₂ in (12 × 19 cm)
Louvre, Dépt. des Arts Graphiques. RF 11596-f2

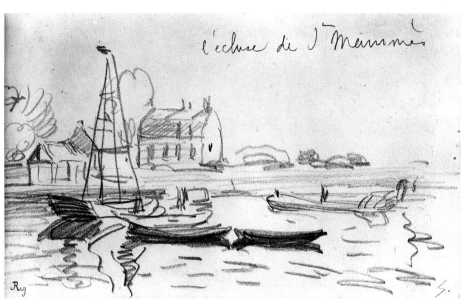

55b *The lock at St-Mammès, c.* 1885
Black chalk
5 × 8¹/₄ in (12.9 × 21 cm)
Boymans-van Beuningen Museum, Rotterdam.
Inv. F-II-144.

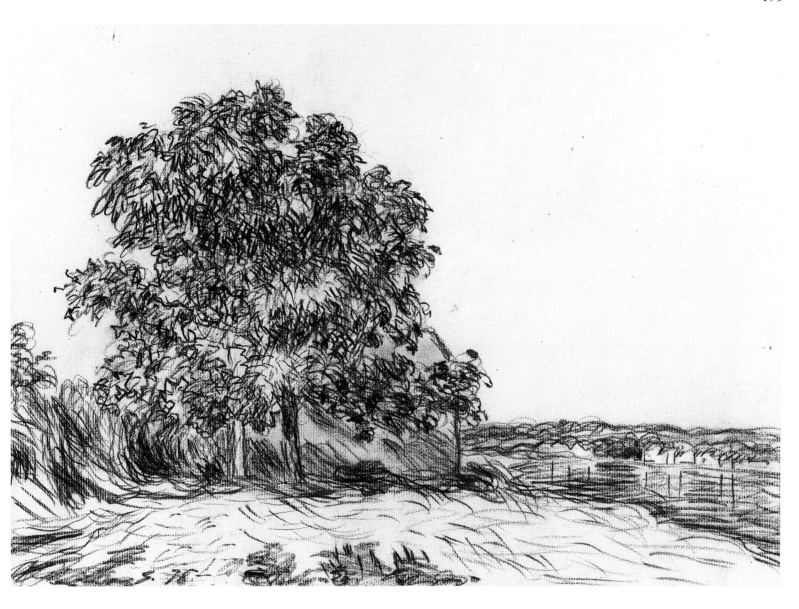

56 ALFRED SISLEY
The artist's son, Pierre
Dated 28 November 1880
Black chalk
9 × 12¹/₅ in (23 × 31 cm)
Walsall Museum and Art Gallery
(Garman-Ryan Collection). Inv. G237

The handful of figure drawings by Sisley that are known includes a group of sketches of his family and domestic interiors from around 1880, drawn perhaps when weather prevented painting. The most impressive of them is this dated study of the artist's son Pierre, who was born in 1867. The fact that the sheet has been cropped on all sides gives it a fortuitous, close-up appearance and makes the image difficult to read at first glance. Through the chaos of the sheet, there are hints of shrewd and fluent drawing that again suggest Sisley to be a more practised draughtsman than is usually recognized.

There were two principal stages to the drawing. The first was largely tonal: soft chalk drawing, rubbed across the area of the coat and table and reworked with vigorous indications of deeper shadow and folds. This was overlaid by the rapid restatement of the principal contours with sharper lines, whose accomplished strength is rather lost in the confusion of the whole fabric. It is in these lines and in the fine drawing of the wrist that we can glimpse the inherent quality of Sisley's drawing.

Another drawing (56a), presumably also of Pierre and also apparently cropped on at least three sides, is less elegant both in the speed of its execution and in the (arbitrary?) choice of a brutally hard or increasingly blunt pencil, which scratches rather than adorns the surface. The sheet with drawings of a boy reading and a young woman knitting shows many of the same characteristics (56b). The only features of technical interest are by-products of its speed. Although there is a semblance of tonal continuity between the two figures, they are each drawn in a quite different manner and may be separate studies sharing a page. (This is certainly true of a related sheet with the same two figures, also in the Louvre, RF 29652.) This drawing too spills off the page. Perhaps the apparent cropping of sheets discussed above was the product of a casual sense of *mise-en-page*.

56a *Head of a child, in profile, c.* 1880
Pencil
8 × 6¹/₃ in (20.5 × 16.1 cm)
Louvre, Dept. des Arts Graphiques. RF 29655

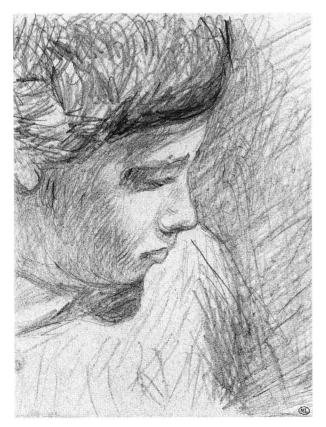

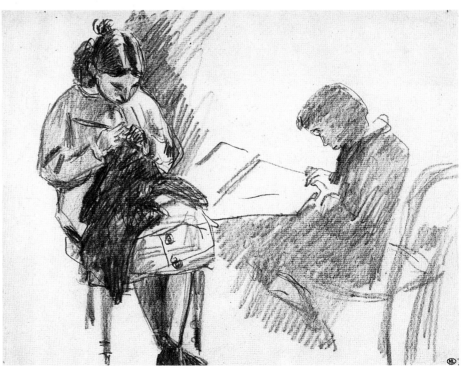

56b *Young woman knitting and boy reading, c.* 1880
Black chalk
9¹/₅ × 12 in (23.4 × 30.7 cm)
Louvre, Dept. des Arts Graphiques, RF 29653

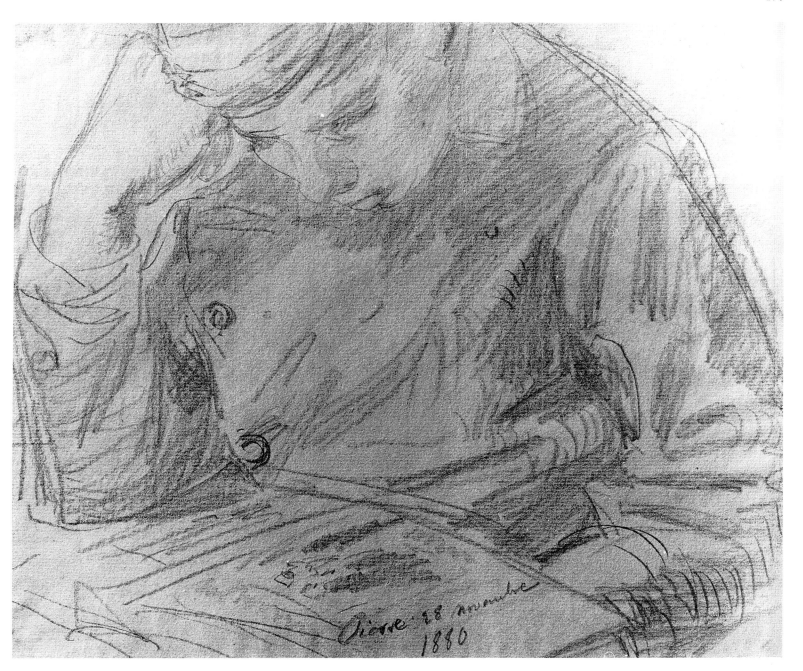

Pierre 28 novembre
1880

57 ALFRED SISLEY
Trees on the shore
Initialled and dated July 1897
Coloured crayons
6¼ × 8¼ in (16 × 21 cm)
Musée du Petit Palais, Paris

Sisley did not show his work in the fourth, fifth or sixth impressionist exhibitions and after his (largest) contribution to the seventh group show of 1882, 27 paintings, he withdrew into a somewhat isolated life in Moret-sur-Loing. He was poor and apparently depressed about his lack of success; Renoir once recalled watching him cross the street in order to avoid speaking to old friends.

His late work has been the subject of some disagreement: partisan writers have been at pains to argue for the positive quality of experiment of his last years as a parallel to the innovative character of Monet's later impressionism. The difference in character between later and earlier drawings corresponds broadly to differences in his paintings, where the crisp handling of the 1870s gives way to a looser, flowing quality of brushstrokes. This late landscape drawing relates to a painting of the coast outside Cardiff harbour (Daulte 866), which shows the same motif from a slightly different viewpoint. The drawing is in coloured crayons and its function appears to have been solely as preparation for the painting: a rehearsal of possible composition and to some extent of the free linear brushmarks used in the painting.

Other coloured drawings of the later years exist in their own right. In a letter of May 1888, Sisley lists a suite of eight pastels to be shown in his one-man-show at Durand-Ruel, including a series of six views of the Gare de Moret, subtitled variously 'snow and frost', 'snow in sunlight', 'frost', 'thaw', 'winter sunlight', 'March snow' (*Archives* II p. 62). It is not clear which of these describes the Cincinnati drawing (57a). This sequence of a single motif under different atmospheric conditions precedes Monet's major series paintings, presumably prompted by similar motives. Other pastel and coloured crayon drawings, principally of geese and some of them densely worked in relatively flat areas of local colour, appear to belong to the same period. A colour lithograph on the same theme was published by Vollard in 1897. The range of Sisley's late drawings suggests the same restiveness as his last paintings.

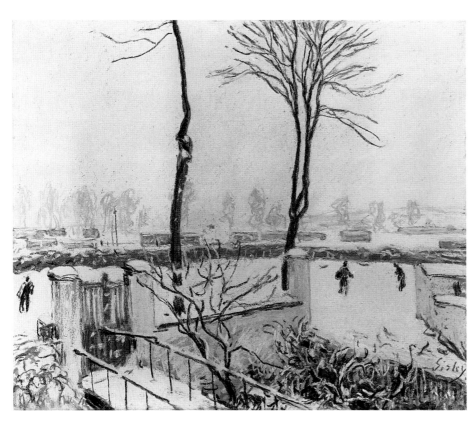

57a *Approach to the railway station at Moret, winter*, 1888, signed
Pastel
15 × 18 in (38.4 × 46 cm)
Cincinnati Art Museum, (Bequest of Mary Hanna). Inv. 1956.120

57b *Studies of geese, a peasant woman with a cow*, 1890s?
Pencil and coloured crayons
Three sheets
2¾ × 5⅛ in (7 × 13 cm) signed
2⅓ × 2¾ in (6 × 7 cm)
2⅓ × 2⅛ in (6 × 5.5 cm)
Metropolitan Museum of Art, New York
(Robert Lehman Collection). Inv. 1975.1.727

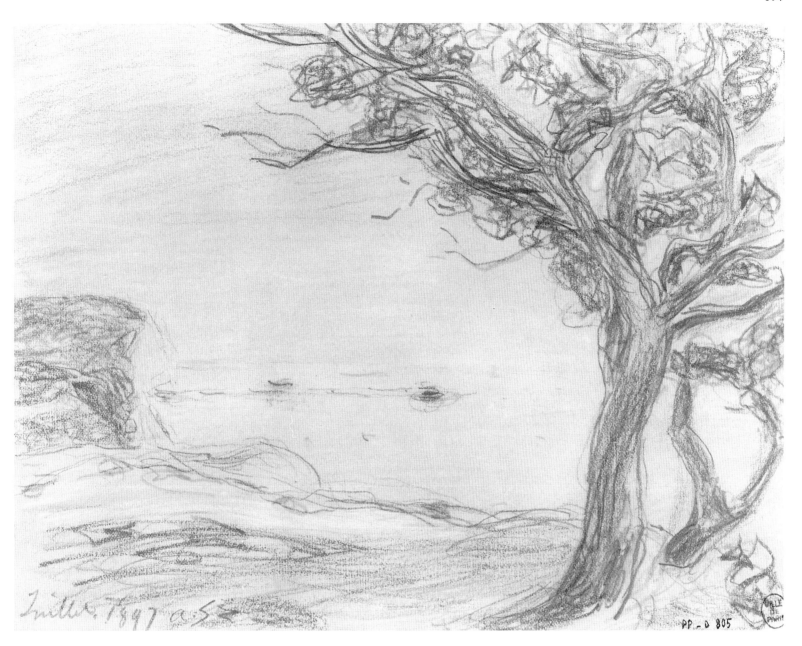

Juillet 1897 a S. PP – D 805

58 PAUL CÉZANNE
Study for *L'Eternal Feminin*
c. 1870/75
Pencil and black crayon
7 × 9¼ in (17.7 × 23.6 cm)
Kunstmuseum, Basel. C258

In a colourful cameo eulogy to Cézanne of 1889, Huysmans mentions among the landscapes and still lifes 'some childish and barbaric sketches . . . disconcertingly off-balance' and, a little later, naked bathers 'enclosed by crazed but passionate lines . . . with the fire of a Delacroix'. He concludes that Cézanne was 'an artist with diseased retinas who, through the exasperated visions that he saw, diagnosed the first symptoms of a new art' (*Certains*, pp. 42–3). Qualities that gave rise to such hyperbole are most apparent in Cézanne's early drawings. Even more than the baroque extravagance of his early paintings, these drawings suggest the sort of artist that Huysmans describes. Scenes of violence and excess, and fantasies of the unattainable are drawn with a furious energy that re-enacts their content and which might aptly be called barbaric.

In this drawing, the abandoned display of naked figures around the margins forms a sort of chorus to the main subject. This type of physically extravagant composition reflects his admiration for Delacroix. The strange figure who peers (smiling?) around the right edge of the frame resembles an earlier drawing of Delacroix, from a photograph, in the Musée Calvet. Gowing sees the principal reclining figure as a self-portrait; it certainly resembles other self-images. The pose of the figure has been likened to Delacroix's *Death of Sardanapalus* (cf. Fig. 33). A more likely source is Michelangelo's figure of *Giorno* from the Medici Chapel, well known at the time from casts and engravings, his head half-hidden by a massive shoulder and left arm bent back in a pose very similar to Cézanne's. There is even a cursory echo of the curved scroll from the sarcophagus.

These drawings say a great deal about the baroque scale of Cézanne's vision, about his predilection for sensual energies in drawing and about his use of drawing as a kind of private workshop. The same tastes and instincts inform his later *Bathers* images; the choice of painting and sculpture that he copies; and – in a subsumed form – the sensuality of his later drawn treatment of landscape and still life.

58a *The Rape, c.* 1868/70
Pencil, page from a sketchbook
4 × 6⅔ in (10.2 × 17 cm)
Kunstmuseum, Basel. C197

58b *Scene of violence, c.* 1869/72
Reed pen, ink and wash
5½ × 7⅙ in (14.1 × 18.2 cm)
Kunstmuseum, Basel. C254

1934. 162 (XV).

59 PAUL CÉZANNE
The Temptation of St Anthony
c. 1873/75
Pencil
5¹⁄₈ × 8¹⁄₄ in (13 × 21 cm)
Staatliche Museen, Dahlem, Berlin,
Kupferstichkabinett. Inv. NG35/72
C448 (as collection unknown)

Scenes of temptation in Cézanne's early work occupy a middle ground between images of display and sexual abandon and those of brutal aggression and death. His interest in St Anthony as a subject was inspired by Flaubert's *Tentation de Saint Antoine* (extracts were published in 1856–7, the book in 1874), but the iconography of his images is freely improvised. In this drawing St Anthony shields his eyes from his temptress, his falling diagonal pose located between the arm of the devil touching his shoulder and an open bible before him. The scene takes place against the mouth of a cave, where a Goyaesque owl flies up in front of sky and mountains beyond. The drawing is aggressively crude. It appears that a more sensitive first state was violently reworked. Insistent redrawing of contours, particularly in the two main figures, almost penetrates the paper – possibly for tracing.

A predilection for narrative drama even haunts his life drawings at the Académie Suisse (59a). The objectivity of this reclining nude, with its Manet-like schematic tonality, is embroidered into drama by the fleeing 'assailant', disappearing into a cavernous arch. This flattened arch is a memory of his early copy of a Granet painting of the Colosseum (Gowing, London 1988, fig. 6). Maybe the cave mouth of *The Temptation* springs from the same memory? About fifteen years later, three drawings of a view looking out of a cave, probably at Bibemus, bear a striking similarity to this setting (59b; R429-30). Rewald writes obliquely of one of them as having 'a monumentality beyond that of the natural aspect' (Rewald 1983, p. 190). Some historians argue strongly against interpretation of the early work as an insight into Cézanne's mature art (e.g. Chappuis 1973, pp. 18–20). For Gowing, by 1872, 'his juvenalia are behind him leaving little mark on his stable and humble maturity' (Gowing, New York 1988, p. 21). But memory was important for Cézanne and his later years were after all spent painting and drawing in the landscape of his adolescence. The early polarity between fantasy and the real was submerged but did not disappear. Our understanding of the late landscapes is impoverished if we insist on purging them totally of the imaginative dimension behind his later drawings of carnival (C935–37) and the great late *Bathers*, whose mood is as much bacchanale as pastorale. Another late drawing, which Chappuis titles 'Venus and Cupids' (C967), is clearly a reprise of St Anthony's temptress.

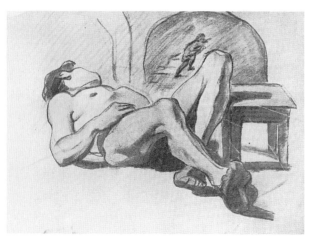

59a *Nude lying on his back, c.* 1865/67
Charcoal
Dimensions and whereabouts unknown. C106

59b *Landscape seen from inside a cave, c.* 1889/92
Pencil, page from a sketchbook
6 × 9¹⁄₃ in (15.2 × 23.7 cm)
Collection Mr & Mrs Paul Mellon, Upperville, Virginia.
C1152

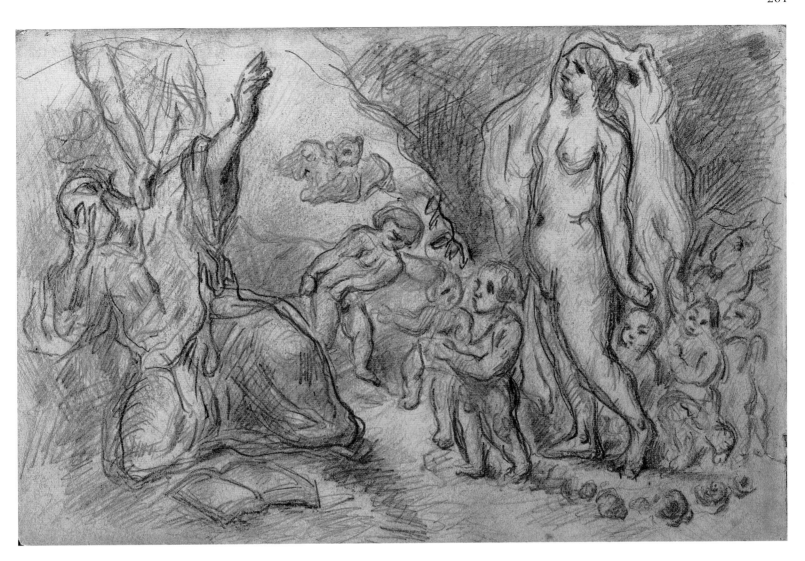

60 PAUL CÉZANNE
Portrait of Achille Emperaire
c. 1867/70
Charcoal
$19\frac{1}{4} \times 12\frac{1}{5}$ in (49 × 31 cm)
Louvre, Dépt. des Arts Graphiques. RF 31.778.
C230

Beside Cézanne's turbulent fantasy images, this moving and accomplished study comes as a surprise. 'Every time he paints one of his friends', an intimate wrote in the 1860s, 'he seems as though he were avenging himself for some hidden injury'. A brutal aggression in many drawings bears this out (60a), but the head of Emperaire is devoid of that black intensity and speaks of a sympathetic sensitivity towards the sitter. The rippling opulence of his imaginative drawings is harnessed here to finely observed detail. The study has a controlled assurance and a warmth unseen in other early drawings and only occasionally approached in later portrait studies.

The painter Achille Emperaire was an intimate of Cézanne's circle in Aix, their personal relationship close enough to become at times violent. Already eccentric in his dwarfed physique, Emperaire compounded this by outlandish behaviour and dress, but although this comes through in Cézanne's *tour-de-force* painting (V88) and in another drawing of Emperaire seated (C228), the two head studies have other concerns. The second of these (60b) is similar in its gentle mood but quite different in what it draws out of the motif. Not only does it establish the pose of the painting, but it explores precisely that poise between heraldic flatness of surface and a robust physical quality for which the painting is so remarkable. This is clear from comparison of the soft shading with which the head as a whole is realized with the area of intense shadow beyond the nose. This enclosed shape assumes a stronger pictorial presence than the nose itself and goes on to absorb the curve of the moustache. It is a product of seeing and of drawing with painting in mind – what Gowing calls 'a rehearsal of the pictorial act'. Cézanne seems to have seen fugitive details as bits of pictorial matter. Even if there are no other drawings that so explicitly prepare for a painting, there are many later drawings in which he may be seen to isolate a shape of shadow or of light as if he had the substance, even the colour, of paint in mind. His looking, drawing and painting educated each other.

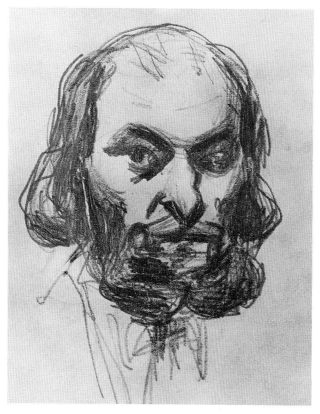

60a *Portrait of a man, c.* 1868/70
Pencil
$5\frac{2}{5} \times 5\frac{1}{3}$ in (13.8 × 13.7 cm)
Formerly collection Sir Kenneth Clark. C157

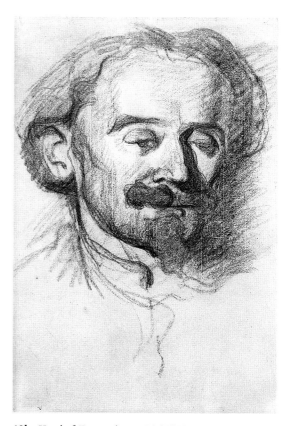

60b *Head of Emperaire, c.* 1867/70
Charcoal
$17 \times 12\frac{1}{2}$ in (43.2 × 31.9 cm)
Kunstmuseum, Basel. C229

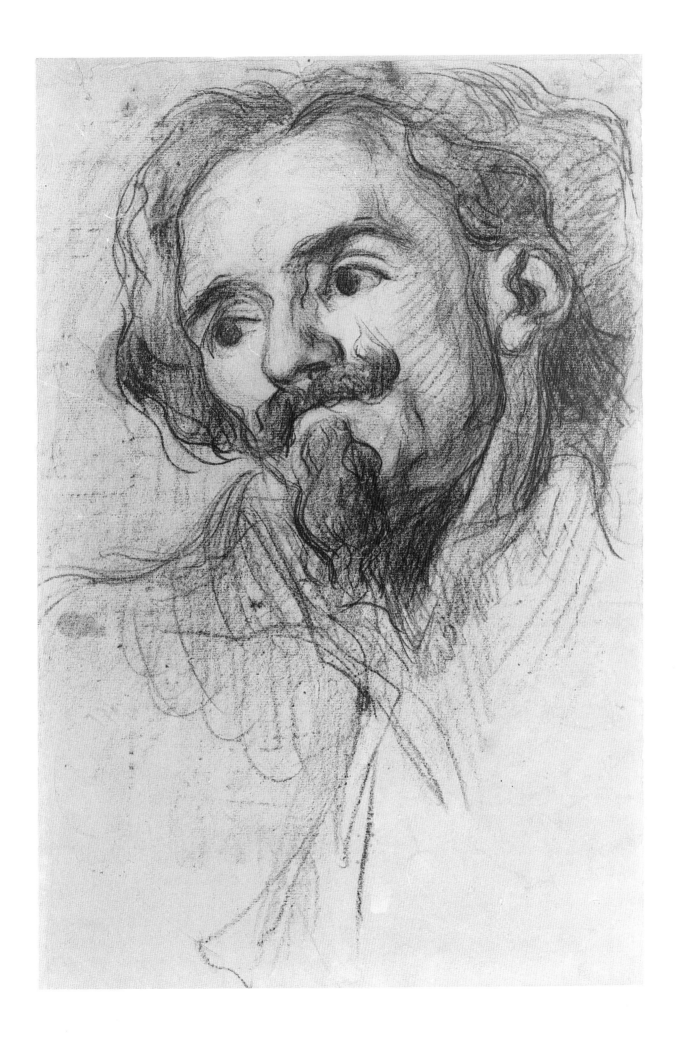

61 PAUL CÉZANNE
View of houses at the viaduct L'Estaque
Early 1880s
Pencil, page from a sketchbook
5 × 8³⁄₄ in (12.6 × 22.3 cm)
Art Institute of Chicago
(Arthur Heun Fund).
Inv. 1951. 1.C790

There are relatively few landscape drawings by Cézanne. Of the 1,223 black-and-white drawings catalogued by Chappuis (1973), the majority are figure studies and only around 200 are from landscape. Most of Cézanne's early landscape drawings are in watercolour, usually with pencil, chalk or charcoal and sometimes heightened with gouache (Pl.IV). He continued to prefer watercolour for landscape drawing: about two thirds of the 645 watercolours in Rewald's 1983 catalogue are of landscape motifs. Landscape was primarily the subject of painting for Cézanne and in his developed use of watercolour he found a medium close enough to his painting for him to use it as a test bed for those ways in which his drawings and paintings informed each other. Chappuis suggests that some drawings may be studies for watercolours and Rewald discusses some watercolours as studies for paintings.

Compared to the systematic handling of impressionist brushstrokes that he developed in paintings under Pissarro's guidance in the mid-1870s, it appears that he found pencil a less easy medium to reconcile to the problem of recording landscape. Early sketchbooks reveal his inclination to use a variety of techniques for pencil drawings of landscape that never entirely disappeared. When in the later 1870s he established a more or less consistent idiom, as in this drawing of l'Estaque, the system of notations is one derived from his painting. The sequence of analogous hatched marks, varying in size, direction and tone, resembles the fabric of brushmarks which had brought order to his painting after the tumult of his early work. Within the methodical plotting of the motif across the page, changes of tone and scale of the marks carry some indications both of distance and of contrasts of light and shadow. There is a rich contrast between full and austere forms, and a pictorial sense of scale.

In other landscape drawings (61a), the complex motif is slowly transcribed into a screen of horizontals and verticals, some of them contours shared between tree and house, or branch and horizon. The most unequivocal lines are superimposed in sharper or harder pencil, but remain various enough to sustain a sense of flux. Watercolours of the period (61b), perhaps partly just from the nature of the medium, retain the billowing fullness of early drawings. This powerful drawing, enormously complicated in the nuances of its cool palette, also hints at the rich dialogue between line and wash that he developed in his late watercolours.

61a *Hills with houses and trees, c.* 1880/83
Pencil
12¹⁄₃ × 18²⁄₃ in (31.3 × 47.3 cm)
Kunstmuseum, Basel. C798

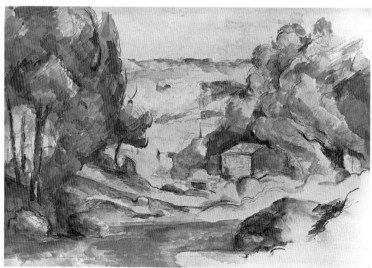

61b *Provençal Landscape, c.* 1880
Watercolour and chalk
13³⁄₅ × 19²⁄₃ in (34.6 × 49.9 cm)
Kunsthaus, Zurich. Inv. 1391. R115

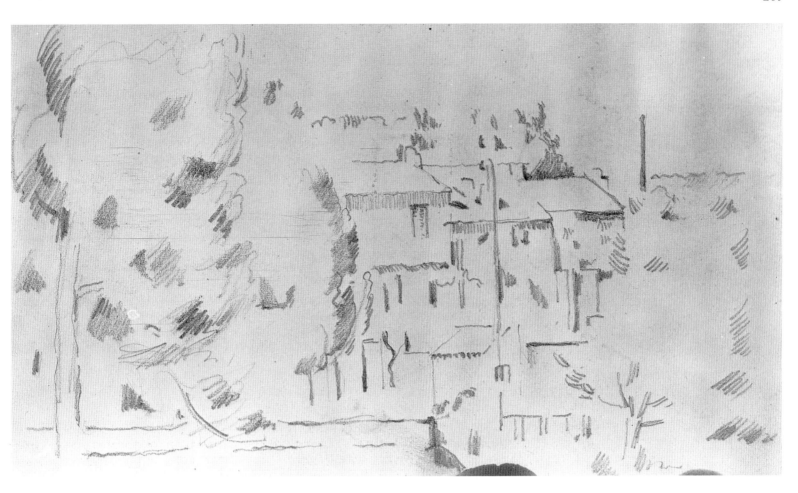

62 PAUL CÉZANNE
Still life with three pears
c. 1882
Pencil and watercolour, page from a sketchbook
4⁷⁄₈ × 8¹⁄₆ in (12.5 × 20.8 cm)
Boymans-van Beuningen Museum, Rotterdam.
Inv. F-II-210. R196

Cézanne is recorded as saying that 'drawing is a relationship of contrasts'. This quality is most explicit in his still lifes. His sketchbooks contain many studies of contrasts seen around his house or studio (head against pillow, elbow against mantelpiece, soft curve against hard angle) that are about the meeting of forms more than the forms themselves. We know from contemporary accounts how much time and care Cézanne devoted to the arrangement of still lifes. Occasionally the drawings may have been connected with paintings (Rewald 1983, pp. 28–29), but generally the still lifes represent a retreat from the changing demands of the landscape to the stability of his studio, where he could compose and control relationships. Rilke's friend Mathilde Vollmoeller imagined Cézanne before his still life: 'He sat there in front of it like a dog, just looking, without any nervousness, without any ulterior motive.' (Rilke 1985, p. 46.)

The arrangements he composed and looked at so intently ranged from formal extravaganzas to the cool simplicity of this drawing of three pears. The broken, repeated contours draw attention to the meeting of one fruit with another or to the meeting of each with the table and its echoing shadow. The few subsequent touches of watercolour amplify the focus on these moments of contact. Drawings as slight as this are sometimes considered unfinished. It is likely that Cézanne stopped work when he had achieved or learned all that he wanted.

The focal point of *Bed and table* (62a) is the coming together of iron bed-head and bedding with the angular top and swelling legs of the table. The central wineglass shape of space is emphasized with tonal contrast. A concern with abutments and coincidence animates Cézanne's drawings of almost everything. In drawings from sculpture, it is usually a particular, axial relationship of forms that absorbs him and he sometimes draws it again and again. In the little drawing of a corner of his studio (62b), he gives so little information about what these overlapping forms are that we are not wholly sure what we are looking at, or even of which way up the sheet should be.

62a *Bed and table*, c. 1885/87
Pencil and watercolour
8³⁄₅ × 10³⁄₄ in (21.9 × 27.3 cm)
Philadelphia Museum of Art (A.E. Gallatin Collection).
Inv. 52-61-11 verso. R186.

62b *Corner of a studio*, c. 1877/80
Pencil, page from a sketchbook
8¹⁄₂ × 4⁷⁄₈ in (21.7 × 12.4 cm)
Fogg Art Museum, Cambridge, Mass.
Inv. 1962.24 verso. C536

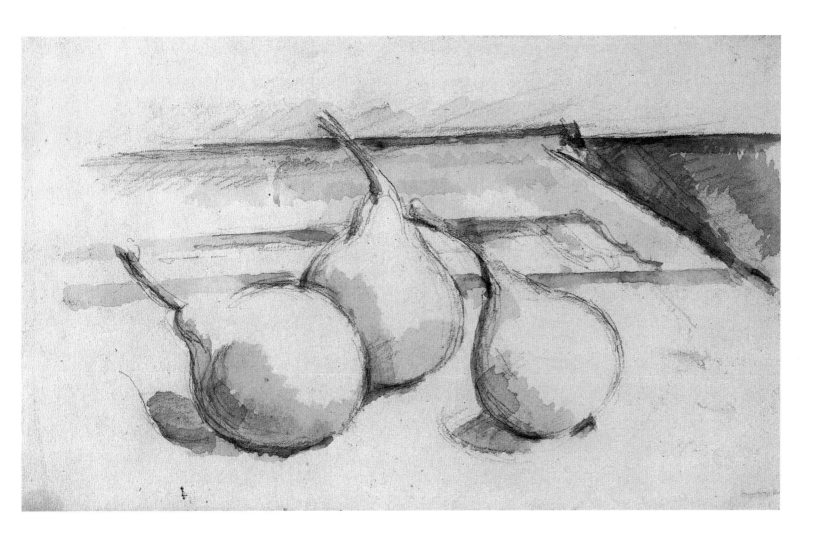

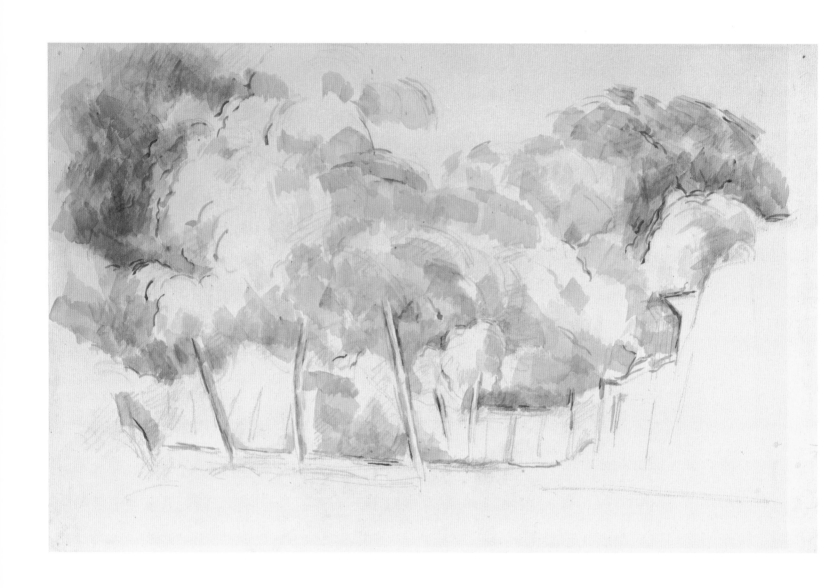

Almost at the end of his life, Cézanne wrote to his son: 'Here on the bank of the river the motifs multiply, the same subject seen from a different angle offers a subject for study of the highest interest, and so varied that I believe I could keep myself busy for months without changing place, simply by leaning a little more to the right or to the left.' (Letter, 8 September 1906.) It becomes clearer in landscape drawings of the 1890s that each 'motif' was not a fragment of nature but an ensemble with its own boundaries. The motif of this beautiful drawing is as complete in its physical entity as any of his drawings from the figure or after sculpture. Various devices curtail the ensemble around its 'edges': the contrast of light foliage against shadow at top left; dark forms against bare paper at top right; and, below that, a more or less continuous contour that runs from the dramatic staccato silhouette of a cornice into the horizontal of the ground.

Cézanne described his landscapes as 'constructions after nature, based on method, sensations and developments suggested by the model'. The whole development of this drawing remains exposed. The construction began with a light pencil drawing opposing lines of trunks and buildings to the fullness of the foliage, whose rhythms were then taken up in cool overlaid washes of blue, violet, blue-grey and yellow. Finally the opposition of billowing and angular forms is restated in brush-drawn lines of more saturated colour. After the relatively austere discipline of drawings in the 1870s and 1880s, the full generosity of his earlier manner returns in these watercolours. Pencil drawings of the period have a similar character. The role of washes is assumed in the Provençal landscape in Basel (63a) by a sequence of overlaid hatchings which, equally, increase in intensity where forms coincide. The ensemble is formed not so much by realization of trees or houses as by the cumulative sum of these relationships. His 'developments suggested by the model' were as different from each other as the models. The subdued role of watercolour in the *Arbres en V* drawing (63b) is to emphasize the austere trunks and to explore events along their contours, the sort of abutments in which his still lifes abound. In the later watercolours there is an increased use of the white paper as a foil to the more densely worked areas, each encroaching upon the other.

63 PAUL CÉZANNE
Trees and buildings
c. 1890/95
Pencil and watercolour
12¾ × 19⅞ in (32.4 × 50.5 cm)
Boymans-van Beuningen Museum, Rotterdam.
Inv. F-II-150. R357

63b *Trees ('Arbres en V'), c. 1890*
Watercolour and pencil
16⅗ × 11⅞ in (42.3 × 30 cm)
Nationalmuseum, Stockholm. Inv. NMH 44/1985. R322

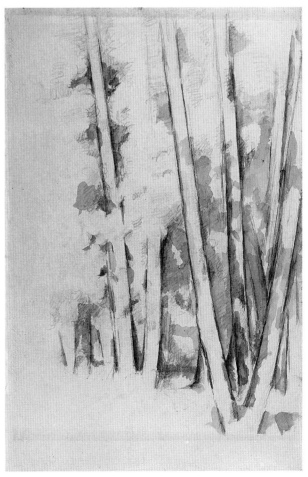

63a *Provençal landscape, c.* 1889/92
Pencil
4⅞ × 8 in (12.5 × 20.3 cm)
Kunstmuseum, Basel. C1148

64 PAUL CÉZANNE
Study after Puget's *Milo of Crotona*
c. 1890
Pencil
7¹/₆ × 4¹/₂ in (18.2 × 11.6 cm)
Philadelphia Museum of Art (Gift of Mr and Mrs Walter H. Annenberg). C977

Cézanne started to draw regularly from antique, renaissance and baroque sculptures in the 1870s and continued the practice for the rest of his life. In the absence of models, it was studies after sculptures and paintings that sustained his interest in the figure as subject. He advised Camoin to 'make studies after the decorative masters, Veronese and Rubens, but as you would do after nature – a thing I was only able to do inadequately' (Letter, 3 February 1902). Although these expressive, energetic drawings echo the urgency of earlier romantic figure studies, they are informed by an authority gained from drawings after nature.

The thirty or so drawings after Puget are of works which are emotive in subject and physically dramatic in their mass and twisted pose. Chappuis dates the earliest of twelve copies after *Milo of Crotona* as 1866/69 and the last two as 1897/1900; the eighteen drawings after *Hercules resting* span roughly the same period. They form the same continuous thread in the background of his drawings from nature as do the *Bathers* as a subject. The two threads fed upon each other and sprang from the same imaginative impulse.

In the series of copies after *Milo*, the image is transcribed in progressively more animated curving lines. In this late version, the repeated arcs of internal and external forms, which in drawings of the 1860s had perhaps expressed uncertainty or impatience, serve to emphasize the sculptural drama of the pose and its spatial rhythms. The darkest and most intensely drawn lines are not the deepest shadows but the salient points of contact. His looking is as enquiring as in landscape and still-life drawings, but the 'development suggested by the model' here is more in the nature of a sharing or recreating of the experience of the artist he is copying. 'There is something of the mistral in Puget', he told Bernard. 'This is what agitates the marble.' (Doran 1978, p. 77.) In the same way that drawing from nature educated his drawing from other art, the reverse is also true. They were faces of the same experience. The rhythmic and sensual properties of his drawings from carved figures find repeated echoes in his drawings of the rocks at Bibemus and the Chateau Noir.

64a *Hercules resting, after Puget, c.* 1884/87
Pencil
18³/₅ × 12¹/₃ in (47.3 × 31.3 cm)
Boymans-van Beuningen Museum, Rotterdam.
Inv. F-II-215. C999

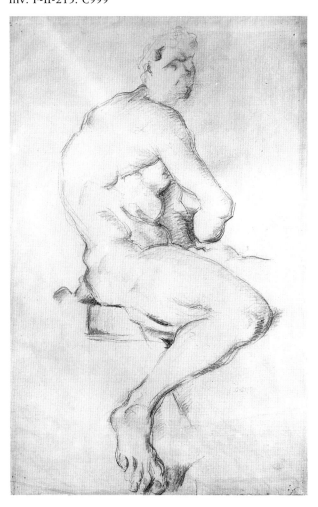

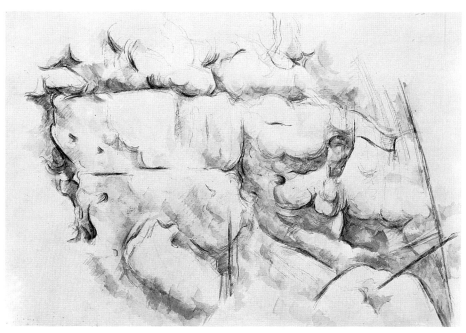

64b *Rocks above the Chateau Noir, c.* 1895/1900
Pencil and watercolour
12¹/₂ × 18³/₄ in (31.7 × 47.6 cm)
Museum of Modern Art, New York (Lillie P. Bliss Collection). Inv. 21.34. R435

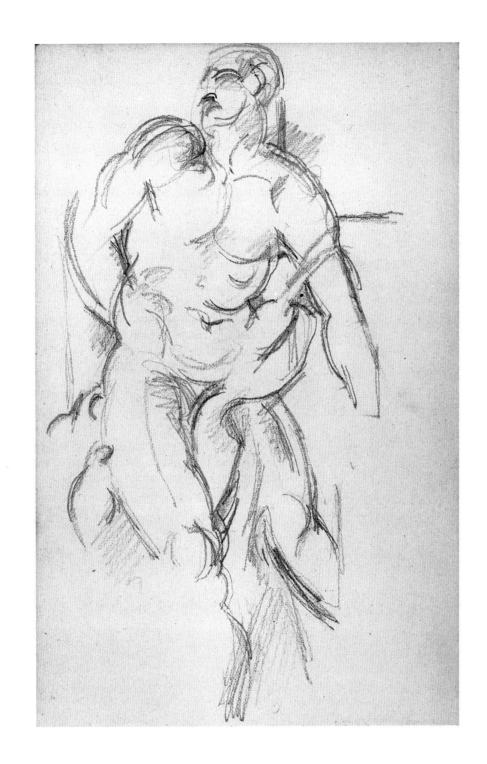

65 PAUL CÉZANNE
Study after the plaster putto
c. 1900/04
Pencil and watercolour
17⅝ × 8⅔ in (45 × 22 cm)
Private collection, Paris. R560

The rhyming repetition of multiple contours in Cézanne's late drawings enabled him to contain a sculptural form without resort to continuous outline and to endow the figure with an exuberant vitality that is almost kinetic. Another obsessive motif was the plaster putto in his studio, attributed to Puget. In earlier versions, such as the masterful drawing in the British Museum (65a), he had approached the asymmetrical rhythms of the pose through a combination of opened contour and internal modelling. In this later watercolour the mass and movement of the figure are realized by his elastic and sensual drawing of its silhouette. His late correspondence includes several references to drawing, and in his efforts to exorcize the 'old-fashioned rubbish' of Bernard's drawing, Cézanne explains his own ideas. He wrote of 'abstractions which do not allow me . . . to pursue the delineation of objects where their points are fine and delicate' and of the continuous contour as 'a black line, a fault which must be resisted at all costs' (23 October 1905). Later Bernard remembered him saying 'there is no such thing as line, no such thing as modelling, there are only contrasts'.

Gowing has suggested that Cézanne's drawn oeuvre 'never evolved a visual code to compare with the analysis of sensation in paint'. Among the drawings, it is only in watercolours that we find comparably refined modulations. In the pencil drawings Cézanne was more concerned with the physical than the transient visual, more with 'something solid and durable, like the art of the museums' in his own much-quoted words. In the last years he often spent morning sessions (from six until eleven) in his studio before an afternoon in the landscape. The plaster putto, skulls, pots and drapery that are still there, were arranged, drawn and painted repeatedly. The work of morning and afternoon were part of the same campaign for 'realization'. The humility with which Cézanne admitted that he was learning to draw all his life was authentic. Still life drawings were another part of the learning process, towards a language in which to treat the landscape.

65a *Study after the plaster putto, c. 1890*
Pencil
19½ × 12½ in (49.7 × 31.9 cm)
British Museum, London. C988

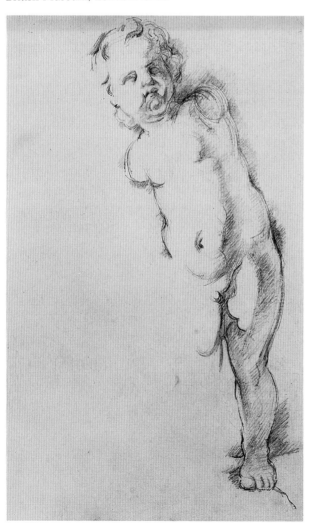

65b *Landscape with houses in the foreground, c. 1892/95*
Pencil
12⅖ × 21⅓ in (31.6 × 54.2 cm)
National Gallery, Prague. Inv. K 13924. C1159

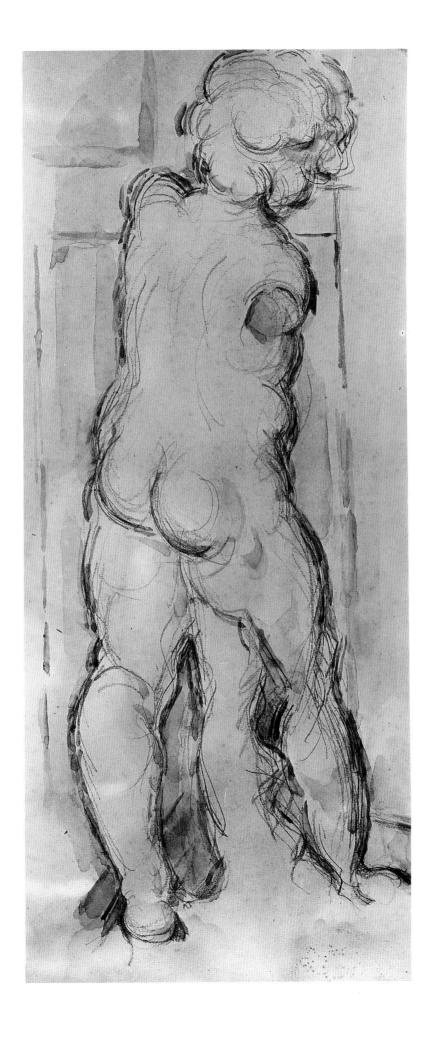

66 PAUL CÉZANNE
Portrait of Vallier
c. 1904/06
Pencil and watercolour
21⅓ × 12⅕ in (47.5 × 31 cm)
Private collection, Los Angeles. R639

Drawings and paintings of the gardener Vallier were Cézanne's last portraits. One of three watercolours, this drawing shows the figure seated, resting, framed by trees. Gasquet's story that when the model was unavailable Cézanne put on Vallier's clothes to pose for himself has been discredited, but in some respects these are images of old age and of man and nature with which Cézanne might have identified. He often describes himself in letters as old and near the end of his life. 'I still see Vallier', he wrote on 28 September 1906, 'but I am so slow in expressing myself that it makes me very sad.' On 20 October his sister wrote to his son that Cézanne had been brought home in a cart after several hours in the rain and carried to bed: 'The next day, early in the morning, he went into the garden to work under the lime tree on a portrait of Vallier, he came back dying.' (He died two days later.)

The presence of skulls in so many later still lifes may also allude to death (66b). Some historians have stressed how commonplace was the skull as a studio property, but it is scarcely a passive motif, nor was it treated as such in Cézanne's earlier work. We can only speculate on conscious or intuitive meanings in these drawings, but it takes some determination to read the clarity and frontality of these three huddled skulls, and the tremulous linear echoes of their sockets and silhouettes in the drapery around them, as neutral. There is also an animated copy after Millet's *Reaper* among the very late drawings (C1213).

The remarkable similarity between the motif of Vallier and Daumier's watercolour of a man reading (66a) is probably coincidental, although there exists an outside chance that Cézanne knew it: it was exhibited at Durand-Ruel in 1878. There are many echoes of Daumier's work in Cézanne: it may have been one of the initiatives behind the motif of card-players and Cézanne's frontal male bathers recall Daumier's wrestlers (Figs. 70–71). Maurice Denis remembered that: 'He often spoke of the caricaturists, of Gavarni, of Forain, and above all of Daumier. He liked exuberance of movement, relief of muscular forms, impetuosity of hand, bravura handling.' (Doran 1978, p. 176.) The fluent relation of line to wash in Cézanne's developed use of watercolour is closer to Daumier than to anyone of his own generation.

66a Daumier: *Man reading in a garden*, 1860s?
Watercolour and black chalk
13⅓ × 10⅗ in (33.8 × 27 cm)
Metropolitan Museum of Art, New York.
Inv. 29.100.199 Maison 361

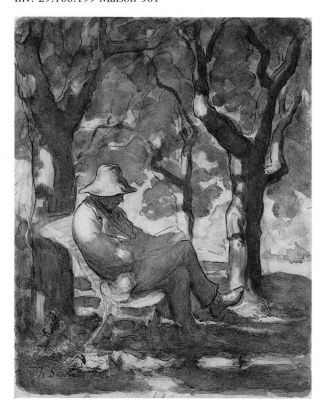

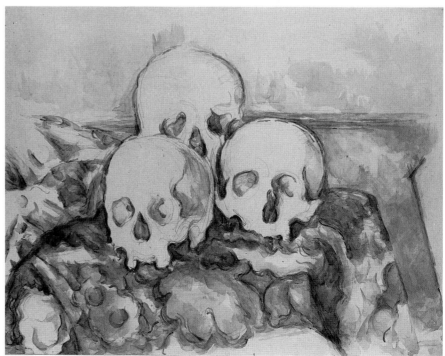

66b *Three skulls*, *c.* 1902/06
Pencil and watercolour
18⅝ × 24⅘ in (47.7 × 63 cm)
Art Institute of Chicago (Mr and Mrs Lewis L. Coburn Fund). Inv. 1954. 183 R611.

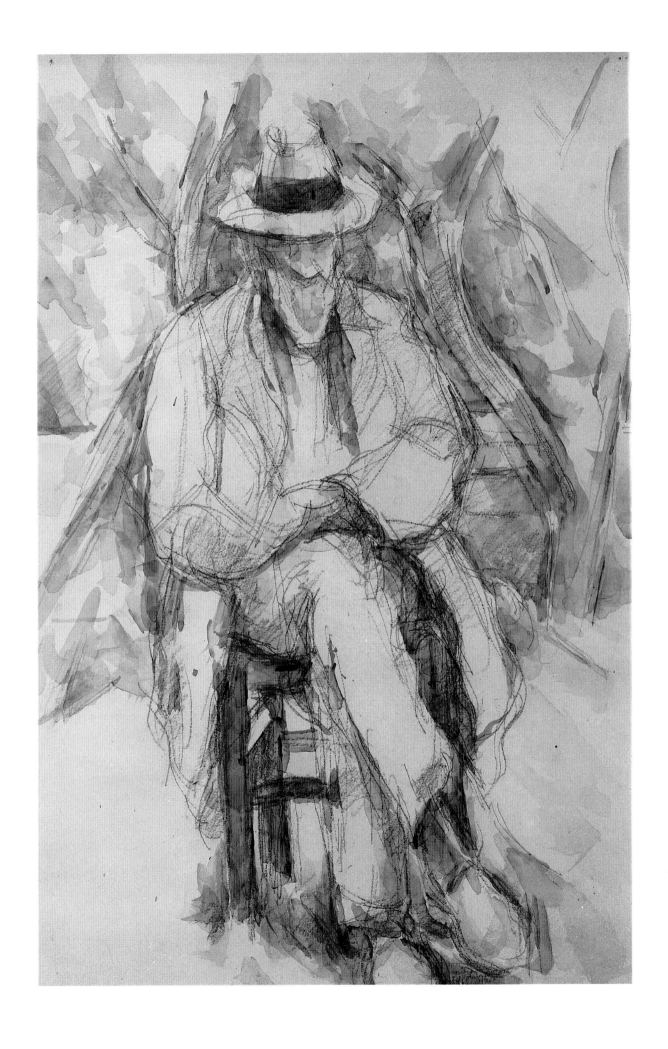

67 PAUL CÉZANNE
Mont Ste-Victoire, seen from les Lauves
c. 1902/06
Pencil and watercolour
18⁶/₇ × 12¹/₅ in (48 × 31 cm)
Private Collection, Philadelphia. R588

Among his late landscapes, the motif to which he returned most obsessively was Mont Sainte-Victoire, the mountain dominating the countryside of his youth. ('When one was born down there, nothing else has much meaning.') There is the same reluctance among historians to read emotive meaning into these late landscapes as with late still life motifs (see for instance Hamilton 1988, pp.231ff). Gowing argues that 'his later engrossment in the actual held in check the very real burden of his fantasy', and goes on to quote the ageing Cézanne telling Gasquet: 'My method if I have one is based on a hatred of the imaginative.' (Gowing, London 1988, p.11.)

Cézanne's engrossment with the actual was much in evidence at the end. He writes most passionately about the beauty of nature and the harnessing of his limited means to 'the magnificent richness of colouring that animates nature'. So he tells Bernard: 'Drawing and colour are not separate things; as one paints one draws; the more the colour harmonizes the more precise the drawing becomes. When the colour is at its richest, so the form is at its fullest.' (1904. Doran 1978, p.36.) And in 1905: 'Draw, but it is the reflection which envelops; light, through the general reflection, is the envelope.' And to his son, he wrote about a watercolour that 'it is all a question of putting in as much inter-relation as possible' (14 Aug. 1906). These were his urgent concerns. The theory followed the practice. The complex fabric of this late watercolour is the typical experience of which he tried to write. His words seem leaden beside the subtlety and delicacy of its correspondences, the animation from foreground to distance of its lines, and its memorable sense of the actual.

At the same time, in his studio, Cézanne was working on the last of his *Bathers* images, the final expression of his fantasy. Imagined figures which echo both his earliest figure drawings and his most recent drawings from sculpture, are set in generalized landscapes. In the years before his death, Cézanne was reading Baudelaire's *Art Romantique* ('he doesn't go wrong in the artists he admired'), his essays on Delacroix, and could recite from *Les Fleurs du Mal* from memory. Unexpectedly perhaps, he told Bernard that he 'liked Redon's talent enormously'. Redon was an artist with whom he shared respect for Delacroix, Monticelli, Goya, and not least Flaubert, whom Cézanne had re-read in 1896. Cézanne talked of Flaubert, as of Puget, as 'fragrant with Provence'. The imaginative initiative behind the *Bathers* also informed his looking at landscape. If the method of his late landscapes seems concerned with the actual to the exclusion of the imaginative, their spirit surely embraced both. He told his son that what Bernard lacked was 'the emotional experience of nature'.

67a *Bathers beneath a bridge, c.* 1900
Pencil, watercolour
8¹/₄ × 10⁵/₇ in (21 × 27.4 cm)
Metropolitan Museum of Art, New York
(Maria de Witt Jesup Fund). Inv. 55.21.2 R601.

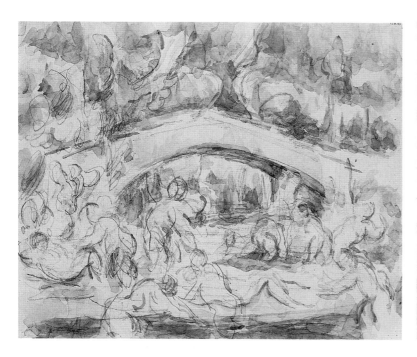

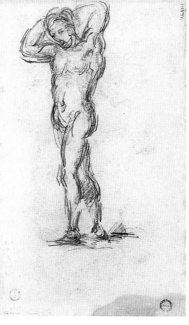

67b *Bather with arms raised,*
c. 1900
Pencil
8 × 4⁷/₈ in (20.4 × 12.6 cm)
Kunstmuseum, Basel. C1217

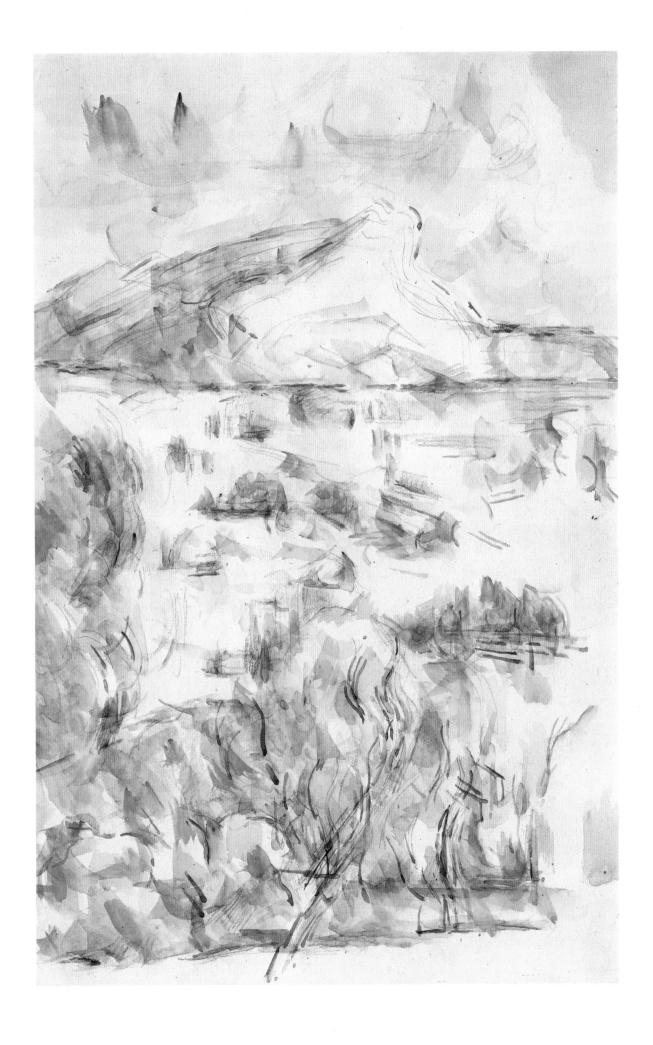

68 PAUL GAUGUIN
Portrait of two children (Clovis and Pola Gauguin?)
signed and dated 1885
Charcoal and pastel on wove paper
28⅓ × 21 in (72 x 53.5 cm)
Collection Mrs David Lloyd Kreeger. GW135

In an earlier pastel double portrait (GW66), Gauguin had created an elaborate ambiguity between two figures who may or may not occupy the same space. The two figures in this drawing share the same pictorial space, but it is difficult to make any realistic reconstruction of their relative position and scale. It appears likely that the two sitters did not pose together for the drawing. The presence of squared-up lines visible beneath the pastel suggest that the younger head on the left at least was based on another drawing or a photograph. The passivity of the figures anticipates the inert, slightly melancholy quality of expression and pose which characterizes Gauguin's figure images throughout his life.

This is one of the most resolved of many drawings of Gauguin's young family running through the late 1870s and early 1880s, the later of which have been compared to contemporary drawings by Cassatt. Although the Cassatt pastel that Gauguin owned was not of a comparable subject, her work formed part of the diet of contemporary art from which Gauguin was learning avidly since his introduction into impressionist circles in 1879.

Among the various manners of drawing that he experimented with in the early years, his experience of impressionist brushwork emerges as the most fertile source. In this drawing, apart from the solid blue vertical of the window frame and attention to the exotic decoration of the armchair, the surface is covered in a sequence of hatched coloured lines that relates closely to the brushwork of Gauguin's impressionist paintings. In other drawings – in pen, chalk or pencil – from the 1880s sketchbooks, there are several different types of hatching, shading and stippling that seem to derive equally from the practice of painting. Gauguin was probably alone among his peers in having no personal experience of academic instruction in drawing. Nevertheless, he became passionate in his castigation of the 'cookery' of academic conventions: he condemned most strongly any notion of drawing as an art that was divorced from colour, or that could be taught separately from painting.

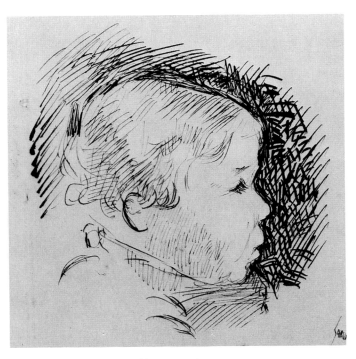

68a *Head of a child in profile, c.* 1883/5
Pen and ink, detail of a page from the 'Breton sketchbook'
Sheet: 6⁷⁄₁₆ × 4³⁄₁₆ in (16.5 × 10.8 cm)
Armand Hammer Collection. Inv.100.23 verso

68b *Head of a woman in profile, c.* 1883/5
Black chalk, detail of a page from a sketchbook
Nationalmuseum, Stockholm. Inv.F1545, f.7 recto

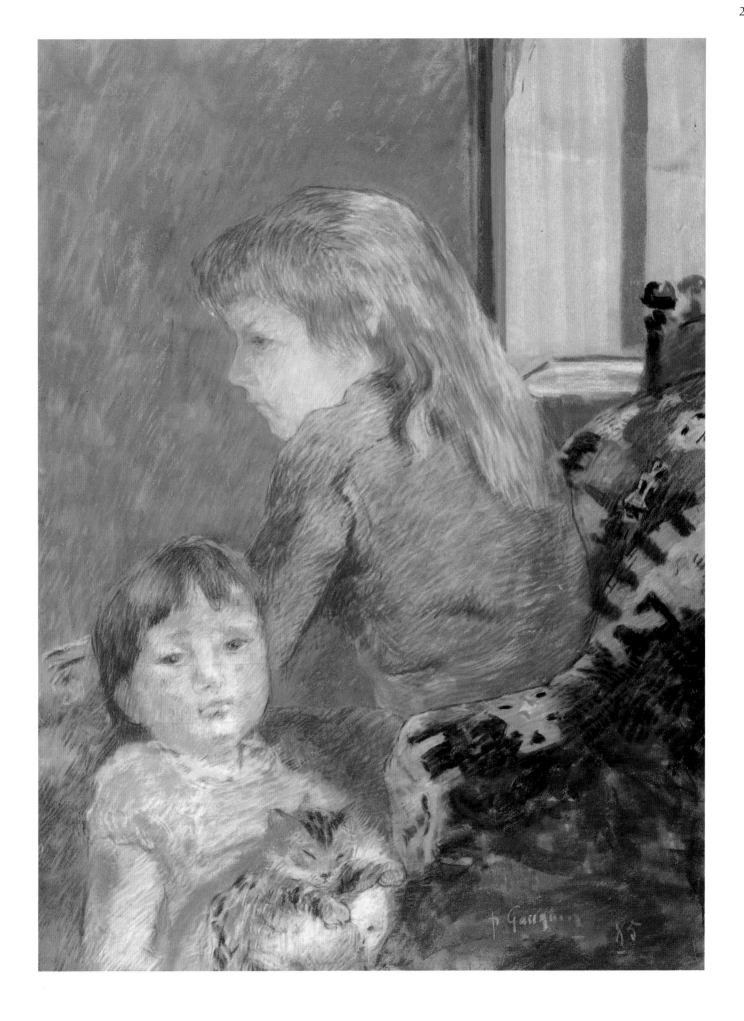

69 PAUL GAUGUIN
Young peasant girl seated,
study for *La Petite Gardeuse de Porcs*
1899
Pastel
33 × 19⁷⁄₈ in (84 × 50.5 cm)
Louvre, Dépt. des Arts Graphiques. RF 29.898

His relationship with Pissarro provides a dependable measure of Gauguin's movement into and then out of the orbit of impressionism. His substantial collection of contemporary paintings, drawings and prints included over a dozen works by Pissarro, but their relationship changed rapidly from collector-artist to disciple-master. Working with Pissarro at Pontoise and Rouen in 1883, Gauguin received the same level of formative guidance as had Cézanne a decade earlier. But in the course of his fifty or so letters to Pissarro, 1879 to 1885, we can also sense the steady shift of Gauguin's thinking away from impressionist ideas that finally led to Pissarro's uncomprehending antipathy.

The influence of Pissarro is repeatedly evident in the subject matter of Gauguin's drawings and paintings in Brittany. Although this pastel also reveals Gauguin's own strongly developed sense of contour of the later 1880s, the motif of the peasant girl and the quiet dignity of her pose reflect the lasting value to him of Pissarro's art. The shorthand manner of Gauguin's pencil and watercolour sketchbook notes, even still in Tahiti, also seems closer to Pissarro than to anyone else.

In other drawings of Breton peasants there is a stronger echo of Degas. By November 1888, he was writing to Bernard: 'I have unshakeable confidence in Degas's judgement.' He became a frequent visitor to Degas's studio and drew copies after Degas pastels. An echo of his interest in Degas may be seen, for example, in the eccentric high viewpoint from which he drew the *Seated Bretonne* (69b), producing an unexpected flattened silhouette. Gauguin came to believe that Degas alone had revived the art of drawing from a state of decadence (*Avant et Après*, p. 75). By the late 1880s, drawing from nature was only a means to an end for Gauguin and what he recognized in Degas's drawings was not truth to nature so much as 'the life of the lines'.

In some jottings from 1880s sketchbooks we catch sight of the vast distance between Gauguin's intuitive aspirations for art and those of impressionism. An apparently trivial, scribbled sketch from a Brittany carnet (69a) shows a face half-concealed behind tremulous lines and hatching. The eloquent ambiguity of this gauche and enigmatic image says far more about the underlying impulse of Gauguin's art than do the studies from nature on adjacent pages.

69a page from the 'Breton sketchbook', *c.* 1886/88?
Pencil
6³⁄₈ × 4¹⁄₈ in (16.5 × 10.8 cm)
Armand Hammer Collection. Inv. 80.100.35 recto

69b *Seated Breton Woman,* 1886
Inscribed '*à Mr Laval/Souvenir/PG*'
Charcoal, pastel and wash
12⁷⁄₈ × 19 in (32.8 × 48.3 cm)
Art Institute of Chicago (Gift of Mr & Mrs Carter H. Harrison). Inv. 1933.910

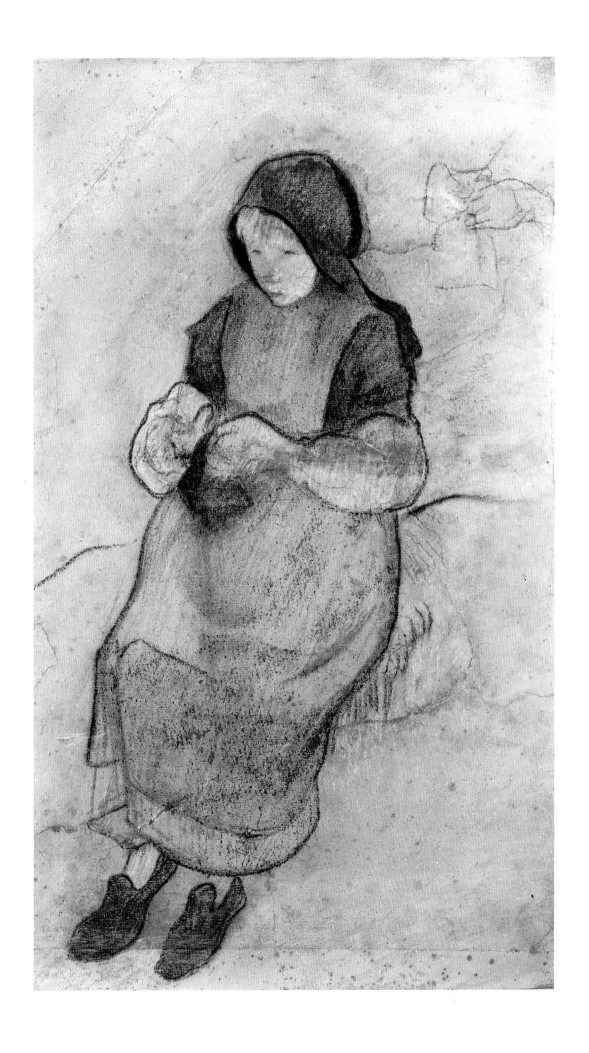

70 PAUL GAUGUIN
Cottages in Brittany
c. 1886/89
Black chalk
$7^7/_8 \times 7$ in (20 × 18 cm)
Private collection

In the long postscript to a letter of May 1885, extolling the art of Delacroix, Gauguin told Schuffenecker that 'Delacroix's drawing always reminds me of a tiger in its supple and strong movements'. Through the experimental variety of his later 1880s work such qualities began to dominate Gauguin's own drawing. The rhythmic continuity of line in this study is comparable to the looping, strap-like coils which Gauguin draped around some of his ceramic pieces of 1886–87. We know that he learnt about expressive colour from his experience of fired glazes and it is likely that the improvisatory linear decoration of his ceramics had a comparable, liberating effect on his drawing. After Gauguin's death, Redon wrote in high praise of the 'new forms' that he created in his ceramics, like 'flowers from a primeval place, where each flower is the original of its species' (*Mercure de France*, November 1903).

In drawings like his black crayon studies of a Breton peasant boy (70a), Gauguin progressively resolved his first sensitive observations of the motif into emphatic, rhythmic contours, containing sheaves of schematic hatching. The dual concerns of such a drawing, initially with the record of something seen and subsequently with its schematic graphic reduction, may be compared to contemporary drawings by van Gogh and Bernard. There is little doubt that the frequent exchange of drawings in letters between these three artists informed their respective graphic styes.

Gauguin's repetitive inscription on this sheet – '*mon cher/mon s/mons/moncher/ Schuff*' – contains something of the same intuitive play between content and form. A trivial whimsy on the face of it, it nevertheless reflects an instinct for formal improvisation that abounds in both his art and his writing. The narrative passages in his manuscripts are animated by alliterative and symmetrical devices. His drawings are comparable in the way that description is overlaid with relatively arbitrary, invented forms. In a letter of 1888, he advised Schuffenecker not to follow nature too closely: 'Art is an abstraction: draw it out of nature while dreaming before it.' (*Correspondance* I, p. 210.)

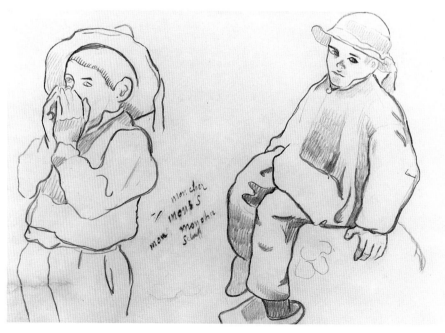

70a *Studies of a peasant boy, c.* 1888
Black crayon
$10^1/_4 \times 13^5/_7$ in (26 × 35 cm)
Musée des Arts Africains et Océaniens, Paris,

71 PAUL GAUGUIN
Study for *The Loss of Virginity*
1891, signed
Charcoal, heightened with white chalk
12²/₅ × 13 in (31.6 × 33.2 cm), irregular.
Private collection, New York

As early as 1885, Gauguin was writing about the expressive properties of lines (*Correspondance* I, pp.87–89). Between then and his appropriation of Bernard's *cloisonniste* technique in 1888, his language moved steadily towards a more linear manner. By 1891, a firmly drawn contour had become the dominant feature of Gauguin's drawing. In this majestic charcoal study for the large painting *The Loss of Virginity* (GW412), the sensual certainty of the redrawn contour echoes the density of velvet black in the girl's hair. The drawing corresponds very closely to the painting: its finality and the cut edges of the sheet suggest that this may be a fragment from a study of the complete figure. The manner of the drawing – simple contours with slight internal inflexions of modelling – recalls very precisely the early paintings of Manet, particularly *Olympia*, of which Gauguin painted a copy (GW413) at exactly this time. The imposing scale of *Olympia*, its drawing, its theatrical tonality and the strangeness of the painting that Gauguin emphasized in his copy all seem to have played a formative role in the evolution of *The Loss of Virginity*.

There is little common ground with Manet, however, in the elaborate symbolism of Gauguin's subject, which brings together sardonic references to sexuality, perversity, helpless inertia and the institution of marriage in an iconography similar to that of the carved relief *Soyez Amoureuses et Vous Serez Heureuses* of 1889. In the heraldic simplicity of this magnificent drawing, Gauguin had evolved a pictorial language that could embody such a programme. He wrote in *Diverses Choses* of drawing as 'using pictorial idioms which do not disguise one's thought'.

The innovative extremes of his graphic language were already clear in a series of prints of 1889 ('The Volpini Suite'). Printed in black or red ink on a paper of dazzling saturated yellow, sometimes reworked in gouache or watercolour, they are startling in their originality. The elements of each motif – many of them reused from earlier paintings or drawings – are assembled together with less thought for homogeneity of any sort than for poetic, allegorical allusion. The two extremes of mood in the series are *Les Misères Humaines* (71b) and *Les Joies de Bretagne* (71a). The former is an image of despair, evoked by the inert, brooding foreground figure – a recurrent image in Gauguin's iconography – and her shadowed companion. They are observed by a giant head beyond the wall. In the latter, the spirit of the dancing Breton girls is echoed in the wit of forms breaking the bounds of the frame and the anecdotal play of two dogs appearing as if from behind its edge.

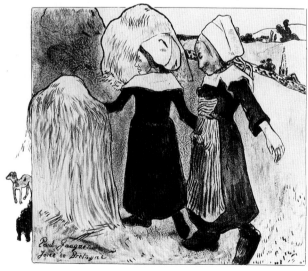

71a *Les Joies de Bretagne*, 1889
Zincograph on yellow wove paper
7⁷/₈ × 8³/₄ in (20 × 22.2 cm)
Art Institute of Chicago (William McCallin McKee Memorial collection). Inv. 1943.1027

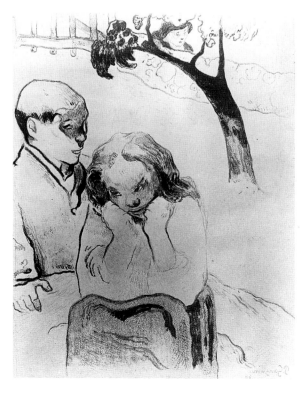

71b *Les Misères Humaines*,
1889, signed
Zincograph on yellow wove pap▸
11 × 8⁶/₇ in (28 × 22.5 cm)
Josefowitz Collection

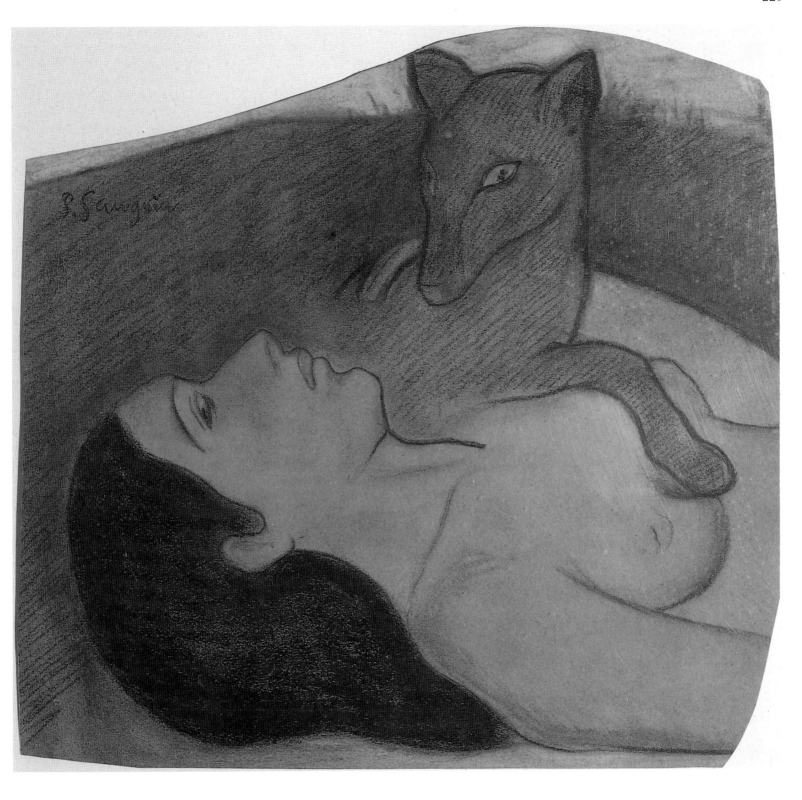

72 PAUL GAUGUIN
Breton peasant woman
1889 or 1894?
Pencil, crayon and wash
8⅘ × 7⅞ in (22.4 × 20 cm)
Fogg Art Museum, Cambridge, Mass. (Bequest of
Meta and Paul J. Sachs). Inv. 1965.283

Once established, the drawing style of Gauguin's maturity had such a basic consistency that, without the external evidence of related paintings (itself unreliable because of his constant re-use of images), it is more than usually difficult to date some drawings. This heroic head of a peasant woman had been variously dated to 1889 and to Gauguin's last stay in Brittany in 1894, between the two Tahitian periods. The consensus among historians is towards the earlier date, but arguments behind both hypotheses are equally reasonable. It is very close in style to the monumental heads from the first Tahitian period (1891–93) that bridges the two dates.

The relationship of this style to Manet has already been mentioned (Pl.71), but its ancestry is complicated. Gauguin assimilated the forms of other art more consciously than any of his peers, to the extent that his appropriation of anything that was useful to him was deemed by many as plagiarism and as morally questionable. For an artist like Pissarro, the problem lay not simply in the issue of originality, but as much in what appeared to him as the incongruous *range* of Gauguin's sources, including the unharmonious and savage. For Gauguin, the underlying principle was no different from his use and re-use of his own images, in endless permutation.

The folio of photographs, reproductions and prints that Gauguin took with him to Tahiti in 1891 ('a little community of comrades') included the work of Giotto, Raphael, Michelangelo, Holbein, Rembrandt, Delacroix, Daumier, Puvis de Chavannes, Manet, Degas, Forain and van Gogh. Most of his written references to them, notably in *Avant et Après* (1903), stress the freedom from rules of great art and the uncluttered eloquence of its drawing. He found an unequivocal clarity of contour in the Egyptian and Japanese art that he looked at, and we may recognize both sources in the simplicity of line in this drawing. The clear contour, he wrote, 'is the only attribute of the hand that is not enfeebled by any hesitation of the will' (*Avant et Après*, p.36).

The monumentality of this head may also reflect his acknowledged admiration of the drawing of Daumier, who 'sculpts irony'. Gauguin owned two Daumier drawings in the early years and had lithographs with him in Tahiti. His practice of reasserting the sensitive first state of a drawing (perhaps too 'enfeebled by hesitation') with contours so heavy that they obliterate the original has much in common with Daumier's drawing.

72a *Tahitian woman, c.* 1892/93
Chalk, pastel
15⅓ × 11⅘ in (39 × 30 cm)
Metropolitan Museum of Art, New York (Bequest of Miss Adelaide Milton de Groot, 1967). Inv. 67.187.13

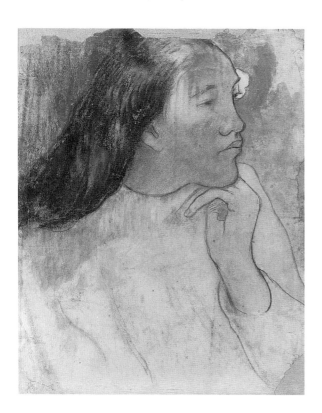

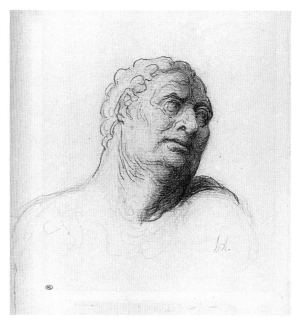

72b DAUMIER: *Head of a man*, initialled
Red and black chalk, pen and ink
10⅙ × 9⅓ in (25.8 × 23.8 cm)
Louvre, Dépt. des Arts Graphiques. Inv.RF 36.798

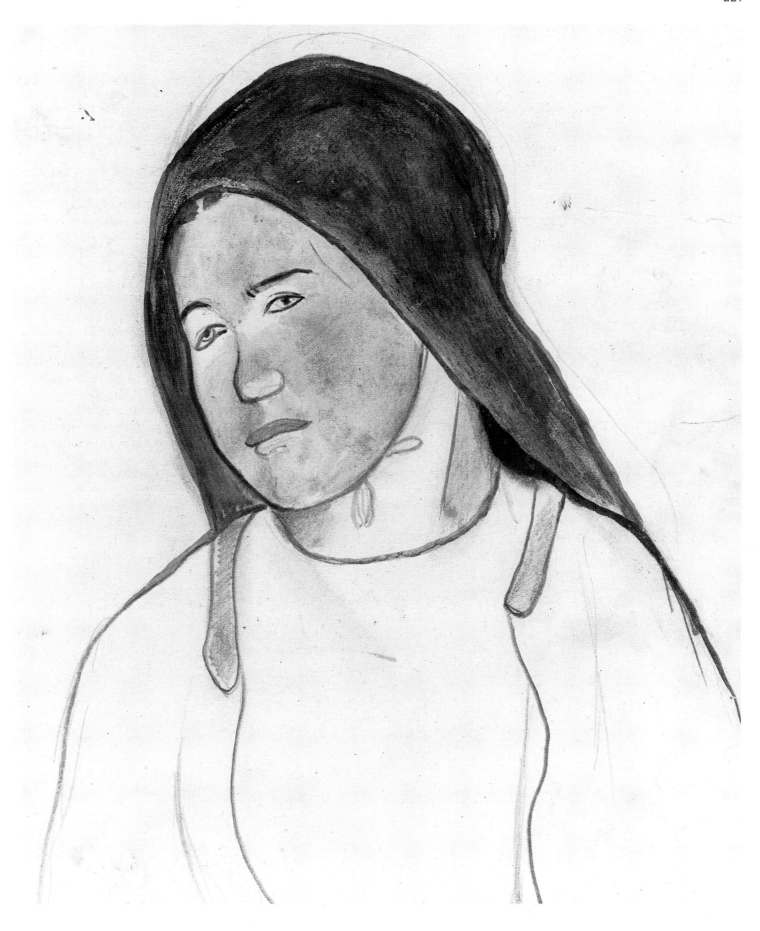

73 PAUL GAUGUIN
The legend of Hiro
c. 1893/95?
(inscribed on verso 'Duplicate from the text of *Noa Noa* which Gauguin sent to my father with various watercolours and drawings destined to feature in the manuscript. [Agnes] DE MONFREID')
Watercolour, pen and ink
$5^7/_8 \times 9^3/_7$ in (15 × 24 cm)
Metropolitan Museum of Art, New York
(Robert Lehman Collection). Inv. 1975.1.632

If you include the more-or-less abortive trip to Martinique (1887), Gauguin made three escapes from Europe. The most significant were those of 1891–93 to Tahiti and of 1895–1903 to Tahiti and, finally, to the Marquesas. The effect of the change of environment on his drawing is twofold. Firstly, he responded strongly to the difference in nature. His acute observation of what he saw around him – for all his talk of drawing from dreams – is reflected directly in details of flora and fauna, of Tahitian faces and physique, of fabrics, and above all in the different effects of light and colour. Secondly, he discovered – and where he could not discover, improvised – traditional forms of Polynesian decoration and a visual iconography of Maori religion and mythology. Inasmuch as his art was cumulative, there are also many qualities in his Tahitian drawing that are unchanged or that draw afresh from earlier experience and European imagery. The little pen-and-wash drawing of Mataeia (73b), like others among his first Tahitian drawings, recalls the textural reed-pen technique of van Gogh that Gauguin had assimilated in 1888. It appears that he still had this drawing with him in 1900, when he used the motif in a monotype (Field 1977, No. 72).

Back in Paris, in 1893, Gauguin embarked on an account of his first two years in Tahiti (in collaboration with the poet Charles Morice) that became the *Noa Noa* manuscript. Part of its contents – words and images – is based on an earlier manuscript, *L'Ancien Culte Mahorie*, probably written in Tahiti, 1892/93. This radiant watercolour is a loose transcription from a drawing in *L'Ancien Culte Mahorie* (p.17), illustrating the story of Hiro, god of thieves, and corresponds exactly in size and in most salient detail to the watercolour in the Louvre *Noa Noa* manuscript (p.57). Either it served as a transition between the two manuscripts or, as the inscription on the verso implies, it was copied from the Louvre manuscript with a later version in mind. Gauguin had obtained all of the text on Maori mythology from a secondary European source he came across in Tahiti, but the illustrations, full of narrative invention and of the most luminous bloom of all his watercolours, were his own fantasy. Like the account of his life in *Noa Noa*, they combine his uplifted response to the un-European novelty and dazzling colours of his environment with his imaginative quest for the origins of a culture unspoilt by European civilization that no longer existed.

There was little indigenous art for him to see in Tahiti and most of the 'primitive' decorative motifs that appear in his carvings and in drawings like the cover of *Cahier pour Aline* (73a) are Marquesan in origin. Pasted into the Louvre *Noa Noa* manuscript (pp.126, 168–9) are several rubbings that he made from Marquesan carved decoration. He responded enthusiastically to the ambiguous, allusive repitions of this ornament: 'Always the same thing, and yet never the same thing.'

73a Front cover of the *Cahier pour Aline*, initialled and dated 1893
Watercolour
$8^3/_4 \times 6^4/_5$ in (22.2 × 17.4 cm)
Fondation Jacques Doucet, University of Paris

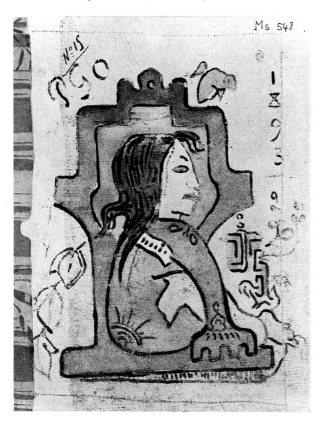

73b *Tahitian landscape*, 1891, initialled
pencil, watercolour, pen and ink
$7^1/_2 \times 11^5/_7$ in (19 × 29.8 cm)
Private Collection, on loan to the Musée Gauguin, Tahiti

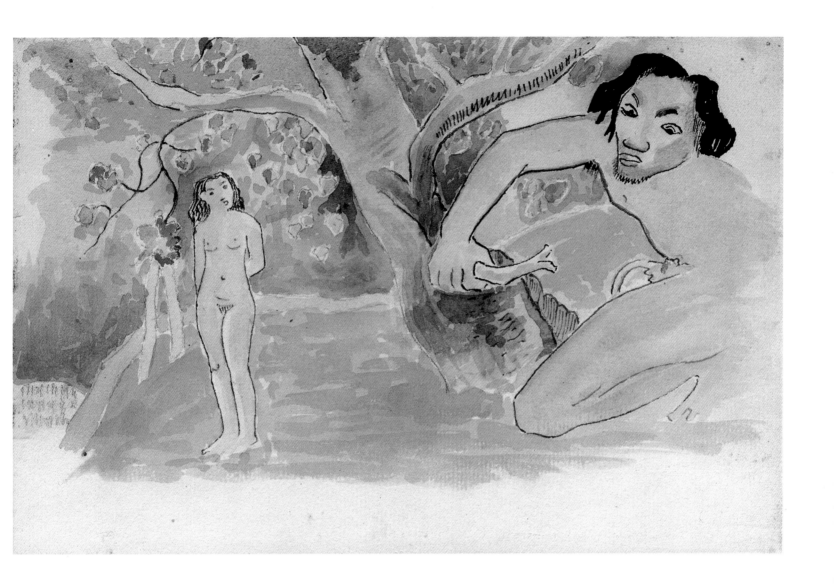

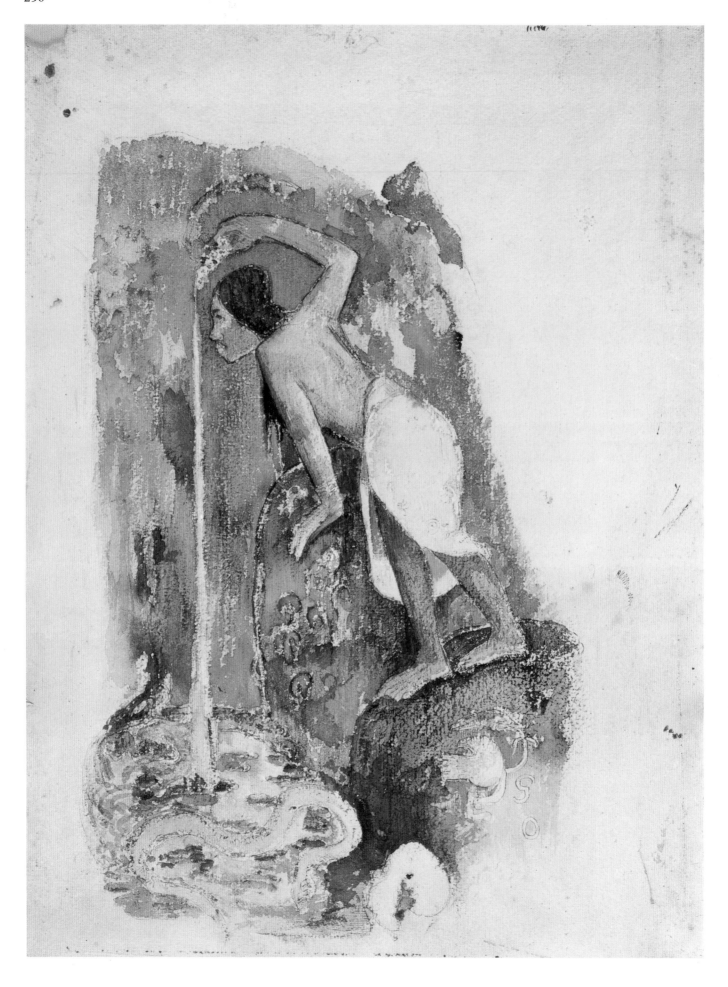

Some of the autobiographical narrative episodes in the *Noa Noa* manuscript were based on Tahitian paintings of 1892–93. One such was *Pape Moe* (1893, GW498), of which this delicate watercolour is a close copy. In *Noa Noa*, the image is elaborated into an incident during Gauguin's trip into the interior of the island, during which he surprised a girl drinking at a waterfall, who then dived into the water and vanished: only an eel swam among the stones (Louvre MS, p. 87). The watercolour may have been made with the publication of *Noa Noa* in mind: possibly it is one of the drawings to which Morice refers in March 1897 as unsuitable for reproduction because of the coarse grain of their paper. That the drawing relates to *Noa Noa*, and that it was made after the first draft was written, is clear from the presence here of a pink eel, which does not appear in the painting. (The only odd feature in this respect is that the figure in this drawing appears just as masculine as that of the painting.)

It has been known for some time that the original motif of *Pape Moe* was not from nature but was taken verbatim from a published black and white photograph of a Tahitian drinking at a waterfall – an exotic traveller's image, another instance of Gauguin's free-thinking attitude towards sources. The distance between this source and the image and story that Gauguin wove around it tells us two things. Firstly, it suggests the predisposition and appetite with which Gauguin encountered his sources: it is as if he prospected among ready-made images, from whatever sources, rather as Monet or Cézanne did in the landscape for their motifs. Secondly it demonstrates the imaginative collage-like improvisation with which he requisitioned them. Vollard remembered Redon coming across a piece of sheet iron discarded by workmen, saying, 'give it to Gauguin: he'll make something precious out of it'. Gauguin's poetic title (meaning 'mysterious water') and his evocative use of colours and shapes all contribute to the layers of meaning, some explicit some allusive, by which the image was absorbed into the repertoire of his art. All of his sources were treated like this, whether from High Art or popular imagery, and once in his repertoire were there for reuse like anything else he had made.

This watercolour is significantly different from his manuscript illustrations in the dryness of the wash across the heavy tooth of the paper. It is also remarkable among his drawings for the elaborate monogram, 'PGO', woven into the ornamental floral forms, bottom right. A predilection for anthropomorphic transformation reccurs in his drawing, writing and looking. An eye for visual pun and caricature underlies much of his work. The calligraphic pen sketch (74b) illustrates a moment in *Noa Noa* when he identified a crested head, symbol of Tahiti's noble past, in the mountainous skyline of the island of Moorea.

74 PAUL GAUGUIN
Pape Moe
c. 1893, initialled
Watercolour
13⅞ × 10 in (35.4 × 25.6 cm)
Art Institute of Chicago (Gift of Mrs Emily Crane Chadbourne). Inv. 1922.4797

74a *Self Portrait*, from a letter to Schuffenecker, 8 October 1888
Musée départemental du Prieuré, Saint-Germain-en-Laye

74b *Crested head*, 1893
Illustration to *Noa Noa*, draft manuscript, page 7
Pen and ink
1⅓ × 1⅓ in (3.5 × 3.5 cm)
Getty Center for the History of Art and the Humanities, Malibu

75 PAUL GAUGUIN
Study for *Words of the Devil*
1892
Pencil
8⅞ × 8½ in (22.5 × 21.5 cm)
Louvre, Dépt. des Arts Graphiques. RF29.332

It is significant that in a letter to Strindberg (5 February 1895), Gauguin compared the languages of Oceania, which had preserved their 'rawness' and disjointed isolation of elements, to 'the savage drawing I have had to use to decorate a Turanian land and people'. The 'savageness' of Gauguin's Tahitian drawings is no more aggressive or artless than his earlier drawings. The quality that so clearly distinguishes them from those of his French contemporaries lies in his montage-like association of disparate elements. The image takes shape from the chemistry of their evolving formal and associative interactions. Comparing himself to the impressionists, he wrote: 'For them, the dreamt landscape, composed of fragments, did not exist.' (*Diverses Choses*, Louvre MS p.263.)

This early study for the painting *Words of the Devil* (GW458), reveals the simplicity with which his images were formed. An often-used Eve-like figure, a diagonal tree trunk, and a seated devil or spirit holding an inverted mask are loosely assembled in the pictorial space, as if in a collage. (A fragment at the foot of the sheet appears to be another drawing of the mask.) As well as the basic disposition of the forms, the painting's themes of primitive superstition, apprehension of spirits, and its allusion to the Temptation in the Garden of Eden, are already resolved. From this drawing to the finished painting was a process of adjusting forms, of elaborating meaningful detail, and of translating the image into the rich, symbolic and decorative language of colour.

The powerful study of a nude in Basel (75a) is an intermediate stage in which the pose of the girl is finalized. This is a full-scale cartoon whose main lines were pricked for transfer to the canvas. It has been suggested (Washington 1988, p.266) that only afterwards was the drawing developed in pastel as a complete work in itself. It is likely that the devil in profile (quoted from another painting, *Manao Tupapau* GW457, which is very similar in subject) was drawn in over the tree at that stage. The devil in the painting, although smaller and no longer holding a mask, is based directly on his first pencil sketch. So these first small drawings, however slight, were of definitive importance in making concrete the idea of a painting. In the same way, the small squared study for *Where do we come from?* (75b) was the launching point for a painting ten times its size, rapidly painted and with only minor alterations to its main features. Most of the figures he had already used in earlier drawings, paintings or prints: it was possibly in this drawing that he assembled them all for the first time.

75a Study for *Words of the Devil*, 1892, signed
Charcoal and pastel, pricked
30⅓ × 14 in (77 × 35.5 cm), irregular
Kunstmuseum, Basel. Inv. 1928.17

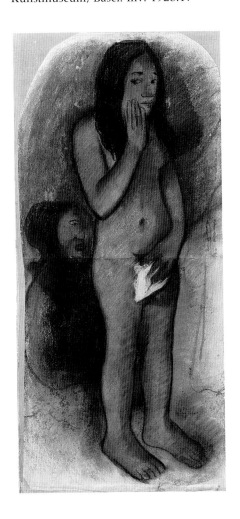

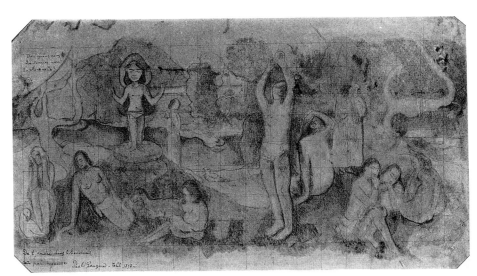

75b *Where do we come from? What are we? Where are we going?*, signed and dated 1898
Watercolour, brown crayon on tracing paper, squared in pencil
8 × 14¾ in (20.5 × 37.5 cm)
Musée des Arts Africains et Océaniens, Paris. Inv. AF 14341

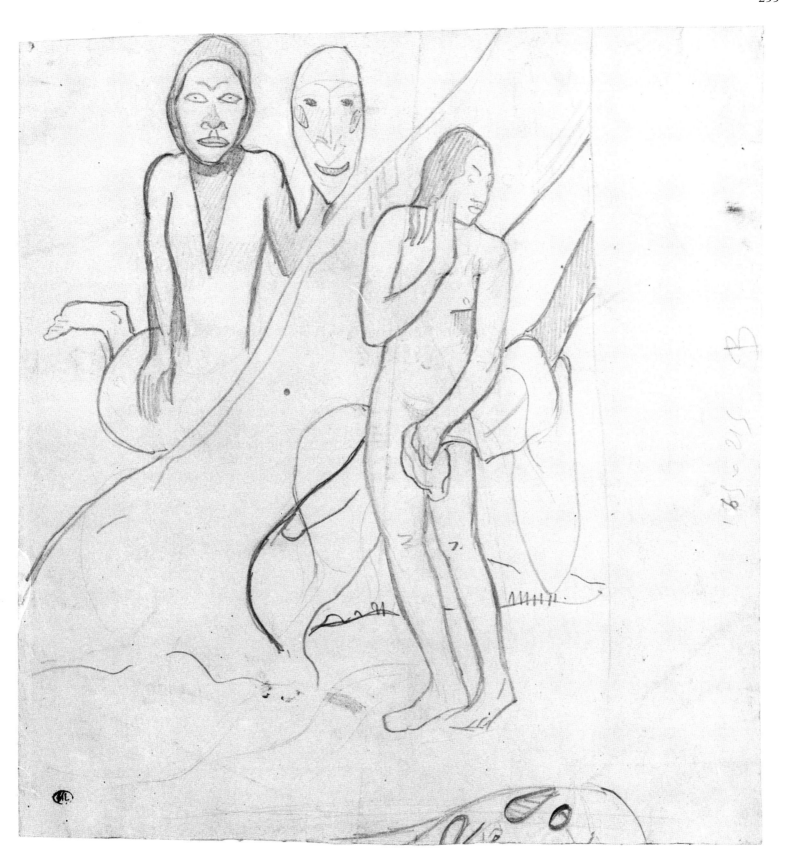

76 PAUL GAUGUIN
Two Tahitiennes gathering fruit
c. 1900, signed on verso
Pencil and blue crayon
24⁴/₅ × 20¹/₄ in (63 × 51.5 cm) (transfer drawing)
Collection Mr and Mrs Paul Mellon, Upperville,
Virginia. Field 64 verso.

In *Avant et Après* (pp.115–16) Gauguin recalled the visit to his house of a critic who, having been perplexed by his paintings, asked to see his drawings: 'My drawings! Not you! They are my letters, my secrets. The public man, the private man. You want to know who I am: are my works not enough for you? . . . I reveal only what I want to reveal . . . Besides, even I do not always see myself very clearly.' The only significant exception to this protective attitude towards the privacy of his drawings occurs in respect of the 'transfer drawings' of his last years. He mentioned them in a letter to his dealer, Vollard (January 1900), as if he was contemplating their exhibition: 'I have just done a series of experiments in drawing with which I am fairly well pleased, and I am sending you a small sample. It looks like a print, but it isn't. I used a thick ink instead of pencil, that's all.' His method was to roll ink onto a sheep of paper, lay on top another sheet and then 'draw whatever you like', generating a form of traced monotype. Some of them were reworked in watercolour or gouache (Field 1973, pp.21–22). This fine drawing of two Tahitian women is an example of the original drawings, and probably one of those sent to Vollard (Field 1973, pp.28–30). *Two Marquesans* (76b) is an example of the 'printed', mirror-image drawings created on the reverse of the paper, where the lines are augmented by incidental textural richness. (The right-hand head is based on a drawing after Delacroix, Fig.35.) His first experiments in this field, encouraged if not inspired by the prints of Degas, took place in Brittany, 1894, when he also made some watercolour monotypes. Several of these earlier prints were given to Degas.

Most of the other drawings from Gauguin's last years were made or used as illustrations. They have a simple, unpretentious directness that has sometimes been seen as a falling-away of quality related to his declining health. The stoic enigma of the three great heads from *Avant et Après* (76a) is typical. Beneath another drawing from the same manuscript (p. 127), he wrote this author's note: 'Sketches of all sorts, at the whim of the pen, at the whim of the imagination, tendencies towards madness.' He told Fontainas that the illustrations 'are like the writing, very unusual, sometimes offensive' (February 1903). In another late letter (July 1901) he explained to Morice: 'Are the forms rudimentary? Yes, they have to be. Is the execution oversimplified? Yes, it is necessarily so. Many people say that I cannot draw because I draw particular shapes. When will they understand that execution, drawing and colour (style) must harmonize with the poem?'

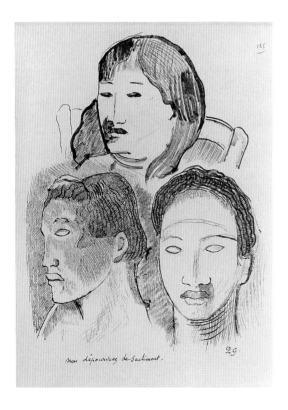

76a *Three heads: 'not devoid of feeling'*, *c.*1902/3
Pen and ink, p.125 of the *Avant et Après* manuscript
8³/₅ × 11²/₃ in (21.8 × 29.7 cm)
Private collection

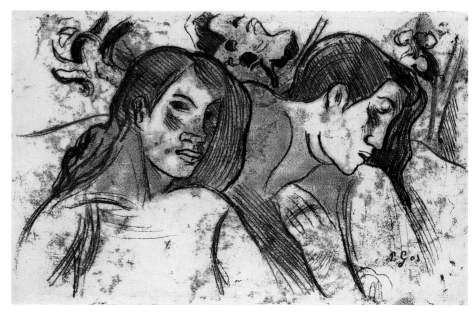

76b *Two Marquesans*, *c.*1902
Traced monotype
12³/₅ × 20 in (32.1 × 51 cm)
British Museum, London (César de Hauke Bequest).
Inv. 1968.2.10. Field 86

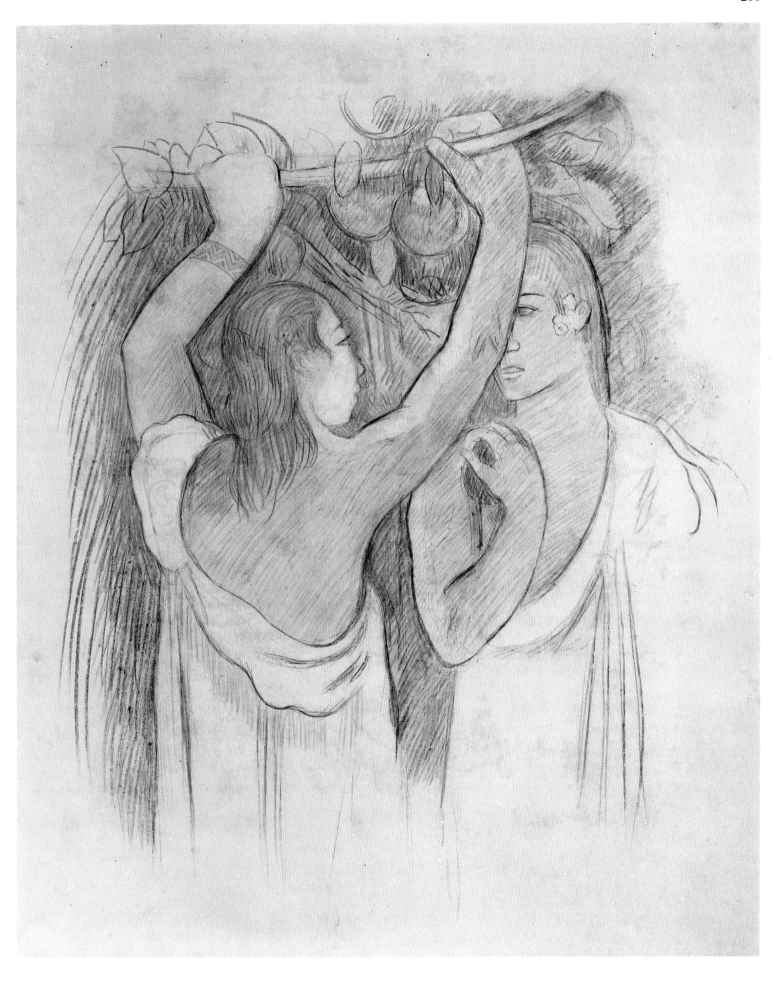

77 ÉMILE BERNARD
The Gathering of Apples
signed and dated 1888
Charcoal and watercolour
$5^7/_8 \times 8^7/_8$ in (14.9 × 22.5 cm)
Louvre, Dépt. des Arts Graphiques
Inv. RF 39.113

77a *Breton women*, c.1889
Pencil on tracing paper
$11^2/_3 \times 7^1/_2$ in (29.7 × 19 cm)
Louvre, Dépt. des Arts Graphiques. Inv. RF 36.524

Bernard's drawings reflect his attempt to make a synthesis from the art and ideas that he respected of those around him. He is remembered almost as much for his writing on and documentation of these artists as for his own art. Rilke described him waspishly as 'a not very likeable painter who associated with everyone for a while'. Bernard had long exchanges, in conversation and letters, with van Gogh and Gauguin in the later 1880s and subsequently with Cézanne and Redon. He also flirted briefly with neo-impressionism. Redon's warm comments testify to the diligence of his enquiry: 'Bernard is always superb, active, bubbling, zealous as an apostle What energy, what vitality, and how different from my own resources at his age.' (Letter, 21 Aug 1904.) Cézanne was concerned about the indiscriminate breadth of all that Bernard sought to bring to bear on painting; encouraged him to look more at nature than at other art and saw him in the end as 'an intellectual constipated by his memories of the museums' (letter, 26 September 1906). By contrast, it was Bernard's intellectual articulateness that attracted Gauguin into their close working relationship in Pont Aven and Paris, 1888–89.

The pictorial clarity of the '*cloisonniste*' manner of drawing and painting that Bernard had evolved by 1887/88 was derived in idea from the spirit of contemporary Symbolist literature and in style largely from his assimilation of forms from medieval and oriental art. *The Gathering of Apples* marries simplified silhouettes with a decorative treatment of textures into a form of pictorial relief. The correspondence of such a manner to Gauguin's search for means of treating nature that were neither dependent on nature's appearance nor vulnerable to its disorderly complexity, explains his instant adoption of the style. Bernard's brief significance in the evolution of drawing lay in his practice and advocacy of this schematic linear arabesque that was to dominate so much drawing of the 1890s. His later jealous hostility towards Gauguin (1891) over credit for the origination of *cloisonnisme* and for the theories of the Pont-Aven school was inflated but understandable.

Bernard's relationship with van Gogh was less intimate and more calm. They met soon after Vincent's arrival in Paris in 1886. The 22 letters that van Gogh wrote to him from Arles in 1888 share much common ground over a wide range of subjects, art and otherwise. Apart from his insistence on working from nature, van Gogh's advice about drawing would have confirmed Bernard's own ideas. 'I try to grasp what is essential in the drawing. Later I fill in the spaces which are bounded by contours – either expressed or not, but in any case *felt* – by tones which are also simplified.' (Van Gogh, *Letters*, III, p.478.) They exchanged drawings regularly and Bernard's use of decorative textures may have been inspired by van Gogh's pen drawings.

78 ODILON REDON
The Accused,
1886, signed
Charcoal on brown paper
21 × 14²/₃ in (53.3 × 37.2 cm)
Museum of Modern Art, New York (acquired through the Lillie P. Bliss Bequest). Inv. 199.52

Compared to that of the impressionists, the development of Redon's art was isolated and the particular character of his drawings is to some extent the product of this isolation. He had a brief academic training under Gérome in the 1860s, which he resented for much the same reasons as everyone else (cf. p. 19). In 1868–69 he wrote perceptive art criticism (for *La Gironde*, Bordeaux), in which he made clear his instinctive antipathy to 'realist' art, which pleases the eye at the expense of the inner senses.

Isolation, in the sense of the attention he did or did not give to other art, was a conscious decision, not lack of awareness. His most fertile contacts were with writers, musicians, a botanist, and with those with an interest in the occult. The significant exception was his relationship with the graphic artist Rodolphe Bresdin, 'whose power resides in his imagination'. Redon wrote of his landscapes as 'vague disquieting reveries, dense with meaning and leaving to the imagination the task of defining things' (*La Gironde*, 10 June 1869). As with all of Redon's lucid writing, his assessment of Bresdin says much of his own values, and it is clear that his intimate appreciation of Bresdin's art was a means of affirming his own position as an artist. When he wrote 'I shall not try to explain his art to you, because the beautiful is beyond explanation', he was rehearsing what he would often write later about his own images. He likens Bresdin to Dürer and to Rembrandt, and they shared a deep admiration for the work of Goya, whose exile had been spent in Bordeaux. Redon often mentions the profundity and musical resonance of lines in Dürer's prints, particularly *Melancholia*, and wrote of the 'fertile ambiguity of shadow' in Rembrandt. Rembrandt 'gave moral life to shadow'. Redon had written earlier of the lack of 'moral life' in realist art. His experiences at the front during the Franco-Prussian war in 1870, although we know little about them, appear to have sharpened his consciousness of the need for a moral dimension in art.

In the case of Goya, Redon was attracted more by the vocabulary of images than the matter of his prints. If the particular closeness of *The Accused* to the Goya drawing *Loco Furioso* (78a) is coincidental (and there are many such comparisons to be made), their similarity shows how close was the disquieting poetry of Redon's early work – often touching on melancholy and the irrational – to the reality and the fantasy of Goya's imagery. Huysmans, whose own writing drew upon Redon's art, stressed its affinities with music and literature: 'his masters are Baudelaire and above all Edgar Poe, upon whose aphorism "all of certainty resides in dreams" he seems to have meditated . . . through him we delight in losing our foothold to drift into dream, far from all schools of painting, ancient and modern' (Huysmans 1883, p.276).

78a GOYA: *Loco Furioso, c.* 1824/26 inscribed with title
Black chalk
7¹/₂ × 5²/₃ in (19.3 × 14.5 cm)
Collection Ian Woodner, New York

78b BRESDIN: *Mountainous landscape, c.* 1865
Pen and ink
7³/₅ × 10 in (19.3 × 25.3 cm)
Rijksmuseum, Amsterdam. Inv. 1960.3

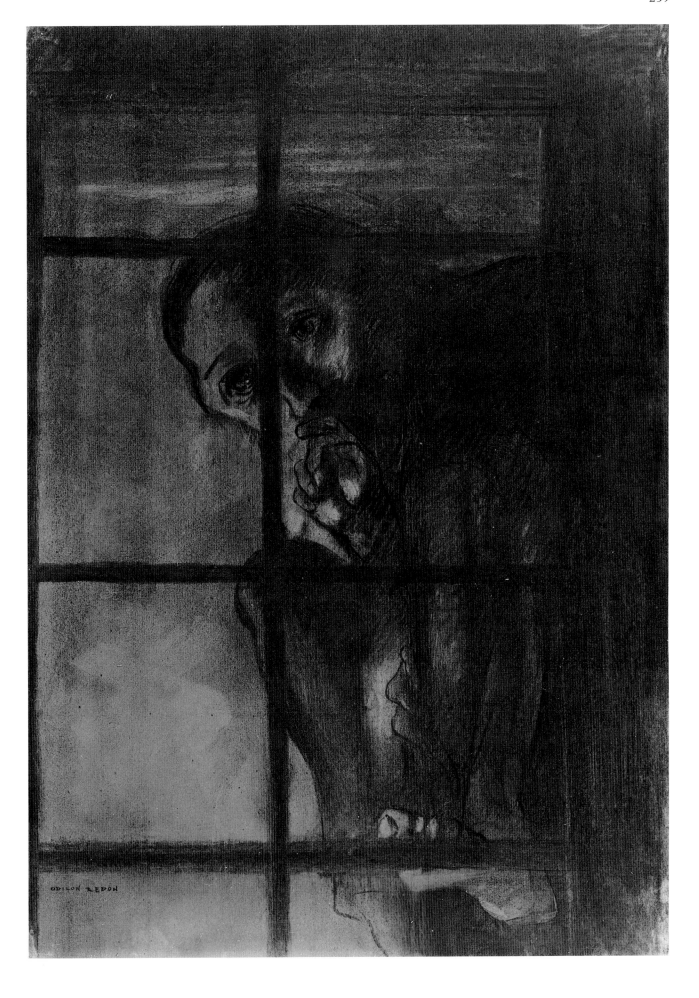

79 ODILON REDON
Diogenes
c. 1885? signed
Charcoal
20³/₅ × 14⁵/₇ in (52.3 × 37.4 cm)
Collection Ian Woodner

Most of Redon's work of the 1870s and 1880s was in black and white, drawings and prints. He called them '*Les Noirs*'. The material and expressive properties of charcoal were for him inseparable. His interests lay in the past, in music, in literature and in the world of shadows, in every sense. Charcoal – free of the incidental seductions of colour – seemed the inevitable vehicle for these concerns. He recalled later: 'Around 1875, everything I did was inspired by the pencil or by charcoal, that volatile powder, intangible, fugitive in the hand. Because this medium expressed me best, it remained with me. This stuff, with no intrinsic beauty whatever, greatly facilitated my researches into chiaroscuro, and into the invisible. It is a material little used by artists, neglected. Yet I should add that charcoal does not allow one to be pleasing: it is grave. One cannot work well with it except in this mood It is on the verge of the disagreeable, the ugly.' (1894. Bordeaux 1987, p.36.)

He wrote of how essential to his art were the austere properties of black: 'Nothing prostitutes it. It neither pleases the eye nor awakens the senses. Far more than the beautiful colours of the palette or the prism, it is the agent of the spirit.' (Redon 1961, p.125.) It was this quality that drew him to the work of Seurat, whose drawings he collected, and it was the beauty of Redon's blacks that attracted the admiration of Degas.

Redon's images are associable with a world seen with eyes closed. He wrote of looking as the nourishment of the artist's soul, springboard for the imagination. ('Whoever has not sufficiently developed the faculty of seeing truly and correctly will have only incomplete understanding. To see is to grasp spontaneously relationships between things.') In the drawing *Eyes in the Forest* (79a), the eyes appear as a dramatic source of illumination. The eye serves the same sort of role in his images as does darkness, standing on those boundaries between the visible and the invisible and between reality and dreams that interested him so much. He sought to stimulate in the onlooker 'all the seduction of the uncertain at the boundary of thought'. His *Diogenes* half-emerges from the darkness of uncertainty in his quest for an honest man and his Lazarus (79b) appears, bewildered, from the shadowed margins between death and life. Redon described the daylight of the 'healthy beauty of nature' as one source of his images of darkness. 'Music is for the evening, for winter, for shadows. It's the same with my drawings.' (Letter, 15 September 1895.)

79a *Eyes in the Forest, c.* 1875/80, signed
Charcoal on paper
13¹/₄ × 10³/₄ in (33.7 × 27.3 cm)
City Art Museum of St Louis. Inv. 234: 1979

79b *The Raising of Lazarus, c.* 1880 signed
Charcoal and gouache
10¹/₄ × 13³/₄ in (26 × 34.9 cm)
Fogg Art Museum, Cambridge, Mass. (Bequest of Meta and Paul Sachs) Inv. 1955.132

80 ODILON REDON
Don Quixote
c. 1890?
Black wax crayon, black chalk, pen and ink and
wash on tracing paper, mounted on board
$11^1/_5 \times 8^3/_4$ in (28.5 × 22.2 cm)
Fogg Art Museum, Cambridge, Mass. (Bequest of
Meta and Paul Sachs) Inv. 1965.328

The origins of Redon's images lie as much in the materials as in the experience
and 'complete understanding' of nature that he wrote of. In an important letter to
André Mellerio (August 1898), he talked of being horrified by a blank sheet of
paper, 'so shocking that I am forced, as soon as it is on the easel, to scrawl on it
with charcoal . . . and this operation brings it to life Nothing in art is achieved
by will alone. Everything is done by docilely submitting to the arrival of the
''unconscious''. When it appears, the analytical spirit must be sharp . . .' (Rewald
1962, pp.24–25). He goes on to say that none of this is important afterwards, but
in many of the densely worked drawings, this sense of the image emerging from
the matter is an enduring characteristic. The pale forms that emerge from the
charcoal or chalk ground are often generated by erasing and rubbing and then
realised by redrawing. For those forms that do emerge, we can often glimpse as
many still incoherent in the darkness, and which we sense progressively, as if our
eyes become accustomed to the dark. The improvisatory process is reminiscent of
the suggestive drawings of Victor Hugo (80b), with which Redon must have been
familiar. Full of dribbles, splashes and frottage, they were praised by Baudelaire,
who wrote in 1859 of the 'magnificent imagination which streams through them'.
Hugo himself was an admirer and supporter of Bresdin.

Some of Redon's images are fantasies, like the hybrid animal-plant-insect
creatures by which he is probably best known; some are coherent but not ident-
ifiable. As Gauguin wrote: 'His dreams become reality through the probability he
gives them.'

In this strange and beautiful drawing of Don Quixote, the tree and the
luminiscent flowers have taken form slowly from the richly varied substance of
chalk and crayon on paper. The elaborate surface is alive with sequences of light-
on-dark and dark-on-light formed by erasures, scratchings and redrawing. The
velvet luxuriance of the landscape environment is complete enough to suggest
that it was there before the figure arrived and his presence was secured in pen and
wash. Redon's Quixote is as probable or improbable as his hybrid creatures: a
bemused freakish figure, touched by madness and self-doubt, with none of the
affectionate pathos of Daumier's hero.

80a *Sea-creature*, 1890s or *c.* 1910, signed
Pastel on grey paper
$25^7/_8 \times 21^1/_4$ in (65.8 × 54 cm)
Louvre, Dépt. des Arts Graphiques. Inv. RF 40.499

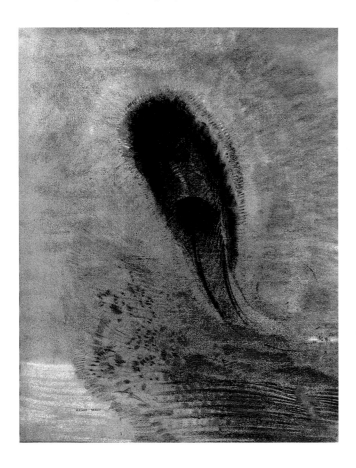

82b VICTOR HUGO: Improvisation
('Spots and frottage'), *c.* 1856
Brush and brown ink, wash
$8^5/_7 \times 4^1/_2$ in (22.1 × 11.3 cm)
Nationalmuseum, Stockholm. Inv. NMH 32/1981

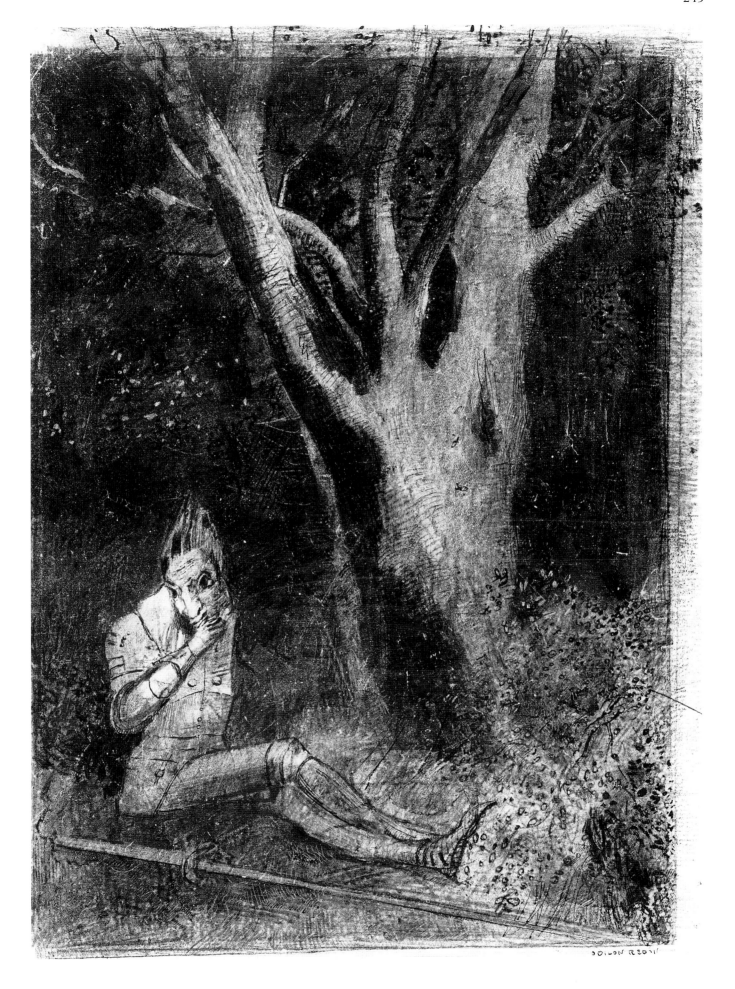

81 ODILON REDON
Three floating heads
1890s? signed
Black chalk
$11^2/_3 \times 9^1/_4$ in (29.6 × 23.6 cm)
Metropolitan Museum of Art, New York (Bequest of Scofield Thayer, 1984). Inv. 84.433.285

During the later 1880s and 1890s, with a shift in some post-impressionist art away from a rigorous study of nature towards a rehabilitation of the imagination, Redon emerged from his earlier isolation to a position of influential importance for younger artists. An increasing number of articles on his work were written, to which Redon's reaction was appreciative, although he was concerned at certain misunderstandings. In *Confidences d'Artiste* he says: 'People are wrong to attribute visions to me. I only make art'; and he explains that misunderstanding of his drawings 'stemmed from a lack of recognition that nothing had to be defined, understood, prescribed or specified, because everything that is truly and humbly new – like beauty itself – carries its meaning within it' (Redon 1961, p.26). Similarly, when Bernard wrote about him in *L'Occident* (May 1904), Redon told a friend: 'I don't agree with him when he writes of me as unconscious I am alive, I am not a medium I think I have acquired some ideas from study and from trial and error: they make me lucid.' (Letter, 21 August 1904.) He was concerned, too, about giving titles to his works which might compound misunderstanding and he believed his titles should be as vague and ambiguous as the drawings 'which inspire and are not meant to be defined'.

Three floating heads exemplifies what he meant by drawings which 'make no statements and set no limits' and which 'lead like music into an ambiguous world where nothing is determined' (*Confidences d'Artiste*). The first state of this drawing appears to have been a complete covering of the paper with chalk, varying in tone. Lighter areas were created by erasures and some of these were developed into images. The heads and plants seem to drift out of the amorphous tones. The relationship between them is at least as oblique as that between the elements on a sheet of separate studies in the Louvre (81a). Perhaps starting from the symmetry of the girl's hair, most of these images are mutations of a single form, variously a butterfly's wings, the wings of an angel, and some sort of floral heraldic banner held by a figure.

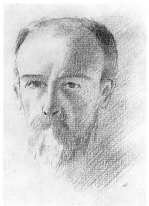

81b *Self-portrait,*
c. 1880/85
Charcoal
$10^5/_7 \times 8^5/_7$ in
(27.2 × 22.1 cm)
Fogg Art Museum,
Cambridge, Mass.
(Anonymous loan).
Inv. 45.1989

81a *Sheet of studies, c.* 1910
Watercolour
$10^3/_5 \times 8^1/_3$ in (27 × 21.1 cm)
Louvre, Dépt. des Arts Graphiques. Inv. RF 29.709

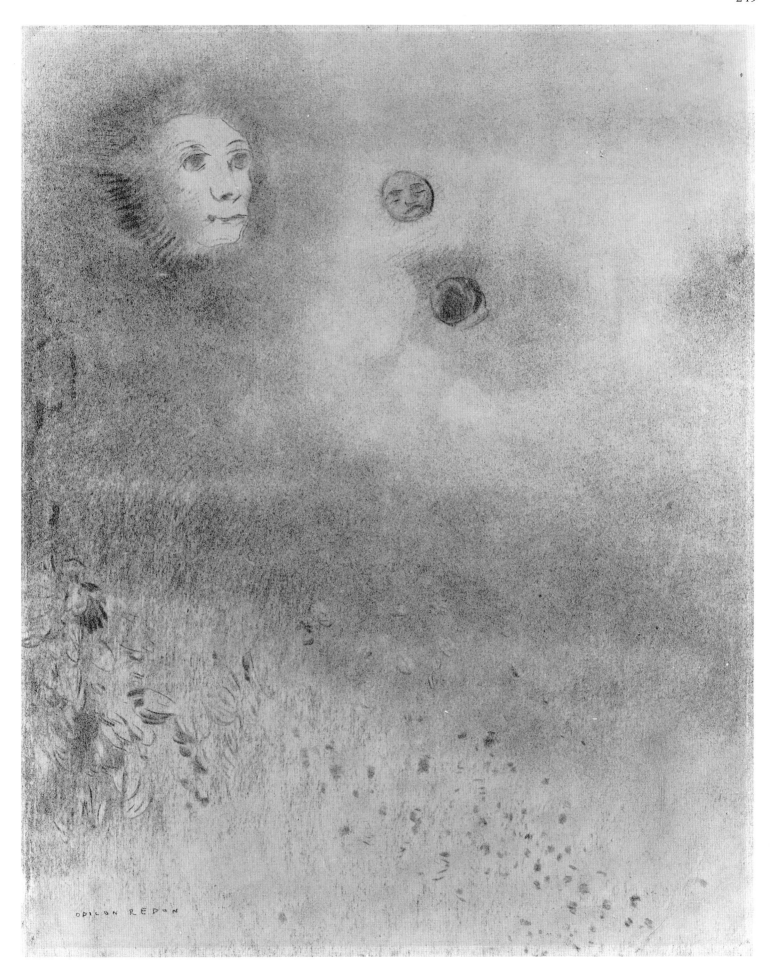

82 ODILON REDON
St Sebastian
1910, signed
Chalk and watercolour
9⁴/₅ × 7 in (24.9 × 17.8 cm)
Kunstmuseum, Basel.
Inv. 1940.15

By the mid-1890s, Redon had moved out of the obsessive world of his drawings and lithographs into a radiant use of colour in his pastels and watercolours. That he could now write of the recaptured hope of giving fuller expression to his dreams through colour suggests that the mood of these dreams had changed. Earlier he had talked of the blackness of charcoal being the essential medium for realizing dreams, dreams whose images drew upon the macabre visions of Poe, Flaubert and Goya. In letters of the 1890s, he wrote of feeling at ease and rejuvenated by working with colour: it did not fatigue him and led to 'new and different things'. On the face of it, the martyrdom of a saint is not far removed from the repertoire of his earlier work, but the delicate, jewel-like colour of this drawing, in which intense blues bleed off into subtle violet and yellow, expresses a different mood.

In the later work there is also a clearer sense of the roots in nature of his art. Working in a rural environment was important to him and he even suggests that had he been left alone in the country, as in childhood, he may have been more prolific. 'It is only after an effort of will in minutely copying a blade of grass, a stone, a branch, the face of an old wall, that I am seized as if by a torment to create from the imagination I owe to the moments following such exercises my best works.' (Bordeaux 1987, p.38.) The tree study (82a) may have been one such exercise and its usefulness to him shows in the variants of its form that appear in different subjects over a long period. He valued Corot's advice to him, that if he was uncertain of something to put beside it a thing of which he was certain.

Alongside the imaginative, literary and allegorical subjects of the last years, he drew a series of pastel still lifes of flowers, deceptively innocent, in which the intensity and contrast of colour is full of ambiguous evocation. Like almost all of his works, they are intimate in scale. He describes himself as 'master of my means in a small domain'. It is perhaps this preciousness of scale more than anything else that has deterred consideration of him as among the *grandes maîtres* of post-impressionism, which in the field of drawing he clearly was. By the 1890s he was held in high regard by contemporaries as widely different as Degas, Cézanne and Gauguin, and the younger generation considered him at least as important a 'master' and seminal influence as these three.

82a *Tree, c.* 1892
Pencil
18³/₅ × 12¹/₂ in (47.3 × 31.8 cm)
Colby College Museum of Art, Maine.

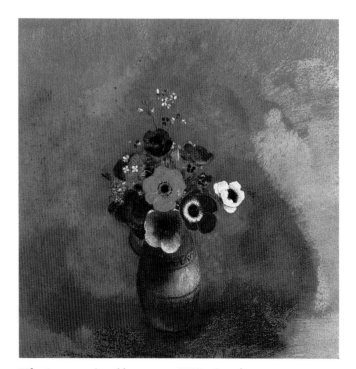

82b *Anemones in a blue vase, c.* 1912, signed
Pastel
25¹/₈ × 24²/₃ in (63.8 × 62.6 cm)
Musée du Petit Palais, Paris. Inv. P.P.D. 1218

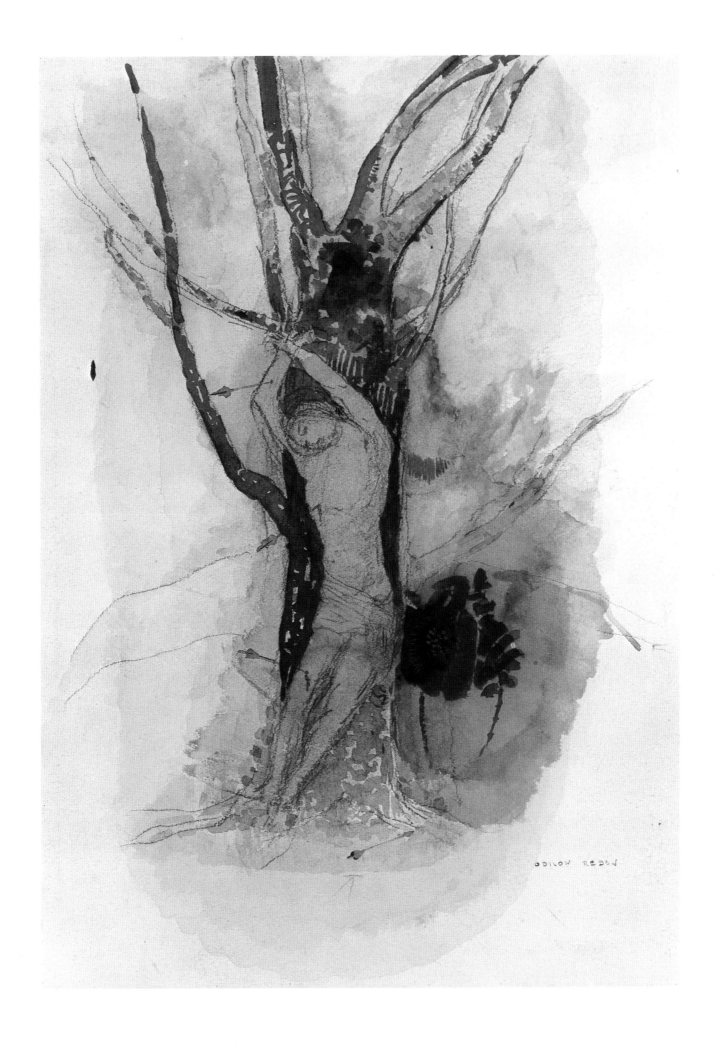

The complexity of Whistler's art bears the same oblique relationship to impressionism as that of Redon, but in some ways he was also an intimate part of the movement. Although he spent most of his working life in England, he was a frequent visitor to Paris; in the 1860s was an imtimate associate of Fantin-Latour, Degas and Manet, and in the 1880s he enjoyed a close relationship with Monet that has not been fully studied. Some of his earliest drawings (83a) are realized in a densely hatched chiaroscuro close to the tenebrist manner of Fantin. The use of close-toned harmonies of muted colour remained a characteristic of many later paintings and watercolours. As early as 1867, Whistler had come to regret his initial adherence to the banner of realism, with its arrogant dismissal of tradition, as some sort of misspent youth: he felt the preoccupation with colour had made him neglect drawing and he even wished he had been a pupil of Ingres. Even if the artful sophistication of his later figure drawings is of a quite different character from those of Ingres, his aspiration towards an elegant stylization of things seen is comparable in degree.

Within their hypersensitive means, the simple strength of Whistler's nude studies is not too distantly removed from Ingresque conventions of drawing. This characteristic pastel study has a firm sense of silhouette, created both by the emphatic contours and the colours which abut its edges (red above, ochre below). Within the contour, slight but telling drawing is heightened by the use of white touches, themselves tinted in places by the faintest additions of pink and grey. The means are economic, but his fine handling of them is so practised that he achieves an extraordinary physical completeness in the figure without losing the ephemeral lightness of touch symbolized by his butterfly monogram. Although the softness of his mannered effects was quite personal, and consciously so, he probably learned much from the pastels of Degas, with which he was familiar. It was a mutual relationship – there are sketches of Whistler's figure compositions in Degas's notebooks – but the contact was most important for Whistler's familiarization with French art and practice. The effete elegance of his mature work and his design-conscious sense of *mise-en-page* were fostered by his devotion to the art of the Japanese print. The more painterly qualities of his drawings and pastels suggest his debt to Degas.

83 JAMES MCNEILL WHISTLER
Nude female model reclining
1890/95? butterfly insignia
Chalk and pastel on brown paper
$7^1/_8 \times 10^3/_5$ in (18.1 × 27 cm)
Fogg Art Museum, Cambridge, Mass. (Bequest of Grenville L. Winthrop). Inv. 1943.607

83a *Sleeping woman* (study for the etching *Weary*), before 1863, signed
Black crayon
9 × 6½ in (22.9 × 16.5 cm)
National Gallery, Washington (Rosenwald Collection, 1948). Inv. B-15,136

83b *Standing woman in black*, early 1880s?
butterfly insignia
Watercolour
8½ × 5 in (21.6 × 12.7 cm)
Fogg Art Museum, Cambridge, Mass. (Bequest of Grenville L. Winthrop). Inv. 1943.618

84 JAMES MCNEILL WHISTLER
Venice
1880, butterfly insignia
Black crayon
4⁷/₈ × 7¹/₂ in (12.5 × 19 cm)
National Gallery, Washington (Rosenwald
Collection, 1943). Inv. 1943.3.8820

84a *At sea*, c. 1901, butterfly insignia
Pen and brown ink
6 × 3³/₄ in (15.2 × 9.6 cm)
National Gallery, Washington (Rosenwald Collection).
Inv. 1943.3.8818

Defending his *Nocturnes* during the Ruskin libel hearing in November 1878, Whistler described them as 'impressions of my own', and explained that they 'are painted off generally from my thought and mind. Sketching on paper is very rare for me.' Although there are some instances of uncomplicated notes made from observation (84a), in general his drawings were an activity parallel to his painting, in which this personal impression was the basis for aesthetic harmonies. He accorded to his pastels and watercolours the same status as to paintings: they were often also given musical titles (cf. Pl.VI).

This musical abstraction of Whistler's art, coupled with the declamatory, art-for-art's-sake position that he adopted in his manifesto-like *Ten O'Clock Lecture* (1884, translated by Mallarmé 1887/8), aligned him so closely with the Aesthetic Movement in England and the Symbolists in France that he appears to stand quite apart from impressionism. Huysmans went so far as to suggest that: 'In his harmonies of nuance he almost passes beyond the boundary of painting. He enters the domain of literature and reaches the melancholy parks where the pale blooms of M. Verlaine grow.' (*Certains*, p.72.) Yet, although more given to a mannered perversity, Whistler's drawings are broadly in accord with Monet's notion of representing not what you know, but only what you naïvely see. In the pen drawing of a reclining woman (84b), the motif is difficult to recognize at first glance. The staccato marks are an impression of appearances rather than the realization of a preconceived subject.

Whistler's drawings, pastels and etchings of Venice, around 1880, are among his most impressionist works (see also Pl.XII). We can reasonably assume that at least some of these were made not from his 'thought and mind', but on the spot. This sensitive drawing of the lagoon is comparable to Monet's atmospheric studies of mirror-image reflections; the vertical axes of reflected elements set against the gentle horizontal insistence of water and sky. Leaving aside the butterfly monogram (which is often the clearest or most strongly coloured element on the paper), Whistler's *plein air* drawings are among the most extreme examples of impressionist dissolution of form in light and atmosphere. Even Pissarro, who found Whistler's affectation distasteful, greatly admired the suppleness and delicacy of the atmospheric inking in his Venice etchings (letter, 28 February 1883).

84b *Reclining woman with parasol*, 1882, butterfly insignia
Pen and brown ink on wove paper
8³/₄ × 7 in (22.3 × 17.7 cm)
National Gallery, Washington (Rosenwald Collection).
Inv. 1943.3.8804

85 HENRI DE TOULOUSE-LAUTREC
Seated male nude, standing female nude
c. 1885
Charcoal
27¹/₈ × 21¹/₄ in (69 × 54 cm)
Musée Toulouse-Lautrec, Albi. Inv. Dortu 2578-D33

As a convalescent fourteen-year-old, Lautrec was taught painting and drawing by the equestrian painter René Princeteau and initiated into rapid drawing from nature. Only later, briefly in the studio of Bonnat and then in that of Cormon, from 1882 to 1886, did he apply himself seriously to an academic study of drawing. 'Cormon's criticisms are far milder than Bonnat's. He looks at everything you show him and encourages you. You'll be surprised to learn that I find this less to my liking. In practice my previous master's strictures put some life into me and I didn't spare myself. Here, I feel rather relaxed and it takes an effort to produce a conscientious drawing when something that is not so good pleases Cormon just as well.' (Letter, 10 February 1883.) His fellow-students describe Lautrec as hard-working, articulate and innovative and suggest that Cormon liked his work well enough to let him get on with it. Compared to the characterful genre realism and impromptu tonal technique of an 1882 drawing (85a), the academic drawings he made from life and from plaster casts in Cormon's studio are remarkable for their assured conformity to conventions. Set beside Bernard's drawing from the same models (Fig. 20), this life study by Lautrec looks authoritative and alert in its observation. As well as the diligent and convincing sense of structure, there are hints in the heads of the models of an interest in individual character pervading his early work (which includes many caricatures).

During his time with Cormon, Lautrec was increasingly drawn to the work of the impressionists, and these interests precipitated his gradual loss of interest in the studio. There were other students there who moved into the impressionist orbit, including, in 1886, van Gogh and the Scots painter Hartrick, according to whom Lautrec was already experimenting with different techniques, drawing in turpentine with coloured hatching. Although he did not meet Degas until 1889 and was never personally close to him, at around this time Degas's art became a yardstick of excellence for Lautrec and a many-sided source of inspiration. Even the manner of his pencil drawings bears a striking resemblance to Degas's portrait studies (85b): the disposition on the page, the fineness of drawing of features and their characterization, and the fading energy of peripheral lines.

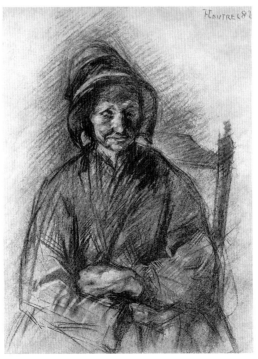

85a *Old woman in bonnet and shawl*, signed and dated 1882
Charcoal
24³/₄ × 18¹/₂ in (62.9 × 47 cm)
Museum of Fine Arts, Boston, Otis Norcross Fund. Inv.62.994

85b *Man in profile, c.* 1885? monogram
Pencil
10²/₃ × 8 in (27.1 × 20.4 cm)
Louvre, Dépt. des Arts Graphiques. RF 29.430

86 HENRI DE TOULOUSE-LAUTREC
The Moulin Rouge, La Goulue
1891
Charcoal, heightened with colour
60½ × 46¾ in (153.7 × 118.7 cm)
Musée Toulouse-Lautrec, Albi

Lautrec had been introduced to the worlds of theatre, circus and racetrack as subject matter by Princeteau and these interests were furthered by his admiration for Degas's original treatments. In the brilliantly inventive language with which Lautrec made them his own, we can identify his assimilation of many sources: of the black-and-white simplicity and asymmetry of Japanese prints (to some extent filtered through the example of Degas), as well as of the radical linear forms from contemporary work by Bernard, Gauguin, van Gogh and Seurat. The intense vitality of Lautrec's moving line prefigures the organic arabesque of art nouveau. As well as being himself a source for the style, Lautrec was familiar with its early, international manifestations: he made several trips to Brussels, where he exhibited with *Les XX* and visited the pioneer designer-architect Henri van de Velde.

The Moulin Rouge, La Goulue is a drawing for his first poster, the success of which precipitated his prolific career as a lithographer. Comparison with any of Degas's drawings of entertainers (Pl.10, Pl.19b) reveals both Lautrec's debts to Degas and the radical independence of his style and vision. They have in common the use of truncated close-up views, frozen movement, unexpected effects of artificial light and the expressive drama of silhouettes. Lautrec is far more extreme in his contrivance of overlapping images – the two main figures and the swinging ellipse of giant globe lamps. He charges the crowded surface with animation. There is also a characterization of personalities that appears affectionate, humorous and vulgar next to the cool objectivity of Degas's observation. Of course the art of designing for posters makes different demands in this respect. The caricatural likenesses that Lautrec developed of La Goulue, Loie Fuller, Yvette Guilbert, Jane Avril, Chocolat and others (embracing physiognomy, movement and costume) were in part a necessary response to those demands (86a, 86b). In addition, in the intense particularity of Lautrec's images, there seems to be a celebration of the extraordinariness of these individuals that is perhaps explainable as some form of identification. Comparison of any of Lautrec's images of Guilbert with, for instance, the posters of Cheret underlines the very particular sensibility behind Lautrec's portrayal (cf. Pl. 107b).

86a *Loie Fuller dancing*, 1893, signed
Oil on card
24⅞ × 17⅞ in (63.2 × 45.3 cm)
Musée Toulouse-Lautrec, Albi

86b *Yvette Guilbert*, 1894
Black crayon on grey paper
8½ × 6³⁄₇ in (21.7 × 16.4 cm)
Louvre, Dépt. des Arts Graphiques. RF 29.576

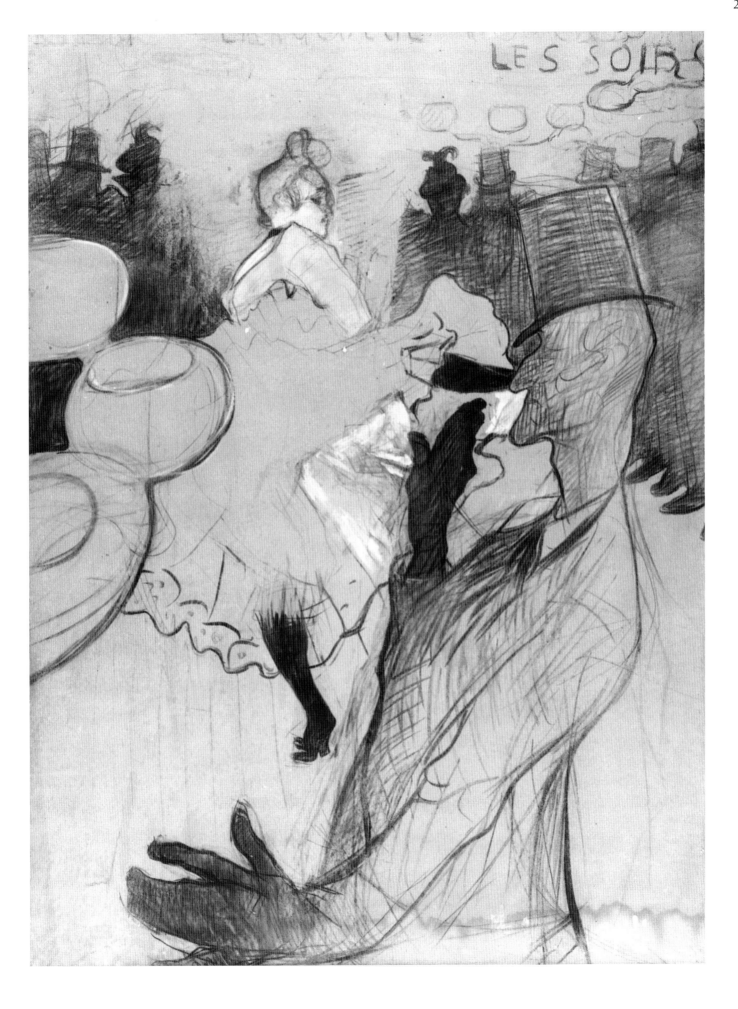

87 HENRI DE TOULOUSE-LAUTREC
Two studies of a sleeping woman
1895/96
(above) red chalk on blue paper
14⁷/₈ × 18⁷/₈ in (37.7 × 48 cm)
(below) red chalk on transparent paper,
8 × 10¹/₂ in (20.3 × 26.6 cm)
Boymans-van Beuningen, Rotterdam.
Inv. nos. F-II-160, F-II-201

These two drawings show the transition of an idea from an early study after life to the discriminate simplification of a final drawing made for transfer to the lithographic stone. The condensed and fluent linear reduction may superficially resemble the decorative forms of Bernard's drawing (cf. Pl.77a), but by contrast, Lautrec's image remains alive with sensitive observation. The contour is taut and informative. The subsequent print, *Le Sommeil* (Delteil 170), is part of a series of lithographs, *Elles*, of 1896. The models were prostitutes in a brothel in the rue du Moulin.

Writers on Lautrec have made much of a brutal realism in his depiction of the *maisons closes*. Acquaintances like Hartrick and Vuillard describe his depressive despair as the source of his cynicism, as well as of his suicidal alcoholism. Vuillard also suggests that his association with the brothel girls was partly an identification with their debased conditions of life (Lautrec being cut off from his aristocratic roots by his grotesque appearance) and partly an attraction to the sentimental *naïveté* of the girls (*L'Amour de l'Art*, 1922). The extremes in Lautrec's work of theatrical exaggeration and intimate sensitivity tend to confirm such a polarity. The precedents for such subjects among the drawings of Guys, Forain and Degas were probably of importance to Lautrec. Although these artists also express an ambivalent range of feelings, many of Lautrec's drawings of prostitutes suggest a sympathetic intimacy that has more to do with individuals than with types.

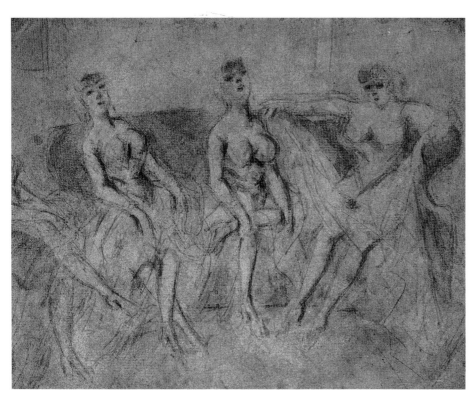

87a GUYS:*Prostitutes seated on a sofa*, 1860s?
Chalk and wash
6³/₄ × 8³/₄ in (17.2 × 22.2 cm)
Kunstmuseum, Basel. Inv. 1978.729

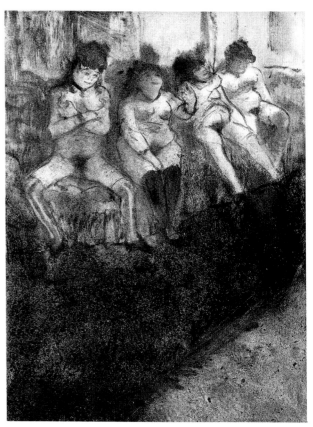

87b DEGAS: *Waiting* (second version), 1879
Monotype
8¹/₂ × 6³/₇ in (21.6 × 16.4 cm)
Musée Picasso, Paris. Donation Picasso RF 35783.

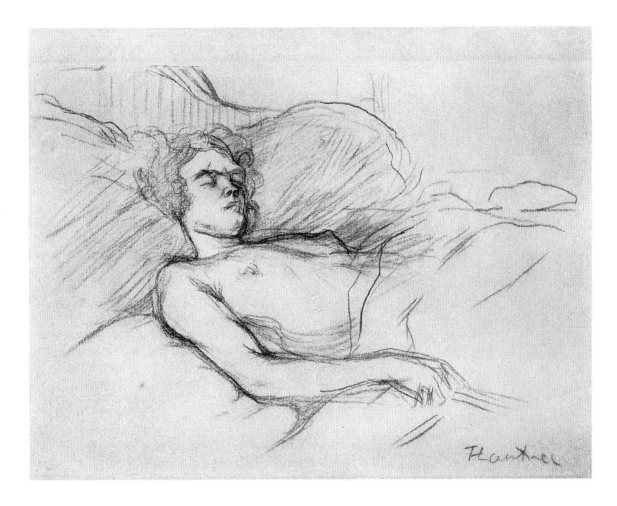

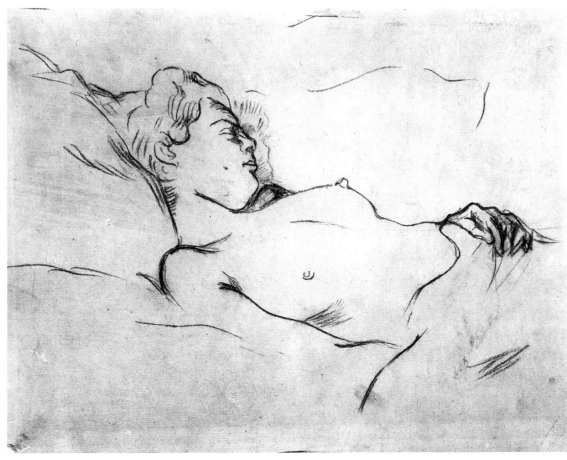

88 HENRI DE TOULOUSE-LAUTREC
Yvette Guilbert 1894
Lithograph
13³/₄ × 9¹/₄ (35 × 23.5 cm)
Delteil 81

As soon as Lautrec started working his lithographs more directly on the stone, around 1892, he embarked on technical improvisations which transformed the medium. Many artists became enthusiastically involved in lithography at around the same time – Degas once mused about what Rembrandt might have made of it – but the originality and influence of Lautrec's use of the medium are difficult to exaggerate. Of course he continued to make *in situ* drawings, but lithography became the focus for his drawings and everything else he did was affected by it. The textural experiments of van Gogh and the neo-impressionists probably encouraged the range of what he attempted, but his own improvisation was dazzling in its invention: stippling of powdery lightness, sprayed with a brush; dragged crayon; stencilled shapes; vigorous tonal hatching and organic shapes of dense black. His drawings for print – sheet music, programmes and menus as well as posters – established a use of images alongside text that did not simply sit neatly in a boxed illustration, but whose animation invaded the whole field of paper. It was a precedent with widespread influence and which is comparable to the visually imaginative use of typography explored by Mallarmé, Apollinaire and others.

The quality of decorative arabesque that pervades many of these drawings seems, on the face of it, to be remote from the origins of impressionism, and Lautrec's obsessions with the bizarre and grotesque to be antipathetic to the healthy basis in sunlit nature of the impressionist landscape. ('Ugliness has its notes of beauty', he told Yvette Guilbert. 'It is thrilling to discover them where nobody else sees them.') Beneath these surface contrasts, the principles of Lautrec's mature endeavour remained basically similar to the impressionist ideas that first moved him. The unprejudiced eye locates fragments of visual appearance, acutely observed, that appear grotesque chiefly because of their unfamiliar immediacy. In this sense the visual drama of the illuminated theatre box seen from below (88a) is no more or less contrived, no more or less grotesque, than Monet's pastel of Etretat (Pl.33).

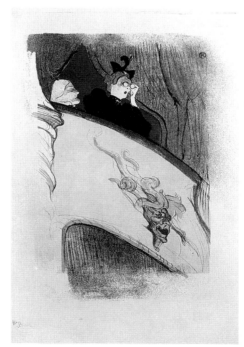

88a *Theatre box with gilt mask*, 1894.
Colour lithograph
14²/₃ × 12 in (37.3 × 30.4 cm)
Metropolitan Museum of Art, New York
(Clifford A. Furst Bequest).
Inv. 58.621.3. Delteil 16

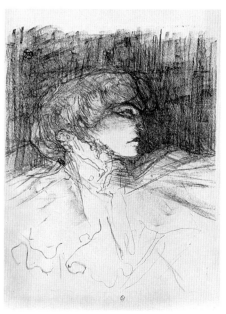

88b *Jane Hading*, 1898
Lithograph
11¹/₂ × 9¹/₂ in (29.3 × 24 cm)
Bibliothèque d'Art Jacques Doucet, Paris.
Delteil 263

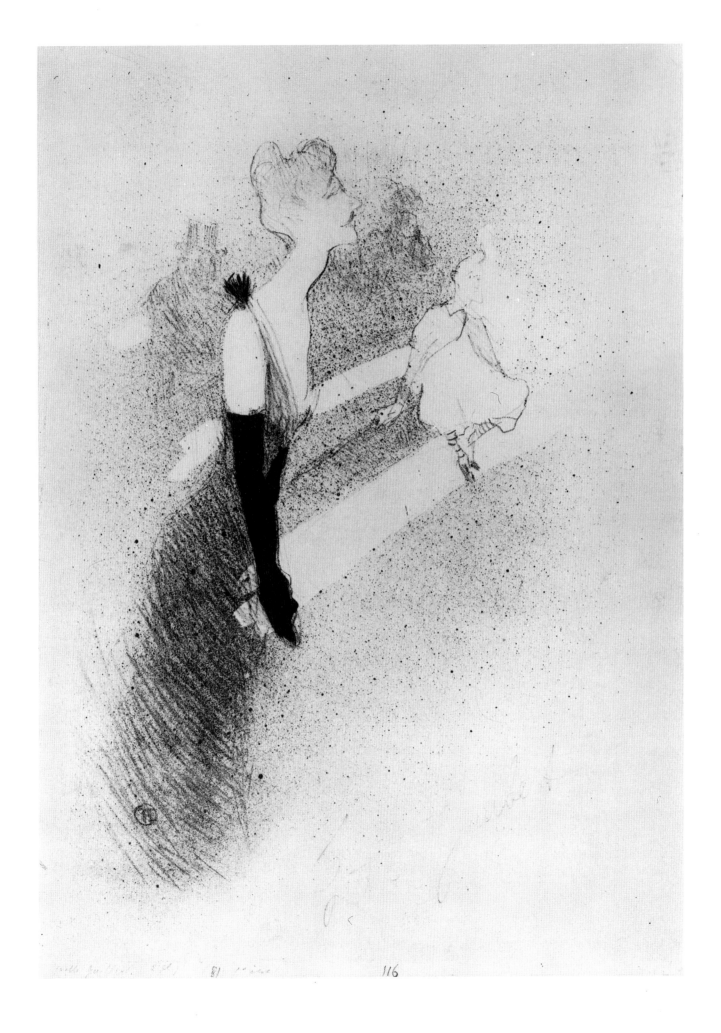

116

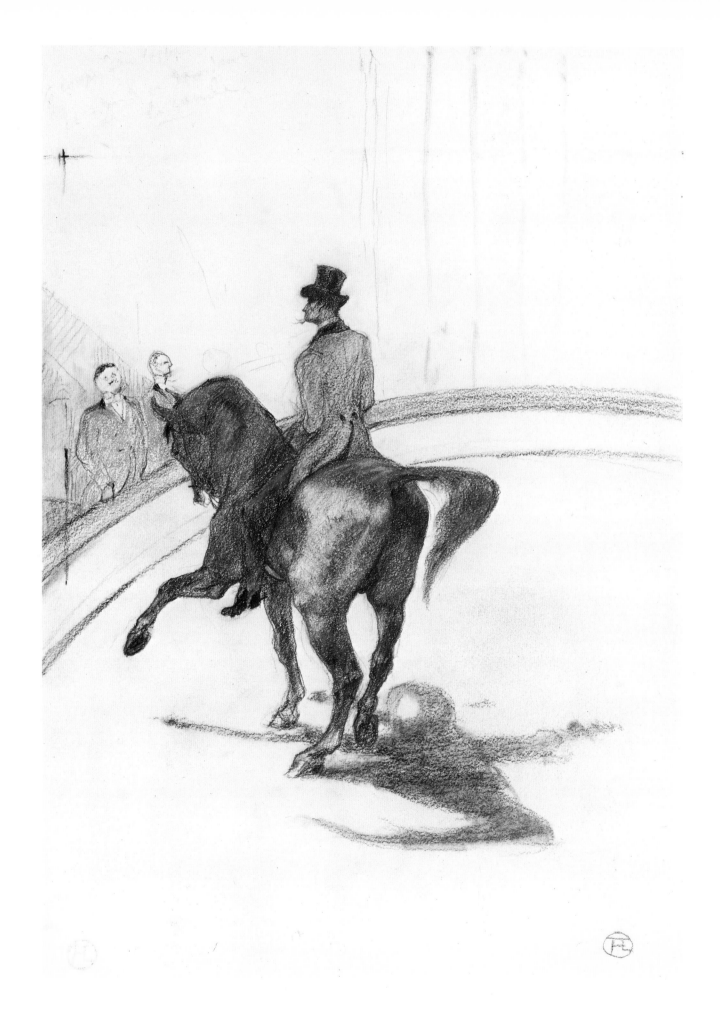

This late drawing is another striking example of Lautrec's interest in silhouette, in which the already elaborate dark shape of the horse and rider is extended into the bizarre pattern of shadow. The final working of the drawing is in graphite, tightening the detail of shapes and darkening the tones. The dramatic linear organization in this drawing is thoroughly characteristic of Lautrec's drawing throughout the 1890s and pervades the series of circus images that he drew in Madrid in 1899. In the extraordinary drawing of a clown and poodle from the same series (89a), the eccentric, slightly comic silhouettes are again extended into sinuous shadows against the simple curves of the arena.

A sense of melancholy beneath the potential gaiety of the subject may be autobiographical. These works were made following Lautrec's treatment for alcoholism in a private sanatorium and the dedication of the clown drawing is as a 'souvenir of my captivity'. Our awareness of this inevitably generates additional nuances in the comic pathos of dog and elephant, the aggression of the clown and the bleakness of the empty spaces around.

The instincts of the caricaturist underlie all of Lautrec's oeuvre from the prodigious facility of his teenage works onwards. They inform his instinctive grasp of silhouette and his remarkable ease in achieving likeness. Forain was the first significant contemporary artist he knew well, and echoes of Daumier abound in his work. What finally distinguishes Lautrec's work from other impressionists more than anything else is its wit, at times sardonic, at times just funny.

89 HENRI DE TOULOUSE-LAUTREC
Le pas Espagnol
1899 monogram
Black and coloured crayons
13³/₄ × 9⁵/₆ in (35 × 25 cm)
Metropolitan Museum of Art, New York (Robert Lehman Collection)

89a *At the Circus*, signed and dated 'Madrid, Easter 1899', dedicated to Arsène Alexandre
Crayon
10¹/₆ × 17 in (25.9 × 43.3 cm)
Statens Museum for Kunst, Copenhagen. Inv. Tu 35b,5

89b *Self-portrait caricature, c.*1890 monogram
Black chalk
10 × 6¹/₃ in (25.5 × 16 cm)
Boymans-van Beuningen Museum, Rotterdam. Inv. MB 1951/T-3

90 VINCENT VAN GOGH
Work in the fields
October 1883, Drenthe
Pencil, pen and sepia ink
12³⁄₅ × 16¹⁄₅ in (32.1 × 41.2 cm)
Museum of Fine Arts, Boston (Gift of John Goelet).
Inv. 1975.375 F1095

In a letter of October 1883 from Drenthe, van Gogh told his brother: 'Yesterday I drew some decayed oak roots, so-called bog trunks These trunks were lying in a pool of black mud.' [331]* If the first stage of this strangely animated drawing was made on the spot, it is likely that the subsequent reworkings, first in pencil, and then in sepia ink, were not. All of the additions are expressive or anecdotal in character, rather than observed. The added figures, startlingly inconsistent in scale and tonal value, add a narrative element; the imaginative redrawing of the roots heightens the drama of their grotesque silhouettes and the symmetry of reflections.

Van Gogh's drawings in Holland, which comprise about two thirds of his prolific oeuvre as a draughtsman, have little to do with impressionism. The landscapes that he drew during three months in Drenthe at the end of 1883 are thoroughly Dutch in character, drawing on the same native traditions as the early landscapes of Mondrian. In his letters from Drenthe he writes of the poetic melancholy of a landscape of heathlands, heather, canals and moss-covered cottages, far from attractive in sunlight but full of subtle colour by twilight. His watercolours of this period (Pl.V) are low and sooty in tone, soft and atmospheric. Their mood reflects the bleak sadness that he describes.

His earlier landscapes were mostly urban or suburban, and further from painting than the Drenthe drawings. In the Hague, 1881-83, he drew a series of window views in which he concentrated on problems of perspective and linear organization. He was both impatient to be able to draw as quickly and naturally as handwriting, and, characteristically, prepared to devote time and effort to achieve this. After reading Dürer's treatise on perspective, he designed and had made a portable perspective frame. The drawing in letter 223 (90b) is apparently of a second, refined version, with long pointed poles allowing the frame to stand squarely in uneven ground. He writes of its value in giving the main lines and proportions of a motif 'which help me make a solid drawing'. Elsewhere he writes: 'Just imagine me sitting at my attic window as early as four in the morning, studying with my frame the meadows and the yard where they are lighting fires to make coffee in the little cottages Behind it all, a stretch of soft tender green, miles and miles of flat meadow and over it a sky, as calm, as peaceful as Corot or van Goyen.' [219] The drawing (90a) was absorbed with technical problems; his romantic description is informed by an imagination that is both literary and visual.

*in the van Gogh notes, numbers in square brackets refer to the *Complete Letters* 1958 (see Bibliography).

90a *Roofs from the artist's window* 1882, The Hague
Watercolour, heightened with white
15¹⁄₃ × 21²⁄₃ in (39 × 55 cm)
Private collection, Paris. F943

90b Perspective frame, drawing from Letter 223, August 1882
Rijksmuseum Vincent van Gogh, Amsterdam

91 VINCENT VAN GOGH
Young Girl
1883, The Hague
Pencil, lithographic chalk, pen, brush, ink,
heightened with white
19 × 10 in (48.3 × 25.4 cm)
Museum of Fine Art, Boston. Inv. 1970.468.
[F]SD1685

Degas and Seurat apart, van Gogh's attitude to drawing differs from his impressionist contemporaries in that from the start he saw drawing as a complete art in its own right. He distinguished between 'studies' and 'drawings' [144] just as between 'studies' and 'paintings' [233]: the drawing and painting were personal visions and the studies in each case were analyses of nature – which came first in the way that sowing precedes reaping.

His first ambition as an artist was to be 'master of black and white'. Moved by the work of Millet and of the graphic artists whose work he encountered in England, 1873-76, he aspired to be a 'draughtsman of the people'. In his hierarchy of values the moving expression of true sentiments in art was ranked more highly than traditional reputations: 'Nothing touches me less than Rubens expressing human sorrow.' [444] There is little rhetoric in van Gogh's figure drawings, neither in gesture nor facial expression. In the great figure drawings of the Hague (1881-83) and Nuenen (1884-85), feeling is usually expressed through a passive, stoic reserve. He identified closely with the lives of his sitters, and compared the art of drawing variously to the miner's work and the weaver's craft. He dreamt of a drawing that might evoke the honesty, dignity and physical demands of labour. In its morality, his early drawing echoed the ideals of his first vocation as preacher and 'friend of the poor'. He admitted to being 'prejudiced against women who wear dresses' [395].

The other subject on which van Gogh wrote passionately in the early letters was the properties of his materials. He experimented freely with his media, mixing charcoal, chalks, wash, gouache, various inks and pencil; rubbing them with breadcrumbs or a stump, fixing and dulling some of them with milk. This characterful drawing of a peasant girl was reworked repeatedly, its charcoal tones lightened with gouache, stump and by scraping and then redrawn with brush (and ink?), chalk and pencil. Drawings of this period are sometimes so complex in their means that it is difficult to reconstruct his technique (see E.B.F.Pey in Otterlo 1990, pp.28-39).

91a *The Soup Kitchen*, March 1883, The Hague
Pencil, black chalk, watercolour
15¹⁄₃ × 19¹⁄₄ in (34 × 49 cm)
Rijksmuseum Vincent van Gogh, Amsterdam. F1020a

91b *'Old Retering'*, Oct./Nov. 1883, The Hague
Pencil, black chalk, washed
17⁵⁄₇ × 11 in (45 × 28 cm)
Collection of H.R.Hahnloser, Bern. F1019

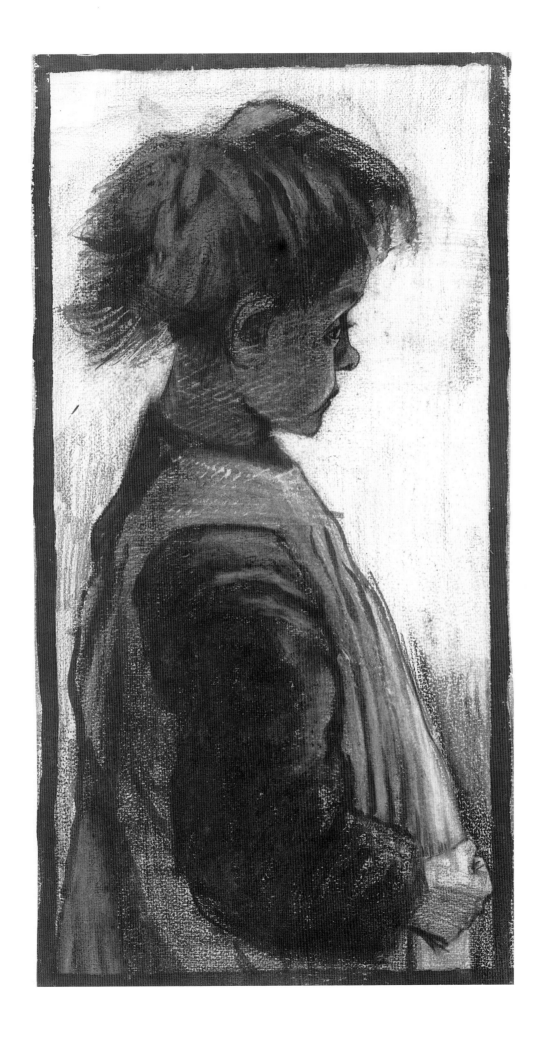

92 VINCENT VAN GOGH
Seated female nude
1887, Paris
Pencil
12 × 9³/₄ in (30.3 × 24.8 cm)
Rijksmuseum Vincent van Gogh, Amsterdam.
[F]SD1718

It is clear that in the early years van Gogh believed there to be 'rules, principles, or fundamental truths for drawing', which might be learned. Apart from his study of other art, most of his diligent self-education in drawing came from drawing manuals by C. Bargue: *Cours de Dessin* (1868-70, co-edited with Gérome) and *Exercices au Fusain* (1871). Van Gogh had both of these manuals on loan from 1880 to 1883, and from them copied drawings from life, the skeleton, casts, and after the 'masters'. By 1881 he had copied all sixty plates from *Exercices au Fusain* three times over (cf. Pl.99b). He learned a method of simplifying his drawing and struggled to apply this to drawing from life, selecting 'the lines which will seem entirely natural' [185]. By 1885, in Nuenen, through his own experience and his study of what he thought of as meaningful (rather than just accomplished) drawing, he felt able to cite the authority of distortions in Michelangelo and Millet, declaring 'I should be desperate if my figures were correct' [418].

Nevertheless, in the Academy of Art at Antwerp, January 1886, and then in Cormon's studio in Paris in November 1886, he undertook academic tuition to 'learn' drawing. Despite an instinctive antipathy, he applied himself to drawing from the cast and the model 'with the patience of an angel . . . he corrected himself, passionately started again, crossed out, and finally tore through his paper with the violence of his erasing' (Bernard 1911, pp.10–11). His academic drawings are in a variety of styles, none of them particularly conformist (Figs.14, 21).

Other figure drawings in Paris, like this seated nude, relate less to conventions of drawing than to the impressionist techniques of painting which he was assimilating, not least through his close relationships with Lautrec and Signac. The faintly visible outlines of the figure are overdrawn in a succession of abrupt, brushstroke-like marks, which Bernard described as 'aligned in whichever direction was most expressive of the form'. More significantly for van Gogh's later development, he explored in these drawings for the first time a way of dispensing with the continuous contour. Under the influence of impressionist painting, he started making rapid transcriptions from nature: drawings in which the whole image is animated by homogeneous marks.

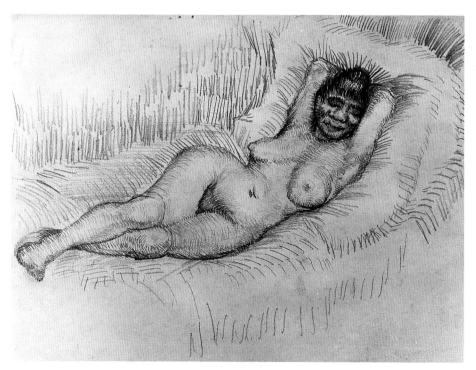

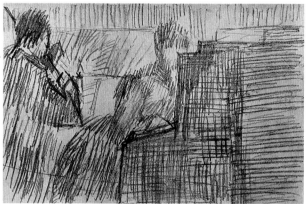

92b *Violinist and pianist*, 1886/87, Paris
Pencil
5¹/₃ × 8¹/₆ in (13.7 × 20.8 cm)
Rijksmuseum Vincent van Gogh, Amsterdam, [F]SD1714

92a *Reclining female nude*, 1887, Paris
Pencil
9¹/₄ × 12²/₅ in (23.5 × 31.5 cm)
Rijksmuseum Vincent van Gogh, Amsterdam. F1404

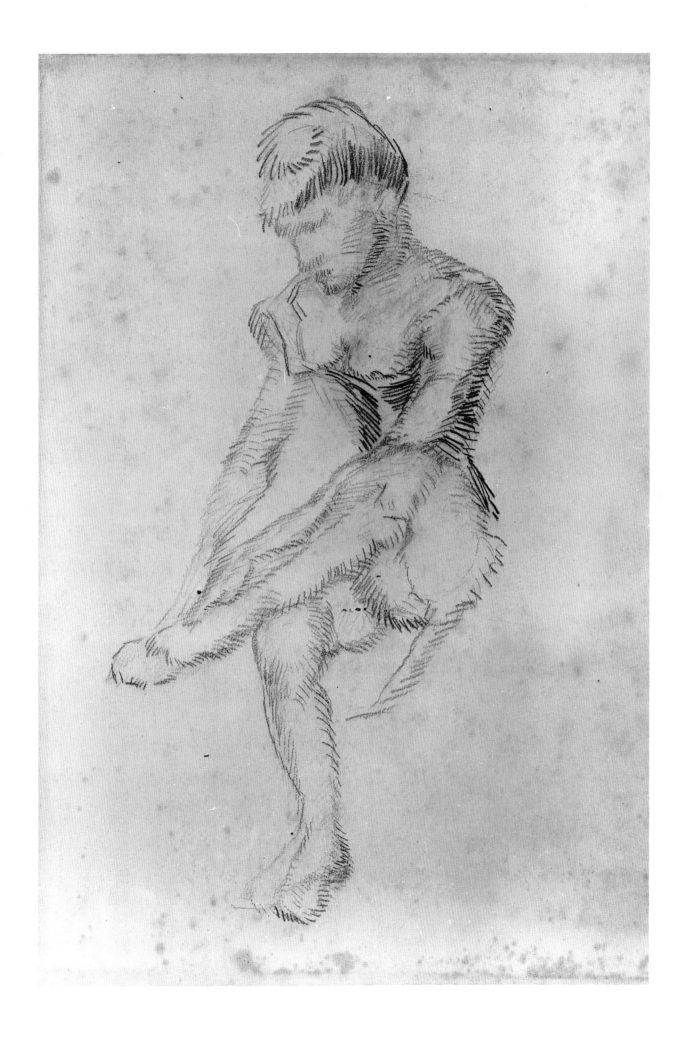

93 VINCENT VAN GOGH
La fenêtre chez Bataille
dated 1887, Paris
Pen, blue chalk, coloured crayons
21¼ × 15¾ in (54 × 40 cm)
Rijksmuseum Vincent van Gogh, Amsterdam. F1392

The Paris drawings of 1886-87 were the closest that van Gogh came to impressionism, in both technique and subject. Most of his drawings of Parisian streets and suburbs show a suppression of detail in the interests of the 'impression'. The *Restaurant de la Sirène* (93b) is as devoid of human presence or feeling as anything in his oeuvre. Compared to the loaded religious intensity of the images he had chosen to draw in Holland, the neutrality of these motifs is remarkable, and as dramatic a 'conversion' at the hand of impressionism as that of Cézanne. A series of *café-concert* vignettes, vigorously drawn in coloured chalks (92b, 93a), also exposes the novel, experimental nature of his Paris drawings.

La fenêtre chez Bataille is different. Although it may have been inspired by Caillebotte's balcony paintings, and although its symmetry within the rectangle may relate to the linear organization of Japanese prints that van Gogh copied in Paris, it has other qualities that are more personal. The fact that it is titled, signed and dated – unusual among his Paris drawings – suggests that as an image it may have held a special place in his own estimation.

The literal subject is the window of a restaurant, but, like some of his drawings looking across Paris rooftops, it is reminiscent of window views drawn in solitude in the Hague. The reference to human presence-absence by hat and coat and the empty chair are the sort of literary and sentimental device he liked and borrowed from English graphic artists. The sombreness of the interior, densely hatched in blue and black, heightens a dramatic interior-exterior contrast and the framing by the window of the street view with two figures may be likened to the use of his perspective frame for what he described as a 'spy-hole', a form of portable window.

As in many of his Dutch drawings, the first state is overdrawn in finer detail with pen and ink. This both erodes the aesthetic unity of the chalk and crayon drawing and heightens the narrative distinctness of the parts. An empty bottle is added on the table.

93a *Double-bass player, c.* 1887
Green chalk
13⁵⁄₇ × 10¹⁄₆ in (34.8 × 25.8 cm)
Rijksmuseum Vincent van Gogh, Amsterdam.
F1244c verso

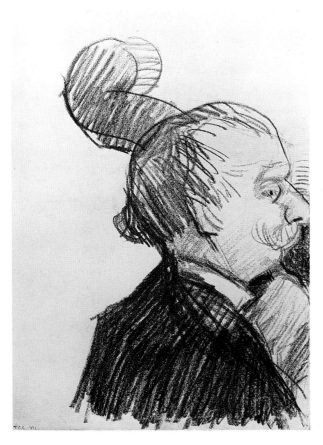

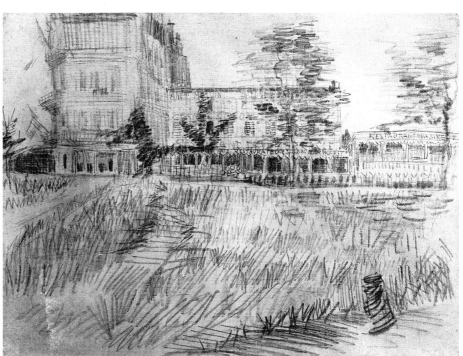

93b *Restaurant de la Sirène*, 1887, Paris
Pencil, green crayon
15¾ × 21½ in (40 × 54.5 cm)
Rijksmuseum Vincent van Gogh, Amsterdam. F1408

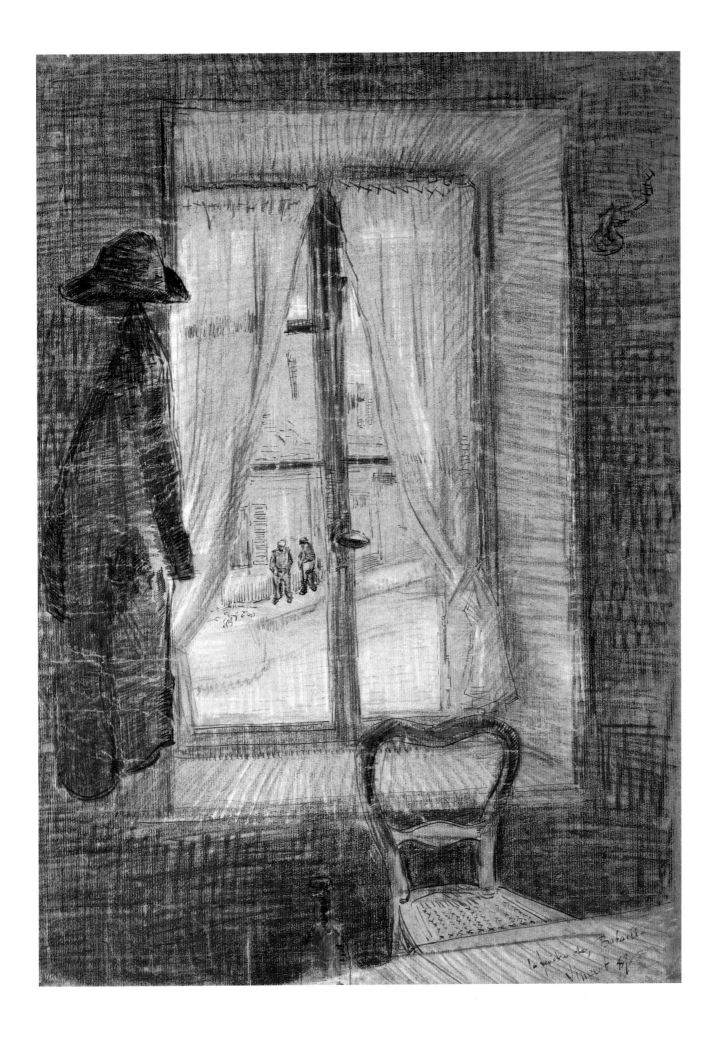

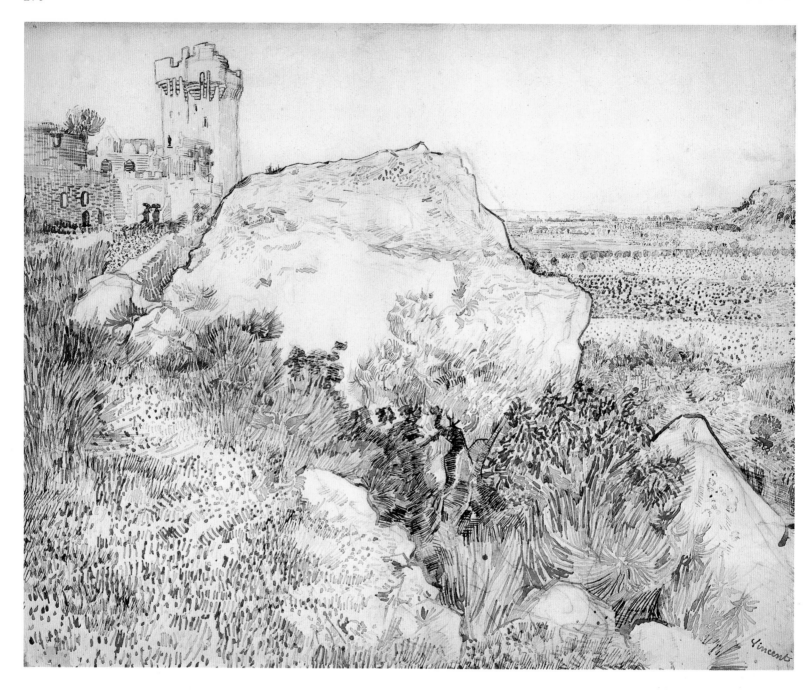

Withdrawing from Paris to Arles in February 1888, van Gogh felt both exhilarated by the new environment and able, in his isolation, to take stock of the bewildering range of experiences and encounters in Paris. While it is a reasonable generalization to say that Paris had transformed him from a 'draughtsman of the people' into a post-impressionist painter, the role of drawing in his oeuvre was also revitalized. Between his arrival in Arles and the autumn of 1888, the marks in his paintings became 'more virile and simple. No stippling, no hatching, nothing, only flat colours in harmony.' [555] Conversely, at the same time, his drawing was realizing an equivalent harmony by increased elaboration of mark. The contrast is most apparent in drawings made from paintings: reinterpretations more than 'copies'. The striking comparison between drawing and painting is of the painting's relatively bland surface, sometimes almost inert beside the vigour and light of the drawing.

The elaborate pen drawing style that he evolved in Arles has roots both in the multiplicity of marks of his 'impressionist' drawings and in his admiration of textural qualities in Japanese art ('black thornbushes starred all over with a thousand white flowers'[B6]). He remembered the advice of Pissarro, to 'boldly exaggerate the effects of either harmony or discord', but realized it in a vocabulary of decorative marks that reflect his desire 'to make some drawings in the manner of Japanese prints' [474].

Looking across the plain of the Crau, in *Montmajour*, the dramatic silhouettes of rock outcrops and the ruined abbey are contrasted with the profusion of grasses, plants and trees in the foreground and a succession of stippled and hatched textures beyond. Compared with the range of marks in a Montmajour drawing of two months earlier (94a), the rapid development of the style is clear, not least in its refining sequence of pencil, reed pen and pen. The range of marks expresses, variously: topographical detail; light and shade; tonal variations of colour; and finally distance, in a diminishing scale of mark. The more distant fields are peppered with light stabs in various sizes of nib-end. These large, independent drawings stood as equals alongside his paintings. In his drawings after paintings (94b), the same variations of texture were used at least in part to emulate the effects of his colour.

94 VINCENT VAN GOGH
Montmajour
July 1888, Arles
Pencil, reed pen, pen and sepia ink, pen and black ink
$18^5/_7 \times 23^1/_5$ in (47.5 × 59 cm)
Rijksmuseum, Amsterdam. Inv. 1962:65. F1446

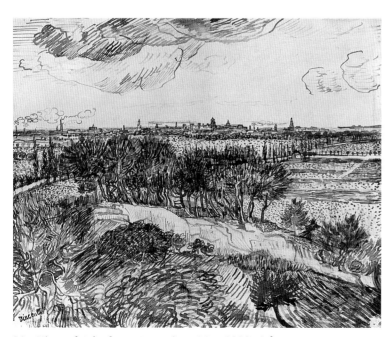

94a *Views of Arles from Montmajour*, May 1888, Arles
Pen and sepia ink
$19^1/_8 \times 23^5/_8$ in (48.6 × 60 cm)
Nasjonalgaleriet, Oslo. B.68. F1452

94b *Haystacks*, June 1888, Arles
Pen, reed pen and sepia ink
$9^2/_5 \times 12^1/_5$ in (24 × 31 cm)
(formerly collection Henri Matisse)
Philadelphia Museum of Art. Inv. 62-229-1. F1427

95 VINCENT VAN GOGH
Patience Escalier

August 1888, Arles
Pen, reed pen and sepia ink
$19^2/_5 \times 15$ in (49.4 \times 38 cm)
Fogg Art Museum, Cambridge, Mass. (Bequest of
Grenville L. Winthrop). Inv. 1943.515. F1460

The great portrait drawings from the Arles period are almost all copies, interpretations in drawing of his painted portraits. As in Arles landscapes, he roughed-in with pencil lines only the main contours (none are visible behind the features, for instance) and then drew directly in reed pen and pen. Describing the paintings, he wrote of first being faithfully naturalistic and subsequently becoming 'an arbitrary colourist'. The same two threads exist in this drawing: the finely hatched and stippled modelling of the face on the one hand; the aggressive, flattening contours and decorative animation on the other.

Pickvance (Otterlo 1990, p.235) is at pains to dissociate van Gogh's use of stippled textures from the dots of neo-impressionism. In one or two drawings (*la Mousmé* F1503), the stippling *is* used tonally in a manner very similar to the pointillism of Pissarro and Signac, but here Pickvance appears justified in talking of van Gogh's *horror vacui* impulse to fill the page, and of his attempt to parallel his own description of the painting of Escalier, in terms of 'the full furnace of the harvest at the height of mid day' [520].

In the same letter, he tells Theo that 'what I learned in Paris is leaving me and I am returning to the ideas I had in the country before I knew the impressionists'. In the content and meaning of his drawings, this was increasingly evident. These portrait heads relate to the series of peasant heads in Nuenen, reinterpreted in his new language. The same is true of landscapes. A Nuenen landscape of March 1884 and an Arles landscape of August 1888 are essentially the same image (95a, 95b), although very different technically. The Nuenen drawing is treated tonally. In *The road to Tarascon*, the marks have other meanings. The stippled sky is dark, even though it clearly represents the cloudless sky of late afternoon. The marks are comparable to those dense, saturated blues that he used to paint the sky, which, despite their opacity of colour and armour-clad paint, achieve a luminous effect. Similarly here, the marks have more to do with colour than light and evoke something of the leaden heat of a Provençal afternoon. 'Black and white are also colours', he wrote to Bernard, 'their simultaneous contrast is as striking as that of red and green.' [B6]

95b *The road to Tarascon, sky with sun*, August 1888, Arles
Pen, reed pen and sepia ink
$9^3/_5 \times 12^4/_7$ in (24.5 \times 32 cm)
Guggenheim Museum, New York (J.K.Thannhauser Foundation). Inv. 18. F1502a

95a *Landscape with willows, sun shining through clouds,*
March 1884, Neunen
Pencil, pen and ink
$13^3/_4 \times 17^1/_3$ in (34 \times 44 cm)
Art Institute, Chicago. Inv. 69.268. F1240a

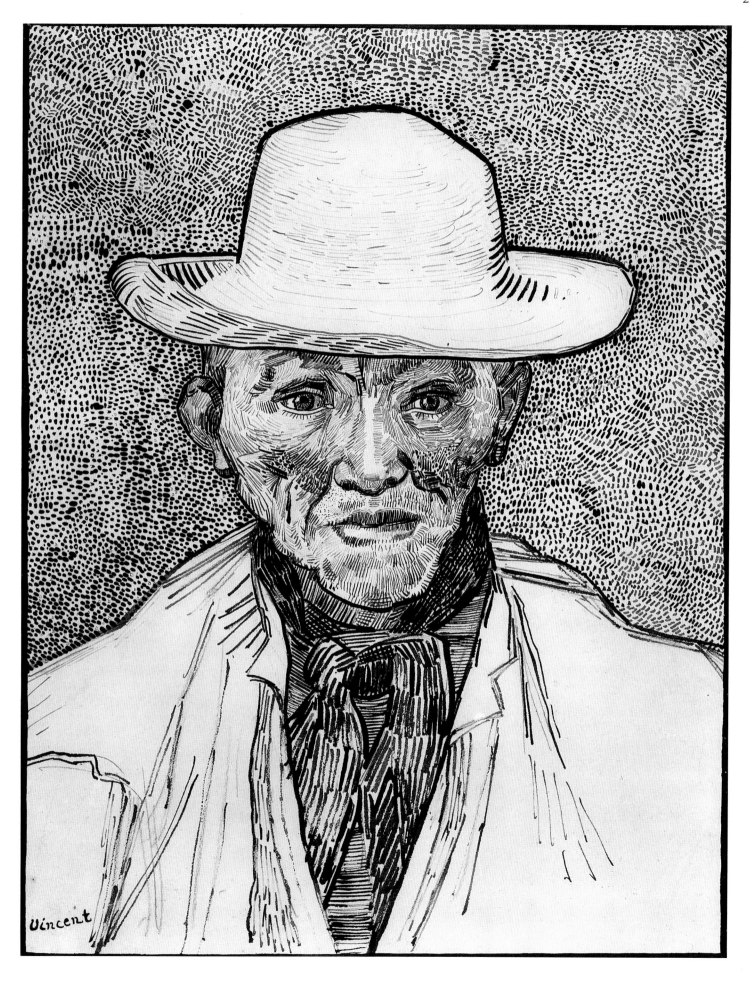

96 VINCENT VAN GOGH
Olive Trees in front of les Alpilles
July-September 1889, St Rémy
Pencil, pen, reed pen and sepia ink
$18^1/_2 \times 24^3/_5$ in (47.2 × 62.5 cm)
National-Galerie, Berlin. Inv. F IV 721, nr.6. F1544

At the asylum in St Rémy, van Gogh continued to make drawings after his paintings to send to Theo. These copies do not present the same striking contrast to the original as those made in Arles. In St Rémy, van Gogh brought painting and drawing closer; the paintings themselves are full of drawing. This powerfully rhythmic drawing follows very closely the linear articulation of brushstrokes in the painting (F712). It is almost possible to see the growth of the drawing as it entered the spirit of the painting, gathering momentum from the relatively bland pencil guide-lines onwards. He draws smaller elements into larger rhythms; paler ink strokes are overlaid by darker, stronger shapes and movements. The language is more animated, but the vocabulary is narrower: rhythm overrides texture and gives little account of relative positions in space. This simplified, flatter manner may reflect the stay in Arles of Gauguin, who later wrote of his influence on van Gogh that 'he had to make a great effort to get his drawing to fit this new technique' (September 1902).

The exaggerated intensity of these rhythms has long prompted interpretive reference by some writers to van Gogh's disturbed state of mind: his brother was put out by the first impression they gave 'of having been made in a fury . . . further removed from nature'. The greater abstraction from nature may be compared to his talk in Arles of acting the 'arbitrary colourist' in the interests of expression. But the source of these forms in the eccentric shapes of the Alpilles mountains and the contortions of ancient olive trees – which to an artist brought up in the flatness of the Dutch landscape appeared dramatic and novel – is no less relevant. A study from nature of clouds (96b) seeks out the same range of pulsing curves. It appears that he was seeing nature in these heightened terms. His written descriptions of Provence – of colours in the night sky for instance – reveal an equally rarefied perception, which might be seen as abnormally sensitive or poetic, or both.

It is also true that no landscape motif was neutral to van Gogh. His return, in Provence, 'to the ideas I had in the country [before Paris]' involved the resumption of his belief that 'all reality is symbolic'. He wrote to Theo that cypress trees 'are always occupying my thoughts . . . it astonishes me that they have not yet been done as I see them'. He associated them with death, 'an Egyptian obelisk . . . a splash of black in a sunny landscape' [596].

96a *Cypresses*, June 1889, St Rémy
Pencil, pen, reed pen and sepia ink
$24^3/_5 \times 18^1/_3$ in (62.5 × 46.5 cm)
Art Institute, Chicago. Inv. 27.543. F1524

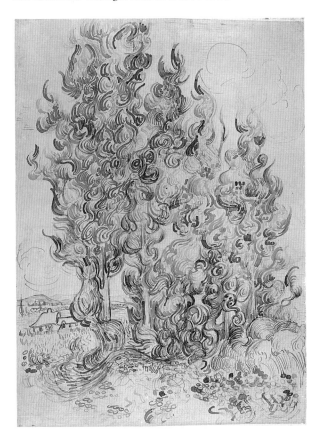

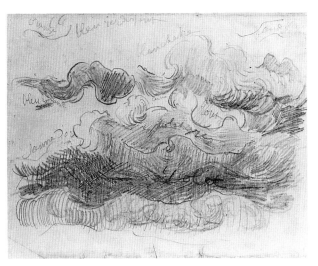

96b *Study of clouds*, Autumn 1889, St Rémy
Pencil
$9^7/_8 \times 12^4/_5$ in (25 × 32.5 cm)
Rijksmuseum Vincent van Gogh, Amsterdam. F1584

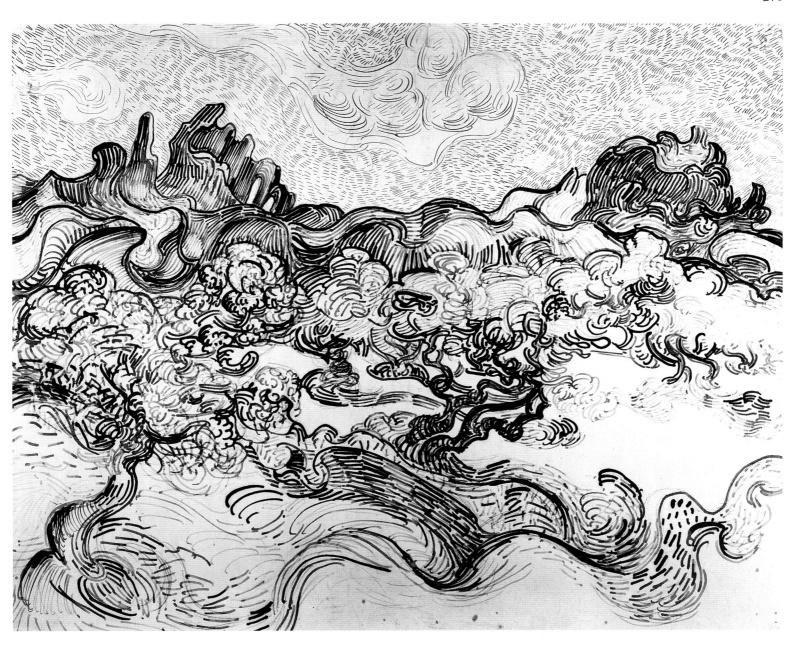

97 VINCENT VAN GOGH
Wheatfield seen from the asylum window
Autumn 1889, St Rémy
Black chalk, pen and sepia ink, heightened with
white chalk
$18^5/_7 \times 22$ in (47.5 × 56 cm)
Rijksmuseum Kröller-Müller, Otterlo. Inv. 1517-70.
[F]SD1728

After the ebullient rhythms of the St Rémy drawings of summer 1889, it has been suggested that the greater sobriety of technique and the more naturalistic transcription in autumn drawings may be a considered response to Theo's perplexity at the earlier work (Pickvance, Otterlo 1990, p.285). In van Gogh's letters there is renewed stress on the need for 'coarse reality', compared to the abstractions of Gauguin and Bernard in which 'nothing is really observed' [615]. Earlier, in Arles, he had written to Bernard: 'I cannot work without a model. I won't say that I don't turn my back on nature ruthlessly in order to turn a study into a picture, arranging the colours, enlarging, simplifying; but in the matter of form I am too afraid of departing from the possible and the true.' [B19] It seems that the summer 1889 drawings were an exploration beyond those certainties from which he subsequently withdrew.

For long periods at St Rémy, van Gogh was restricted to the interior and grounds of the asylum. Some of the autumn drawings express a sense of confinement. This densely-worked landscape – one of few large, finished St Rémy drawings that are not after paintings – was made from his window. The sense of enclosure of the walled field is heightened by the heavy cross-hatching in the wall. The sun, so often a symbolic generation of light and energy in his Arles drawings, is overshadowed by the organic animation of the heavy, almost anthropomorphic cloud formation reaching across the sky. the angularity of the hatching recalls the manner of his Dutch drawings.

In several other St Rémy drawings, a window or doorway features as the central motif, emphasizing a contrast of interior and exterior, again reminiscent of earlier motifs. The association of window with picture frame has a long history in the iconography of European art, but for van Gogh it had potent personal meanings. It may also be related, as mentioned earlier, to his perspective frame, which he continued to use intermittently in Arles and St Rémy. The sketches of St Rémy windows (97b), with bars and double shutters, give little sense of exterior; they are oppressive and claustrophobic.

It is possible to become so accustomed to reading such nuances of meaning into van Gogh's images that we lose sight of his fidelity to nature. Most of the interiors of St Rémy (e.g. F1528–30) are animated by his acute perceptions of reflected light and colour.

97a *The Park of the Asylum of St Paul,*
October 1889, St Rémy
Black chalk, pen, reed pen and sepia ink
$18^1/_2 \times 24$ in (47 × 61 cm)
Private Collection. F1545

97b *Windows,* 1890, St Rémy
Black chalk
$9^2/_5 \times 13^3/_5$ in (24 × 32 cm)
Rijksmuseum Vincent van Gogh, Amsterdam.
F1605 verso

98 VINCENT VAN GOGH
Montcel, houses behind trees
July 1890, Auvers
Black and blue chalk, pen and ink
Rijksmuseum Vincent van Gogh, Amsterdam.
F1637 recto

The technical variety of the drawings that van Gogh made during the last ten weeks of his life at Auvers, is almost as great as of those made in Paris. The fact that he abandoned the developed discipline of the drawing practice used since Arles – pencil, reed pen, pen – for a new and erratic mixture of media suggests a less fixed focus on the art of drawing. It may also reflect the confused state of feeling and confidence that precipitated his suicide.

In the vital chaos of this extraordinary drawing the reed pen is relegated to a minor role, as if it lacks the urgent immediacy that he obtains here from the chalks. The expressive abstraction of the drawing and its violence, both of speed and in the almost brutal aggression of lines, marks one extreme of the Auvers drawings. Without the forceful structure of even the most abstract St Rémy landscapes, the lines generate a nervous instability. At the other extreme are landscape drawings as naturalistic, in their certain identity of things and their place, as anything done since Drenthe (98b). The sense in which they constitute a reminiscence of the North is confirmed by the reappearance of figures in the fields, even if often added as an afterthought.

Van Gogh's renewed interest in figure drawing in St Rémy and Auvers involved conscious reference to his Dutch drawings. There are several reprises of the *Potato Eaters*, and, in other drawings, windmills appear in landscape backgrounds. Although the *Peasant Digging* (98a) is drawn with the lumpen curvilinear energy and characteristic 'sheaves' of hatched lines of his late manner, the *mise-en-page* and the sense of physical toil echo early copies from Millet in a way quite absent from the symbolic sowers and reapers who appear in some of his Arles and St Rémy landscapes. Until now, apart from portraits, the figure played a small role in his mature oeuvre, but whenever he wrote of his vision of the artist of the future it was in terms such as 'who will be in figure painting what Claude Monet is in landscape?' [482] His request to Theo in June 1890 for a copy of Bargue's *Exercices au Fusain* – because 'If I neglect the study of proportion and the nude again, I shall be badly muddled later on' – is either another, confused re-enactment of his years in Holland or an indication of serious intent to embark on more ambitious figure drawings and paintings.

98a *Peasant Digging*, Spring 1890, Auvers
Black chalk
$11^{1}/_{5} \times 9^{1}/_{4}$ in (28.5 × 23.5 cm)
Rijksmuseum Vincent van Gogh, Amsterdam.
F1587 verso

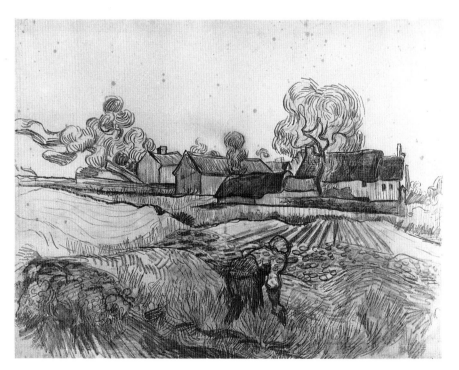

98b *Farm of Pierre Eloi, Auvers*, 1890
Pencil, pen and ink
$18^{1}/_{2} \times 24^{2}/_{5}$ in (47 × 61.5 cm)
Louvre, Dépt. des Arts Graphiques.
Inv. RF 30.271, L.Suppl.1886a F1653

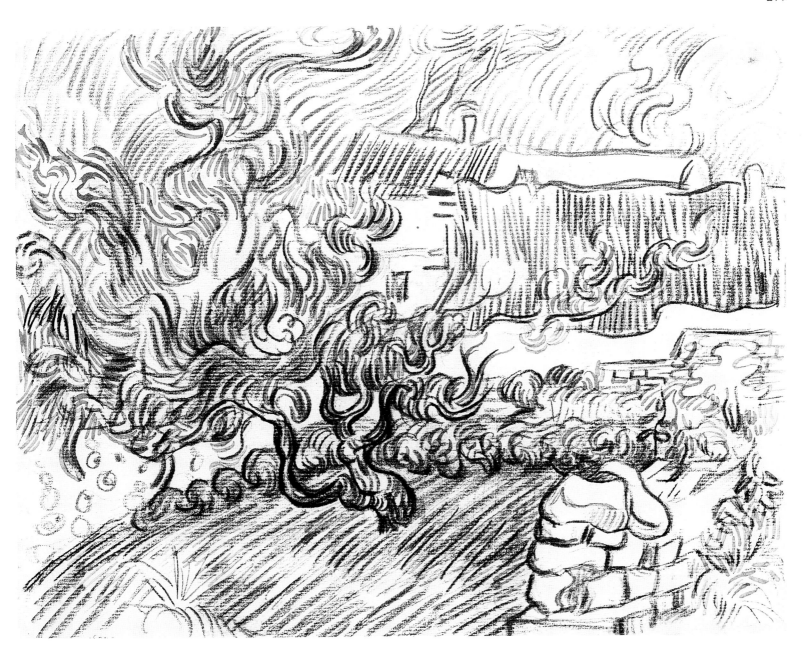

99 GEORGES SEURAT
Woman on a bench
c. 1880/81
Pencil, page from a sketchbook
$6^{1}/_{2} \times 4$ in (16.5 × 10.4 cm)
Collection Robert & Lisa Sainsbury,
University of East Anglia, Norwich. dH403

Of the very different artists who moved into impressionist circles, Seurat appears the most unlikely to have done so. The almost total anonymity of his personal life only compounds our feelings about the incongruity of such a man among artists of whom we know so much that we may begin to think of them as people. He is described by an acquaintance as 'withdrawn, taciturn and mysterious'. His participation in the eighth and last impressionist exhibition of 1886 is some measure of how much the scope of the group had diversified since its inception. The relatively austere abstraction of his art was incompatible with the ideas and practices of many of the other artists. Despite this, the technique of his mature drawings, their subject matter and the nature of his use of materials became pivotal in the history of post-impressionist drawing.

In the studio of Lehmann at the Ecole des Beaux Arts, 1878–79, his assimilation of academic conventions was highly accomplished, and his *académies* (Pl.106a, Fig. 13) display an educated transition, from the ideal of antique casts to drawing from life, with equal facility. The most idiosyncratic and prophetic feature of these drawings, as Herbert has pointed out (1962, pp.21-22), is a predilection, within the idiom, for 'forthright naturalism' in the eccentric characteristics of particular models.

The first glimpse of an independent manner in Seurat's drawing came in the angular shaded sketches from life of 1880-81. Its sources in the angularity of the linear academic sketches that preceded a full-blown *académie* are clear (cf.99a). This is the same blocked-in manner that van Gogh was learning from drawing manuals at exactly the same time (99b), and is also visible in the early work of Degas and others. Seurat improvises a broad use of tonal shading within the blocked contour that also echoes the low-relief illusion of academic drawing. The independent originality of drawings like this *Woman on a bench* lies in the impromptu breadth of the handling and in their perceptive observation of fragments from life. The peculiar paradox of Seurat's suspension of the casual within a schematic abstraction is already present.

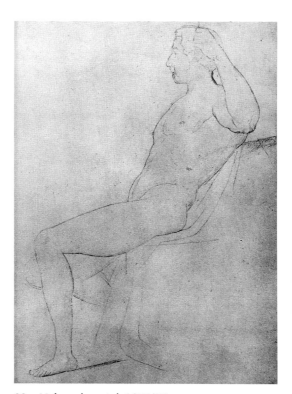

99a *Male nude seated*, 1875/76
Pencil
dimensions $11^{5}/_{7} \times 9$ in (29.9 × 22.9 cm)
Private collection, New York

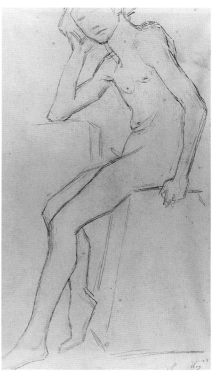

99b VAN GOGH: *Seated nude, study after Bargues*, c. 1881 or 1890
Pencil
$10^{3}/_{5} \times 17^{1}/_{8}$ in (17 × 43.5 cm)
Rijksmuseum Vincent van Gogh, Amsterdam. F1609 verso

100 GEORGES SEURAT
Promenade
c. 1882/1887
Pen and ink (faded)
11⁵/₇ × 8⁴/₅ in (29.8 × 22.4 cm)
Von der Heydt Museum, Wuppertal.
Bequest Inv. 302. dH498

By 1882, the salient characteristics of Seurat's mature drawing manner were established. They remained so constant that without external evidence – principally of a relationship to dateable paintings – the chronology of the drawings is problematic. This beautiful, elusive drawing has been dated variously from *circa* 1882 (de Hauke) to *circa* 1886/87 (Herbert). The fact that it is in pen (very rare in Seurat's oeuvre) does not simplify the problem. His earliest drawings are in pencil or charcoal and there are a few coloured crayon drawings of *circa* 1879–81, but from around 1882, he drew almost exclusively in black conté crayon. Stylistically, his mature manner is distinguished by its shift from a drawing concerned with line to one concerned with tone. Although on close examination the tones are built from many overlaid lines, of a marvellous secret vitality, generally lines appear in the form of edges rather than contours.

Franz and Growe (1983) have written well of a quality of 'withdrawn proximity' in Seurat's drawing, by which all the things depicted elude our possession despite their apparent closeness to us. Each drawing appears to start from a scattering of lines across the sheet – more ordered in some, more random in others – out of which the image coalesces. However succinct and memorable the image that is realized, it remains embedded in the matter of this fabric. In *Promenade*, the two more or less coherent figures are formed from the same scrambled pen lines as their environment. In his conté drawings, the same range, from disorderly atmospheric marks to the dense matter of the heaviest blacks, is unified additionally by a homogeneous texture from the dragging of crayon across the heavy grain of the paper.

The duality between the substantial and insubstantial and between the evocative sense of human presence and the elusive abstraction of the drawings, echoes the complexity of Seurat's whole endeavour. His artistic allegiances embraced artists in the classical tradition, from the Renaissance to Poussin to Ingres, as well as the work of Millet, Courbet and Daumier: we may sense them respectively in the form and subject matter of his art. His wide reading embraced both theoretical writings on the science of aesthetics and the modern novels of Zola and the Goncourts. *Promenade* and *The Couple* (100a) depict man and woman in the modern urban world. Compared to the same sort of subject drawn by Caillebotte, for instance, Seurat's image becomes more potent by being held back on the very brink of naturalism.

100a *The Couple*, 1882/83
Conté crayon
12¹/₂ × 9²/₅ in (31.7 × 24 cm)
Collection Mme D. David-Weill, Neuilly. dH605

100b *The Colt*, c. 1883
Conté crayon
9 × 12 in (22.9 × 30.5 cm)
Metropolitan Museum of Art, New York
(Robert Lehman Collection). Inv. 1975.1.706 dH527

101 GEORGES SEURAT
Two men in a field
c. 1882/84
Conté crayon
12½ × 9½ in (31.8 × 24.3 cm)
Baltimore Museum of Art (The Cone Collection).
Inv. 1950.12.664 dH524

Like all well-read, educated artists Seurat would have been familiar with academic conventions of contrasting dominant bright and dark areas in any well-composed picture. His accomplished portrait drawing of his friend and former fellow-student, Aman-Jean (101a) was perhaps accepted at the Salon of 1882 for reasons of its formal propriety. The velvet surface is relatively inert and, by Seurat's own standards, virtually conceals its making. In its tonal contrast, Seurat created the sort of *tour de force* from a moment of light in a darkened environment in which Redon took pleasure.

The polarity of black and white is central to a lot of Seurat's drawings. In *Two men in a field* it has many resonances. Because of the developed polarity between the two characters, it is difficult to accept that the drawing was originally of a single figure in this Millet-like, twilit field, but the second, distant figure was evidently added, drawn over the setting. The subject has the appearance of 'city meets country': a confrontation of the two focal areas of Seurat's drawings of the early 1880s. As always, his shaping of the physical matter of the drawing is inseparable from any muffled emerging meaning available to us. The no-man's-land of the setting moves from a tangle of curving lines into a blander shading that stretches away to the horizon. The figure walking towards us stands out against its ground in a counterpoint of complementary tones: the sky at its lightest around the dense black of head and coat, the ground darkened around the paleness of his trousers. His elegant, youthful silhouette is contrasted with the grey, older, behatted figure leaning on a stick (or spade?), who merges with the context. Father and son? Prodigal son? Echoes of the iconography of Millet's drawings are even stronger in a related drawing (101b). The same black and white polarity is again intensified by complementary lightening and darkening of the ground: the white of the left-hand figure appears to have been heightened by erasure. Both drawings appear to tell us no more than do the descriptive titles that they have been given. Nevertheless, the intensity with which they are drawn and the theatrical confrontation of the opposing figures, provoke thoughts of further, concealed meanings.

101a *Portrait of Aman-Jean*, signed and dated 1883
Conté crayon
24½ × 18¾ in (62.2 × 47.6 cm)
Metropolitan Museum of Art, New York
(Stephen C. Clark Bequest). Inv. 61.101.16. dH588

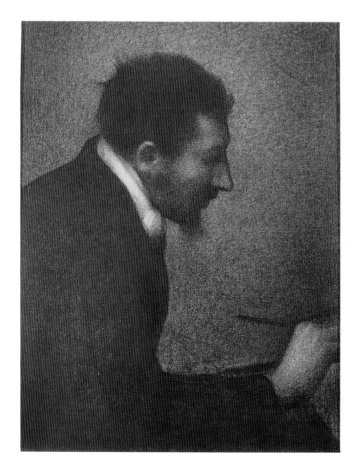

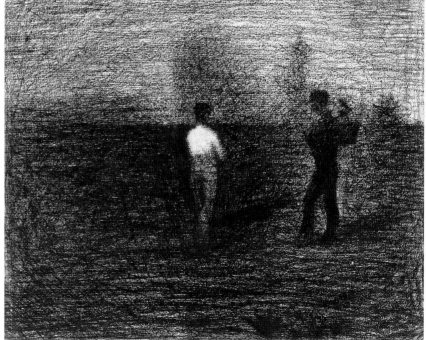

101b *Two men in a field*, c. 1883
Conté crayon
9³⁄₅ × 12²⁄₅ in
(formerly in the collection of Félix Vallotton)
Metropolitan Museum of Art, New York (Bequest of Miss Adelaide Milton de Groot, 1967). Inv. 67.187.34. dH523

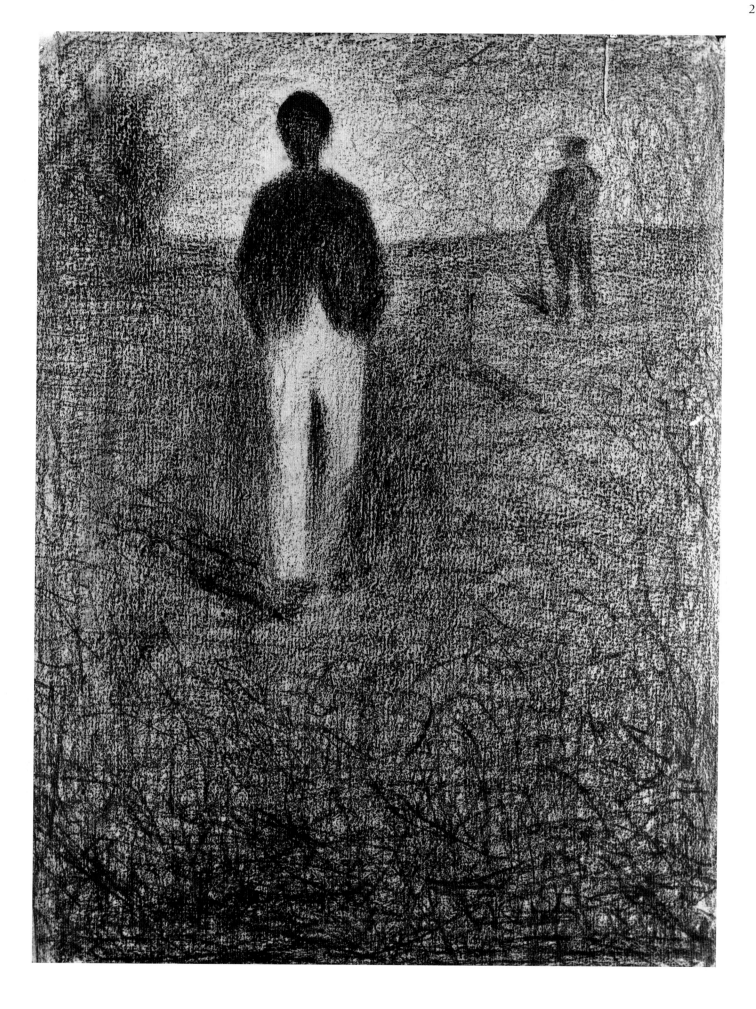

102 GEORGES SEURAT
Peasant gathering plants (The Gleaner)
c. 1882
Conté crayon
12³/₅ × 9²/₅ in (32 × 24 cm)
(formerly collection Paul Signac)
British Museum, London. dH559

It is remarkable that a drawing that owes so much to another artist, Millet, both in its nocturnal tonality and in subject matter, can also be as original as Seurat's *Gleaner*. The profile pose of the working man is modest. The heroic dignity of the image that sets it so firmly in the tradition of Millet's peasant images originates in the grand scale achieved by the simple light/dark division of the ground – more or less on the golden section – and the intense black of the silhouette. The hieratic simplicity of this shape is enlivened by eccentric animation in the lines of the bundle he carries, epitomizing the drawing's poise between the observed and the composed.

Some landscape drawings of the period, similar in technique but presumably drawn from nature, are less obviously composed and come closest of all Seurat's drawings to the sensory abstraction of impressionism. Comparison of Seurat's *Haystacks* (102a) with Monet's paintings of similar motifs a few years later might appear to be more a matter of difference: Seurat's shadowy world beside the dazzling polychrome effects of sunlight in Monet. Like Monet, Seurat showed little interest in topographical or picturesque aspects of the motif. We need the title to help us identify his subject as much as Kandinsky tells us he did in 1895 to recognize a Monet haystack. As incoherent and as insistently memorable as Monet's images, Seurat's *Haystacks* generates luminosity from the velvet density of its blacks. The opposition of the most saturated blacks and an isolated moment of virgin white paper beyond the horizon gives rise to an extraordinary radiance. The purity of the effect is eminently comparable to those that Monet created by colour contrasts. Such landscape drawings – among the sparest in the late nineteenth century – anticipate the drawings of the Italian sculptor Medardo Rosso (102b). Rosso's drawings may be compared to his modelling with wax in the sense that they are dense in their impressionist handling, but slight in their identifiable reference to nature. They are unthinkable without the precedent of Seurat.

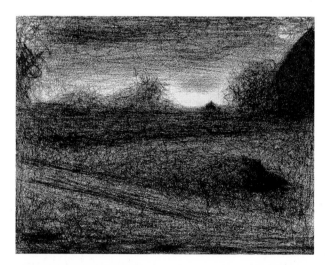

102a *Haystacks, c.* 1883
Conté crayon
9²/₅ × 12¹/₅ in (24 × 31 cm)
Collection Ian Woodner,
New York. dH540

102b MEDARDO ROSSO: *Landscape, c.* 1912
Pencil on card
4¹/₃ × 8¹/₄ in (11 × 21 cm)
Museo Rosso, Barzio. Inv. 141

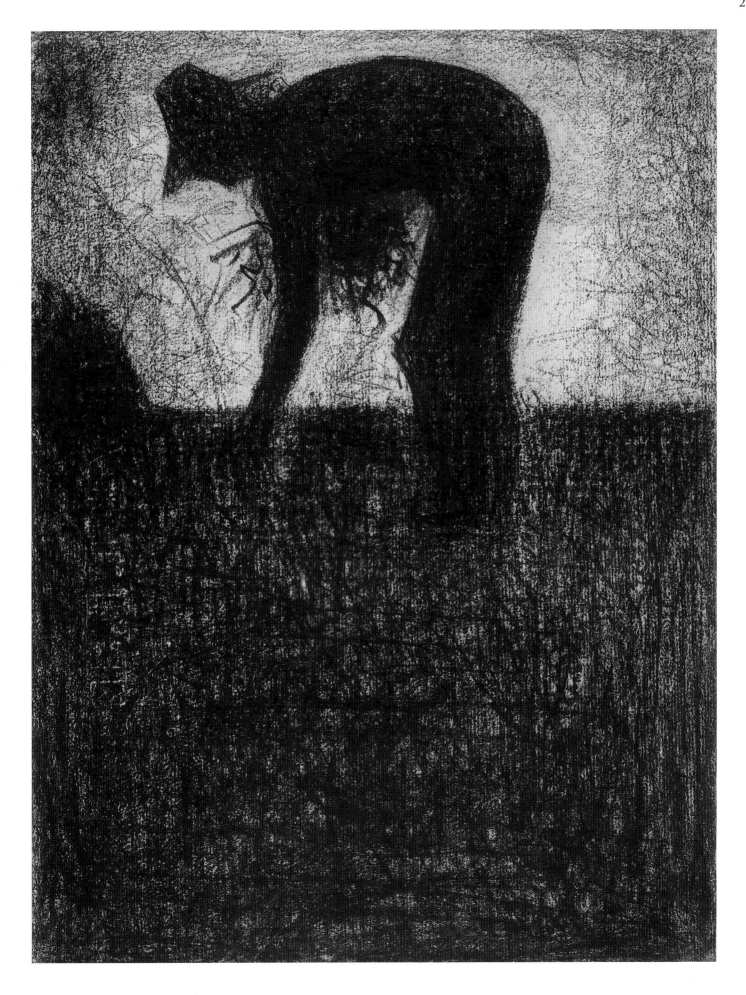

103 GEORGES SEURAT
The Ragpicker
1882/83
Conté crayon
9²⁄₅ × 12¹⁄₅ in (24 × 31 cm)
(formerly collection Paul Signac)
Private collection. dH520

The most original subject matter in Seurat's drawings is that of the industrial backwaters of Paris. His concern with the melancholy of underprivileged urban life stands in the tradition of Daumier and Doré, but this focus on the desolate fringes of the city is new. He draws a shadowy world of railway sidings and embankments, or of the barren areas between industrial buildings, populated by anonymous figures, telegraph poles and chimney stacks. In an article on the content of neo-impressionism, in which he discusses 'the great social struggle that is now taking place between workers and capital', Signac singled out Seurat's 'strong feeling for the degradation of our era of transition' (1891). The 'Zone', the suburban area around Paris where this transition was transforming the city most, became the focus of many drawings in the wake of Seurat's example. *The Ragpicker* was owned by Signac and may have been the inspiration for the principal figure in his pointilliste drawing of Clichy (103a). The degree to which the social content of Signac's work evaporated after Seurat's death is a guide to the balance of their relationship.

The Ragpicker typifies Seurat's images of figures, isolated and without identity, against a generalized urban background. The speed of the drawing suggests that it was based closely on observation and, in general, his city drawings are less composed than those of peasant subjects. The desolate figure, emotive but passive, is clearly visible against a sloping white ground bearing his shadow, which may be lamplit or snow covered. He is surrounded by other less coherent marks, which inadvertently contribute to the mood of the image.

These drawings by Seurat evoke the lost condition of the urban poor in an industrial wasteland. Their mute pathos is quite distinct from the realist imagery of the mid-nineteenth century. A lack of anecdote and the picturesque in these drawings touches the primitiveness of existence in these surroundings. Although not literary in the same sense as van Gogh's Dutch drawings, the anonymity of Seurat's figures in the inhuman environment of the modern city is comparably close to the spirit of contemporary novels.

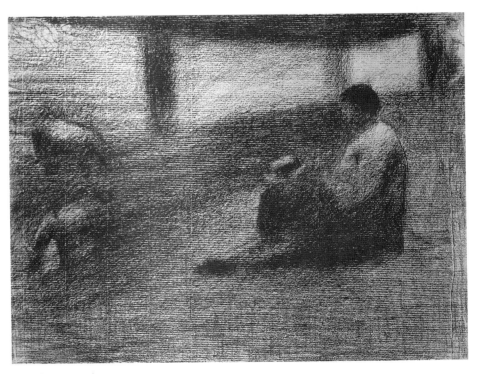

103a SIGNAC: *Passage du Puits Bertin, Clichy*, 1886, signed
Pen and sepia ink on card
9³⁄₅ × 14²⁄₅ in (24.5 × 36.6 cm)
Metropolitan Museum of Art, New York (Dick fund 1947). Inv. 48.10.4

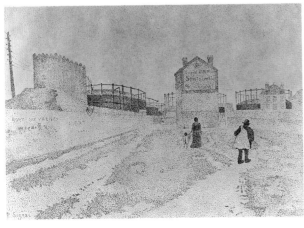

103b *Woman seated near a washing line, c.* 1883
Conté crayon
8²⁄₃ × 11⁴⁄₅ in (22 × 30 cm)
(formerly collection of Paul Signac)
Musée d'Art Moderne de Troyes (Gift of Pierre and Denise Lévy). dH541

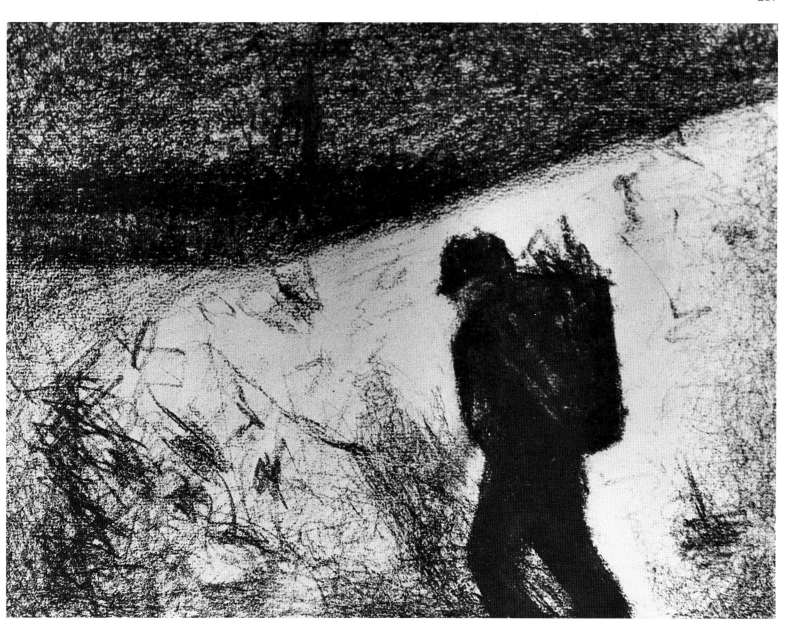

104 GEORGES SEURAT
Man next to trees (study for *La Grande Jatte*)
1884/85
Conté crayon
24 1/5 × 18 5/7 in (61.5 × 47.5 cm)
Von der Heydt Museum, Wuppertal.
Bequest Inv. 342. dH616

The concerns of Seurat's many drawings of urban and suburban subjects of 1882-83, were given their most resolved, formal expression in his two large paintings *La Baignade à Asnières* (1883-4, dH92) and *Un Dimanche d'Été à l'Ile de la Grande Jatte* (1884-6, dH162). The surviving studies for these great tableaux suggest that there were roughly equal numbers of drawings and painted sketches, and many more of each (about thirty drawings exist) for the second painting. For each painting, he made drawn and painted studies both on the spot and in the studio. Drawing or painting *in situ* gathered material for the compositions; studio drawings resolved the tonal structure of separate parts of the motif, just as painted studies began to resolve their colour. Seurat had assisted Puvis de Chavannes in squaring-up drawings for one of his vast mural commissions, 1883-84, but only one of his own surviving studies is squared-up. Although there are fairly complete painted composition sketches of each painting, there are no extant drawings in the form of a cartoon. Much adjustment and resolution took place during the long process of painting. The relation of individual drawings to the paintings varies considerably and it is possible that some studies were made during the painting.

The trees in *Man next to trees* look as if they were observed *in situ*, as if it were their bizarre coincidence – clarified only by their separate shadows – that attracted Seurat to them. The contours are heavily redrawn at their point of merging. By comparison, the amorphous, oddly proportioned man has no such observed particularity, and the ambiguous treatment of the silhouette of the grassy bank is an intellectual abstraction about pictorial space. In the painting, the coincidence of the trees became more paradoxical: because it is partly obscured by figures, we see only one trunk, but two strong shadows.

The monumental studio drawing, *Seated nude* (104a), corresponds very closely to the painting and appears to be a final study, resolving the figure's pose and the complementary light/dark relationships of edges to ground. It is about one quarter the size of the figure in the painting. The delicate study of the girl in white (104b) is less detailed and less symmetrical than the final image and is about twice its size. As well as being working studies, each of these drawings has the same self-sufficient completeness as have the independent characters in the hieratic schema of the two paintings.

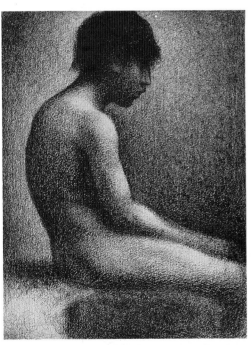

104a *Seated nude* (study for *Une Baignade*), 1883/84
Conté crayon
12 1/2 × 9 1/2 in (31.7 × 24.1 cm)
National Gallery of Scotland, Edinburgh. dH598

104b *Girl in white* (study for *La Grande Jatte*), 1884/85
Conté crayon
12 × 9 1/6 in (30.5 × 23.3 cm)
Solomon R. Guggenheim Museum, New York.
dH631

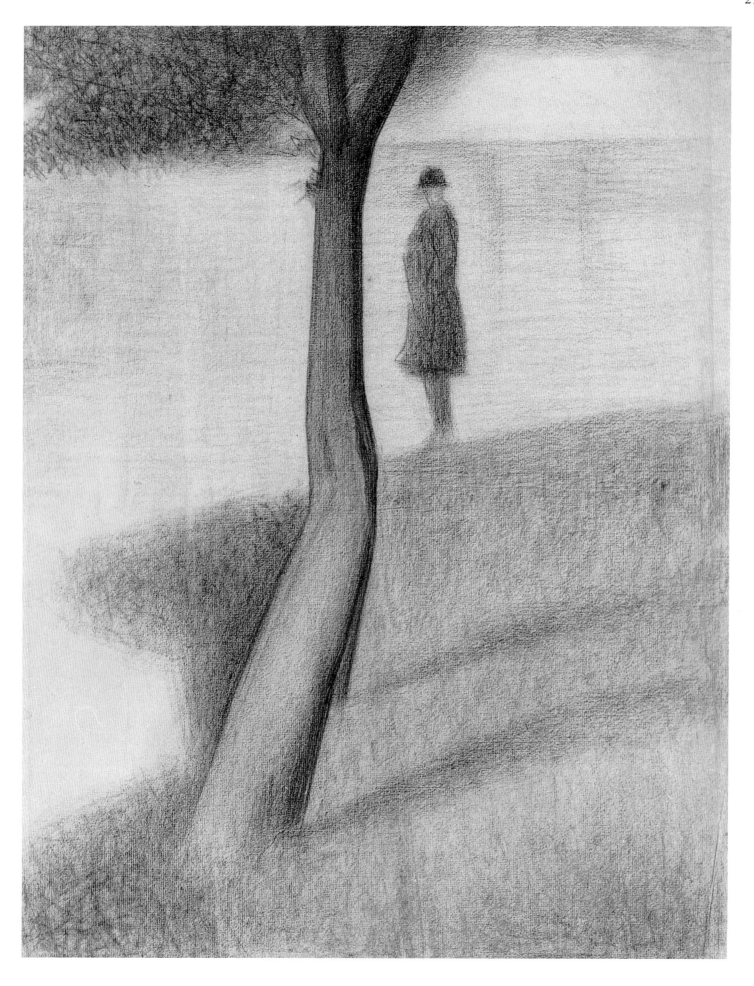

105 GEORGES SEURAT
At the Gaîté Rochechouart
1887/88
Conté crayon, heightened with white
12 × 9¹/₅ in (30.7 × 23.4 cm)
Fogg Art Museum, Cambridge, Mass. (Bequest of
Grenville L. Winthrop). Inv. 1943.918 dH686

The abiding expression of Seurat's urban drawings is of varying shades of emptiness: submerged identities, drained feelings. The pessimism of much of his comment on the human condition in the modern city is inescapable. By contrast, the *café-concert* drawings have been described as representing an 'harmonious world' and compared positively to Degas's images of 'lonely people in chance movements caught off their guard' (Franz/Growe 1984, p.39). The harmony of Seurat's forms is clear, and knowing the exacting nature of his enquiry into expressive properties of lines, tones and colours, we should perhaps be guided in understanding their expression by the predominance of ascending (i.e. 'gay') lines in many of these images. Even so, there are qualities in these drawings that are so much at odds with the inherent gaiety of the subject matter that it is difficult not to read into them something of the same melancholy of a twilight world evoked by his drawings of city streets. Signac referred to them as 'the synthetic representation of the pleasures of decadence'. The pervasive shadow always puts the visible survival of his figures at risk. In the Gaîté Rochechouart drawing, the floor of the stage and the two lights are retouched with lead white paint. Beside the tactile presence of this illumination the figures appear as phantoms.

The actuality of Paris in the 1880s, the brittle glamour of *café-concert* or theatre that Degas evokes so sharply, is not present here. Seurat seems uninterested in surfaces either literally or metaphorically. The technique that he uses makes no tactile distinction between stuffs. Although his images are expressly and essentially from the modern world, the quality of his expression is less impressionistic than universally symbolic. His singers are devoid of the particularization of Degas or Lautrec, usually facially inarticulate. His marvellously vital *saltimbanques* are without the declamatory narrative rhetoric of the Daumier images to which they pay such explicit homage (105a, 105b). Seurat's interpretation of motifs which were the hallmark of nineteenth-century urban realism constantly suggest activities that have always happened. It is well known that he wanted 'to make modern people move about as on these [classical] friezes in their most essential characteristics' (1888). These are not archaizing images. By virtue of an abstraction that Baudelaire had dreamed of, Seurat's drawings give perhaps the clearest and least sentimental picture of modern Paris in the realist tradition.

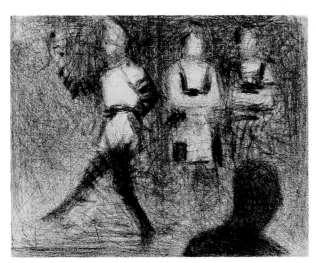

105a *Les Saltimbanques, c.* 1886
Conté crayon
9²/₅ × 12¹/₅ (24 × 31 cm)
(formerly collection Paul Signac)
Collection Ian Woodner, New York. dH670

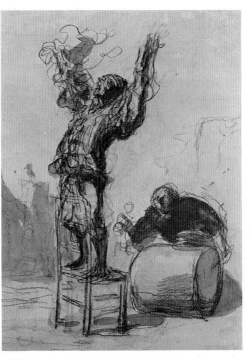

105b DAUMIER: *Clown and drummer*
Black chalk and watercolour
14 × 10¹/₄ in (35.6 × 26 cm)
Metropolitan Museum of Art, New York. Inv. 27.152.2

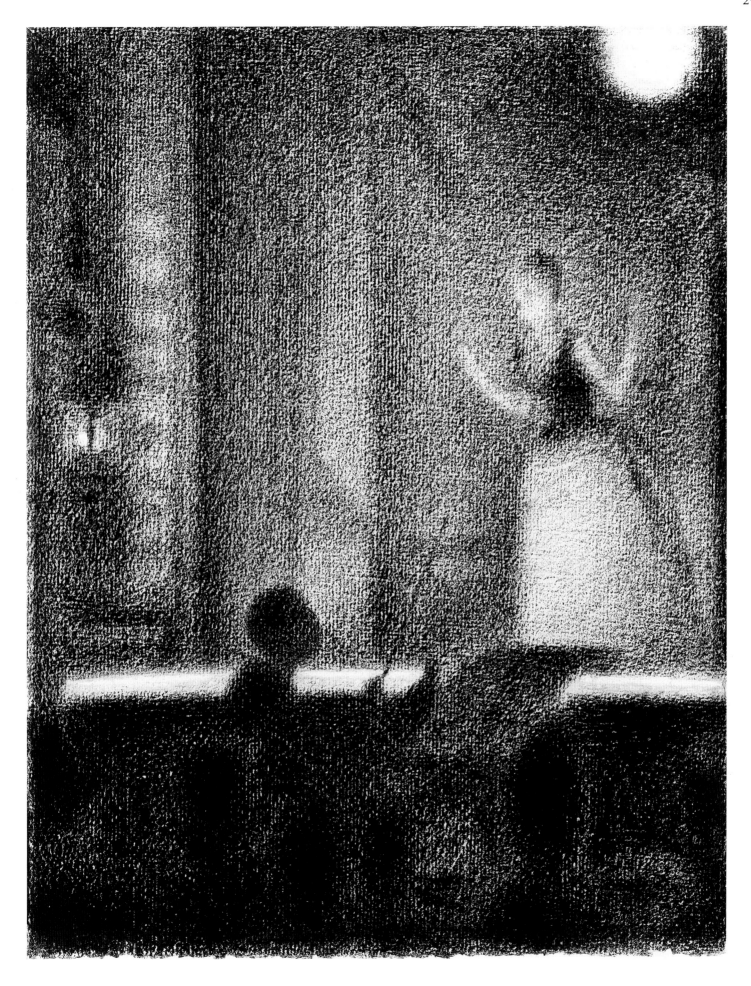

106 GEORGES SEURAT
Standing nude (drawing after *Les Poseuses*)
1888
Pen and ink, over chalk or pencil
$10^1/_3 \times 6^2/_5$ in (26.2 × 16.3 cm)
Armand Hammer Collection, Los Angeles. dH665

This wonderful drawing is exceptional in Seurat's oeuvre in several ways. It was made as a copy from the painting *Les Poseuses* (dH185) for reproduction in *La Vie Moderne*, 15 April 1888. It is not an exact copy from the painting and characteristically, Seurat made slight adjustments to compose the fragment into an image that satisfied him for reproduction. The drawing of the nude model was not copied from the painting itself, as usually stated, but from a painted study of this single figure (dH183), to which it corresponds exactly in size and in the few details in which it differs slightly from the painting (the position of the fingers, the space between her left arm and waist, the prominent hair ribbon). The correspondence is exact enough to suggest that it was traced from the painted study. The flanking details of still-life elements and the (altered) backs of the two other models were then added to the drawing, copied from *Les Poseuses* but moved closer to the figure than in the painting.

Seurat presumably used pen and ink on this occasion to simplify the image for reproduction. Compared to a preparatory tonal study in conté crayon for the same figure (106a), it has a purity of line of great beauty that is exceptional in his mature drawings and more like the defined silhouettes of his paintings. It recalls the simple beauty of Ingres's drawing and reminds us how deeply an admiration of Ingres underpinned all of Seurat's art. The subject of the painting *Les Poseuses* is the artist's studio: of all Seurat's paintings, it is most explicitly concerned with art as part of modern life. The three figures are artist's models, surrounded by studio props and juxtaposed with the (lifesize) figures of Seurat's *Grande Jatte*, hanging on the studio wall behind them. In this light, it is not surprising that the drawing strongly resembles his École des Beaux Arts *académies* not only in iconography, but also in that homogeneity of a schematic technique that informs all of his mature drawing. The delicacy of feeling is carried in the purity of technical means. The linearity anticipates the manner of his late drawings.

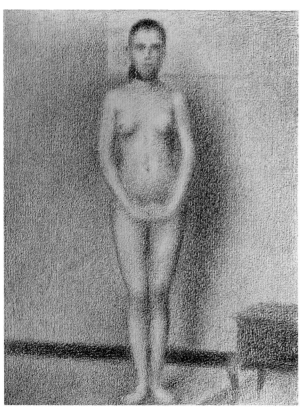

106a Study for *Les Poseuses*, c. 1887
Conté crayon
$11^2/_3 \times 8^4/_5$ in (29.7 × 22.5 cm)
Metropolitan Museum of Art, New York
(Robert Lehman Collection). Inv. 75.1.704 dH664

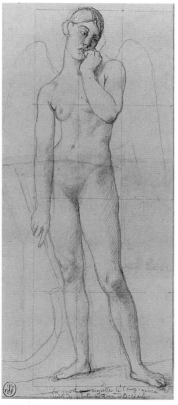

106b INGRES: study for
Angel of Death, 1842
Pencil
$12 \times 5^7/_8$ in (30.4 × 15.1 cm)
Nationalmuseum, Stockholm.
Inv. NM 131/1959

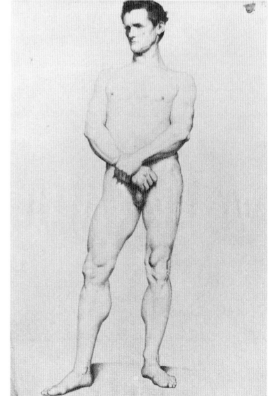

106c *Male nude, hands crossed*, c. 1875/76
Charcoal
$24^3/_4 \times 19$ in (62.9 × 48.2 cm)
Private collection, Paris. dH275

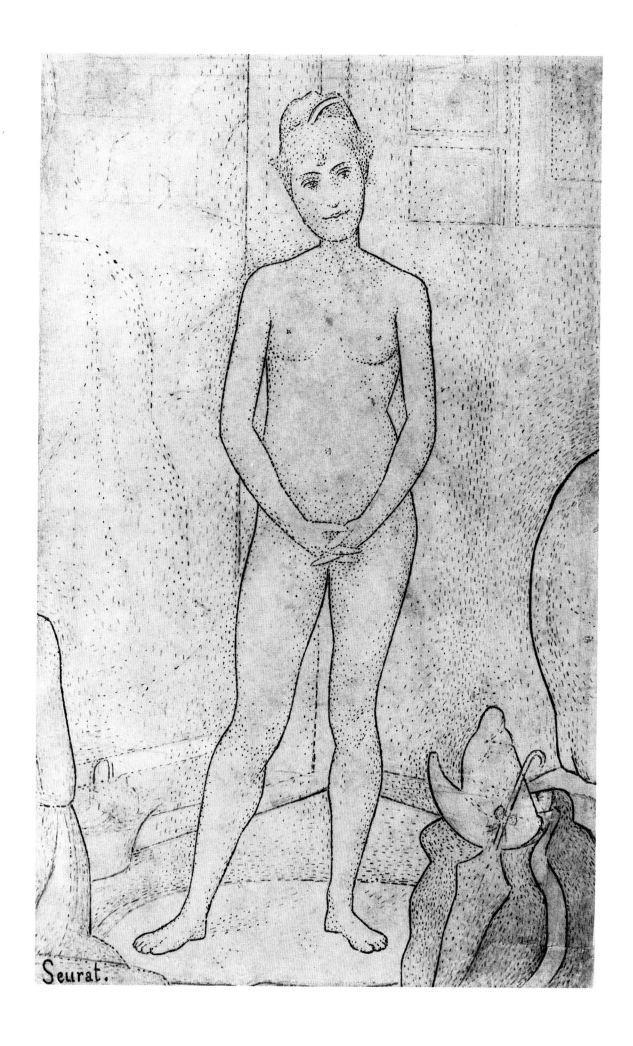

Seurat.

107 GEORGES SEURAT
Clown's head (study for *Le Cirque*)
1890
Pencil, squared
$24^2/_5 \times 18^5/_7$ in (62×47.5 cm)
Private collection, Paris. dH709

In a famous draft letter to Maurice Beaubourg (August 1890) Seurat summarized with unambiguous economy, the aesthetic theories he had assimilated from Blanc, Henry, de Superville and others. He wrote of the harmony in art lying in analogies of contrary and similar elements of tone, colour and line. Gaiety was expressed by luminous tones and lines ascending above the horizontal; calmness by an equality of tones and horizontal lines; sadness by predominantly dark tones and descending lines. In the late drawings and paintings, we are more aware of an expression of mood by line than by tone. Studies for his last large painting, *Le Cirque* (dH213, see also Fig. 83), are full of ascending arcs. This spirited linear drawing, Seurat's only extant squared-up study for a painting, is a full-scale cartoon. The simplicity of outline with which it is animated may be compared to vital contours in the work of the painter-lithographer Jules Cheret, whose posters Seurat admired (107a). In 1890 he designed the cover for a novel, *L'Homme à Femmes* by Victor Joze (dH695), which also bears comparison with Cheret. The caricatural quality of some of Seurat's last figure drawings reflects his lifelong interest in popular art: in the 1870s, he apparently amassed a large collection of popular printed images (Herbert 1962, p. 166 n6). The spread of his serious interests across high and low art may be likened to that of van Gogh.

The marvellous late seascape drawings have a simplicity and sensitivity that is equivalent to the subtle, blond ('gay') tonality of his last paintings at Gravelines (107b). His drawings paralleled and complemented his paintings throughout his short career, a working life little longer than van Gogh's. They also reveal values and concerns that his paintings do not. It is something of commonplace to compare the intimacy of drawings to the public face of painting, but in Seurat's case this contrast allows real insights into an art that is full of restrained enigma. When Teodor de Wyzewa, who knew and respected Seurat, wrote in 1891 that 'experiments and drafts are all that remain', he was referring to the paintings: only in the drawings did de Wyzewa feel able to recognize the fullness of Seurat's genius.

107a CHERET: *La Parisienne*, signed
Watercolour and gouache
$48^4/_5 \times 34^1/_3$ in (124×88 cm)
(formerly Collection Claude Monet)
Musée Marmottan, Paris. Inv.5113

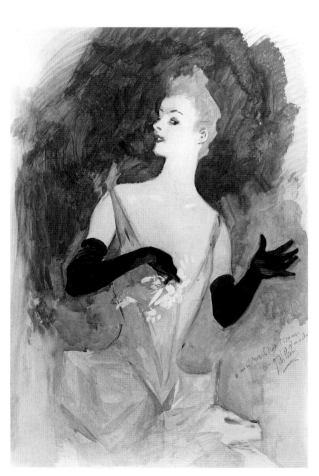

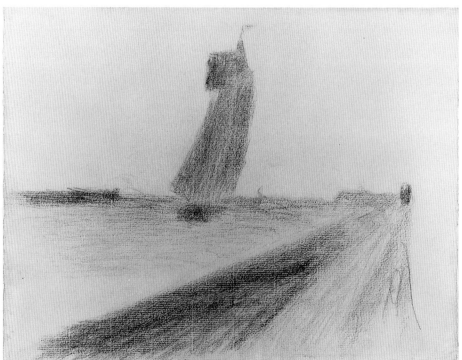

107b *Petit Port-Philippe*, 1890
Conté crayon
$8^2/_3 \times 11$ in (22×28 cm)
Private collection. dH701

108 PIERRE BONNARD
Street scene with horse and cab
c. 1899
Pastel
$8^{7}/_{8} \times 13^{1}/_{3}$ in (22.5 × 34 cm)
Wallraf-Richartz Museum, Cologne. Inv.1925/3050

The practised artlessness of Bonnard's drawing belongs to the history of impressionist drawing. The subject of this vivid sketch may be compared to similar motifs in the drawings of Pissarro and Seurat, and its urgent disarray has all the spontaneous qualities of drawing against time that characterize pursuit of the impression. But there is such a deft hand at work that the few lines indicating the horse amount to a penetrating caricatural resumé, comparable to Degas or Lautrec. The same might be said of the dramatic close-up head in the foreground. The black lines in the drawing represent local values (shadow or colour) in some places, and in others, like the lines of the cab driver or the horse's back, seem to stand for values of emphasis or movement. The drawing relates obliquely to a lithograph of 1899 (Bouvet 1981, No. 68) and the framing white lines top and left suggest the doctoring for other purposes of an on-the-spot sketch.

Bonnard moved towards this sort of artful informality after an earlier manner of drawing that owed more to the decorative arabesque of the Pont-Aven school and to the elegant asymmetry of Japanese prints. The playful character of his early urban motifs which, in his graphic work of 1891-96 particularly, is full of spatial puns, was anticipated by the whimsicality that is visible in some of Gauguin's Breton drawings (cf. Pl.71b). As an intimate of Nabi circles in the early 1890s, Bonnard would have been familiar with this work. His drawing for *The Little Laundress* lithograph (108a), made in lithographic crayon during work on the print, shows in the flat silhouettes of girl and dog a similar witty observation to the incidental animal cameos in the Gauguin.

Bonnard's laundress is a far cry from the pathos-laden figures of Daumier, or even from the resignation of Degas's women. It is picturesque and anecdotal – as a social comment closer to Chaplin than to Zola – and reflects the shift away from heroic mid-century realism effected by the impressionists' treatment of city images: precisely the sort of change and loss that van Gogh lamented. The early art of Vuillard, Sérusier, Denis and the other Nabis was formed by broadly the same instincts, tastes and influences as that of Bonnard. The evolution of Vuillard's drawings during the 1890s enacts a similar transition from a flat Nabi arabesque redolent of various post-impressionist tendencies, towards a more textural manner derived from impressionist painting (108b, cf. Fig.88).

108a Study for *The Little Laundress*, 1896
Lithographic crayon
$12^{1}/_{4} \times 8^{1}/_{4}$ (31.2 × 21 cm)
Metropolitan Museum of Art, New York
(Elisha Whittelsey Collection). Inv. 88.1016

108b VUILLARD: *Four ladies with fancy hats*, 1892/93, initialled
Watercolour over pencil
$8^{1}/_{3} \times 11^{2}/_{3}$ in (21.2 × 29.5 cm)
National Gallery of Art, Washington (Gift of Mr & Mrs Frank Eyerly, Mr & Mrs Arthur G. Altschul, Malcolm Weiner, and the Samuel Kress Foundation). Inv. 1987.12.1

Bibliography

The bibliography does not attempt to be an exhaustive account of the vast but patchy literature: it is constructed around the works most relevant to research for this study. There is a good and substantially different, recent bibliography in Christopher Lloyd and Richard Thompson's pioneering exhibition catalogue, *Impressionist Drawings* (Oxford, 1986).

After a general section, the bibliography is arranged alphabetically by artist. Letters and other primary texts are given first under each artist. Exhibition catalogues are listed under place of origin.

Books that are referred to in the text are cited there by author (or place of origin) and date only, with the exception of catalogues raisonnés and some other definitive works, such as Venturi's *Archives de L'Impressionnisme*. The abbreviations used in these cases are given in front of the relevant entries below. Where there is a definitive edition of an artist's letters, it is cited in the text and notes simply as *Letters* or *Correspondence*, as appropriate, following the artist's name. Where there are several editions of a book, the edition cited in the text is indicated by date.

General and Theoretical writings

Baudelaire, Charles, *Variétés Critiques*, 2 vols., Paris, 1924.
 English translations:
 Jonathan Mayne (ed.), *The Painter of Modern Life*, London, 1964; *Art in Paris 1845–1862*, London, 1965.
 Peter Quennell (ed.), *My Heart Laid Bare and other prose writings*, London, 1986.
Blanc, Charles, *Grammaire des Arts du Dessin*, Paris, 1870.
Boime, Albert, *The Academy and French Painting in the Nineteenth Century*, London, 1971. New edition, New Haven and London, 1986.
Brookner, Anita, *The Genius of the Future: Essays in French Art Criticism*, London, 1971. New edition, Cornell University, 1988.
Chu, P. ten-Doesschate, 'The Evolution of Realist and Naturalist Drawing' in *The Realist Tradition: French Painting and Drawing 1830–1900*, Cleveland Museum of Art, 1981, pp. 21–36.
Couture, Thomas, *Méthode et entretiens d'atelier*, Paris, 1867. Translated as *Conversations on Art Methods*, New York, 1879.
Delacroix, Eugène, *The Journal of Eugène Delacroix*, Paris, 1893–95. English translation, London, 1951; reprinted Oxford, 1980.
Dewhurst, Wynford, *Impressionist Painting, Its Genesis and Development*, London, 1904.
Dewhurst, Wynford, 'What is Impressionism?' in *The Contemporary Review*, Vol. XCIX, March 1911, pp.286–302.
Diderot, Denis, *Sur l'Art et les Artistes* (selected writings), edited by Jean Seznec, Paris, 1967.
Duranty, Edmond, *La Nouvelle Peinture: à propos du groupe d'artistes qui expose dans les Galeries Durand-Ruel* (1876). Text by Marcel Guérin, Paris, 1946 (also, with English translation, in Moffett 1986, pp.37–47).
Fénéon, Félix, *Au delà de l'Impressionnisme* (selected writings), edited by Françoise Cachin, Paris, 1966.
Flint, Kate (ed.), *Impressionists in England: The Critical Reaction*, London, 1984.
Hamilton, George Heard, 'The Dying Light: the late work of Degas, Monet and Cézanne' in Rewald & Weitzenhoffer (eds.), *Aspects of Monet*, New York, 1984.
Huysmans, J. K., *L'Art Moderne*, Paris, 1883.
Huysmans, J. K., *Certains*, Paris, 1889. New edition, 1925.
Laforgue, Jules, 'Impressionnisme', c.1881/83. First published in *La Revue Blanche*, 1896; reprinted in Mireille Dottin (ed.), *Laforgue, Textes de Critique d'Art*, Lille, 1988.
Lecoq de Boisbaudran, Horace, *The Training of the Memory in Art and the Education of Artists*, Paris, 1847; revised 1862. English translation, London, 1911.
Leymarie, Jean, *The Graphic Work of the Impressionists, Manet, Pissarro, Renoir, Cézanne, Sisley*, catalogue by Michel Melot, London, 1973.
Martelli, Diego, *Les Impressionnistes et l'Art Moderne* (selected writings), Paris, 1979.
Moffett, Charles S., and others, *The New Painting: Impressionism 1874–1886*, San Francisco and Oxford, 1986.
Monnier, Geneviève (ed.), *Pastels du XIXe siècle*, Inventory of the collections of the Cabinet des Dessins, Louvre, and the Musée d'Orsay, Paris, 1985.
Nochlin, Linda (ed.), *Realism and Tradition in Art 1848-1900*, New Jersey, 1966.
Oxford, Ashmolean Museum, *Impressionist Drawings*, exhibition catalogue. Text by Christopher Lloyd and Richard Thompson, 1986.
Paris, Louvre, *L'Aquarelle en France au XIXe Siècle*, exhibition catalogue. Text by Arlette Sérullaz and Régis Michel, 1983.
Paris, Musée du Petit Palais, *Pastels*, exhibition catalogue. Text by Marie-Christine Boucher and Daniel Imbert, 1983.
Rawson, Philip, *Drawing*, Oxford, 1969. Revised edition, Pennsylvania, 1987.
Rewald, John, *The History of Impressionism*, New York, 1946. Second edition, 1955.
Rewald, John, *Post-Impressionism, from van Gogh to Gauguin*, New York, 1956.
Rewald, John, *Studies in Impressionism*, London, 1985.
Rewald, John, *Studies in Post-Impressionism*, London, 1986.
Rosen, Charles, and Henri Zerner, *Romanticism and Realism: The Mythology of Nineteenth Century Art*, London, 1984.
Ruskin, John, *The Elements of Drawing*, second edition, London, 1857.
Schiff, Richard, *Cézanne and the End of Impressionism*, Chicago, 1984.
Signac, Paul, *D'Eugène Delacroix au Néo-Impressionnisme* (1899), edited by Françoise Cachin, Paris, 1978. New edition, 1987.
Valéry, Paul, *Degas, Manet, Morisot*, introduction by Douglas Cooper, Princeton, 1960. Includes a translation of *Degas, Danse, Dessin* (1936).
[*Archives*] Venturi, Lionello, *Les Archives de l'Impressionnisme*, 2 vols., Paris, 1939. Reprinted, New York, 1968.
Volland, Ambroise, *En écoutant Cézanne Degas Renoir*, Paris, 1938. New edition, 1985.

Boudin

de Knyff, G., *Eugène Boudin raconté par lui-même. Sa vie – son atelier – son oeuvre*, Paris, 1976.
Paris, Louvre, *Boudin, Aquarelles et Pastels*, exhibition catalogue. Text by Lise Duclaux and Geneviève Monnier, 1963.
Paris, Musée d'Orsay, *Eugène Boudin, dessins inédits*, exhibition catalogue. Text by Laurent Manoeuvre and Rodolphe Rapetti, 1987.

Caillebotte

Berhaut, Marie, *Caillebotte, sa vie et son oeuvre*, Paris, 1978.
Chardeau, Jean, *Les Dessins de Caillebotte*, preface by Kirk Varnedoe, Paris, 1990.
Varnedoe, Kirk, *Gustave Caillebotte*, New Haven, 1987.

Cassatt

Breeskin, Adelyn D., *The Graphic Work of Mary Cassatt, A Catalogue Raisonné*, New York, 1948. New edition, Washington, 1979.
Mathews, Nancy M. (ed.), *Cassatt and her Circle: Selected Letters*, New York, 1984.
Paris, Musée d'Orsay, *Mary Cassatt*, exhibition catalogue, 1988.
Pollock, Griselda, *Mary Cassatt*, New York, 1980.
Washington, National Gallery of Art, *Mary Cassatt: The Color Prints*, exhibition catalogue. Texts by Nancy Mowll Mathews and Barbara Stern Shapiro, 1989.

Cézanne

Paul Cézanne, Letters, edited by John Rewald. Revised edition, Oxford, 1975, Paris, 1978.
Paul Cézanne, Sketchbook, text by C. O. Schniewind, New York, 1951. New edition, 1985.
Cézanne, Carnets de Dessins (facsimile), text by John Rewald, Paris, 1951.
Album de Paul Cézanne (facsimile), text by Adrien Chappuis, Paris, 1966.
Bernard, Émile, *Sur Paul Cézanne*, Paris, 1925.
[C]Chappuis, Adrien, *The Drawings of Paul Cézanne*, 2 vols., London, 1973.
Doran, P. M. (ed.), *Conversations avec Cézanne*, Paris, 1978.
London, Royal Academy, *Cézanne, the early years. 1859–72*, exhibition catalogue. Texts by Lawrence Gowing, Mary Tomkins, Gotz Adriani, Sylvie Patin, 1988.
Newcastle and London, Arts Council of Great Britain, *Watercolour and Pencil Drawings by Cézanne*, exhibition catalogue. Text by Lawrence

Gowing and Robert Radford, 1973.

New York, Museum of Modern Art, *Paul Cézanne, The Basel Sketchbooks*, exhibition catalogue. Text by Lawrence Gowing, 1988.

[R]Rewald, John, *Paul Cézanne: The Watercolours. A Catalogue Raisonné*, London, 1984.

Rilke, Rainer Maria, *Letters on Cézanne* (1952). English translation, New York, 1985.

[V]Venturi, Lionello, *Cézanne, son art, son oeuvre*, 2 vols., Paris, 1936.

Degas
Degas Letters, edited by Marcel Guérin, Oxford, 1947.

Adhémar, Jean, and Françoise Cachin, *Degas, The Complete Etchings, Lithographs and Monotypes*, Paris, 1973, London, 1974.

Chicago, Art Institute, *Degas in The Art Institute of Chicago*, exhibition catalogue. Texts by Richard Brettell and Suzanne McCullagh, New York, 1984.

Copenhagen, Ordrupgaardsamlingen, *Degas et la famille Bellelli*, exhibition catalogue. Texts by Hanne Finsen and Jean Sutherland Boggs, 1983.

[L]Lemoisne, P.-A., *Degas et son Oeuvre*, 4 vols., Paris, 1946–49.

Manchester, Whitworth Art Gallery, *The Private Degas*, exhibition catalogue. Text by Richard Thompson, 1987.

Reff, Theodore (ed.), *The Notebooks of Edgar Degas*, 2 vols., Oxford, 1976.

Reff, Theodore, *Degas, The Artist's Mind*, New York, 1976. New edition, 1987.

Valéry, Paul, *Degas, Danse, Dessin*, Paris, 1936. New edition 1983. English translation in Valéry, *Degas, Manet, Morisot*, Princeton, 1960.

Vollard, Ambroise, *Degas, An Intimate Portrait*, New York, 1926. New editions, 1937, 1986.

Fantin-Latour
Fantin-Latour, Madame, *Catalogue de l'Oeuvre Complet (1848-1904) de Fantin-Latour*, Paris, 1911. New Edition, Amsterdam and New York, 1969.

Ottawa, National Gallery of Canada, *Fantin-Latour*, exhibition catalogue. Text by Douglas Druick and Michel Hoog, 1983.

Gauguin
Notes Synthétiques, c.1844–88, in the Breton Carnet, Armand Hammer Collection. Facsimile edition with text by Raymond Cogniat and John Rewald, New York, 1961.

Cahier pour Aline, 1893, Fondation Jacques Doucet, University of Paris. Facsimile editions, Paris, 1963, Bordeaux, 1989.

Diverses Choses, c.1896/98, in the *Noa Noa* manuscript, Cabinet des Dessins, Louvre, Paris. Excerpts translated in *Oviri, Writings of a Savage*, 1978.

Racontars de Rapin, c. 1898–1902, Josefowitz Collection, Paris, 1951.

Avant et Après, 1903. Facsimile edition, Leipzig, 1918.

Paul Gauguin, Lettres à sa Femme et ses Amis, text by M. Malingue, Paris, 1946.

Lettres de Gauguin à Daniel de Monfried, edited by A. Joly-Segalen, text by Victor Segalen, Paris, 1918. Fourth edition, 1919.

Correspondance de Paul Gauguin, I, edited by Victor Merlhès, Paris, 1984.

Oviri, Ecrits d'un sauvage, edited by Daniel Guérin, Paris, 1974. Translation, with additional text by Wayne Andersen, New York, 1978.

Le Carnet de Paul Gauguin (facsimile), text by René Huyghe, Paris, 1952.

P. Gauguin, Carnet de Tahiti (facsimile), text by Bernard Dorival, Paris, 1954.

Bodelsen, Merete, 'Gauguin the Collector' in *Burlington Magazine*, September 1970, pp.590–615.

Field, Richard, *Paul Gauguin: Monotypes*, exhibition catalogue, Philadelphia Museum of Art, 1973.

Guérin, Marcel (ed.), *L'Oeuvre Gravé de Gauguin*, 2 vols., Paris, 1927.

Pickvance, Ronald, *The Drawings of Gauguin*, London, 1970.

Wadley, Nicholas, *Noa Noa, Gauguin's Tahiti*, Oxford, 1985.

Washington, National Gallery of Art, *The Art of Paul Gauguin*, exhibition catalogue. Texts by Richard Brettell, Françoise Cachin, Claire Frèches-Thory, Charles Stuckey, 1988.

[GW]Wildenstein, Georges, *Gauguin*, Vol. I, *Catalogue*, Paris, 1964. Edited by Raymond Cogniat and Daniel Wildenstein.

Manet
Bareau, Juliet Wilson, *The Hidden Face of Manet* (text to an exhibition at the Courtauld Institute Galleries, London), in *Burlington Magazine*, April 1986.

Guérin, Marcel (ed.), *L'Oeuvre Gravé de Manet*, Paris, 1944.

Hamilton, George Heard, *Manet and his Critics*, New York, 1954.

Harris, J. C. *Edouard Manet: Graphic Works, a Definitive Catalogue Raisonné*, New York, 1970.

[JW]Jamot, Paul, and Georges Wildenstein, *Manet*, Paris, 1932.

[dL]de Leiris, A., *The Drawings of Edouard Manet*, Berkeley and Los Angeles, 1969.

Paris, Grand Palais, *Manet*, exhibition catalogue. Text by Françoise Cachin, Anne Coffin Hansen, Charles S. Moffett, Michel Melot, 1983.

Proust, Antonin, *Edouard Manet, Souvenirs* (1897). New edition, Paris, 1988.

Washington, National Gallery of Art, *Manet and Modern Paris*, exhibition catalogue. Text by Theodore Reff, 1982.

Monet
Aitken, Geneviève, and Marianne Delafond, *La Collection d'Estampes Japonaises de Claude Monet à Giverny*, Giverny, 1983.

Bakker, Boudewijn, and others, *Monet in Holland*, catalogue by Ronald Pickvance, Amsterdam, 1986.

Delafond, Marianne, *Monet et son Temps*, catalogue of the Musée Marmottan, Paris, 1987.

Geffroy, Gustave, *Claude Monet, Sa Vie, Son Oeuvre*, Paris, 1924. New edition, Paris, 1980.

Gordon, Robert, and Andrew Forge, *Monet*, New York, 1983.

House, John, 'Monet's Drawings' in House, *Monet, Nature into Art*, New Haven and London, 1986, pp.227–230.

Rewald, John, and F. Weitzenhoffer, (eds.), *Aspects of Monet*, New York, 1984.

Seitz, William, *Claude Monet*, New York, 1960.

Stuckey, Charles (ed.), *Monet, a Retrospective*, New York, 1985.

Thiébault-Sisson, F., 'Claude Monet, un Entretien', in *Le Temps*, 27 November 1900. Trans. *Art News Annual* 1957, Part II.

[W]Wildenstein, Daniel, *Monet, biographie et catalogue raisonné*, 4 vols., Lausanne and Paris, 1974–1985. (The catalogue raisonné of drawings is about to be published.)

Morisot
The Correspondence of Berthe Morisot, edited by Kathleen Adler and Tamar Garb, London, 1986.

Bataille, M.-L., and G. Wildenstein, *Berthe Morisot, Catalogue des Peintures, Pastels et Aquarelles*, Paris, 1961.

Mongan, Elisabeth, *Berthe Morisot – Drawings, pastels and watercolours*, New York, 1960.

Paris, Musée Jacquemart-André, *Berthe Morisot*, exhibition catalogue (incorporating facsimile sketchbook), 1961.

Pissarro
Camille Pissarro, Letters to his son Lucien, edited by John Rewald, New York, 1943. New edition, 1980.

Brettell, Richard, and Christopher Lloyd, *A Catalogue of the Drawings by Camille Pissarro in the Ashmolean Museum, Oxford*, Oxford, 1980.

Lloyd, Christopher (ed.), *Studies on Camille Pissarro*, London and New York, 1986.

London, Hayward Gallery, *Pissarro*, exhibition catalogue. Text by Richard Brettell, Françoise Cachin, Christopher Lloyd and others, 1980.

Pissarro, Ludovic, and Lionello Venturi, *Camille Pissarro, son art, son oeuvre*, 2 vols., Paris, 1939.

Redon
Redon, Odilon, *A Soi-Même*, journal 1867–1915, Paris, 1922 (includes 'Confidences d'Artiste', 1909). New editions, 1961 (cited here) and 1979. English translation of extracts, *To Myself*, New York, 1986.

Odilon Redon, Critiques d'Art, Bordeaux, 1987.

Lettres d'Odilon Redon, 1878–1916, Paris, 1923.

Lettres Inédites d'Odilon Redon, edited by Suzy Levy, Paris, 1987.

Lettres de Gauguin, Huysmans, Mallarmé . . . à Odilon Redon, edited by Arï Redon, Paris, 1960.

Bacou, Roseline, *Odilon Redon*, 2 vols., Geneva, 1956.

Mellerio, André, *Odilon Redon. Peintre, Dessinateur, Graveur*, Paris, 1923.

Rewald, John, 'Some Notes and Documents on Odilon Redon' (1956), in Rewald, *Studies in Post-Impressionism*, London, 1986.

Rewald, John, 'Odilon Redon' in *Odilon Redon, Gustave Moreau, Rodolphe Bresdin*, New York, 1962.

Renoir
Renoir: Carnet de Dessins – Renoir en Italie et en Algérie, text by Albert André and Georges Besson, Paris, 1955.
Leymarie, Jean, *Les Pastels, Dessins et Aquarelles de Renoir*, Paris and London, 1949.
Renoir, Jean, *Renoir My Father*, London, 1962.
Rewald, John, *Renoir Drawings*, New York, 1946. New edition, 1958.
Vollard, Ambroise, *Tableaux, pastels et dessins de P.-A. Renoir*, Paris, 1918. New edition, 1954.
White, Barbara E., *Renoir*, London and Paris, 1986.

Seurat
Dorra, Henri, and John Rewald, *Seurat*, Paris, 1959.
Franz, Erich, and Bernd Growe, *Georges Seurat, Drawings*, Boston, 1984.
[dH]de Hauke, César M., *Seurat et son Oeuvre*, 2 vols., Paris, 1961.
Herbert, Robert L., *Seurat's Drawings*, New York, 1962.

Toulouse-Lautrec
Delteil, Loys, *Le Peintre-Graveur Illustré X–XI, H. de Toulouse-Lautrec*, Paris, 1920.
Dortu, M. G., *Toulouse-Lautrec et son Oeuvre*, 6 vols., New York, 1961.
Goldschmidt, Lucien, and Herbert Schimmel, *Unpublished Correspondence of Toulouse-Lautrec*, London, 1969.

van Gogh
The Complete Letters of Vincent van Gogh, 3 vols., London, 1958.
Bernard, Émile (ed.), *Lettres de Vincent van Gogh à Émile Bernard*, Paris, 1911.
[F]de la Faille, J. B., *L'Oeuvre de Vincent van Gogh, Catalogue Raisonné*, Vols. III and IV (drawings, watercolours and lithographs), Paris,

1928. Revised edition (cited here), *The Works of Vincent van Gogh: His Paintings and Drawings*, edited by A. M. Hammacher et al, Amsterdam, London and New York, 1970.
London, Marlborough Fine Art, *Van Gogh's Life in his Drawings*, exhibition catalogue. Text by A. M. Hammacher, 1962.
New York, Metropolitan Museum of Art, *Van Gogh in Arles*, exhibition catalogue. Text by Ronald Pickvance, 1984.
New York, Metropolitan Museum of Art, *Van Gogh in St Rémy and Auvers*, exhibition catalogue. Text by Ronald Pickvance, 1986.
Nottingham University, *English Influences on Vincent van Gogh*, exhibition catalogue. Text by Ronald Pickvance, 1974.
Otterlo, Rijksmuseum Kröller-Müller, *Catalogue of 272 Works by Vincent van Gogh*. Text by J. G. van Gelder, 1959.
Otterlo, Rijksmuseum Kröller-Müller, *Vincent van Gogh, Drawings*, exhibition catalogue. Text by Johannes van der Wolk, Ronald Pickvance, E. B. F. Pey, 1989.
Paris, Musée d'Orsay, *Van Gogh à Paris*, exhibition catalogue. Text by Ronald Pickvance, 1988.
Wadley, Nicholas, *The Drawings of van Gogh*, London, 1969.
van der Wolk, Johannes, *Seven Sketchbooks of Vincent van Gogh*, London, 1987.

Whistler
Whistler, James McNeill, 'The Ten-o-Clock Lecture' 1888, in *The Gentle Art of Making Enemies*, London 1890, revised 1892. New edition, New York, 1967.
Pennell, E. R. and J., *The Life of James McNeil Whistler*, Philadelphia, 1925.

INDEX